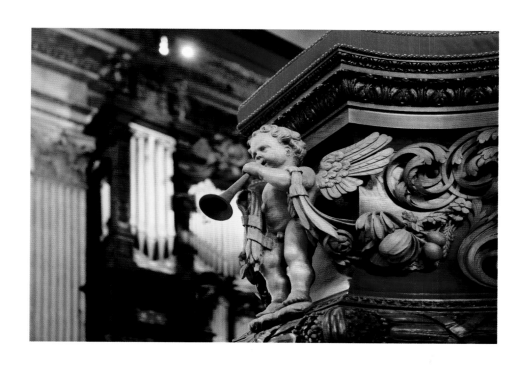

LONDON
EXPLORED

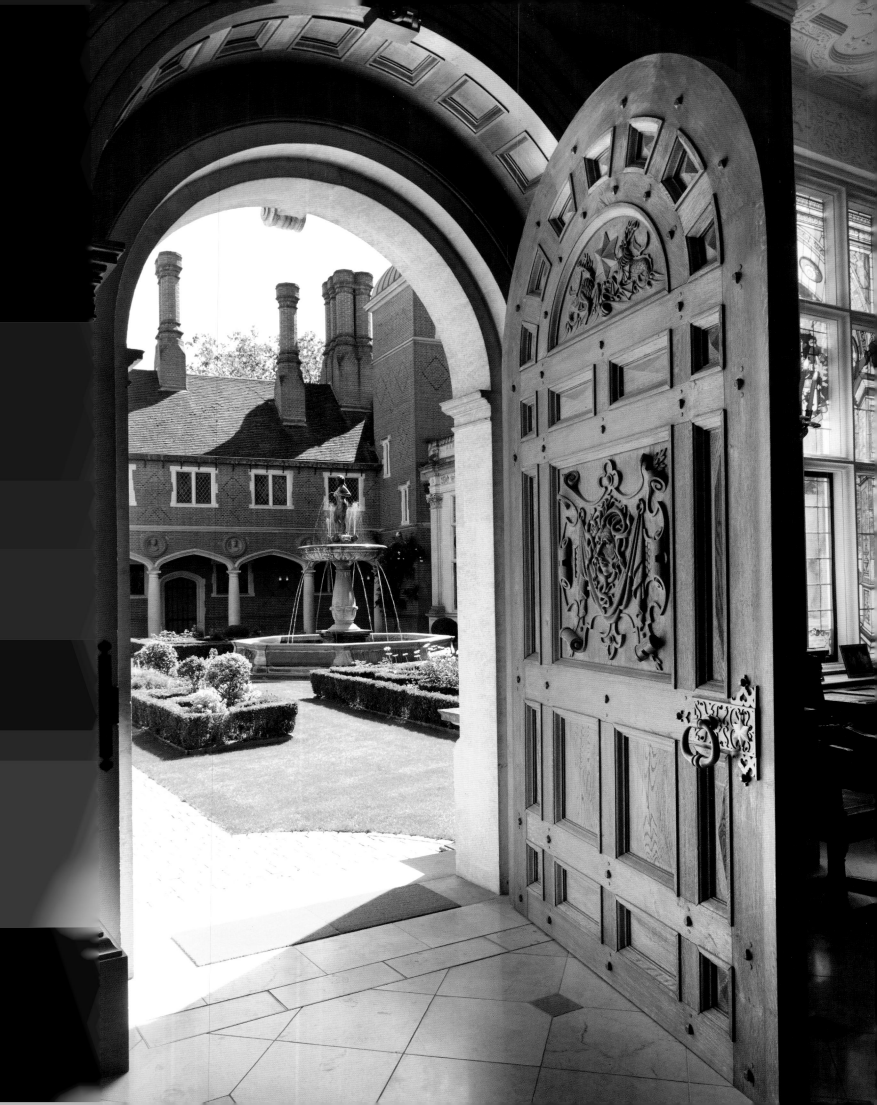

PHOTOGRAPHS BY **PETER DAZELEY**
TEXT BY **MARK DALY**

LONDON EXPLORED

SECRET, SURPRISING AND UNUSUAL
PLACES TO DISCOVER IN THE CAPITAL

F

FRANCES
LINCOLN

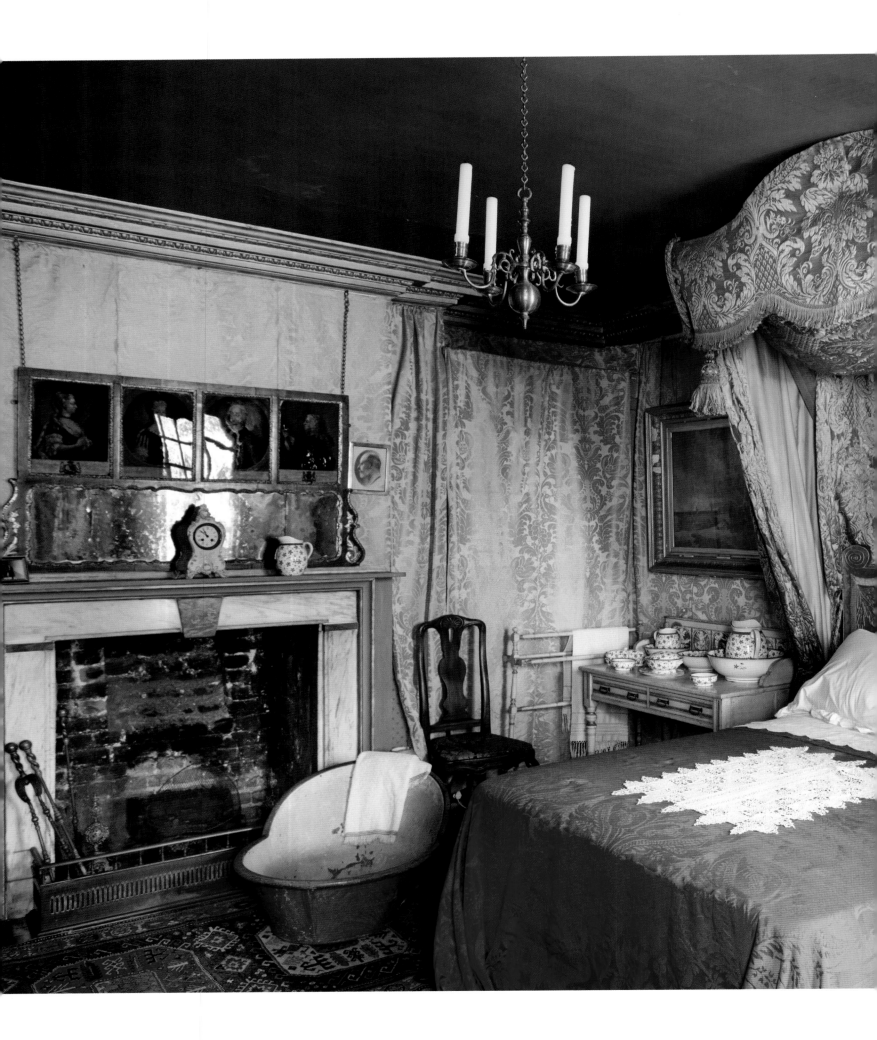

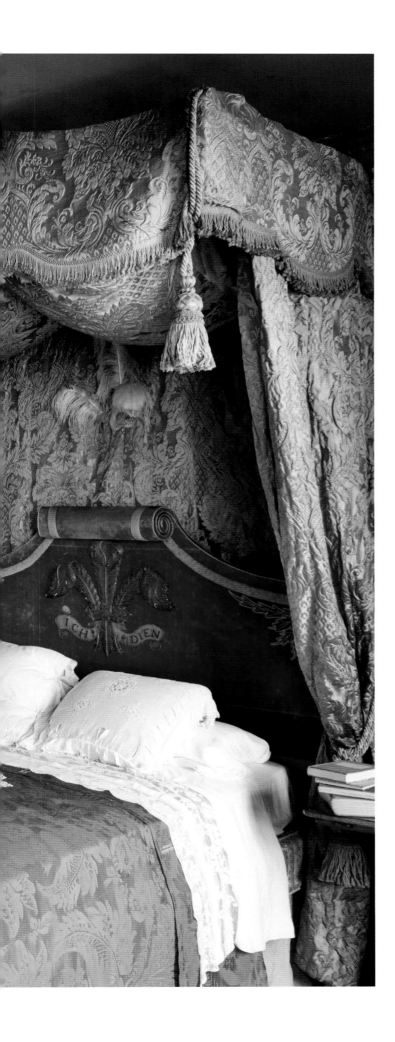

Contents

HALF-TITLE *A wood carving of a cherub with trumpet, St Paul's Cathedral.*

TITLE PAGE *The massive oak door of Crosby Moran Hall's Great Hall is embellished with the head of Medusa.*

LEFT *The Prince of Wales Bedroom, Southside House.*

Introduction

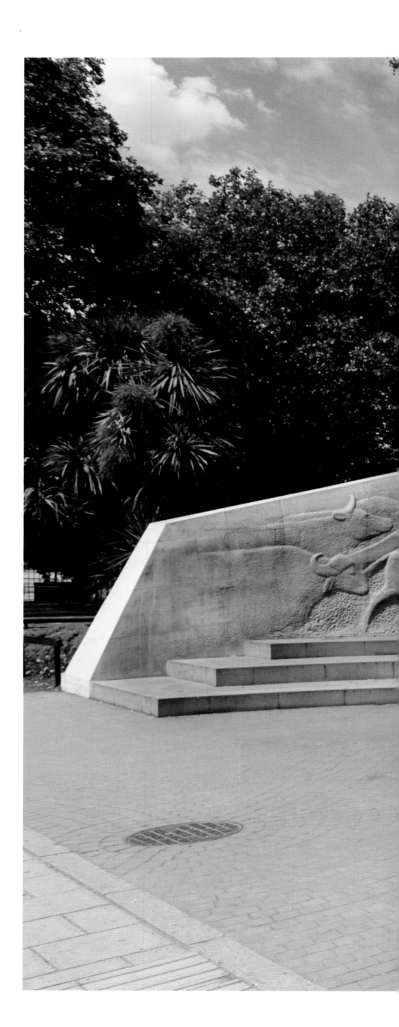

Five churches and a café, two distilleries and a brewery, two poets and an actor, three subterranean enigmas: it is tempting to look for over-arching classifications for the 213 pictures on the following pages, but the only common factors are the discerning eye of the acclaimed photographer Peter Dazeley and, of course, London itself.

In *London Explored*, the images have been grouped by location within areas of London and points of the compass. Following the books *Unseen London*, *London Uncovered*, and *London Theatres*, Peter Dazeley has aimed his lens at locations that are sometimes further afield and less familiar, although that is not true in every case. Nothing could be more conspicuous or monumental, for example, than Admiralty Arch, poised for a change of purpose as this book closed for press. The tallest place featured here is the dome of St Paul's Cathedral. The deepest is the shelter at Clapham South tube station. In each place, fascinating facets and angles have been captured. At the OXO Tower, for example, the medium truly is the message. A colossal machine lurks in Southwark Street. At Ealing, the cleanly restored Pitzhanger Manor, country home of architect Sir John Soane, now stands in contrast with his teeming house-museum at Lincoln's Inn.

Memorials stir mixed emotions. The massive Albert Memorial profiled here was regarded for years as an anachronism, disliked by the modern-minded, and neglected, yet now restored and rehabilitated. There is also a pump standing as a monument commemorating actions to tackle a cholera epidemic in 1854, now resonating more strongly in post-COVID-19 London. The Animals in War Memorial on the eastern side of Hyde Park at Brook Gate, Park Lane, unveiled in 2004, was warmly received from the start and is now established as a landmark. The curved Portland stone wall represents the arena of war, with bronze statues of animals –

The Animals in War Memorial, Park Lane.

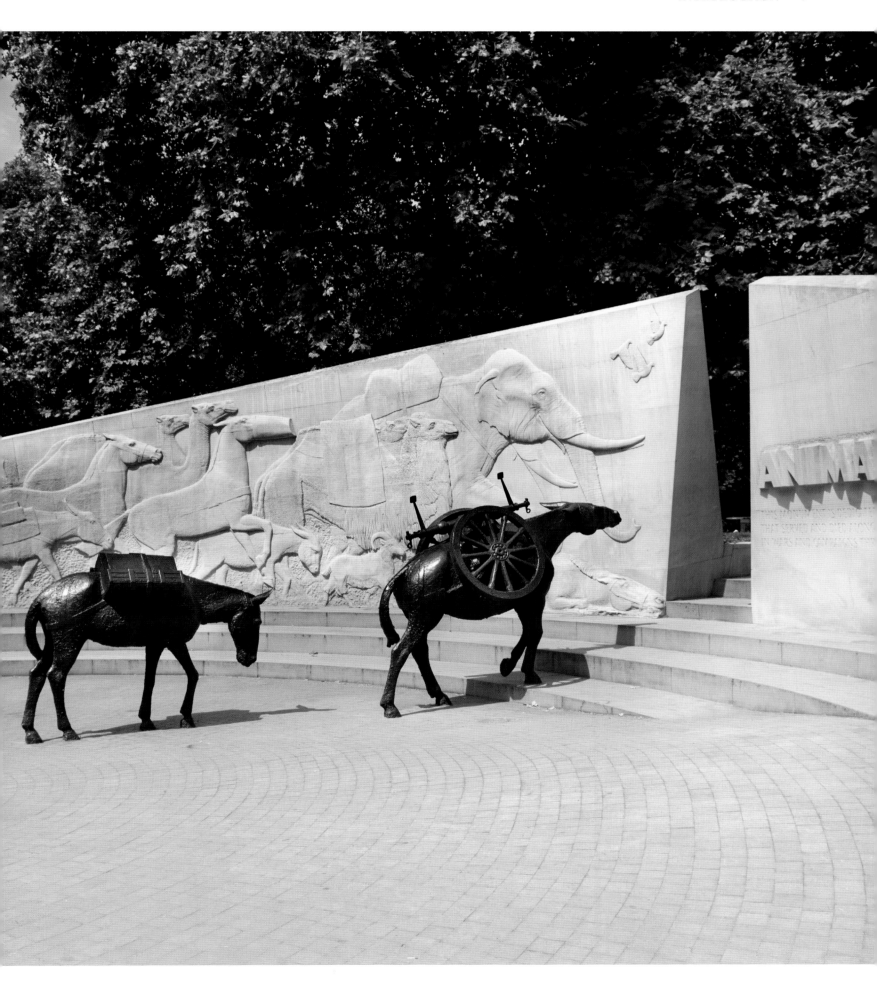

horse, dog and mules – commemorating the numberless creatures that have served and died under British military command. The statue of the leading mule is particularly precise and detailed – the load it is carrying is part of a gun carriage. An inscription pays tribute to the role of animals ranging from 'the pigeon to the elephant'. Animals used in twentieth-century conflicts are depicted in bas-relief on the inside of the wall, while on the outside a line of ghostly silhouettes is carved, representing the animals lost. The sculptor is David Backhouse.

A quite different monument, or something resembling a monument, is the notorious EdStone, whose creators might wish to live down. The carved tablet carried manifesto pledges over the engraved signature of then Labour Party leader Ed Miliband for the General Election of May 2015 and was unveiled in a car park in Hastings, a marginal parliamentary seat. It was said that the intention was to erect the stone in the rose garden at 10 Downing Street or in the party's headquarters had Labour won the election. Widely mocked and derided, the EdStone was not seen for two years until it appeared in the Ivy Chelsea Garden Restaurant, 195 King's Road, in 2017 and it has since been moved to the house of a collector. It was said at the time that it had been found in a charity auction and purchased as a garden ornament. That, at least, is the legend, although there are some who insist the stone was destroyed in the weeks following the election and there was talk of a replica

being made. Some mystery still remains about the lost years of the EdStone.

Ancient stonework with mysterious migration more accurately describes the ruins of the Temple of Mithras (London Mithraeum), unearthed in 1954, rebuilt in a car park near the Bank of England and now spectacularly repositioned under the Bloomberg Building in one of the most advanced display environments in London. Similarly, London Stone, now to be seen at Cannon Street, has moved at least five times to avoid destruction or disposal. Its purpose remains obscure – again, myths and legends apply. The most remarkable example of migration must be Crosby Moran Hall, built at Bishopgate in the 1400s and once occupied by Sir Thomas More, which was dismantled brick by brick and relocated to Chelsea in 1910 and was still being developed in 2021.

Peter Dazeley has lived in London all his life and his previous books have profiled more than 150 places in London. Yet, for him, the journey of discovery is far from complete and he says research is still taking him to places that he once had no idea existed. He says: 'I hope this book will entertain and inspire people to go out and explore London for themselves.'

The 2015 Labour Party's EdStone, photographed in the Ivy Chelsea Garden Restaurant. It has now mysteriously disappeared.

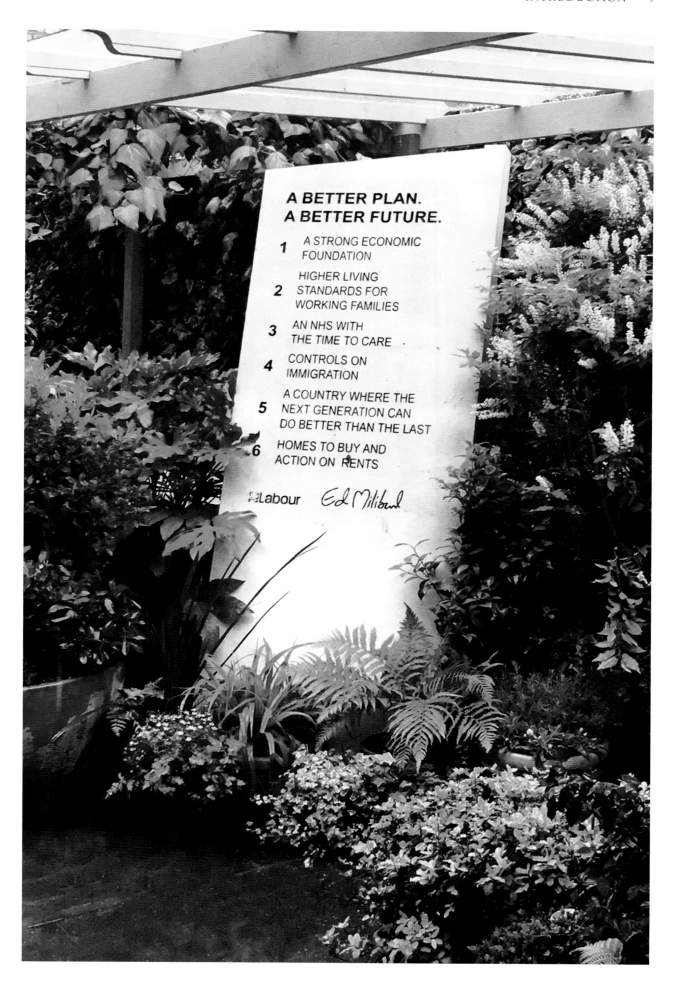

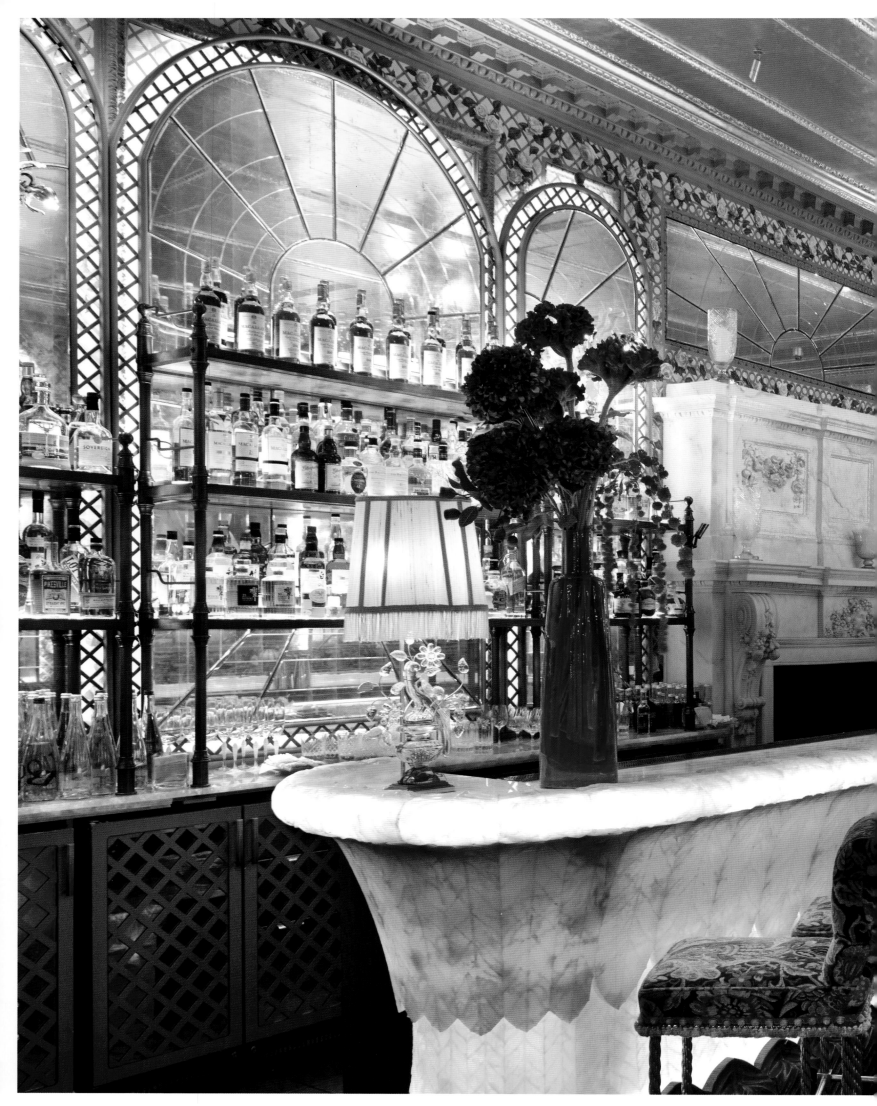

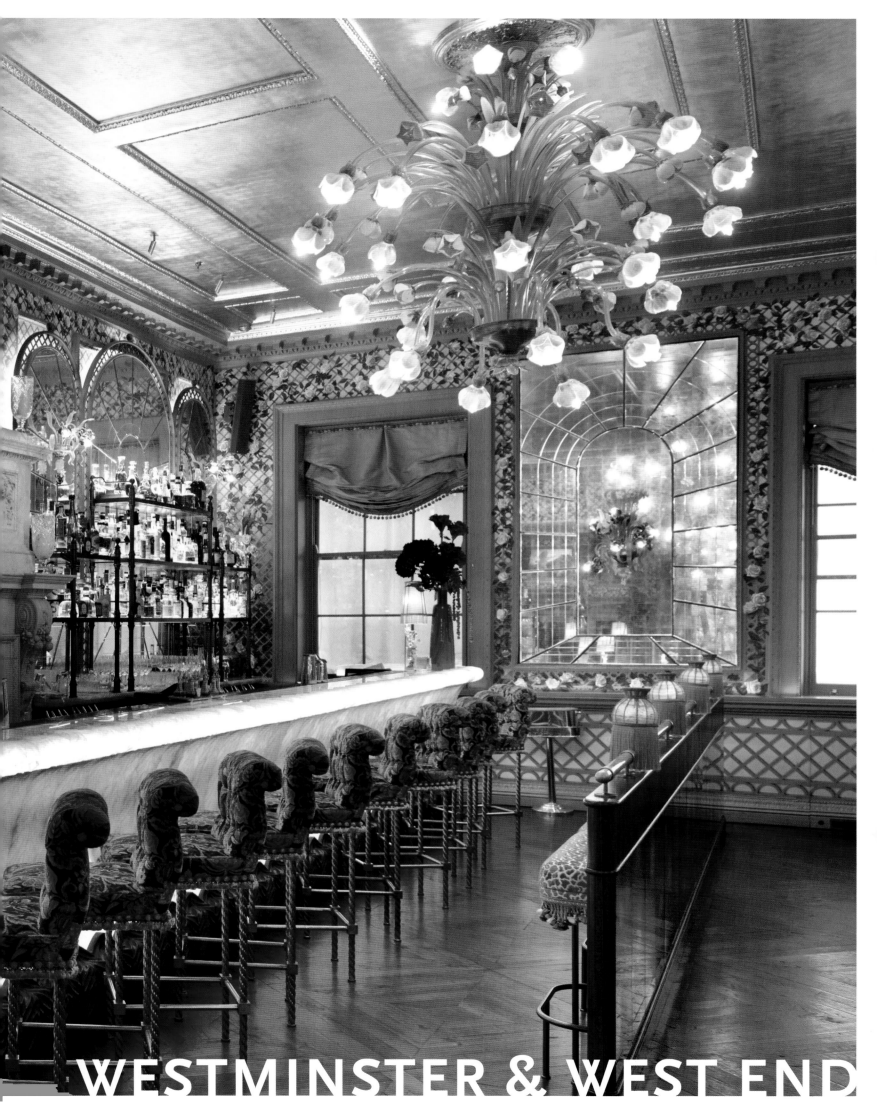

WESTMINSTER & WEST END

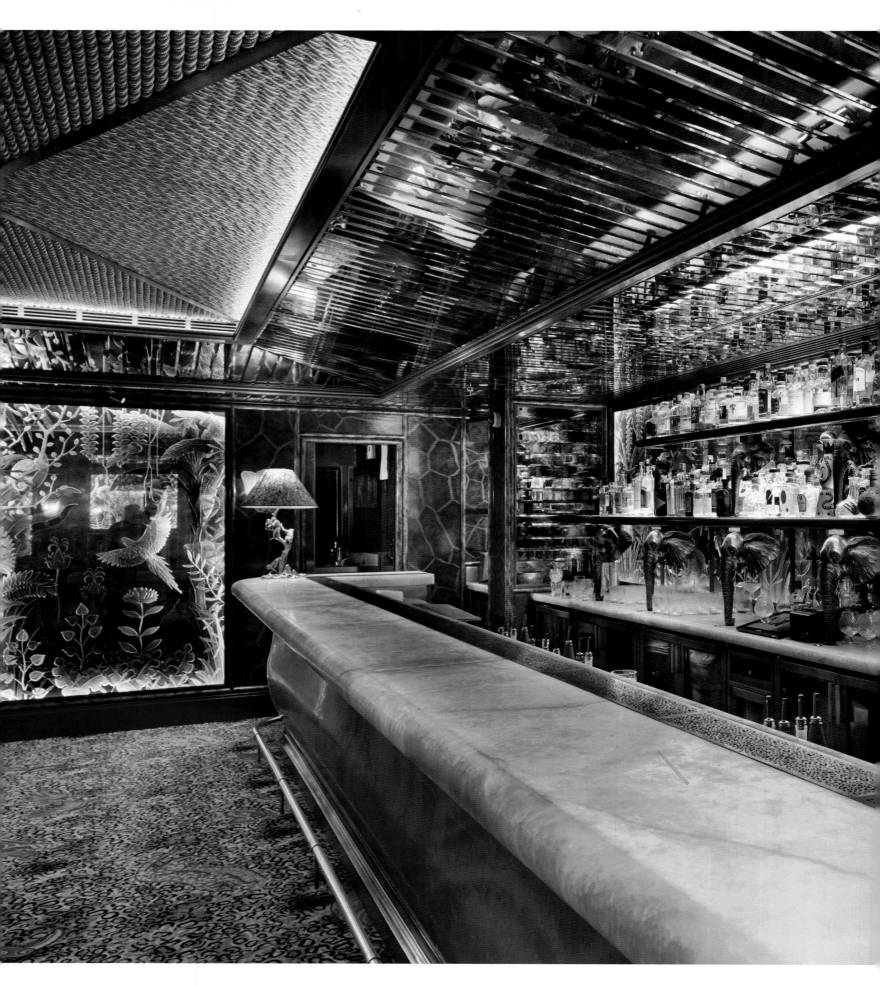

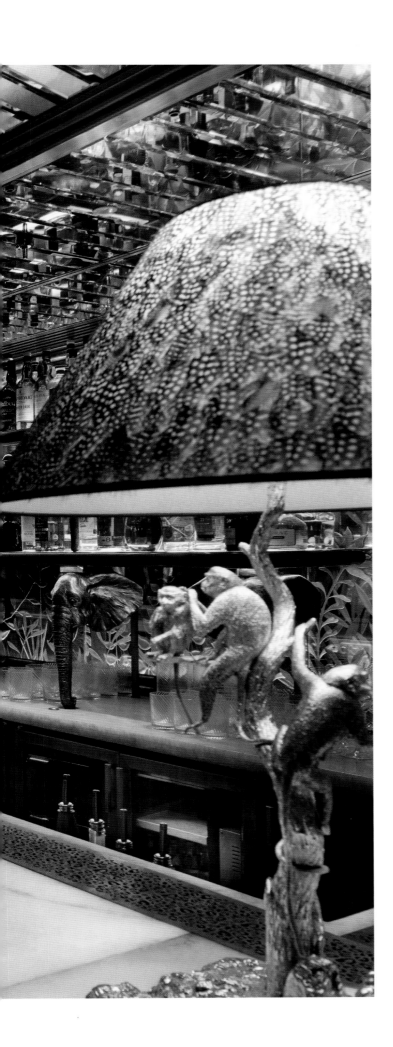

Annabel's

Annabel's club is spread across four floors of an eighteenth-century townhouse in Berkeley Square. Its seven bars, four restaurants, private dining rooms, cigar salon and garden terrace are all decorated in a lavish maximalist style. In the basement lies a nightclub with dancefloor and stage, a place described by the operators as a seductive decadent paradise.

Annabel's owner, Richard Caring, fashion tycoon and restaurateur, commissioned interior designer Martin Brudnizki to transform the house with decorative themes of flora and fauna running throughout the building. The result left seemingly every surface painted, carpeted, tiled, papered or mirrored, with decorations from floor to ceiling inspired by creatures wild and gardens exotic. The theme is followed through to the Jungle Room, the Elephant Room and the Rose Room. The subterranean nightclub was inspired by the style of the painting *Adam and Eve in the Garden of Eden* by Johann Wenzel Peter, its hydraulic dance floor rising to make a stage as faux palm trees made of brass and glass vibrate to the beat of music.

Real trees on the garden terrace evoke a verdant woodland glade or a Georgian orangery, with seats and tables surrounded by extensive plantings. This can be experienced inside or out – the terrace is topped with a powered retractable steel-and-glass roof, designed by renowned steel designers, architects and engineers, Waagner Biro.

It was the exotic frivolity of the ladies' powder room that generated the most headlines when Annabel's reopened in 2018. Thousands of handmade silk flowers line the ceiling and hand-carved basins of pink onyx in the shape of oyster shells are fitted with gold swan taps, while the walls are covered in

PREVIOUS PAGES *The Rose Room bar at Annabel's.*

LEFT *Illuminated amber onyx counter, silver elephants under the shelves and cavorting creatures on the lamps in the Jungle Room bar.*

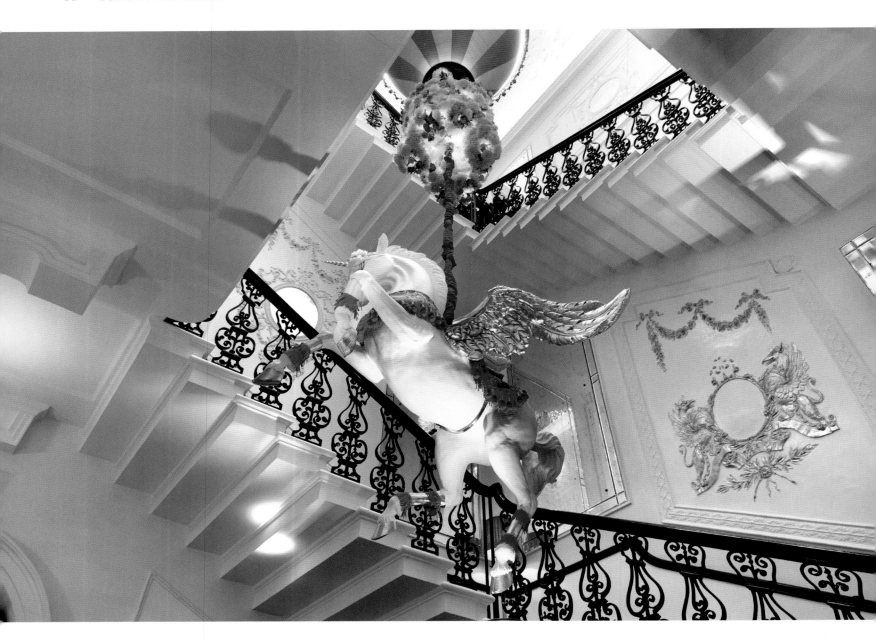

embroidered fabric, and the floor and lower walls are made of pink and grey marble.

The Legacy Bar in the basement, reserved for a special higher tier of membership, has a green agate tiled floor, antique mirror-glass walls and hangings including work by Modigliani, Léger and Chagall. In the reception hall, illumination is provided by floor-to-ceiling chandeliers and visitors are greeted with a painting by Pablo Picasso dating from 1937, once known as *The Girl with the Red Beret and Pompom*. This was purchased for more than £20 million by the club owner and was boldly re-christened *Annabel*. A grand, open-well stone staircase with fine ironwork

from the 1740s remains and the stairwell is finished entirely in white as a soothing contrast to the rest of the decor. In the void flies a sculpture of Pegasus with a unicorn's horn, suspended from a hot-air balloon.

Annabel's opened in 1963 just as London began to get hip. Mark Birley, a well-connected, well-born and artistically inclined businessman, started it in the basement of 44 Berkeley Square, under the floors of the Clermont Club (see pages 42–7), London's first licenced casino. Birley's then wife, Lady Annabel Vane-Tempest-Stewart, who lent her name to the club, has said this quickly became the most hedonistic address in London.

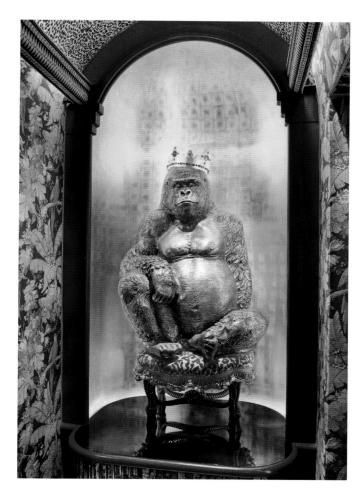

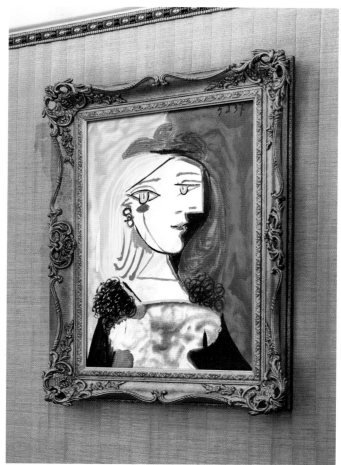

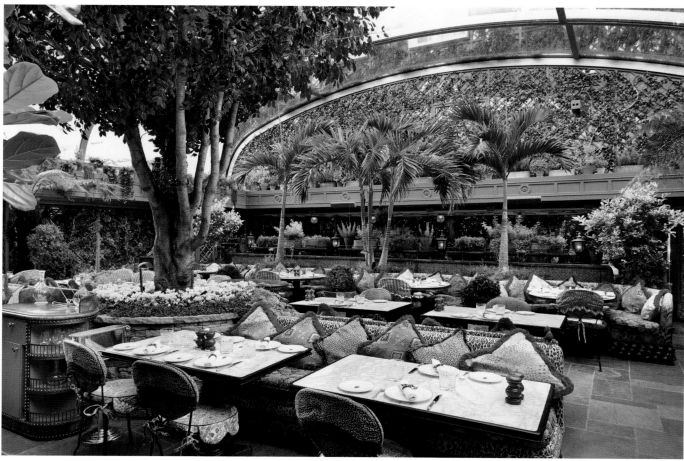

Annabel's club forged a style of its own, managing to be both old-exclusive and modern-eclectic. A place where aristocrats and visiting Hollywood players rubbed shoulders with contemporary rock stars and occasionally a member of the Royal Family, and where music met film and fashion in the spirit of the changing age. Frank Sinatra was an early member, John Wayne, Elizabeth Taylor and the Beatles and the Rolling Stones were visitors, and later Jack Nicholson, Kate Moss, Naomi Campbell, Diana Princess of Wales and Madonna. Birley's eye was for a decorative style that evoked a cosy English country house with his own collection of animal paintings and prints; at candlelit tables guests ate dinner seated on banquettes trimmed in red velvet; there were intimate nooks and the tiny dancefloor hidden at the back of the club was dimly lit. There was no real cabaret, but occasionally performers such as Ray Charles and Ella Fitzgerald played one-night stands. An unverifiable claim is that it is the only nightclub ever attended by the Queen, who drank a martini there in 2003.

Annabel's relocated to 46 Berkeley Square in 2018, having moved a few paces from number 44, to become no longer enclosed in a basement, much expanded and also no longer nocturnal. The club is open from 7.30a.m. to 3p.m. during weekdays. It remains a private members club, although it is sometimes home to launches and prestige parties and gatherings. The membership is described as 'diverse, eclectic and cosmopolitan', a 'hand-picked alchemy of like-minded people'.

—

Annabel's

46 Berkeley Square

London W1J 5AT

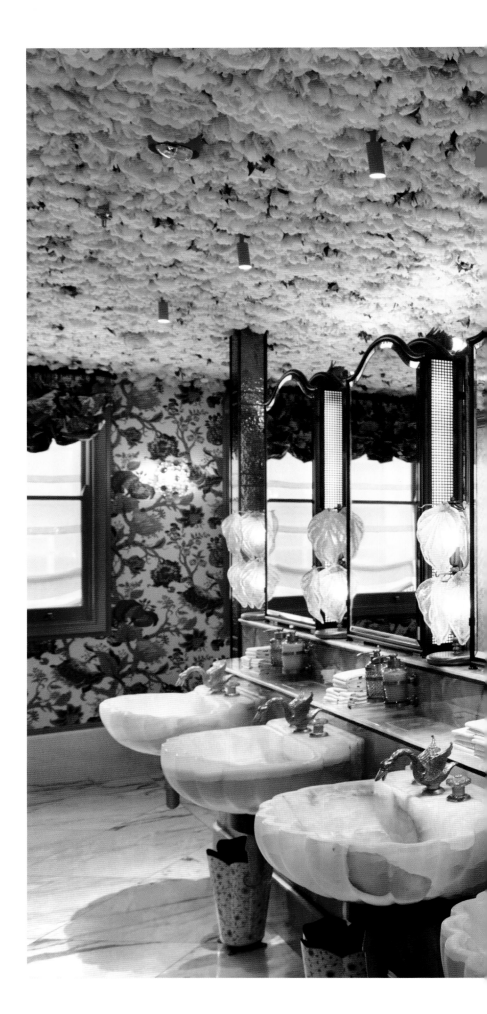

The ladies' powder room with gold swan taps and basins hand-carved from pink onyx.

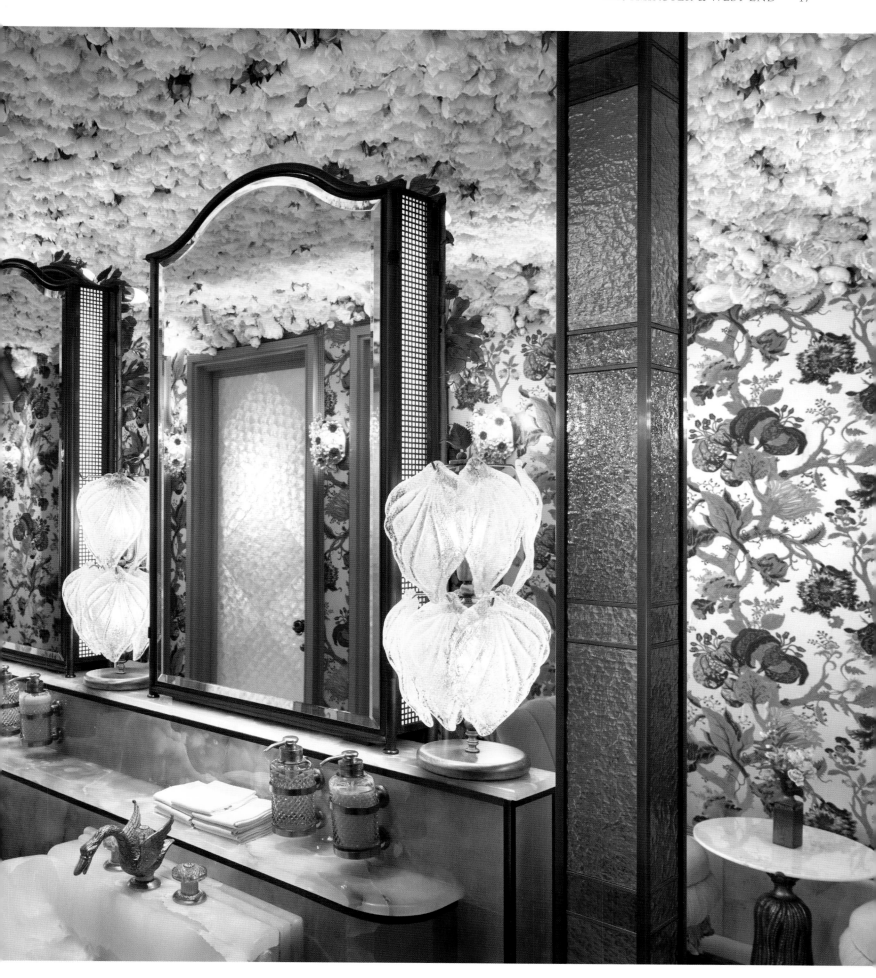

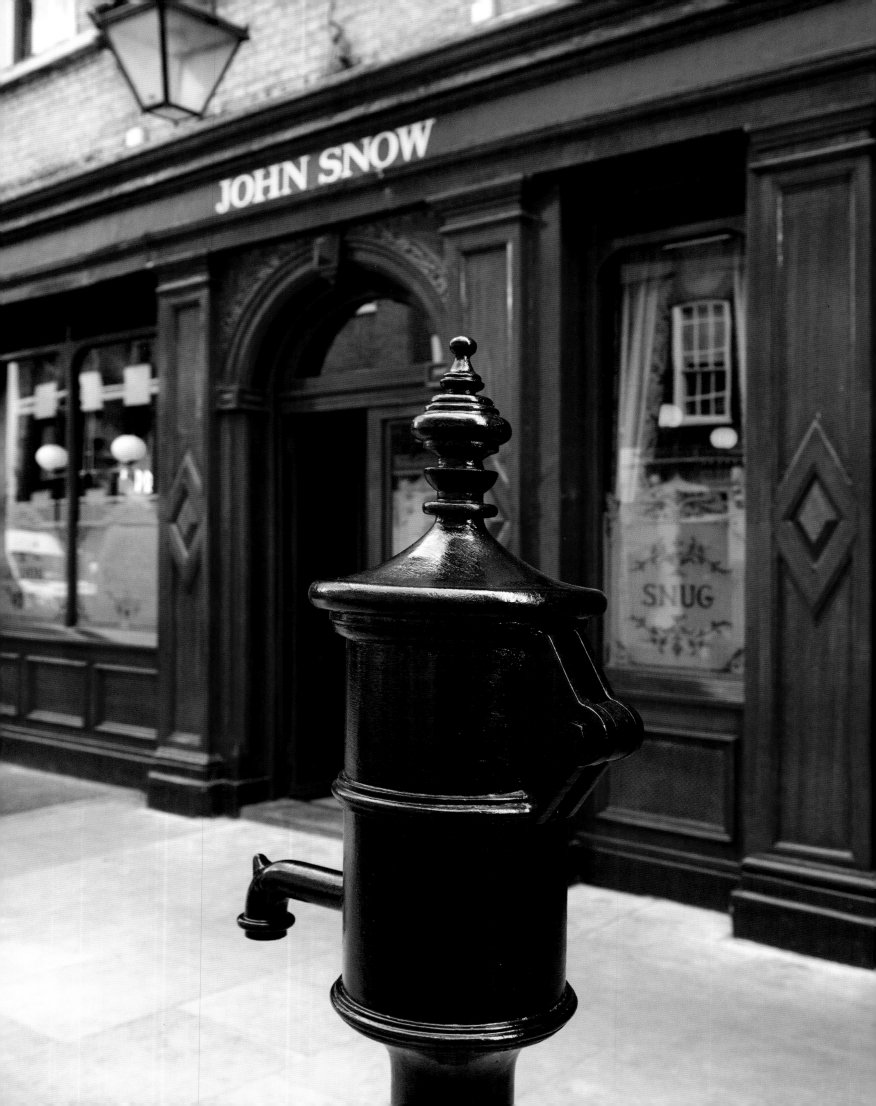

John Snow Water Pump

A piece of street furniture in Soho stands as an idiosyncratic symbol of an advance in public health. The Victorian pump on Broadwick Street outside the John Snow public house can never function because the handle has been removed.

The pub is named for a doctor who discovered that cholera was transmitted through water. John Snow, surgeon, early anaesthesiologist and pioneer of epidemiology, lived nearby in Sackville Street in 1854. He had studied cholera and developed a theory about its communication. In a new outbreak, he noted the cluster of deaths in the area and plotted them on a street map. Through enquiries made door to door, he had already found where the victims had drawn their water. The evidence was that those who fetched water from the pump on Broad Street developed cholera, but the idea was hard to support. The well had been established for around one hundred years; its water was cool, sparkling and visibly clean, being preferred by local people over other sources. There seemed to be no fault with the pump. Snow's idea also denied the prevailing theory held by medical authority at the time that cholera was transmitted by emanations through the air in a form of miasma.

Against the grain Snow persuaded the parish Board of Governors to remove the handle from the Broad Street pump. This was done on 8 September 1854 and can be claimed as the first scientific act of intervention in public health medicine. The pump shaft was later proved to be contaminated with water leaking from a hidden cesspit – the source of the cholera. Snow was vindicated, but years passed before his theory was confirmed by science and gained full acceptance. The shaft was relined; the handle was refitted in 1855. The pump was reported disused and covered over by 1884. A pub opened just by the site. This was named the John Snow in the hundredth year after the removal of the handle. Broad Street had become Broadwick Street in the 1930s. Strict unbroken continuity does not apply, but the site of the pump was logged, and a replica was erected nearby in 1992. When the pavement outside the John Snow was widened in 2018, the replica pump was moved to the original site.

The John Snow Society, which includes many leading figures in public health medicine, holds its annual general meeting at the pub. Its keynote talk at the London School of Hygiene & Tropical Medicine is called the Pumphandle Lecture, which is accompanied by the ceremony of removing and then replacing a pump handle.

—

John Snow Water Pump, Broadwick Street, London W1 9QJ

The John Snow Water Pump outside the John Snow pub on Broadwick Street.

Tower Lifeboat Station

The busiest lifeboat station in Britain, on Victoria Embankment close to the centre of London, handles the greatest number of launches annually out of all the 238 lifeboat stations operated by the Royal National Lifeboat Institute (RNLI) around the UK and Ireland. In a single year, the crews at Tower Lifeboat Station have deployed as many as 624 times. In London, the dangers are multiplied by the greater number of places where deep and dangerous water can be entered, taken together with the high number of people active on or around the river. There are thirteen road and pedestrian bridges on Tower Station's patch, from Tower Bridge in the east to Battersea Bridge in the west. To this is added the long lengths of embankments and piers, basins and wharves on the 26 kilometres/16 miles of riverside between Battersea and Barking Creek. The Thames can be a dangerous force; it flows fast and cold, rises and falls 7 metres/23 feet with the tide and carries heavy commercial and leisure traffic.

Tower Lifeboat Station is manned continuously with ten full-time permanent helms and mechanics and more than fifty volunteers working two shifts each month. Volunteers work at least two twelve-hour shifts per month, while full-timers work four days on and four off. True to RNLI tradition, the volunteers come from a range of backgrounds, many working in the City, so a banker or account director can be working a shift alongside a restaurant manager or post-graduate student. At any time, two of the crew will be full-time and one or two crew are volunteers. The rescue boats lie afloat alongside the pier; the launch requirement is to be 'lines-off and underway' within 90 seconds of the request from the coastguard.

Equipment is an E-class Mk 2 lifeboat designed specifically for working on the Thames and closely tailored to the task. Two 435 hp diesel engines can power the craft to a top speed of

RNLI lifeboat crew Steve King, Louisa Campbell, Craig Burn and Robert Sorrell.

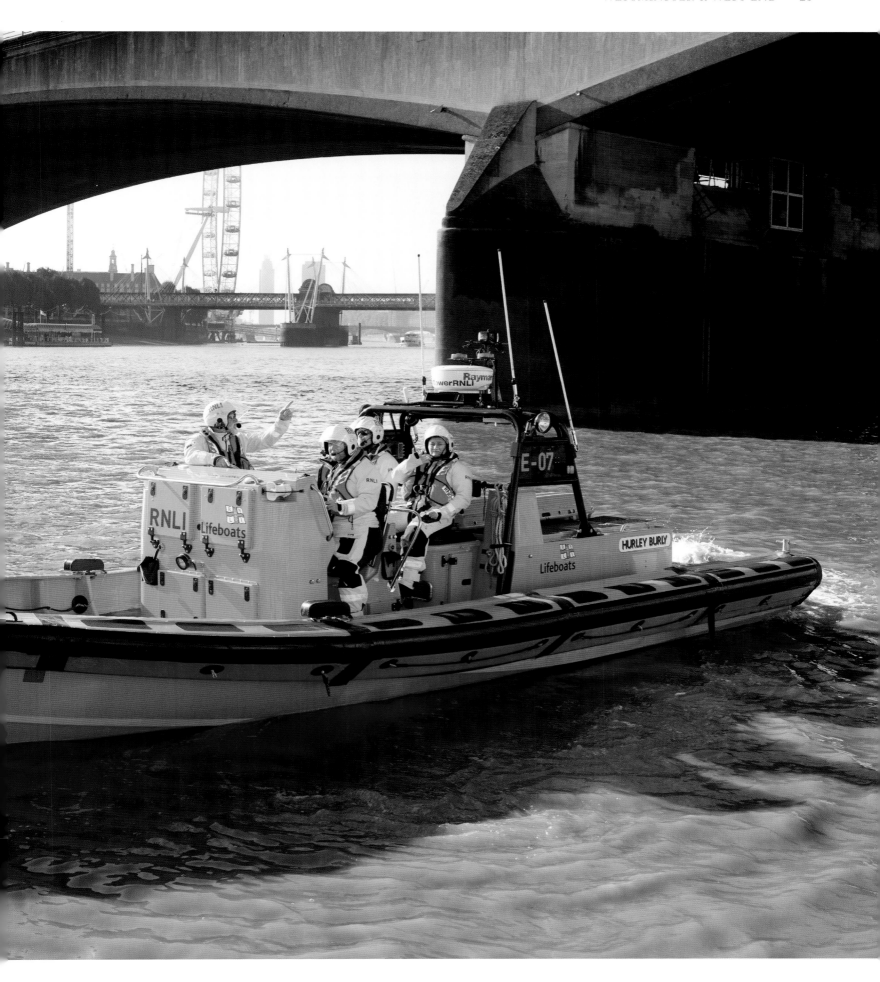

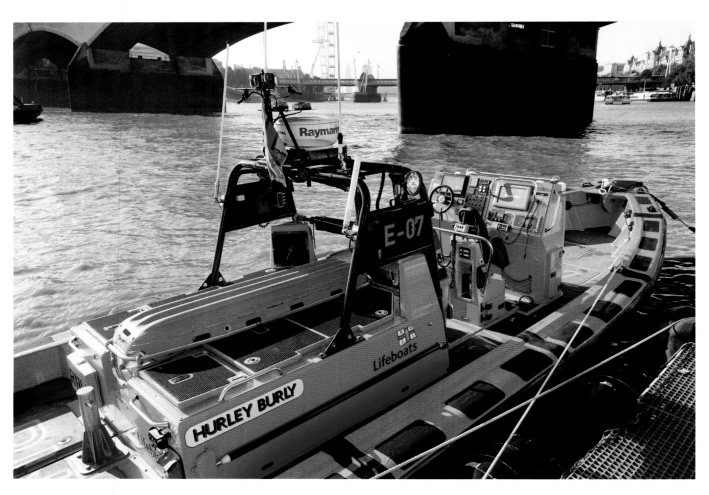

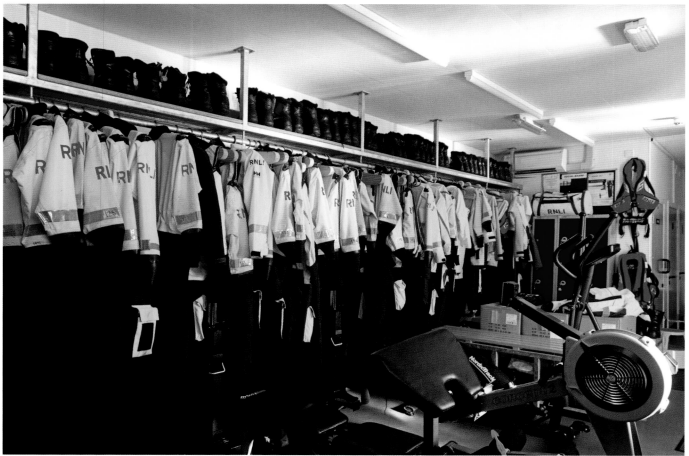

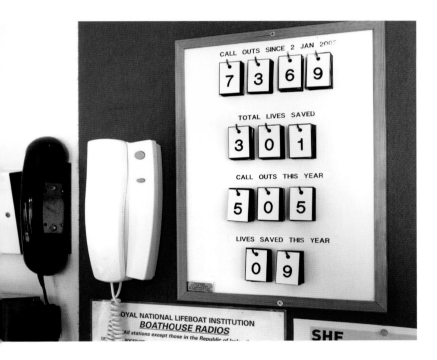

ABOVE *Recorded call outs since 2002 for the busiest RNLI station in the UK.*
OPPOSITE *RNLI E-class lifeboat* Hurley Burly *at the Tower Lifeboat Station*
(above); changing room and gym (below).

with the dredger *Bowbelle* near Cannon Street railway bridge. The *Marchioness* sank in seconds and fifty-one people died. The controversy over the tragedy continued for more than ten years. The government asked the Maritime and Coastguard Agency, the Port of London Authority (PLA) and the RNLI to work together to set up a dedicated search-and-rescue service for the Thames with a particular need for fast response. The RNLI had previously covered the Thames estuary solely from lifeboat stations at Southend-on-Sea and Sheerness, with rescues in the tidal reaches handled by the PLA or police vessels. In January 2001, the RNLI announced it would establish four lifeboat stations, Teddington, Chiswick, Tower and Gravesend to cover the tidal reaches of the Thames, which were opened in January 2002. Tower, Chiswick (the second busiest station) and Gravesend are all crewed twenty-four hours a day. Teddington, at the top of the tidal reach, operates D-class inflatables with volunteer crews.

Tower Lifeboat Station was first positioned at Tower Millennium Pier. It moved to its current location near Waterloo Bridge in 2006, at a pier which had been a base of the Thames Division of the police force, operating from a pontoon at this position since 1873, later called the Metropolitan Police Marine Policing Unit. The RNLI took over the role of primary search-and-rescue service from the police.

A high proportion of the incidents attended by the lifeboat from Tower Station are to help people who have jumped into the Thames or who are threatening to jump. Others are passengers who have become ill or have been injured on commercial vessels. There are cases of people caught out by the rising tide while walking along the foreshore or rescuing a dog or going for a badly judged swim. The lifeboat assists with recovery of bodies from the water. There have also been acts of terrorism, which have forced rescues from London Bridge. The RNLI patrols the river at busy times, including large events such as boat races, New Year and other festivities.

It is possible to visit the Tower Lifeboat Station by prior appointment, giving at least fourteen days' notice.

—

Tower Lifeboat Station, Lifeboat Pier

Victoria Embankment

London WC2R 2PP

40 knots, the fastest in the RNLI fleet, with propulsion through waterjets rather than propellers, designed for manoeuvrability in fast-flowing waters and allowing operations in shallows and fine control alongside other vessels and in confined waters. No wheelhouse is fitted to the E-class and the crew are open to the elements at all times. Twenty casualties, including one stretcher-borne, can be carried. In addition, towed inflatable craft are pre-positioned along the Thames and can be attached to the E-class to handle a further sixty survivors. The E-class can also operate as a powerful tug, which can prove useful.

The provision of lifeboat cover for the Thames came after one of the river's greatest disasters when, in August 1989, the pleasure cruiser *Marchioness*, with 131 souls on board, was in collision

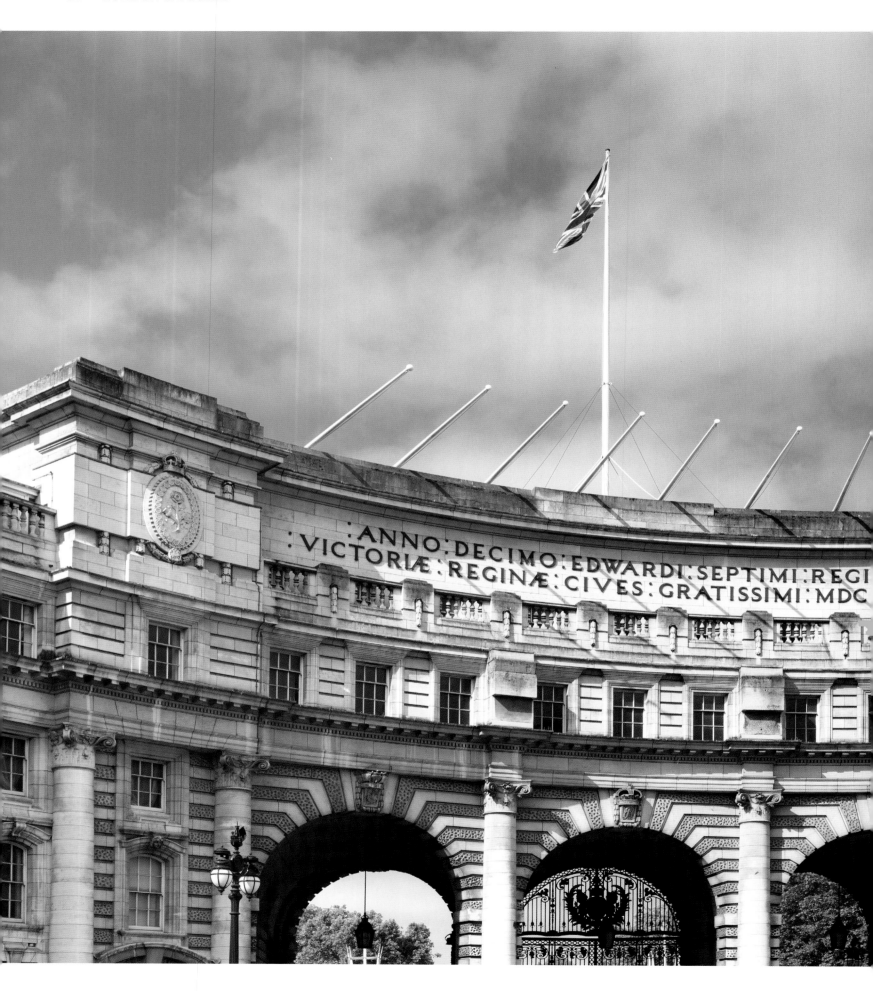

Admiralty Arch & Trafalgar Square

Admiralty Arch, the monumental landmark at the very centre of London, kept its interior concealed for more than a hundred years. That is poised to change in the 2020s as the building becomes a luxury hotel.

Designed by Sir Aston Webb in 1901, it forms part of a memorial to Queen Victoria commissioned by her son King Edward VII, and includes the Mall, the Victoria Memorial, the Memorial Gardens and the re-facing of the east façade of Buckingham Palace. It housed offices and residences for the Sea Lords of the Admiralty and was used by the Royal Navy and the Ministry of Defence until 1994 and later by the Cabinet Office.

By 2012 the building was empty and for sale. The bidding was won by Prime Investors Capital, which was awarded a 250-year lease. Westminster City Council granted permission for the restoration and conversion into an hotel, private residences and club. A government statement at the time put a positive spin on the transaction: 'For years the Arch has been inaccessible to anyone beyond government, however under the agreement the building will be opened up to the public, including through restaurant and bar areas.' Capital appointed Waldorf Astoria as the operator of the hotel, to be known as Admiralty Arch Waldorf Astoria, London.

The restoration has aimed to present a series of traditional English rooms, ninety-six in the south wing, with views along the Mall or towards Trafalgar Square, and up to four apartments in the north wing. Decorations are more colourful than the original Edwardian style with furnishings a mixture of antique and contemporary, but the plan has also been to replace or restore many Aston Webb features lost over time, even down to researching and replicating the original door handles on the First Sea Lord's former

Admiralty Arch – a landmark building on the Mall and Trafalgar Square – commissioned by King Edward VII in memory of his mother Queen Victoria.

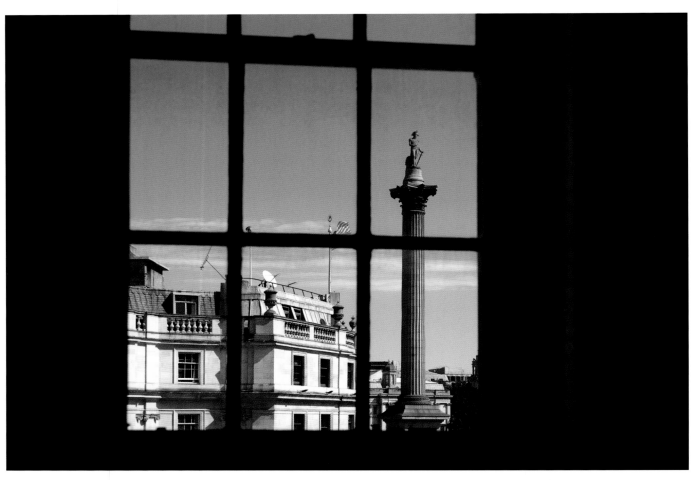

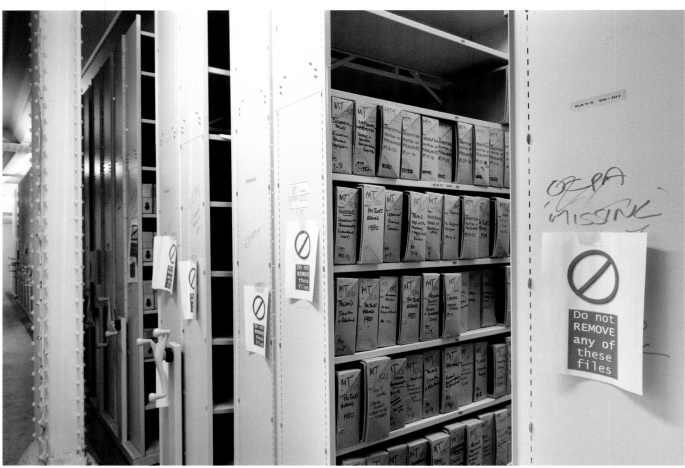

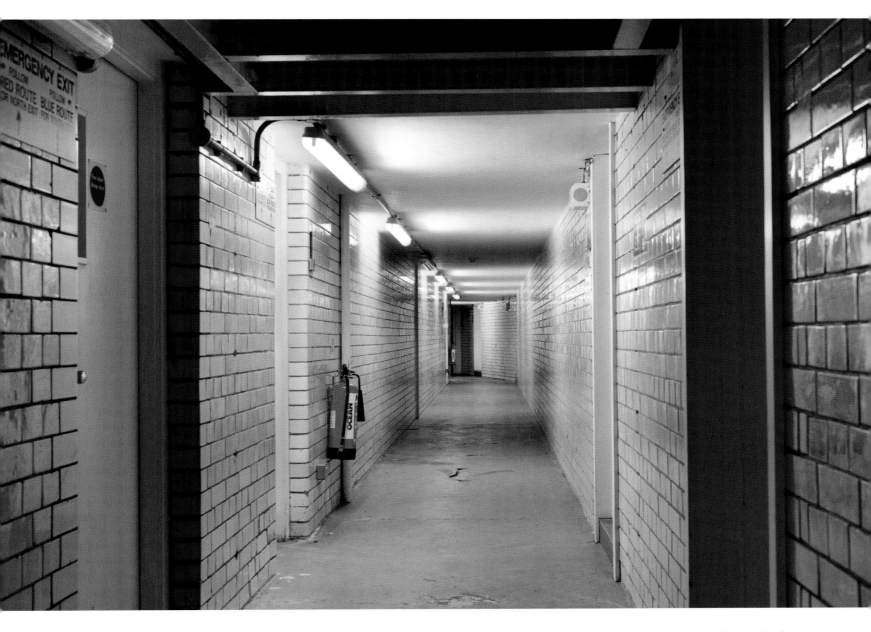

The tunnel corridor under the Mall connects the two wings at basement level. *View of Nelson's Column from Admiralty Arch (above); file boxes dated 1979 and 1980 marked MT for Margaret Thatcher stored in the basement, part of the Cabinet Office, which once occupied Admiralty Arch (below).*

apartment. There are original lightwells constructed from white ceramic bricks and restored stairwells with bronze balustrades and dark wood. The arched section will house bars and restaurants in its two upper bridging floors and the basement with two floors has been deepened with two more levels for recreational and support facilities.

Even in plain sight Admiralty Arch has always been deceptive. The building has concave façades on both sides, which enable an ingenious visual trick. It was first intended to build the Mall in a straight line from Buckingham Palace to Trafalgar Square. This would have required the demolition of Drummonds Bank at the corner with Charing Cross. There were serious objections to this, and the solution was to turn the last few yards of the Mall's route

northwards. Admiralty Arch was arranged to hide the abrupt change of direction while framing an unimpeded view down the ceremonial approach towards the Palace.

Admiralty Arch appears to be symmetrical, even though the wings are completely different in shape and area. There are four stories to the north wing and five to the south, both appearing as the same height. This was achieved by making higher ceilings in the residential north wing.

Its secret connections, both above surface and subterranean, are found in both fact and myth. Admiralty Arch has a bridge connecting it to the Old Admiralty Building next door, once providing associations with the Naval Intelligence Division and the codebreakers of Room 40. When the Cabinet Office was in

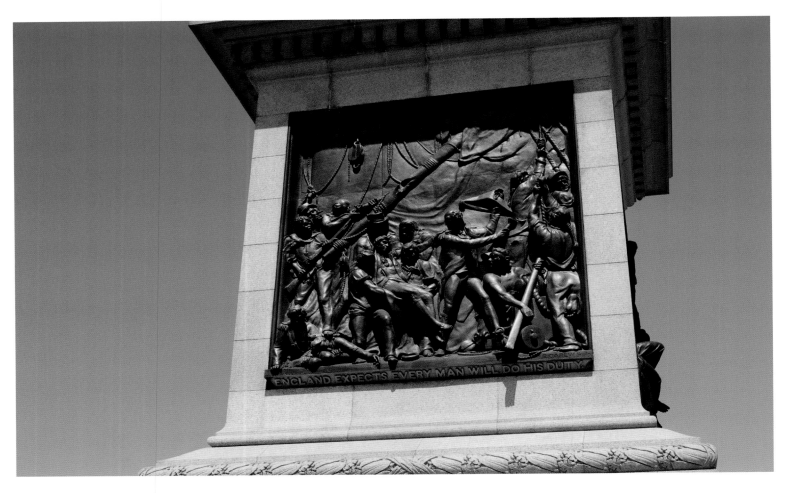

ABOVE *Inscription on the base of Nelson's Column 'England expects every man will do his duty' – a signal sent by Vice Admiral Horatio Nelson from his flagship HMS Victory as the Battle of Trafalgar was about to commence on 21 October 1805.* OPPOSITE *Restored staircase in Admiralty Arch, in the south wing with glazed lightwell (above left); the smallest police station in London's Trafalgar Square (above right); the imperial measures of Trafalgar Square were installed in 1876, detailing the official measurements of inches, feet, yards, links, chains, perches and poles (below).*

possession, the aim was to connect five adjacent buildings along Whitehall, including Admiralty Arch, with its headquarters at 70 Whitehall, and some of this connection work was completed in the final years of government ownership.

What can be described as a tunnel certainly does exist to join the two wings of the Arch at the original basement level. Deep below that there are proper tunnels, quite unrelated because they belong to London Transport and British Telecom. A likely subterranean link, never confirmed, was to the Admiralty Citadel – the windowless ivy-covered fortress nearby, which was owned by the Ministry of Defence, lately a communications hub for warships. There were also reputed links with a Whitehall government pedestrian route, and, more unlikely, to special escape tunnels for VIPs. In any case, secret links are now likely severed and sealed. Until recently the basement housed rows of archive file boxes marked with the initials of former prime ministers, believed to be relics of the Cabinet Office days.

Churchill was an early resident, as First Lord of the Admiralty from 1911–15, a civilian role, and again in 1939–40. As First Sea Lord, Admiral Prince Louis of Battenberg lived here when the order was given to mobilize the fleet in 1914. His son, Lord Mountbatten of Burma, was resident later. Admiral Sir Jock Slater was the last First Sea Lord to live in the north wing, leaving in 1997. On separate occasions during the 1990s he invited Queen Elizabeth II and the Queen Mother to lunch. Neither had been inside Admiralty Arch before.

Admiralty Arch lies truly at the centre of London, which can be confirmed by walking a few paces towards Trafalgar Square to where King Charles I's statue stands. Here, a marker plaque confirms the official centre of London from where all distances are measured. A walk in the vicinity reveals a place bristling with strange features, such as official units of measurement set in stone and bronze; what was once London's smallest police station converted from a lantern and curious burn damage to the base of Nelson's Column, but nothing as enigmatic as Admiralty Arch.

—

Admiralty Arch Waldorf Astoria
The Mall, London SW1A 2WH

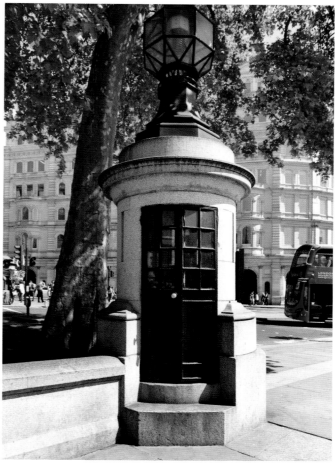

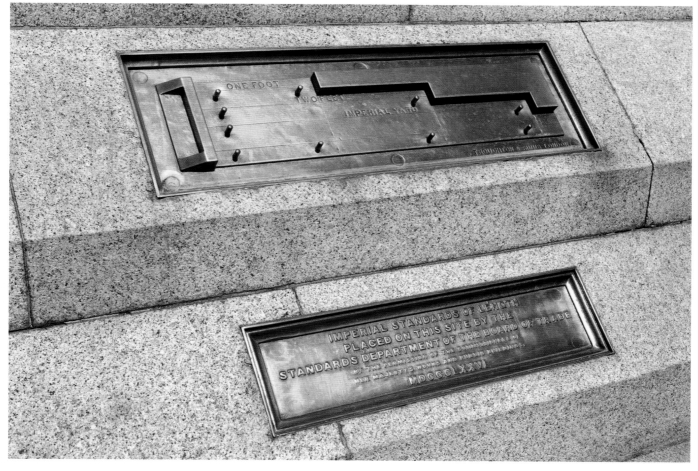

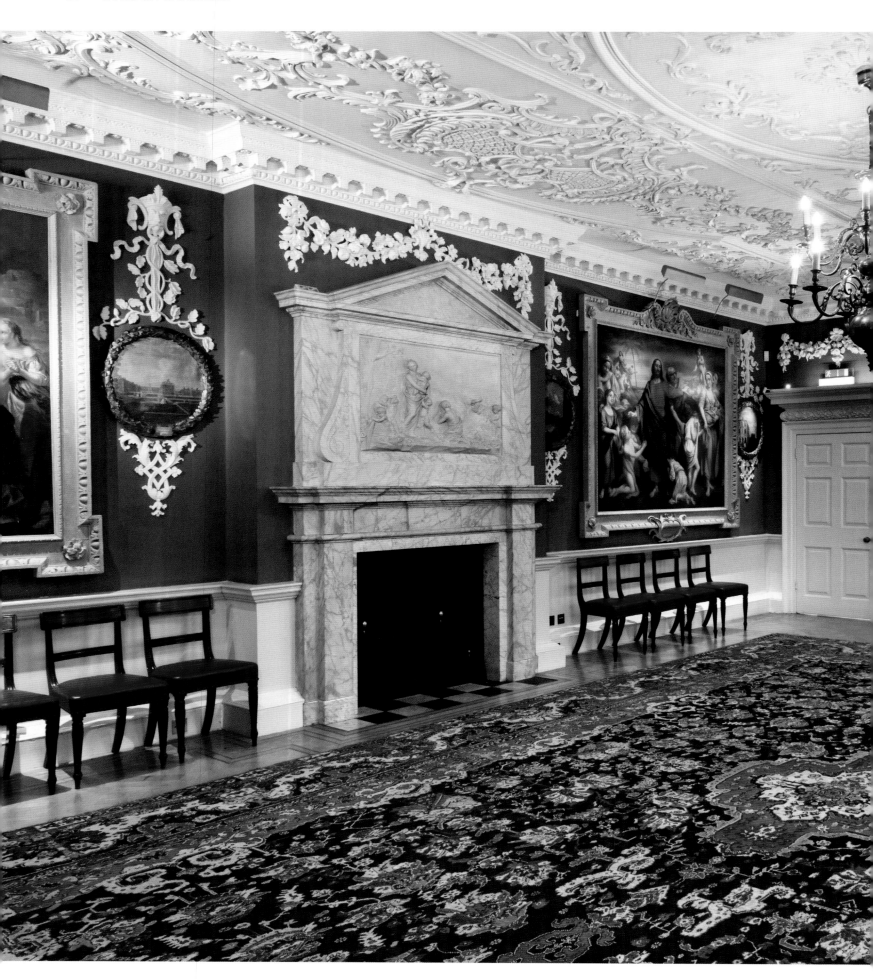

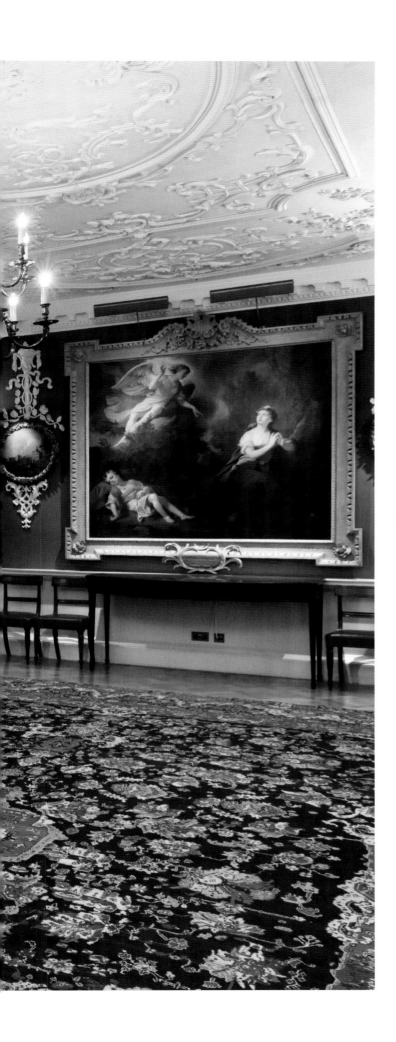

The Foundling Museum

There cannot be many charities that can boast Hogarth and Handel among their benefactors, but the Foundling Hospital, which was established by philanthropist Thomas Coram in London in 1741, is one. The symbiotic relationship forged between the arts world and the hospital became so successful that both prospered: while the esteemed benefactors helped to raise the profile of this innovative institution to attract patronage and funds, the hospital became a showcase for their paintings before the idea of an art gallery had developed.

The need for a children's welfare institution in eighteenth-century London was great. Poverty and disease resulted in high mortality rates: more than 74 per cent of children born in the city died before they reached the age of five.

Some babies at the Foundling Hospital were not foundlings in the accepted sense. Their mothers had brought them to the hospital and given them identifiers. These were scraps of material, coins or trinkets, which were pinned to the baby's records so that they might be reclaimed at some future time when the mother was in improved circumstances. Sadly, few were. Of the 16,282 babies brought to the hospital between 1741 and 1760, just 152 were reclaimed. Many of these tokens of identity are displayed in the museum and, along with the stories of foundlings, they are a poignant testimony to the heartbreaking circumstances.

Thomas Coram, a former seafarer and trader living in Rotherhithe, was appalled by the sight of starving and abandoned children in London. Mounting a determined campaign, he found a way of reaching mostly aristocratic supporters, appealing to a growing fashion for sentiment and benevolence. This pioneering form of philanthropy won a Charter of Incorporation from King George II, which launched the Foundling Hospital. It was

The Rococo court room, which is believed to have been designed by Hogarth. All the paintings on display are on the theme of benevolence towards children.

established on what was the edge of London in the 1740s, becoming Bloomsbury as the city grew. It operated there until 1926, later becoming a school at Berkhamsted until the last of its children were placed in foster care in 1954. The building housing the Foundling Museum at Brunswick Square was opened as the hospital's London headquarters in 1939, close to the original site. The court room, picture gallery, committee room and staircase from the original 1740s building were reassembled here. The museum opened in 2004, housing some of the original art collections. Coram, as it is now known, was the UK's first charity dedicated to children. Its work continues, providing a range of services.

During the twentieth century, the Foundlings' boys generally joined the army on leaving and the girls went into domestic service.

Their stories are told through the museum's Foundling Voices archive, which includes narratives by seventy-six former pupils on audio interview, and in photographs and film.

Daily life at the hospital can be seen in a reconstruction of one of the hospital interiors in the committee room. One of the features is the chimneypiece and overmantel, which are thought to have been designed by Hogarth. Paintings here include four by Emma Brownlow which depict life at the hospital. One of these – *The Foundling Restored to Its Mother* – represents her father, John Brownlow, himself a foundling, who was the hospital's secretary from 1849 to 1872. In the archive is a letter to Brownlow from Charles Dickens, who wrote *Oliver Twist* while a close neighbour. Also featured in this room is Hogarth's *The March of the Guards to*

BELOW *A handcrafted token left by a mother to identify her child (left); statue of Thomas Coram by William Macmillan, outside the Foundling Museum (right).*

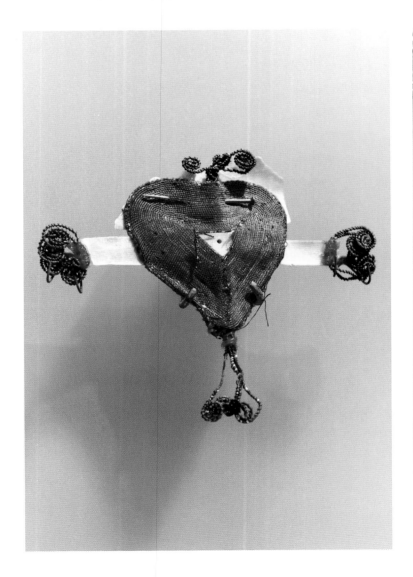

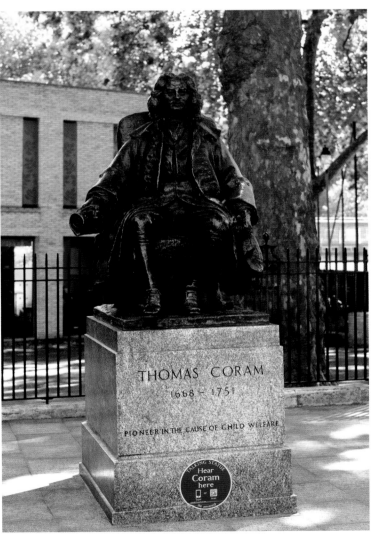

ABOVE *The picture gallery. Many paintings were gifted to the hospital by the artists, the first of which was a portrait of Thomas Coram by William Hogarth, the figure in the red coat, second on the left.*

Finchley, which recounts the defeat of the Jacobite Rebellion in 1745. But it was his magnificent painting of Thomas Coram, the first be donated to the hospital, which inspired other eminent artists to follow suit, including Thomas Gainsborough, Joshua Reynolds, and John Michael Rysbrack. Hogarth did more than contribute paintings. As an enthusiastic supporter, he also designed the hospital coat of arms and, it is thought, the children's uniforms. His empathy with the foundlings stemmed from the hard times he had experienced when his father had been jailed for five years for bankruptcy. It was memories of this that led him and his wife, Jane, to foster a number of foundlings.

Handel also did much to publicize and support the hospital. His benefit concerts of the *Messiah* were highly popular and attracted the aristocracy and royalty. His concerts raised huge sums and when he died he willed a copy of the score and orchestra parts of the *Messiah* to the hospital. A copy of his will is part of the museum's Gerald Coke Handel Collection, which features more than 12,000 items from the eighteenth century to the present. These items, which were collected by businessman Gerald Coke over a period of sixty years, include manuscripts, printed scores, libretti, books, periodicals and programmes.

—

The Foundling Museum

40 Brunswick Square

London, WC1N 1AZ

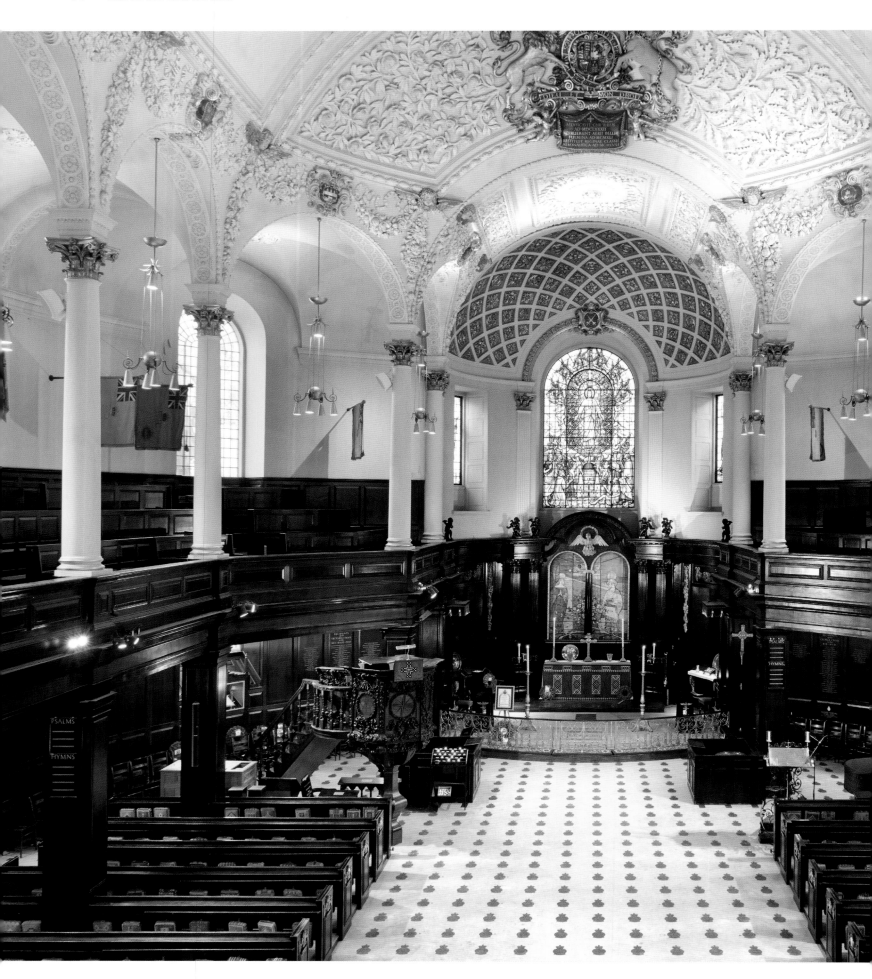

St Clement Danes

St Clement Danes stands prominently on an island on the Strand at a spot where Christians first gathered more than a thousand years ago. It is the Central Church of the Royal Air Force and its history is steeped in layers of conflict, destruction and rebirth.

When the Romans abandoned Londinium in the fifth century, the Anglo-Saxon population drifted to the bustling marketplace of Lundenwic, a mile up the Thames. As this medieval port grew, it became a trading hub, and by the end of the eighth century it had attracted the attention of marauding Vikings from Denmark. The ferocity and frequency of their raids in the ninth century forced the Anglo-Saxons back inside the walls of Londinium, leaving the Danes free to establish their own town to replace Lundenwic. The Viking settlement became known as the old town or 'Ealdwic', now Aldwych.

Alfred the Great's victory over the Danes came in 878 and Danes with English wives were allowed to remain in Ealdwic. They converted to Christianity and it seems they adopted the Anglo-Saxon church already established there. In the eleventh century, a stone church was erected on the site of the wooden-framed building and dedicated to St Clement, patron saint of mariners, becoming St Clement-of-the-Danes. It was rebuilt to a Norman design following William I's conquest in 1066.

By the middle of the seventeenth century, the church, which had narrowly escaped the Great Fire of London, had become dilapidated and Sir Christopher Wren was commissioned to undertake not just a restoration but a radical rebuild. In designs for other churches Wren faced limitations posed by constricted ground plans, but here he had a freer hand and, with stonemason Edward Pearce, constructed a masterpiece incorporating the Saxon-Norman base of the tower into the new design. It was

Main stained-glass window of the risen Christ; the pulpit by woodcarver Grinling Gibbons is an original feature of the Wren church.

RIGHT *Monastic-style pew stalls at the west end of the nave, which are reserved for members of the Air Force Board, managers of the RAF.*

OPPOSITE *The upper tier of the belfry (above). Fixed to the beam are the Sanctus Bell, left, which dates from 1558, and at centre front, the flat fourth bell, tuned with the carillon to ring 'Oranges and Lemons'. Its inscription translates as 'I have outlived my troubles and give thanks to the stars'. The bell ringers' ropes (below).*

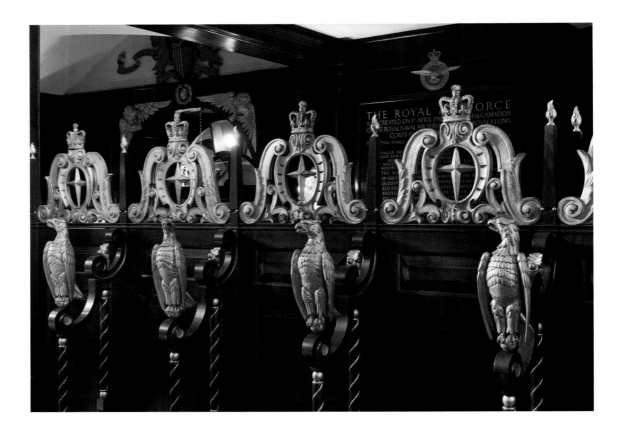

finished by the end of 1682 and shortly afterwards a pupil of Wren, James Gibbs, was commissioned to extend the tower with a three-tiered spire and a clock chamber. By the end of the eighteenth century, St Clement Danes became one of London's most fashionable churches, with worshippers including the theatre manager-actor David Garrick, writer Samuel Johnson and his biographer James Boswell.

As London's society moved westward during the nineteenth century, St Clement Danes declined, eventually requiring a major restoration. Inspired by the incumbent rector Septimus Pennington, the renovation saw bright stained-glass windows transform the church. A later rector, William Pennington-Bickford, inaugurated an annual service for primary school children, at which each child was given an orange and lemon, linking to the nursery rhyme with the line: 'Oranges and lemons say the bells of St Clement's'. The source of the rhyme and its meaning are obscure, but the connection became legend and a carillon machine in the tower was made to play the melody.

On 10–11 May 1941, the last night of the main Blitz, St Clement Danes was hit by incendiary bombs and its roof, wooden-framed and lead-covered, was set ablaze. The wooden interior quickly became a torch. All but the outer shell of the church and the tower were consumed. The Royal Air Force received the ruins from the Diocese of London in 1953. Using £250,000 of donations from a worldwide appeal and a trust, St Clement Danes was rebuilt between 1955 and 1958 as close as possible to the Wren design, and re-consecrated to remember all who have given their lives in service with the RAF. A new peal of bells was recast from the metal of the old at the Whitechapel Bell Foundry in 1955. Twelve bells are installed, including the Sanctus bell, which dated from 1558 and survived intact.

The timing of the church's adoption enabled a commemoration of the Royal Air Force at its most prominent and widely affiliated. Over 800 RAF and Commonwealth squadrons, units and stations are marked in the central aisle with badges of Welsh slate. The organ was donated by the US Air Force, and there is a shrine in the west gallery to the 16,000 members who died in the Second World War. Below is a simple crypt, the altar and sanctuary a gift from the Royal Netherlands Air Force, the font from the Royal Norwegian Air Force and the candelabrum from Belgium.

The wide central aisle is a divergence from the Wren layout and includes one of its several secrets: the flanking pews are telescopic and when extended provide extra seating and regain the original proportions of the church.

The focus of the church is the Book of Remembrance, containing the names of every airman and woman who has died in service in over a century of RAF operations. Encased in glass cabinets around the inner wall are ten volumes and the pages are turned each day.

—

St Clement Danes

Strand, London WC2R 1DH

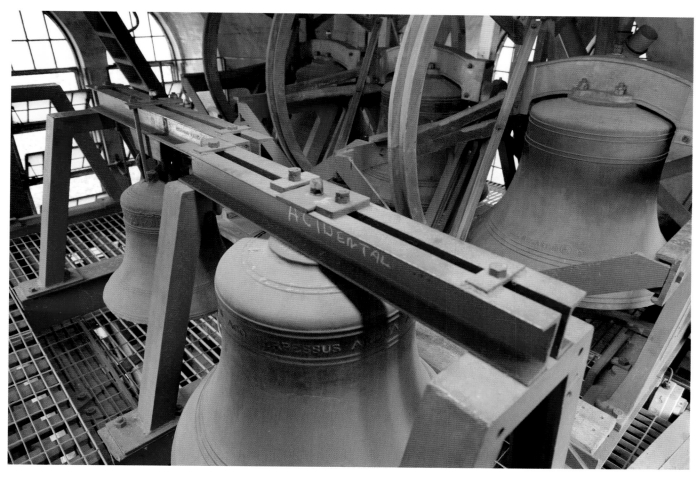

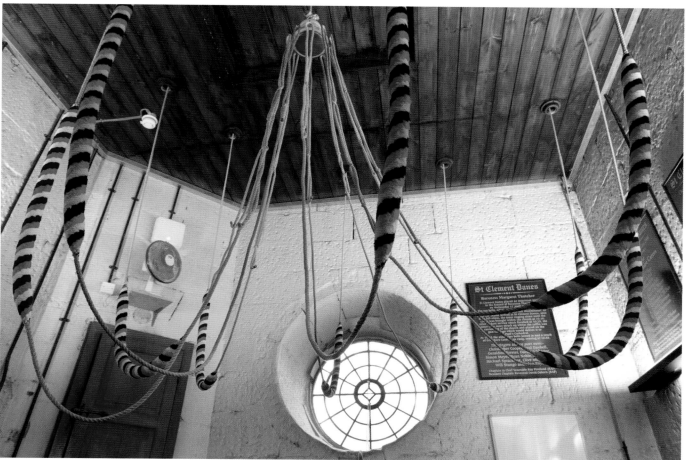

Liberty London

From the start of the Liberty business on Regent Street in 1875, the company set a distinctive style. First selling coloured silks and fans imported from Japan, it added silver, jewellery, wallpapers and carpets from across the Far East and Middle East. Taking inspiration from these designs, Liberty was soon printing and selling its own fabrics. Although the merchandise was an eclectic range, it came with an unmistakeable Liberty look that set the emporium apart from other department stores in London. When more floor space was required, a new half-timbered Tudor building emerged on Great Marlborough Street looking unlike anything else in the West End.

Sir Arthur Lasenby Liberty was by profession a retailer and fabric manufacturer rather than a designer, although he became a participant in the Arts and Crafts Society during the 1880s and developed a wider interest in the craft of printmaking. While still importing merchandise, the production of distinctive fabrics for dressmaking and furnishing increasingly occupied Liberty's business. More space was acquired alongside the original shop at 218a Regent Street, and round the corner into what was to become Great Marlborough Street. Architects Edwin Thomas Hall and Edwin Stanley Hall were commissioned to design the new buildings, which were built between 1922 and 1925. The site in Great Marlborough Street was freehold and therefore the conditions usually determining the design of buildings on the Crown Estate did not apply. Instead of creating another Nash-style classical building, the architects were free to adopt a different style and the chosen look was Tudor.

English Heritage research has suggested that the intention was to make the frontage on Great Marlborough Street resemble a group of shops rather than a continuous frontage, and the medieval buildings of the city of Chester may have been the inspiration for

The hammerbeam roof under pitched glazing in the east gallery.

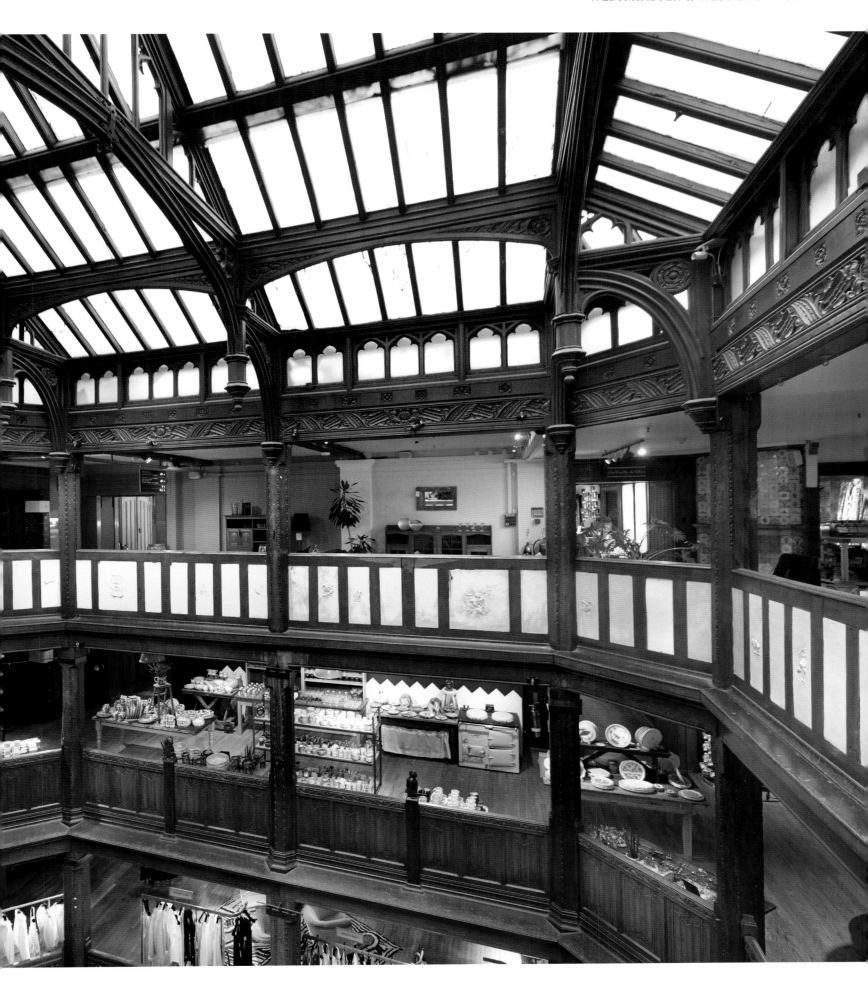

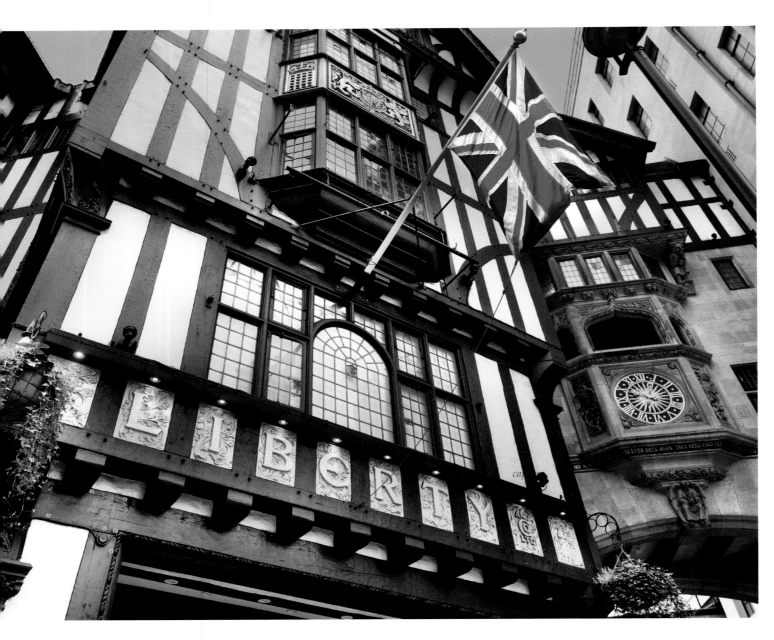

the design, particularly those in the Rows, where covered galleries enclose shops on the first floor. The Liberty building accordingly has gables and windows appearing to be at differing heights, all in black and white with an irregular style and topped with clusters of twisted chimneys. There is a large gilded copper weathervane in the shape of the *Mayflower*. Inside, the building was intended to evoke a feeling of luxury and spaciousness at the same time as having the intimacy of a comfortable country house – some of the spaces resemble rooms and even have fireplaces. Galleries rise in four storeys grouped around three wells, resembling the courtyard layout of old coaching inns. There are pendant hammerbeam roofs in different styles on each of the wells and seasoned oak doorcases and staircases throughout.

There is a great deal of wood because the architects and builders made particular efforts to design as much timber as possible into the construction. Two old wooden warships, HMS *Impregnable* and HMS *Hindustan*, which had lingered for years before being broken up at Woolwich in 1921, contributed their timbers to Liberty. The oak gun decks of the *Hindustan* became the floors and its ribs and stanchions were used in the galleries. Other wood from these two ships was used as cladding on the exterior of the building. The external frame was assembled in traditional style with morts, tenons and pegs and over 680 cubic metres/24,000 cubic feet of timber was supplied. Some bricks are set between the timber framework and covered with Portland cement. The price of all this Tudor authenticity was high, requiring great craftsmanship,

ABOVE *A hand-carved hungry bear on the post of the third-floor east gallery is a product of Liberty's Arts and Crafts furniture workshop (left); the suspended pendant lanterns on the back staircase are reputed to form the longest chandelier in Europe (right).*

special materials and longer construction time, and it went against the trend of steel-frame construction that had been used at the new Selfridges store on Oxford Street.

The wooden detailing at Liberty was also to a high standard and can be seen particularly on the gallery posts on the third floor of the east atrium, where there are a series of intricately carved animals by Lawrence Turner, who ran Liberty's Arts and Crafts furniture workshop, which supplied decoration on panels and pillars in the store. More than twenty carvers worked on the interior fittings.

The nautical theme is continued in the back staircase, where a series of suspended pendant lamps descend from the roof almost to the lower basement, six lamps in all, evoking ships' lanterns in style. It is claimed by Liberty that this may be the longest chandelier in Europe.

The Tudor-styled Liberty store is so arresting that is easy to neglect the beaux arts classical building built one year later which lies alongside, connected to it by a bridge that transitions from one architectural style to the other. A fine clock, designed by the chairman of the British Horological Institute, is mounted over the archway. Under it lies the legend 'No minute gone comes ever back again take heed to see ye nothing do in vain'.

—

Liberty London
Regent Street
London, W1B 5AH

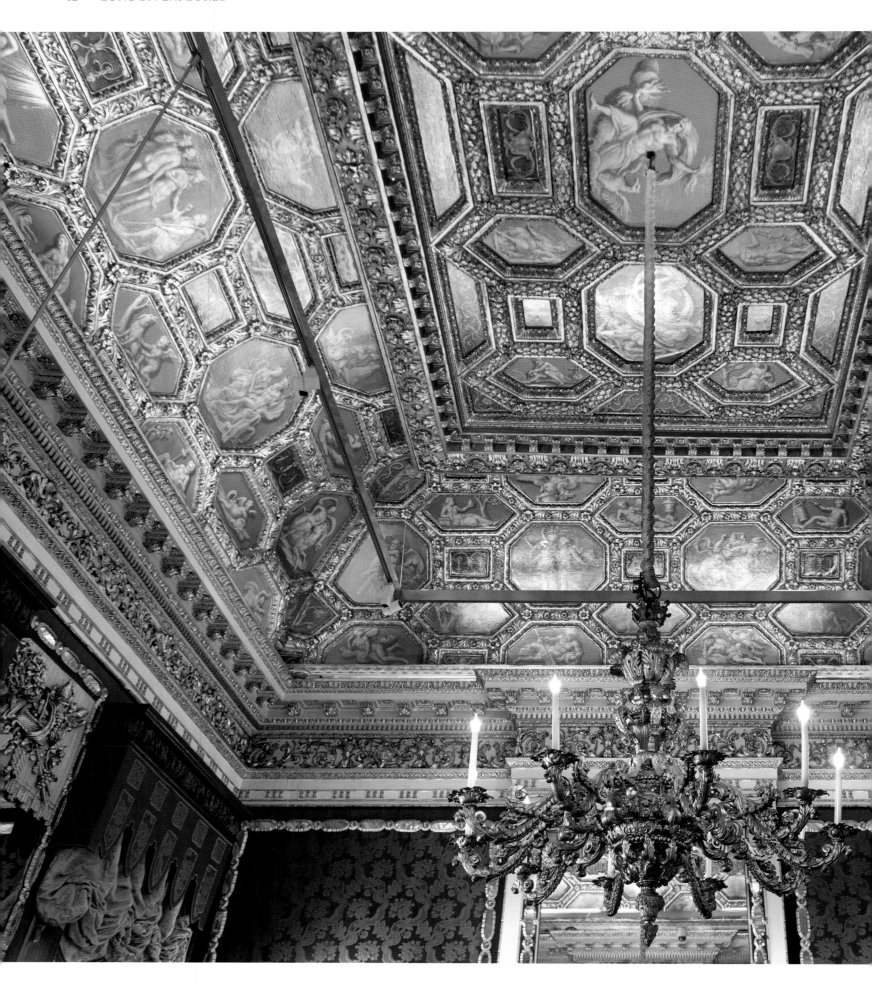

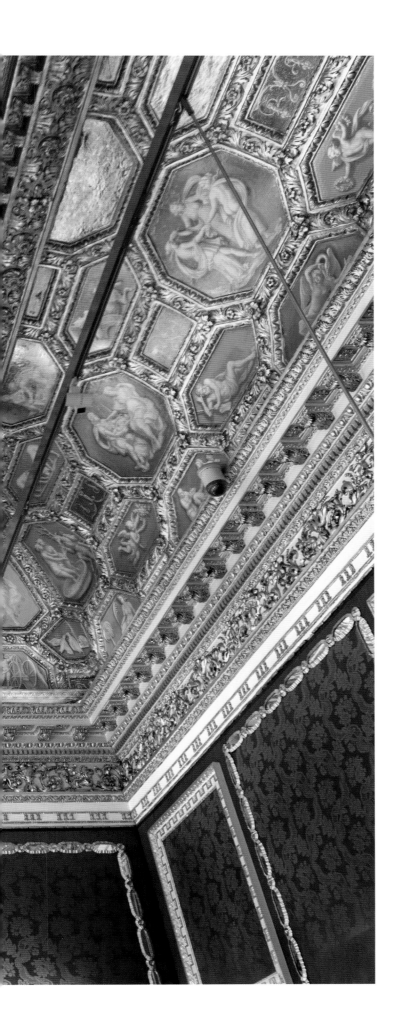

Clermont Club Casino

The house at 44 Berkeley Square receives high praise from Historic England in its listing. Describing it as 'part of the best terrace of townhouses in the square', Historic England also notes the 'exceptional quality of its magnificent interiors and spectacular staircase'. It is a Grade I listed building, and equally notable, it is home to the Clermont Club Casino.

It was an entrepreneur and gambler named John Aspinall who created the Clermont Club and the process of its formation has since become gambling legend. In 1957, the police raided a gambling party that Aspinall had organized in a private house in Belgravia, which seemed to have broken the prevailing archaic law barring gambling, namely the Gaming Act of 1845. In the subsequent court case, the jury was directed to deliver a verdict acquitting John Aspinall, who had argued that the party was a friendly game of chemin de fer for a group of twenty-four friends. The verdict was seen as a sign that the law was flawed and change was coming. The new Betting and Gaming Act of 1960 unlocked the licencing of regulated casinos for the first time in Britain and John Aspinall took a lease on 44 Berkeley Square where he opened the Clermont Club in November 1962, the first casino in London. It was named after the Earl of Clermont, a former owner of the house. Membership was limited to 600 and was reputed to include five dukes, five marquesses, twenty earls and two cabinet ministers.

The following year, in the basement of the house, Annabel's nightclub (see pages 12–17) was established and the address gained a reputation for great hedonism. The Clermont set included James Goldsmith and the infamous Lord Lucan. A distinct subset of influential businessmen were associated with the Clermont and the activities of businessmen and aristocrats who played and

The elaborately decorated ceiling of the grand saloon with painted cameos of gods and goddesses.

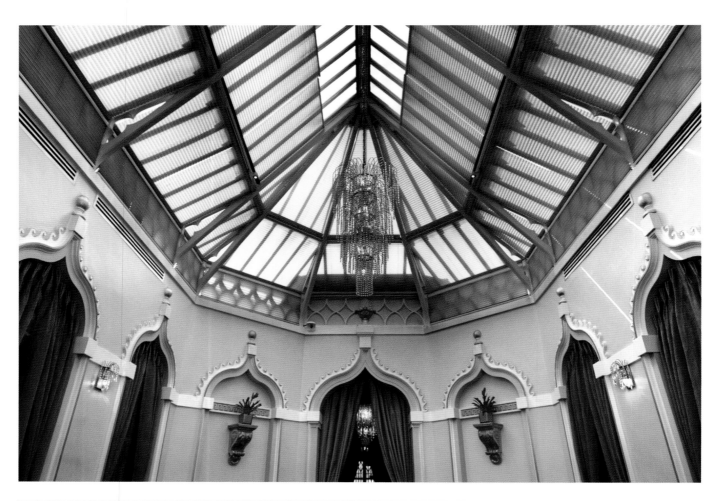

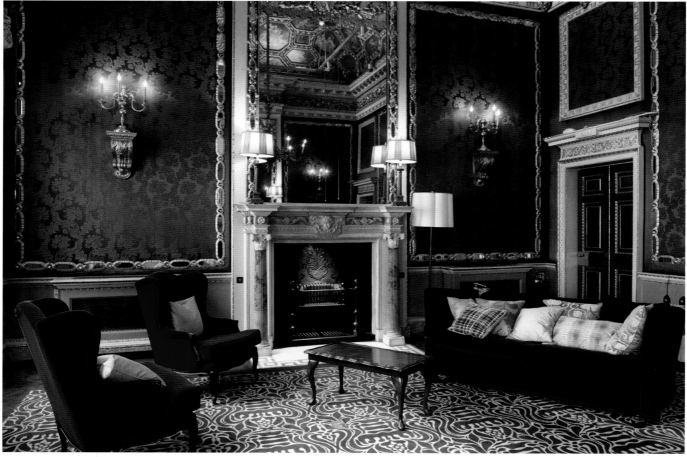

partied there generated many headlines in the British press over the next ten years.

John Aspinall is famous also for owning two zoos, which required increasing attention. Consequently, the casino was sold in 1972 to Playboy Enterprises and ownership changed once again through Mecca and Rank to the BIL company owned by Malaysian Quek Leng Chan by 2006. The casino closed down in 2018 but was poised to reopen in 2021 under the banner of Mayfair Casinos and offering games including blackjack, punto banco, baccarat, three-card poker and roulette in six gaming rooms and the top-floor library. In its latest form, the casino interiors have been designed by WISH Interior Architecture, while still paying respect to the original.

Throughout these changes, 44 Berkeley Square has remained the architectural gem behind the gaming tables. The frontage on the square seems relatively modest – a nicely proportioned three-bay house of brown brick, with only the large rusticated archway over the door hinting at something special within. Inside, the staircase ingeniously fills a square space at the centre of the building, running from the entrance hall to a half-landing and dividing into two arms up to the first floor. The staircase leads to the grand saloon, which has a ceiling covered in painted cameos of gods and goddesses, with Jupiter at the centre.

The building dates from 1745 when Lady Isabella Finch commissioned architect William Kent to design a house that would be much used for display and entertaining. The timing of the construction may have positively influenced the design of 44 Berkeley Square as William Kent was simultaneously working on the house that was to be his masterpiece – the grand Holkham Hall in Norfolk – and the staircase and grand saloon show similar features. After the death of Lady Isabella, the next owner was the

Earl of Clermont, a friend of the Prince of Wales, later George IV, who had a standing invitation to the house and frequently dined there. Lord Clermont's main interests were sporting: horse racing and shooting and also gambling, which later inspired Aspinall's naming of the club. The Clermont family departed the house early in the nineteenth century and ownership eventually came into private hands. The last private occupant was in residence until 1959.

A great change in gambling behaviour came about in 1995 when the first online casino started trading, offering easy access and easy use, yet casinos still prevail. More than twenty-five casinos are active around central London in the 2020s and the hub of London's upmarket casino scene remains Mayfair, with the top six high-end gambling houses found in an area of about one square mile. At the centre of this is the house that the architectural authority Nikolaus Pevsner described as 'the finest terrace house in London'.

—

Clermont Club
44 Berkeley Square
Mayfair
London, W1J 5AR

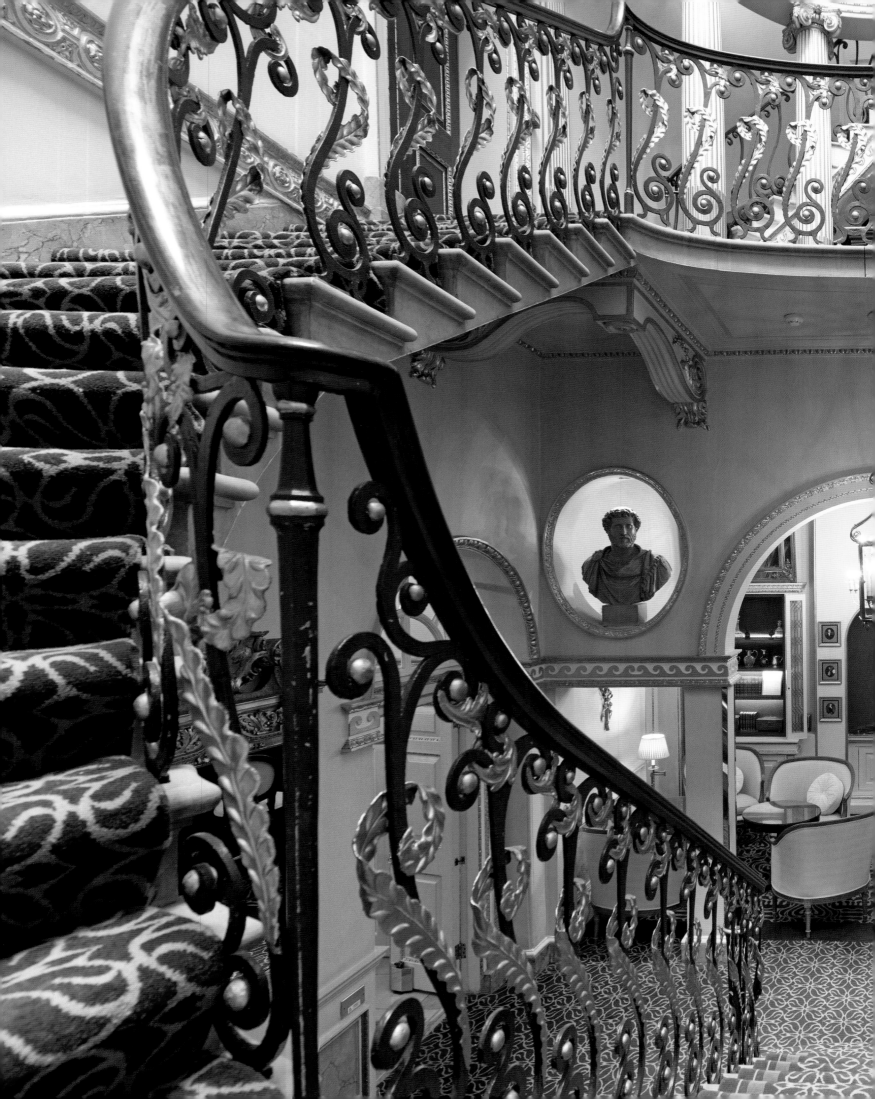

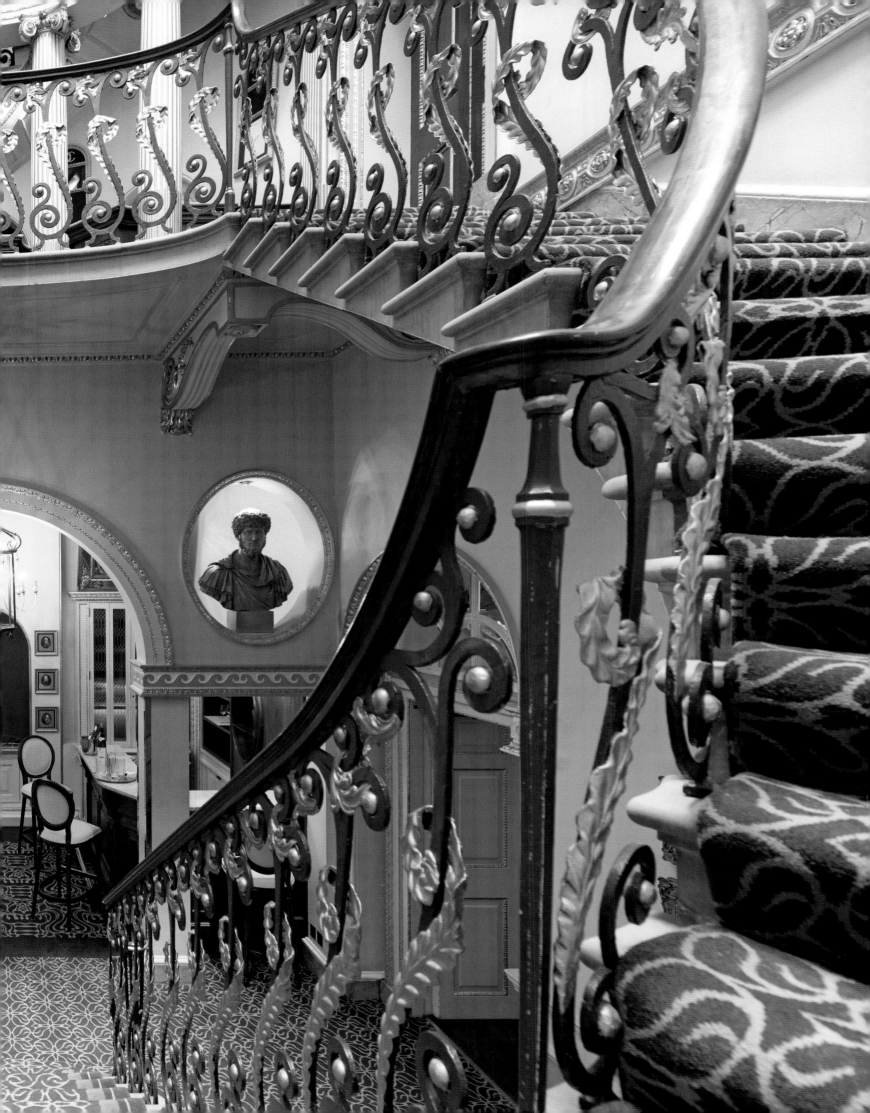

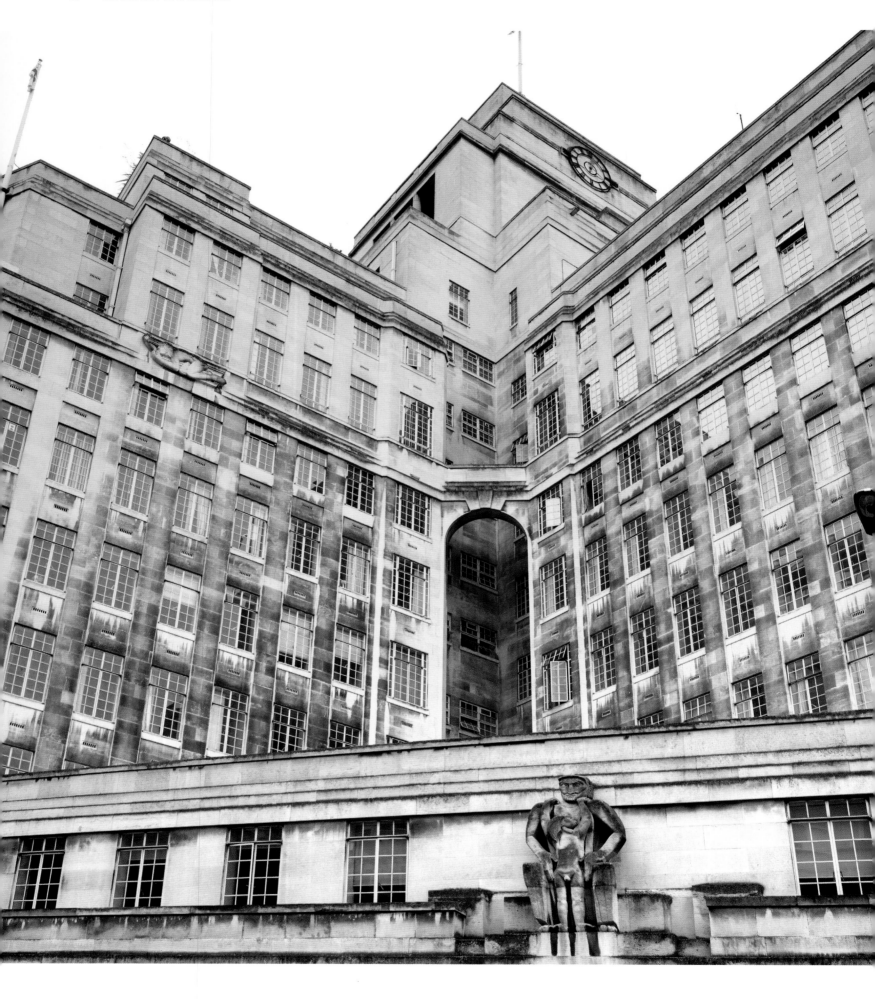

55 Broadway

A true colossus on Broadway, the headquarters of Transport for London and the unmistakeable symbol of mass transit was pensioned off into private ownership just as its centenary loomed. Number 55 Broadway was hailed as London's first skyscraper in 1929 when it was built for the Underground Electric Railway Company London (UERL). Its height was modest at just over 53 metres/174 feet, with regulations stipulating that buildings could be built no taller than St Paul's Cathedral, but it possessed a massiveness by other measures. In 1933, it became the headquarters of the newly inaugurated London Transport on the amalgamation of all forms of local transport in the capital and its image was widely deployed for publicity purposes.

The building came about due to an association between Frank Pick, general manager of UERL, and architect Charles Holden. Pick came from a legal-commercial background but took a special interest in design and understood how it could be coupled to modern corporate identity. Pick had influence on the use of a distinctive roundel and typeface and the style of posters used for publicity. He had hired Holden to design a façade for a side entrance at Westminster station and, liking the result, commissioned him to design seven new stations on the extension of the underground line from Clapham Common to Morden. Holden delivered a series of plain Portland stone ticket halls carefully tailored to the suburban street locations, which opened in 1926. The commission to design 55 Broadway came later that year. Charles Holden was an architect able to work in several different styles and he designed more than forty underground stations in total. He was influenced by trends in modern European architecture towards simplicity and clean lines. He was also a member of the Design and Industries Association and the Art Workers' Guild.

The exterior of 55 Broadway – the tallest building in its time.

OPPOSITE *The corridor of the management floor (above); the main staircase of TfL's Art Deco headquarters (below).*

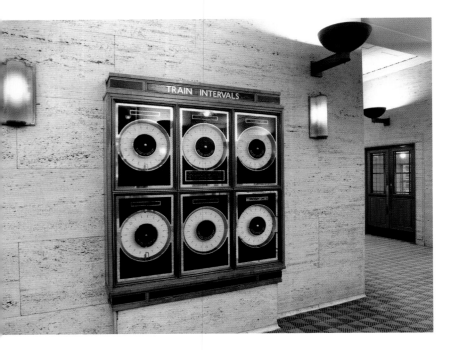

ABOVE *A train intervals indicator, which is situated in the reception area.*

The site for 55 Broadway close to St James's Park was constricted by existing structures and narrow spaces and required a tall building to be made over the existing underground station. St James's Park was a cut-and-cover station dating from the first generation of underground railways and lay in a shallow cutting partly under a roof. Some of the station roof had been removed to make an earlier building. This time, concrete piles were driven and massive steel girders were built to span the rails. The building was steel-frame encased in concrete and faced in Portland stone, built with wings to a cross-shaped ground plan with a central tower. The tower and the wings stepped back in rising stages like a classic American skyscraper and the cruciform plan enabled maximum daylight to pour into all the offices.

In a style of building where lack of adornment was to be expected, the decision was taken to incorporate figurative sculptures and reliefs to the façades. The most conspicuous and controversial were sculptures by Jacob Epstein representing

day and night, one of which raised much criticism. Set higher are reliefs by British artists Eric Gill, Henry Moore, Allan Wyon, Eric Aumonier, Alfred Gerrard and Samuel Rabin depicting the winds at all compass points. These were partially carved in situ from scaffolding and cradles. Henry Moore's *West Wind*, shown typically as a reclining female figure, is the earliest example of the artist's work on display in London.

The interiors at 55 Broadway are to a high standard, tending more to lavish than to the austere, with travertine (a polished limestone) and bronze applied widely. A certain hierarchy can be seen in the east wing of the seventh floor where a walnut-panelled spinal corridor leads to the large boardroom, an elongated octagonal space. The influence of the US skyscraper is found in a curious feature known as the Cutler mail chute, a slot for which is found on each floor. Commonplace in the high buildings of Chicago and New York during the 1920s, but rare in the UK, it was designed to speed the handling of mail by enabling letters to be fed to a central pick-up point, gravity being the sole motive power. The building shows other signs of being fixed in time; the train interval indicator in the lobby shows only six lines, a state of play that applied when the building first opened for business. There was once a matching set of six headway recording clocks for trolleybus routes but these were removed with the end of trolleybus services in 1962.

From 2015, Transport for London staff at 55 Broadway were migrated to new offices in the Olympic Park. It seemed certain from 2012 that Transport for London would dispose of its headquarters and permissions were sought for conversions into apartments, for commercial use or development into an hotel, but finalization of a deal did not come until September 2019, when the organization Integrity International Group announced the acquisition of the building. The company's plan for the site was not disclosed at that point.

—

55 Broadway

Westminster

London, SW1H 0BD

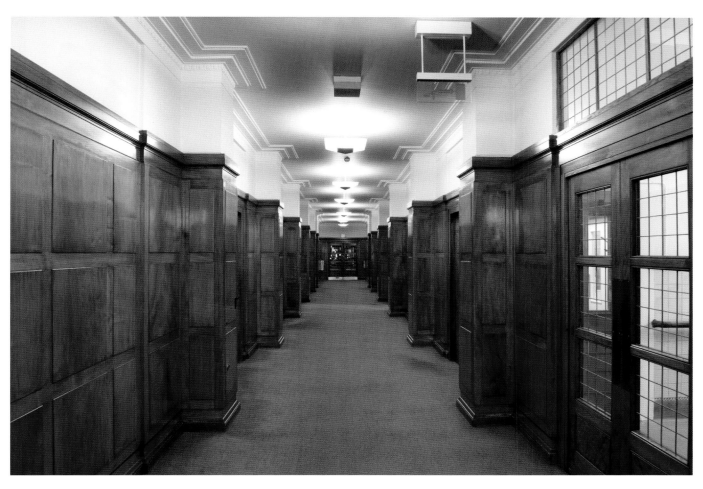

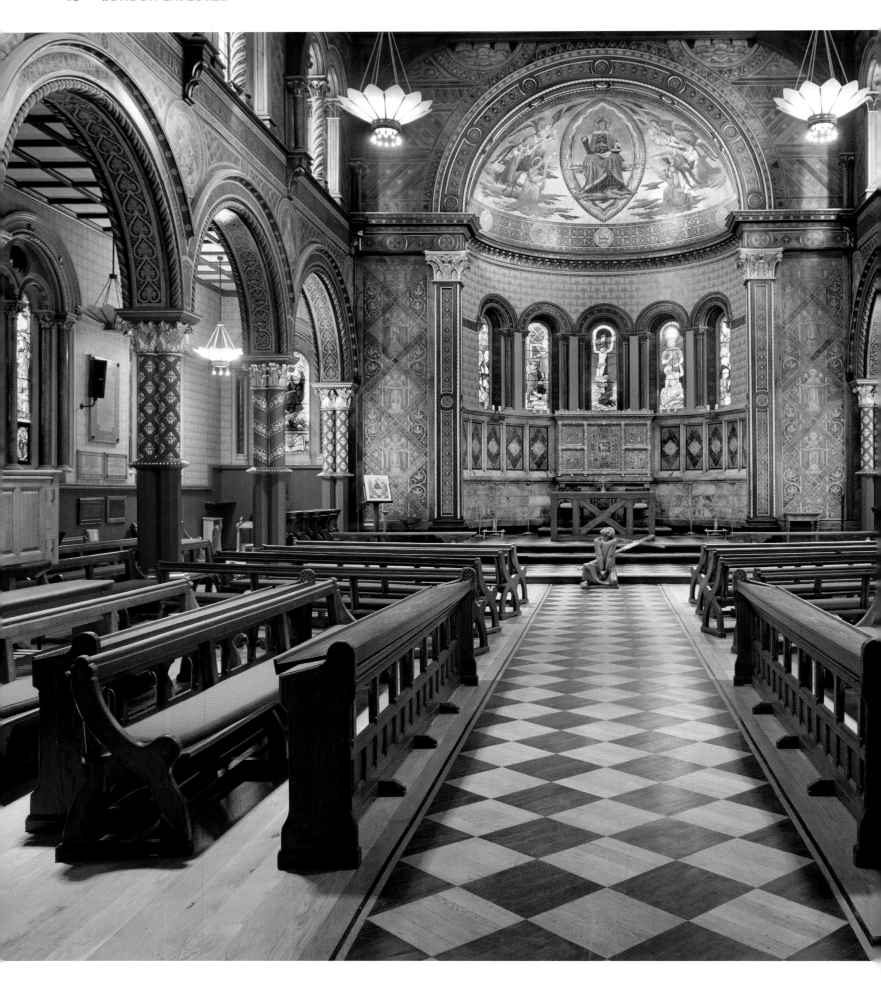

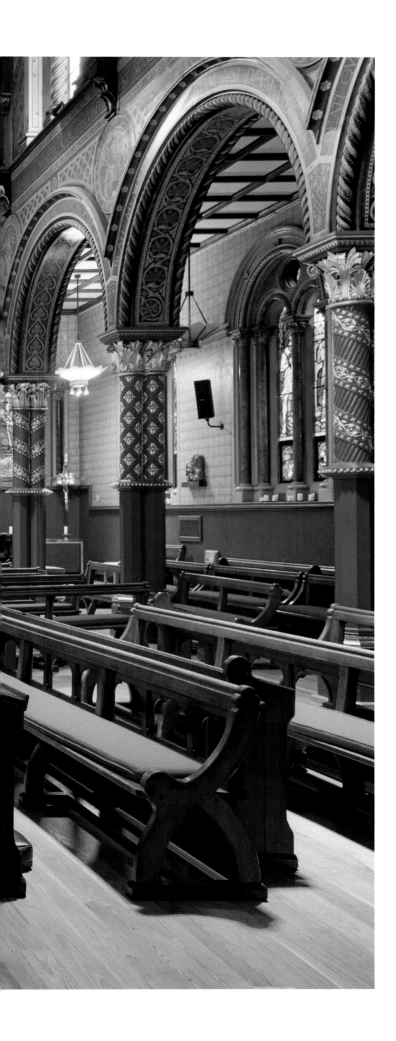

King's College Chapel

King's College Chapel is a secret place deep inside a university campus on the Strand. Within this multi-storey complex, the chapel is located below an anatomy lecture theatre and above the university's Great Hall. From a modern concrete entrance, it is reached by a double staircase and then via an academic corridor. Here, the spectacular chapel is revealed, variously described as Gothic-Byzantine, or Normano-Byzantine or simply Romanesque.

An austere chapel existed here in 1829 when King's was first established, but the College Council decided in 1859 that a grander place was required. Sir George Gilbert Scott, prolific architect of the Gothic Revival, was commissioned. He took inspiration from the ancient Christian churches of Rome, the classic basilica where a central nave is flanked by two aisles and an altar is housed under a semi-dome. The chapel itself was built upon in 1932 when the Hambleden Building of Anatomy was constructed above.

With the chapel embedded inside the King's College Building, visitors wonder how it manages to catch the sunlight that streams through its stained-glass windows. The answer is that the chapel has a secret street aspect. This can only be seen from the obscure passageway, Strand Lane. Some who explore this alley go in search of one of London's best-known curiosities, an ancient bath, supposedly Roman, found behind a window at pavement level. At this place it is necessary to look upwards to see how part of the nave and the apse of King's College Chapel project eastward from the jumbled assemblage of the main building.

King's College Chapel, with its decorations in parquetry, tile and paint, has been extensively restored to Scott's original design; modern stained-glass windows with characters from the Old and New Testaments are in the theme of the originals.

—

King's College Chapel, Strand Lane, London WC2R 2LS

The double columns are cast iron decorated with brass.

Grant Museum of Zoology

Visitors to the Grant Museum of Zoology are greeted by a line of skeletons seemingly looking down from the balcony, three simian and one human. They make a good introduction to a collection that contains 68,000 zoological specimens from the whole of the animal kingdom. The museum is packed with skeletons, mounted animals and specimens preserved in fluid. Some of the species represented are extinct, including a skeleton of a quagga and bones of the dodo and thylacine; others are endangered and extremely rare species such as the dugong. The museum is associated with University College London and is the last remaining university natural history collection in London.

The collection was started in the nineteenth century and is named after Robert Grant, who came to what was then called the University of London in 1827 to take the chair of zoology. His progressive scientific ideas were shaped late in the Scottish Enlightenment in Edinburgh, where one of his pupils was none other than Charles Darwin.

Grant was a natural choice for the newly founded English university, which set out to be secular, radical and liberal in thought. He taught zoology and comparative anatomy. Lacking any teaching materials with which to conduct his courses, he began to amass specimens, material for dissection, diagrams and lecture notes, and by the 1850s, the collection comprised 10,000 items. Comparative anatomy was just starting as a discipline and was seen as important for medical students.

Grant's successors to the chair of zoology became, according to the precedent set by him, the curator of the comparative zoology collection and the museum continued to grow. It has become the foremost zoological museum in London as collections from other colleges, hospitals and societies were taken in.

Looking down at visitors from the balcony are skeletons, from left to right, of an orangutan, chimpanzee, human, gorilla and donkey.

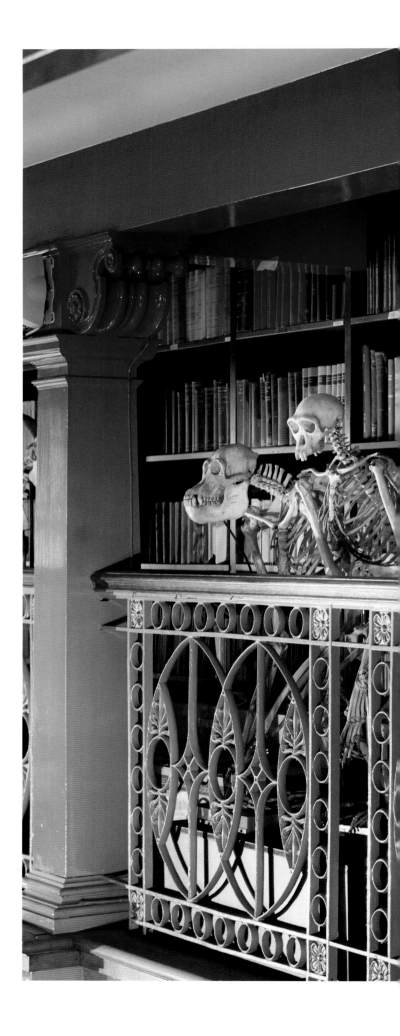

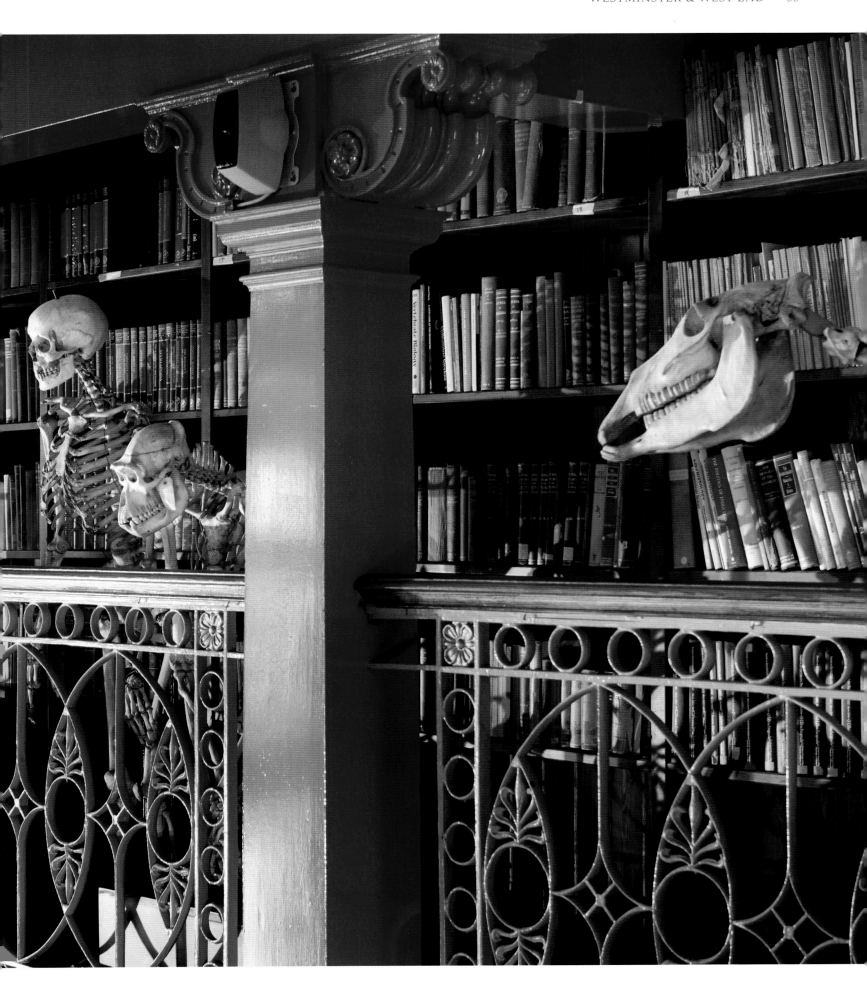

The museum continues to be a resource and a teaching aid. Since first opening to the public in 1996, access has been extended and it has reached out further to visitors, schools, local communities and especially young people who are captivated by exhibits such as bisected heads, the brain collection, the walrus baculum, skulls of elephants (African and Asian), a complete wall formed of 4,000 mice specimens and a jar filled with moles, which generates a high level of fascination. There are the skull and antlers of the giant deer, also known as the Irish elk, found in a hotel in Country Kildare and bought to the museum in 1961. There is the Blaschka collection of models of jellyfish, sea anemones, sea cucumbers, gastropods and cephalopods. All the specimens in this collection were made from glass by Leopold Blaschka and his son Rudolph in the late 1800s. The soft bodies of marine invertebrates are particularly difficult to preserve, so the Blaschkas were commissioned to make anatomically accurate models from

glass. The Blaschkas' skills died with them and their work has not been repeated.

The dugong skeleton in the Grant Museum is another valuable treasure. The specimen is 2.7 metres/9 feet long, which would indicate it was an adult. Unlike their sea cow relatives, which reside in estuaries and freshwater, dugongs are found only in coastal marine habitats. Adult dugongs usually grow to up to 3 metres/10 feet in length and weigh over one tonne. The closest living relative to the dugong is the elephant.

At the other end of the scale is the Micrarium, a small brightly backlit space constructed from more than 2,000 examples of microscope slides and magic lantern slides, mostly of invertebrates, although mammoth hair and giraffe horn can be found here. It was designed to overcome two problems with natural science collections: firstly, some 95 per cent of all known animal species are tiny, yet most of the specimens on display are large animals,

The skeleton of a dugong, a relation of the manatee, which is a sea mammal found in South East Asia. These interesting creatures have long fuelled mermaid myths and legends across cultures.

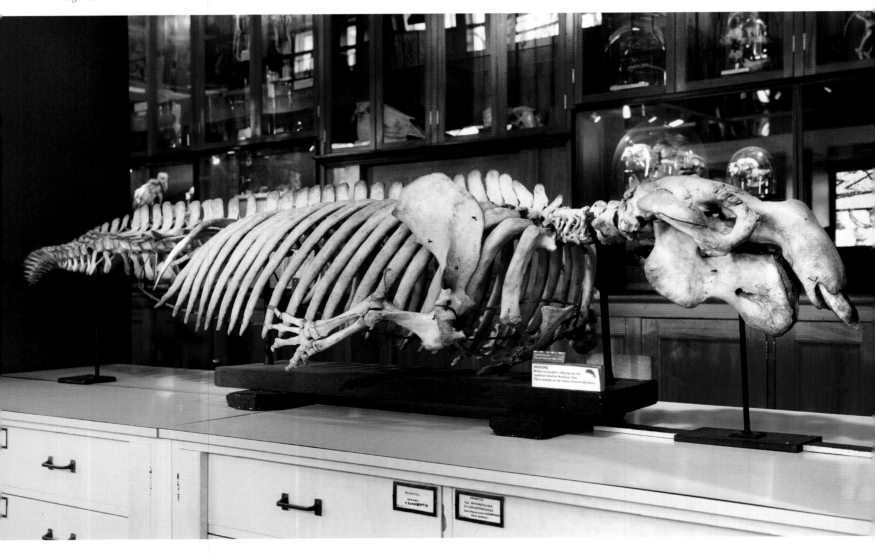

with museum galleries therefore deeply unrepresentative of the natural world. Secondly, most natural history museums have extensive microscope slide collections, largely made obsolete by modern imaging techniques. The Micrarium is a single solution to both issues. The museum claims it is arguably the most beautiful 2.52 square metres / 27 square feet in London.

A special characteristic throughout the Grant Museum is an authentically old-fashioned look to the room which, according to the curating team, causes visitors to say: 'This is what a museum should look like.' The distinctive decor is evident in the polished display cases, apparently Victorian, which carry a very large number of specimens densely displayed, and on the balcony with further exhibits and book-laden shelves. It seems as if the collection has been installed here for years, but in reality the museum has moved many times. This particular home was found in March 2011, in a room that was formerly the UCL Medical School library. The old-time ambience is tempered by some more advanced interactive displays where visitors can engage in dialogue about the evolutionary past via iPads and smartphones.

—

Grant Museum of Zoology
Rockefeller Building
21 University Street
Bloomsbury
London WC1E 6DE

A porcupine fish or pufferfish, housed in the fish cabinet. These curious creatures raise their spines and puff themselves up when threatened by predators.

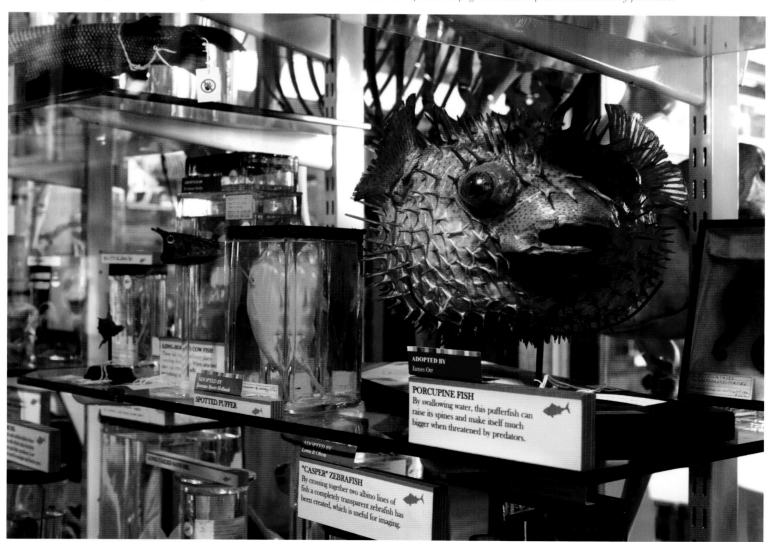

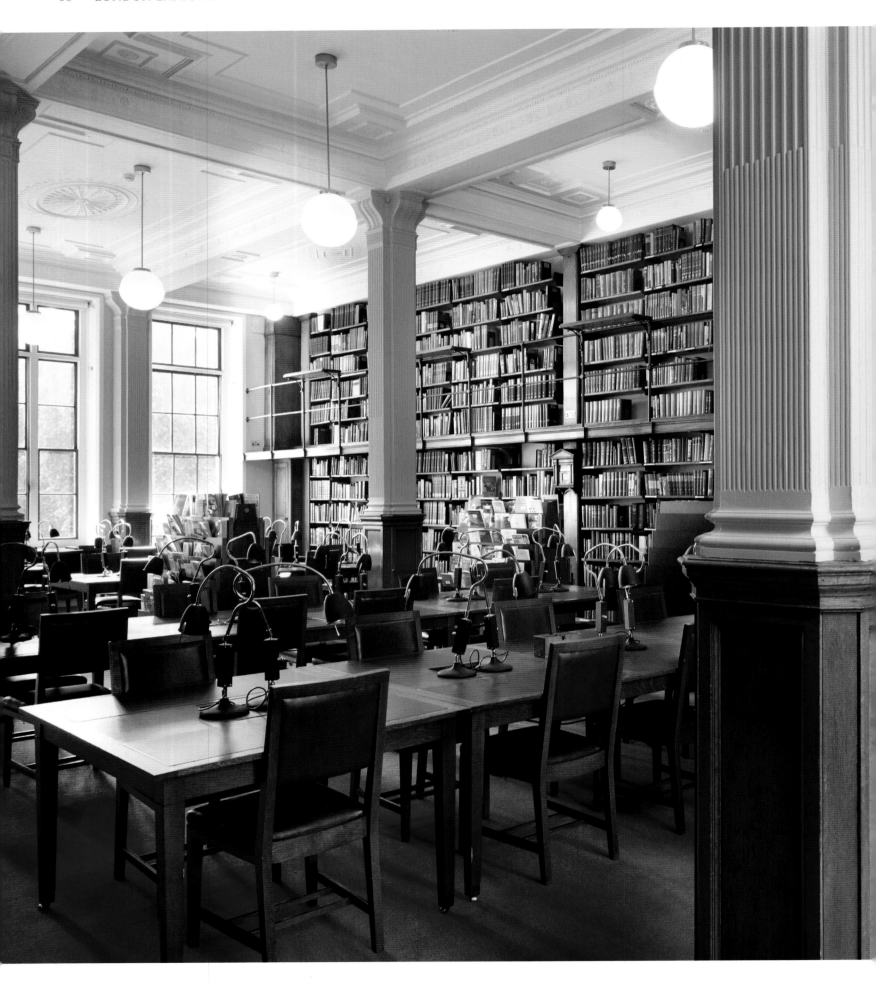

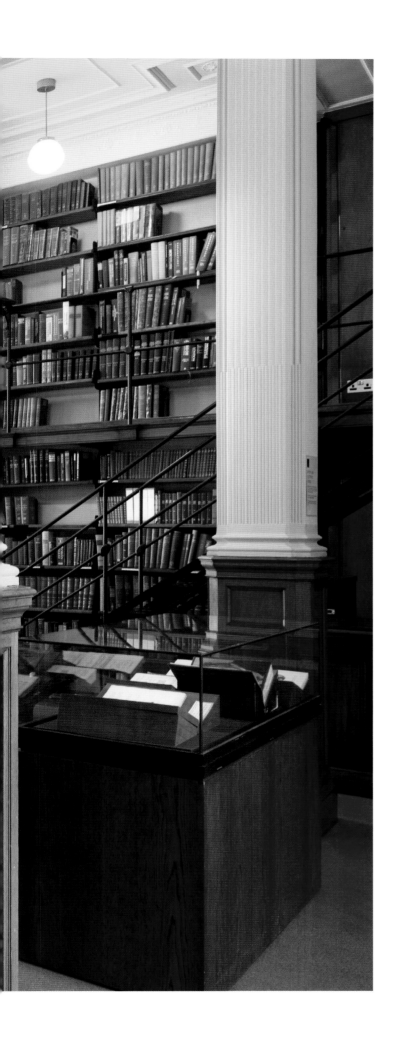

The London Library

The London Library can be described as a marvel in multiple dimensions. It occupies a fine location in the corner of one of London's historic squares, where its narrow façade hides a complex of rooms and spaces spreading behind, below, to the side and above. It thrives as a subscription library in an age when the use of hardcopy books has supposedly declined. It carries accumulated layers of its own history and legends. The London Library holds more than a million books on its shelves, which measure some 27 kilometres / 17 miles, more than the length of the Circle Line.

Based in a house on St James's Square since 1845, the library building was entirely rebuilt between 1896 and 1898 with a traditional Portland stone frontage concealing an advanced construction for the Victorian age. It incorporated a space-efficient metal frame for three new floors of bookstacks behind. These dense 1890s bookstacks, with utilitarian exposed beams, columns and grille floors, remain the most famous feature of the library. More bookstacks, this time with opaque glass floors, were added in 1922, and a further six-floor wing was built in 1934. With extra additions in the 1990s and 2000s, its entire ground-floor plan now combines seven buildings between the square and Duke Street behind.

Visitors first enter the double-height issue hall and then the lofty galleried reading room on the first floor. Stairs rise to the shelf levels behind. There are more reading spaces and a writers' room providing 140 desks in total, including an art room for large books, a tiled lightwell covered to make a study area and an elegant committee room with a transplanted Adam fireplace. In the labyrinthine basement lies a modern roller racking system for periodicals, alongside original copies of *The Times* newspaper spanning 200 years.

Stephen Fry once said of the reading room: 'What gyms can do for your body, this magical place can do for your mind.'

The history floor features an extensive collection, including works on monarchs, historical events and topics such as feudalism, international relations and chivalry.

The standard Dewy Decimal Classification is not used in the London Library, which has its own system. There are still ancient finger signs to aid navigation around the stacks and some members say that simply browsing is the best experience, although its digital online catalogue is now rated as a powerful instrument. An increasing amount of its space can be described as virtual through its digital connectivity. In every respect, it is a serious, functional library, strong in history, literature, biography, art, philosophy and religion. There are French, German, Italian, Spanish and Russian collections.

Many direct connections can be made to writers across the literary spectrum and across time. Joseph Conrad, George Eliot, Henry James, George Bernard Shaw, Virginia Woolf, Rudyard Kipling, E.M. Forster, John Betjeman, Siegfried Sassoon, Agatha Christie and Harold Pinter all belonged to the London Library. Tennyson was an early president of the library. T.S. Eliot, a member since 1918, was president between 1952 and 1965, a role later occupied by Sir Tom Stoppard, and now Sir Tim Rice.

Sometimes membership, fact and fiction overlap. Member Sir Arthur Conan Doyle deployed Dr John Watson to the library for an intensive study of Chinese pottery in the Sherlock Holmes story *The Adventure of the Illustrious Client*. Recent research has shown that Bram Stoker used his membership to borrow and study titles such as *Transylvania* and *Round About the Carpathians* during the seven years it took him to write *Dracula*. It is not clear if Ian Fleming was a member, but he made sure that James Bond was,

The art room displays works on the fine and applied arts, including painting, sculpture and architecture, as well as on topics such as aesthetics, artistic anatomy and colour.

as Fleming equips his agent with *Burke's General Armory*, stamped Property of the London Library, when he is assigned to tackle the villain Blofeld in *On Her Majesty's Secret Service*.

Thomas Carlyle, the philosopher and historian who wrote an account of the French Revolution, is credited with doing much to launch the London Library after his frustration with the British Museum Library, which did not lend books. Carlyle shipped two cartloads of books on the French Revolution taken from the library to help Charles Dickens write *A Tale of Two Cities*.

Antonia Byatt set the opening chapter of *Possession* in the reading room. It is reported that the 2017 Nobel laureate Kazuo Ishiguro discovered a copy of Harold Laski's *The Dangers of Being a Gentleman* here and was inspired to write *The Remains of the Day*.

The library's warren-like spaces are more smoothly connected than before following refurbishing and rebuilding, but a fine eccentricity remains. Even outside at street level, a sharp-eyed observer might see that the façade, which is asymmetrical, creates an illusion. In 1896 the architect took what was the narrowest house in the square and made it look older and wider than it is. The frontage appears to go under the cornice of the neighbouring building, which dates from the 1730s. It is a hint that more lies behind. To see more, it is sometimes possible to go inside the library during certain evenings by booking in advance.

—

The London Library

14 St James's Square, London SW1Y 4LG

James Purdey & Sons Ltd

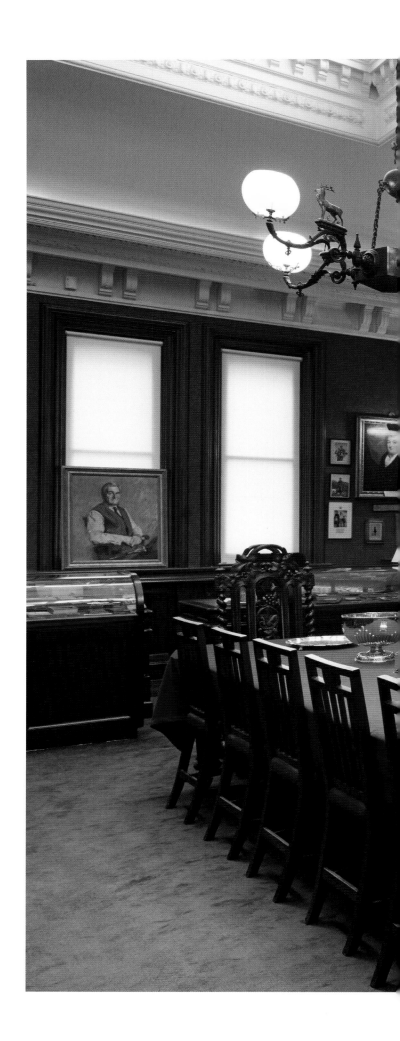

A fine sporting gun entirely made in London carries a special distinction and a high price. There are still a handful of great London makers, including Boss and Holland & Holland, but the most recognized name is Purdey, with its showroom in Mayfair and workshop in Hammersmith.

In the 2020s, a capable shotgun can be bought off the shelf for much less than a thousand pounds; a Purdey gun can cost a hundred times more than that. The smooth-bore shotgun with bead sight is one of the simplest types of firearm; Purdey take up to two years to produce a shotgun and make only about a hundred guns and rifles each year, all of them 97 per cent handmade.

The company's reputation was forged on making the best-handling guns of the Victorian period. A patent of 1870 provided an ingenious and simple design of bolt and top-lever mechanism. This innovation for aiding the opening and closing of drop-down guns did much to put the firm at the forefront during the golden age of gunmaking. Today, collectability is often the aim of the owner, who appreciates the high level of finish, and some guns are destined from the start to become what is known as a 'safe queen'. 'If you want to lock it away, it's the buyer's choice', says a spokesman for the company. Experienced sporting shots say the sheer functionality of any Purdey is undiminished: strong, reliable, neat, well balanced and generally light. The firm makes side-by-side and over-and-under shotguns, hammer-ejector guns, bolt-action rifles and double rifles.

The showroom is in Mayfair, centre of luxury retailing, but its location is rooted in history rather than prestige. The West End was once the home of diverse expert craftsmen, including gunmakers. From 1814 the first muzzle-loading flintlocks made by James

The historic Long Room at the Mayfair showroom, where Purdey portraits look down on a side-by-side 12-bore, a new trigger plate over-and-under and a Purdey best over-and-under with fine engraving; archive ledgers date back to 1818.

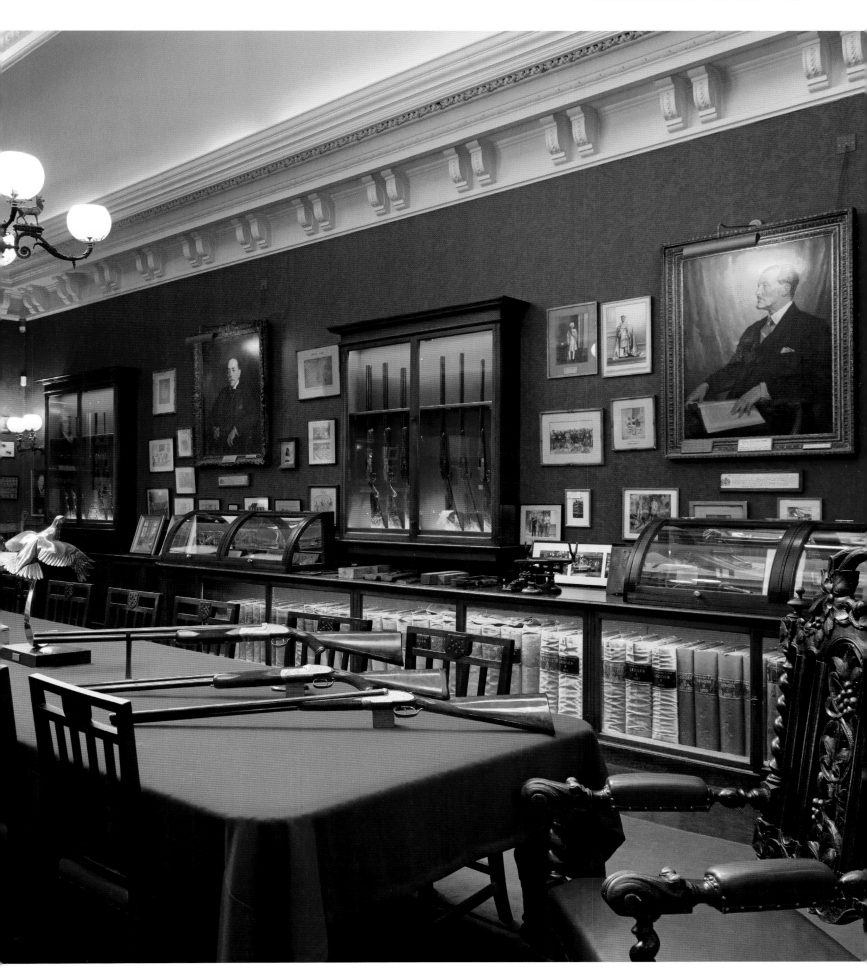

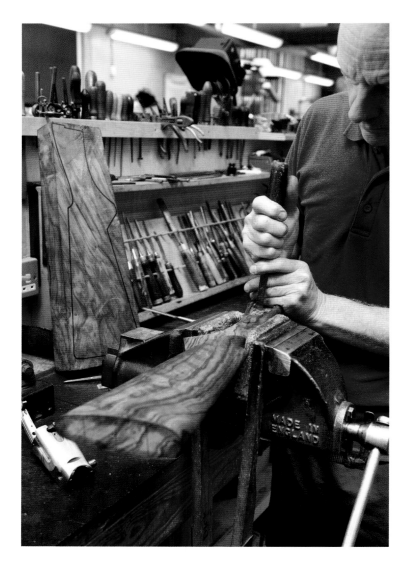

Purdey came from a workroom in what is now Wardour Street, and later from a shop in Oxford Street. By 1883 the thriving James Purdey & Sons had moved to Audley House, a building which the firm had commissioned in Queen Anne-style red brick and red stone on the corner with Mount Street. The royal coat of arms over the entrance door is unsurprising. *Country Life* reported that by Edwardian times there was no crowned head of state in Europe without a Purdey.

On the top floor, thousands of cartridges were loaded by hand and originally guns were fitted with stocks and finished and engraved on the premises. On the ground floor is the Long Room, once an office, where James Purdey the Younger, the founder's son, would watch the craftsmen at work below through a well in the floor. In 1938 the well was closed over and a long table installed, which is still in place today. The space has been restored and has been described as resembling the gun room of an old country house combined with the smoking room of a London club. It is hung with portraits of the Purdey patriarchs, lined with memorabilia, and houses historic ledgers. The selection of wood for the stock by customers and the taking of measurements are still handled in the Long Room.

In 1949 Purdey acquired James Woodward & Sons, a London maker noted for an exceptionally good design of over-and-under guns. This became and remains the basis for Purdey 'best' over-and-unders. Over time, Purdey's factory for making actions and working on gun tubes for barrel-making has been located at various places in west London, eventually settling in Hammersmith in 1979, where all gunmaking is now concentrated. The factory was extensively reworked in 2015 to give a modernized environment and includes an indoor range for testing and regulating. Here, the traditional trades of the barrel-maker, actioner, stocker, engraver and finisher continue. Computer numerically controlled machines cut the outline of the action, which starts as a solid forged ingot. This goes to the actioner who uses smoke black from a paraffin lamp to deposit soot over the surfaces to reveal any unevenness. Locks, triggers and ejectors are made by hand. Racks of hand tools line the benches. While most of the materials, such as Turkish walnut and case-hardened EN36 steel are unmysterious, many of the processes certainly are. Application of a certain oil called slacum, devised by a legendary craftsman and factory manager early in the last century, takes up to six weeks. Numerous coats are applied to the stock. The deep glossiness of the blacking on Purdey barrels is widely admired and hard to copy. Assembly, known as 'putting together', is a two-part process, spread over three months.

In the Hammersmith workshop, a high volume of work is repair and servicing. Purdey guns from the 1890s, some with original barrels, are still supported.

—

James Purdey & Sons Ltd

57–58 South Audley Street, Mayfair, London W1K 2ED

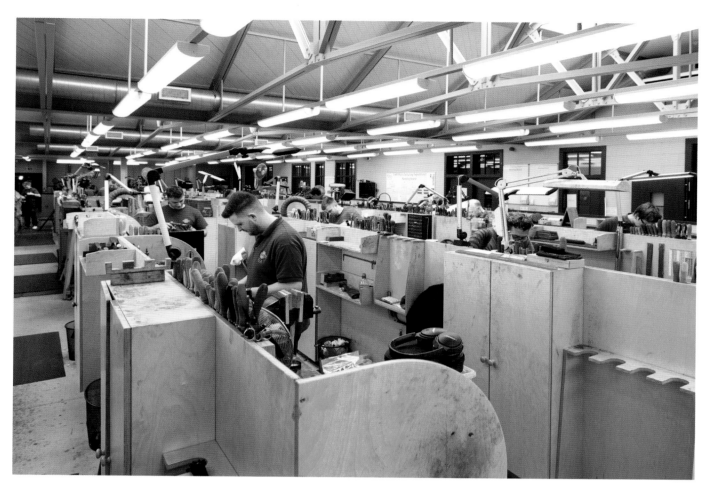

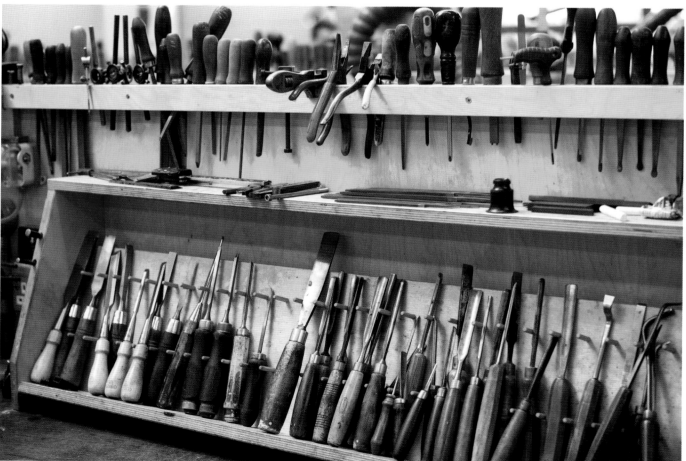

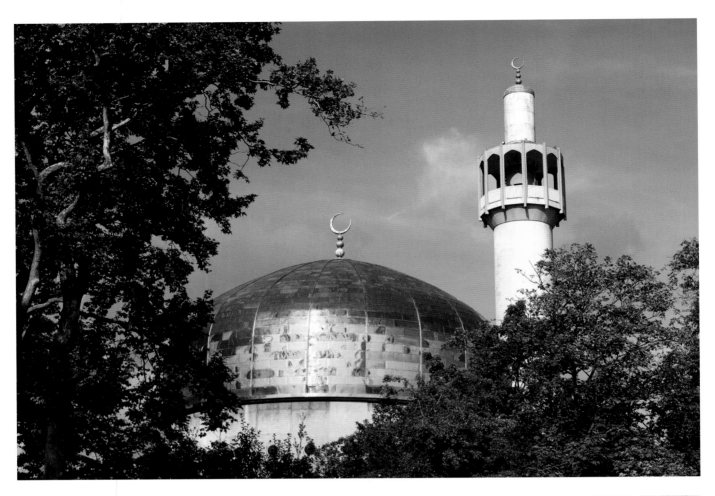

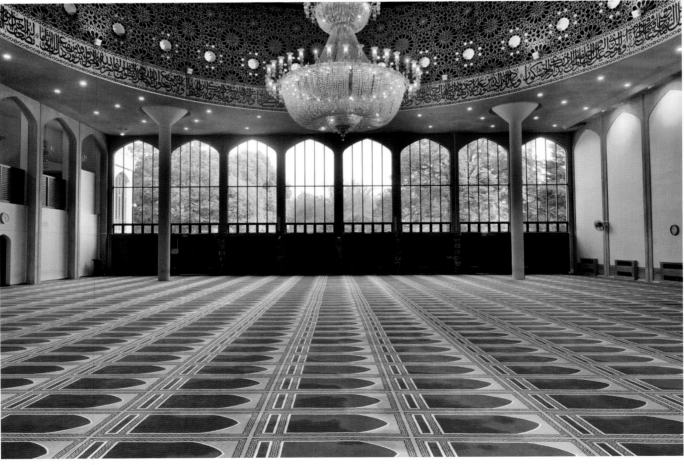

London Central Mosque
& Islamic Cultural Centre

Regent's Park Mosque, properly known as the London Central Mosque and Islamic Cultural Centre, received a National Heritage Grade II* listing in March 2018. The listing described its symbolic role as a landmark of the Muslim faith, saying its completion reflected the acceptance of the Muslim faith by the British Establishment and its importance in the nation's Islamic heritage.

The white minaret, golden copper dome and prayer hall rose up between 1974 and 1977 near Hanover Gate alongside Nash Regency terrace townhouses. Plain in external decoration, its architect, Sir Frederick Gibberd, described it as a largely prefabricated building. All eighty-five façade units forming the walls were precast off-site. Some are glazed and some in-filled in a shape known as the four-centred arch, which is recognizably Islamic in architectural style. Special techniques were needed to build the dome, which is mounted on a ring-beam over the main hall on tubular steel lattice frames. Four slender pillars rising through the prayer hall support the dome. The minaret is a double-walled tube with a spiral staircase enclosing a lift, and the twelve-sided gallery on top of the minaret continues the characteristic arch shapes. The prayer hall building is joined by a pair of three-storey wings containing administration offices, accommodation and the library, reading room and study areas of the Islamic Cultural Centre.

Its emergence spanned seventy years, punctuated by delays, false starts and setbacks, and influenced by shifts in international relations and two world wars. With an Empire inhabited by more Muslims than Christians, an appeal was made to the British government towards the end of the First World War for a central place of worship to be created as recognition for the thousands of Muslims fighting for King and Country. When this did not develop, a separate trust fund was established by the Nizam of Hyderabad in 1928, and a foundation stone laid, but that development also

stalled. It was after the start of the Second World War that Winston Churchill's war cabinet, mindful of need for support from Arab nations in the Middle East, approved £100,000 for purchase of a site. A substantial two-storey house known as Regent's Lodge, standing in a hectare of land on the Outer Circle of Regent's Park, was acquired. With the Islamic Cultural Centre and a temporary mosque established in Regent's Lodge, work on a grand new mosque seemed poised to start in the 1950s, but support from Muslim nations faded after the British military action at Suez in 1956. When revived in the early 1960s, there was another setback: the design submitted for a monumental traditionally styled mosque was rejected by the planning authorities.

An architectural competition launched by the mosque trust in 1968 received fifty-two entries; the Gibberd design was selected, and construction was supported by a significant donation from King Faisal of Saudi Arabia and later by Kuwait, the UAE, Oman and Qatar. These added to the funds accumulated in trusts over the years by British Muslims. In 1994, with the addition of an administration wing, the forecourt alongside the prayer hall became an enclosed courtyard. At one time, inside and outside, as many as 6,000 worshippers can pray at the Regent's Park mosque.

The mosque was far from the first to be established in Britain nor the first be awarded Grade II* status, that distinction belonging to Shah Janan Mosque in Woking, founded in 1889, listed in 1984, but London Central Mosque was long overdue for recognition. After more than forty years in the harsh London environment, the minaret and dome were being prepared for the first round of restoration and refurbishment in 2021.

—

The London Central Mosque and Islamic Cultural Centre
146 Park Road, London NW8 7RG

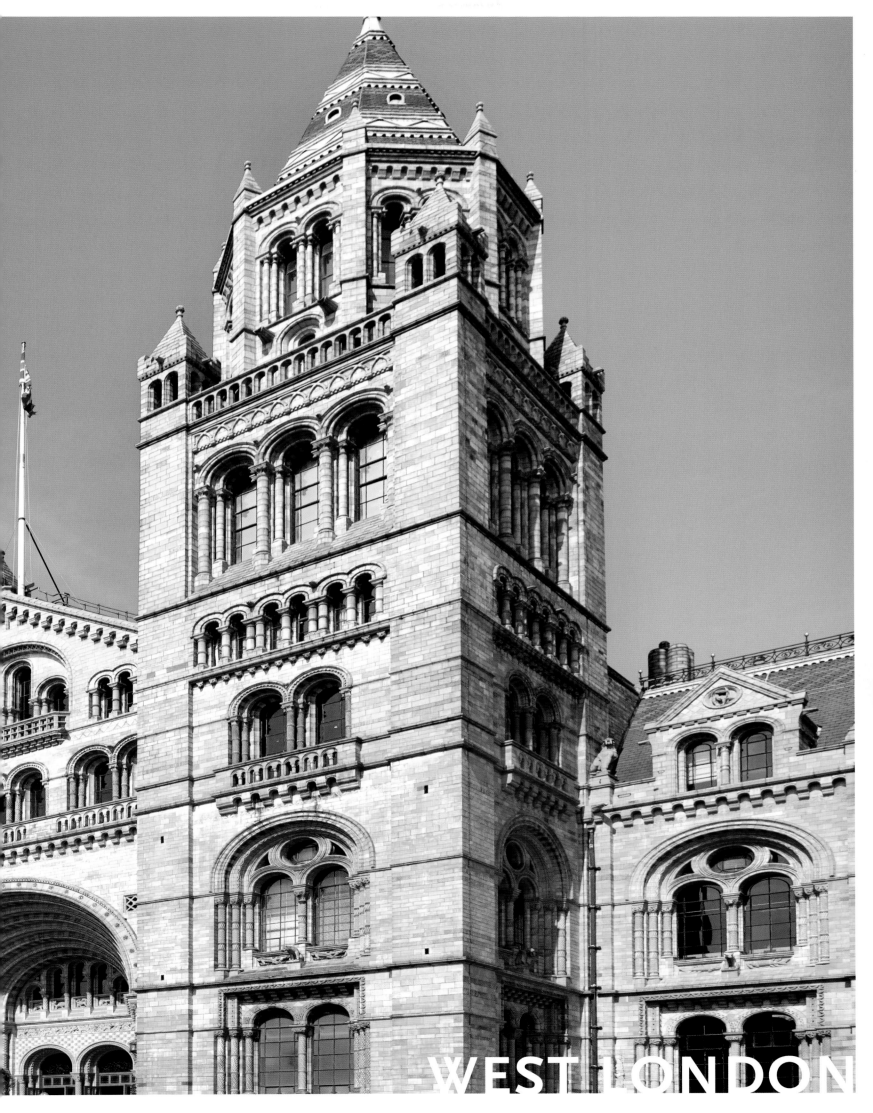

WEST LONDON

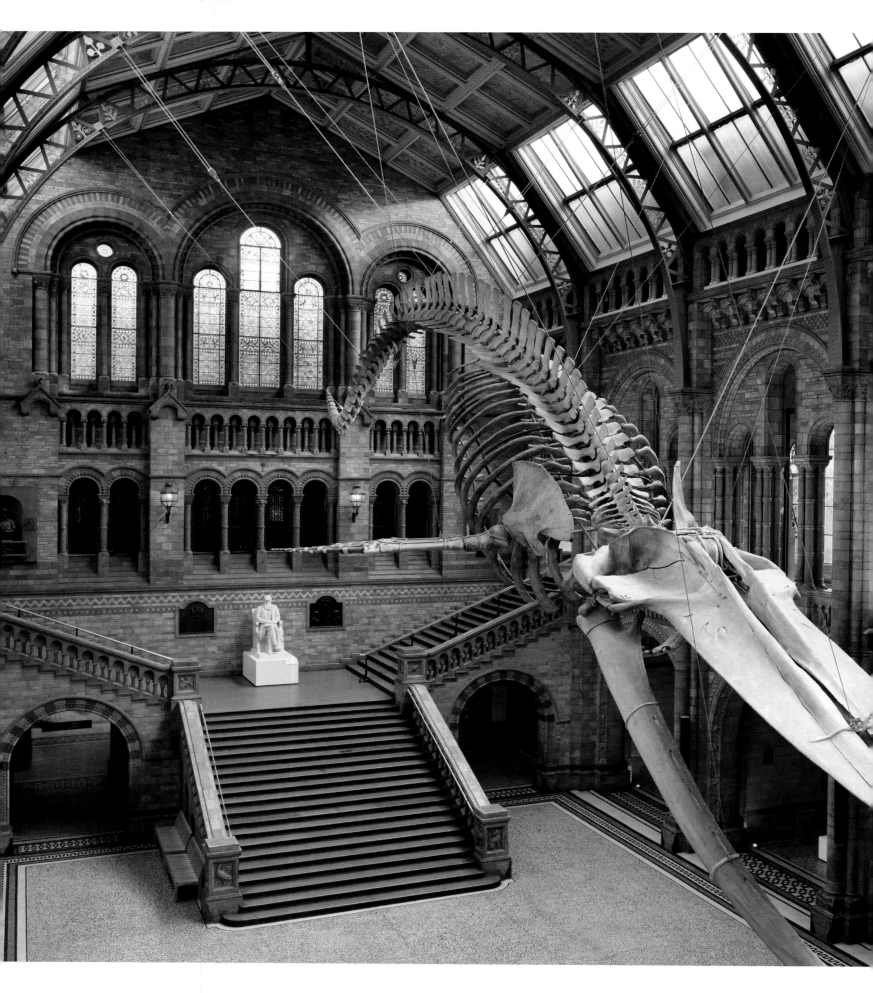

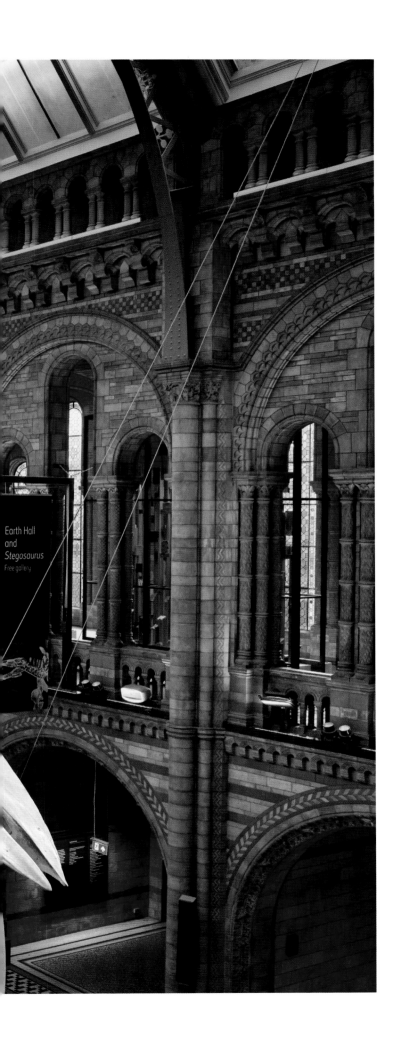

Earth Hall
and
Stegosaurus
Free gallery

Natural History Museum

South Kensington is intensively educational, home to the Science Museum and the Victoria & Albert Museum, as well as that favourite of school parties, the Natural History Museum.

This palace of knowledge for the history of life on Earth was opened in 1881 and it was one of the first buildings in England to have a terracotta-clad frontage, which conceals an iron frame. The Natural History Museum's architect, Alfred Waterhouse, worked closely with the first superintendent of the museum, Richard Owen, on the building's design. Owen, a biologist and palaeontologist, provided the specimens to enable the architect to develop the decorative mouldings. Terracotta mouldings outside and in enabled the extensive depictions of flora and fauna. According to the museum, 'From the imposing gargoyles on the façade to the most delicate interior detail, every element of Waterhouse's design pays homage to the natural world.' Its imagery reflected the prevailing scientific state of awareness.

A visitor generally enters through the Hintze Hall, most famous perhaps for being home to 'Dippy the Diplodocus', whose bones hung from the ceiling until January 2017. When Dippy was despatched on a tour of Britain, the dinosaur's skeleton was replaced by the bones of a blue whale named Hope, the largest animal to have ever lived. The hall, refurbished and reopened by the Duke of Cambridge in July 2017, has huge stone arches along its length, underneath which are alcoves containing various animal skeletons, display panels and other exhibits. These include the remains of a gem-filled meteorite that dates back to the dawn of the solar system and remains of an Ice Age American mastodon.

These have been chosen to show just some of the huge number of fossils, bones and other remains of flora, fauna and naturally occurring materials the museum has in its collections, most of which are not on display.

Hope, the blue whale, whose skeleton was mounted in the Hintze Hall in 2017.

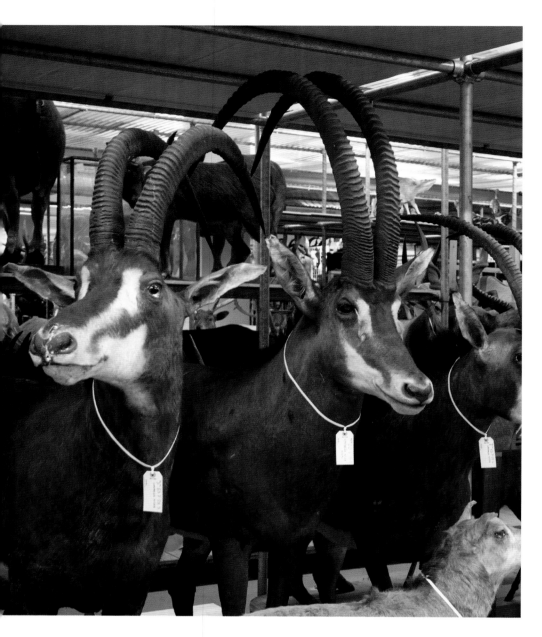 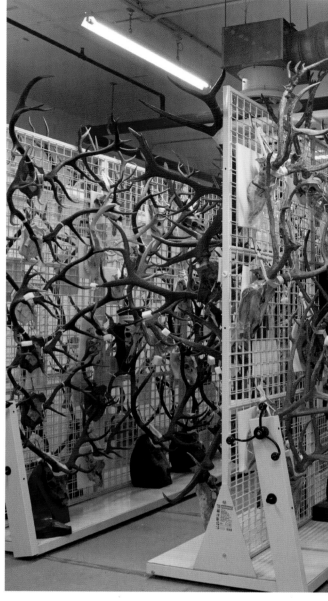

ABOVE *Taxidermy specimens of sable antelope, giant sable antelope and East African oryx members of the subfamily Hippotraginae (left); reference skulls of deer and antelope (right). Both images show specimens located at the Natural History Museum's storage facility.*

The museum has more than 5,000 fragments from some 2,000 individual meteorites, for instance; more than 250,000 fossil mammals in its palaeontology collection; and fossilized plants, algae and fungi dating from the last 3.5 billion years of Earth's history in its palaeobotany collection, including an estimated 6 million plant specimens collected between the 1600s and today. It claims 80 million specimens spanning 4.5 billion years of history, dating from the formation of the solar system to the present day.

Dominating the Hintze Hall is an imposing flight of stairs that lead up to the museum's first floor. Those climbing these stairs pass a statue of a seated Charles Darwin. His *On the Origin of Species*, published in 1859, changed how people view the world and was based on his collection of thousands of specimens while

voyaging in the HMS *Beagle* between 1831 and 1836. Many of these specimens are on display and behind the scenes at the museum.

There is a painting on the same stairwell of Alfred Russel Wallace, who developed the theory of natural selection at much the same time as Darwin; the two were friends and corresponded to share their ideas and learn from each other. A statue of Wallace is also found on the third floor of the museum. He is immortalized here carrying a butterfly net, a nod to the time he spent in Indonesia and the Malay Archipelago, collecting specimens.

Away from the Hintze Hall's ground floor, the museum is divided into four colour-coded zones, a guide for the visitor who wishes to focus on a particular subject. These areas contain galleries devoted to geology, mineralogy, botany and zoology.

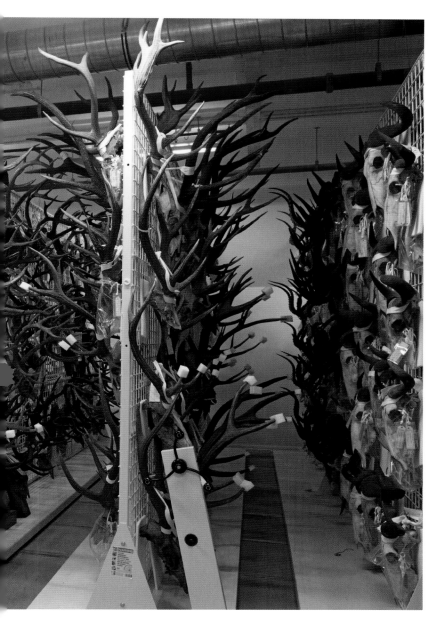
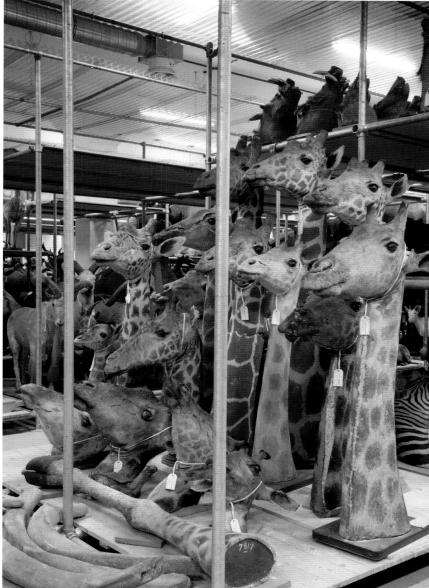

ABOVE *A giraffe audience comprising taxidermy heads of Rothschild's reticulated and Masai giraffes, held at the storage facility of the Natural History Museum (right).*
OVERLEAF *Charles Darwin statue on the Hintze Hall staircase at the Natural History Museum.*

The stone arches of the Hintze Hall feature ornate carvings, including representations of small monkeys, birds and rams. The roof is a gilded canopy depicting diverse plants from across the world of 'economic, medicinal and horticultural importance', including tea and coffee, aloe and opium. Above the entrance on the first floor is a cut-away of a giant sequoia tree. The tree, which was felled in 1891, is believed to have been 1,335 years old, sequoias being among the longest-living species on the planet.

Throughout the building are other details, not all connected with natural history. A wall plaque featuring the design of a secret agent descending by parachute is dedicated to 'The Spirit of Resistance', to the men and women of the Special Operations Executive (SOE), a British spy network that undertook dangerous work during the Second World War. Between 1942 and 1945, SOE 'Station XVb' occupied three sealed galleries of the museum, known as the Demonstration Room, housing the specialized and secret military equipment that served as teaching aids for SOE staff. A workshop here for the sabotage branch modelled explosive devices disguised as pieces of coal and even dead rats.

The full importance of the Natural History Museum is not obvious to the casual visitor to Cromwell Road, yet it has more than 300 scientists and researchers working around the world to further develop knowledge of Earth's flora and fauna.

—

The Natural History Museum
Cromwell Road, London SW7 5BD

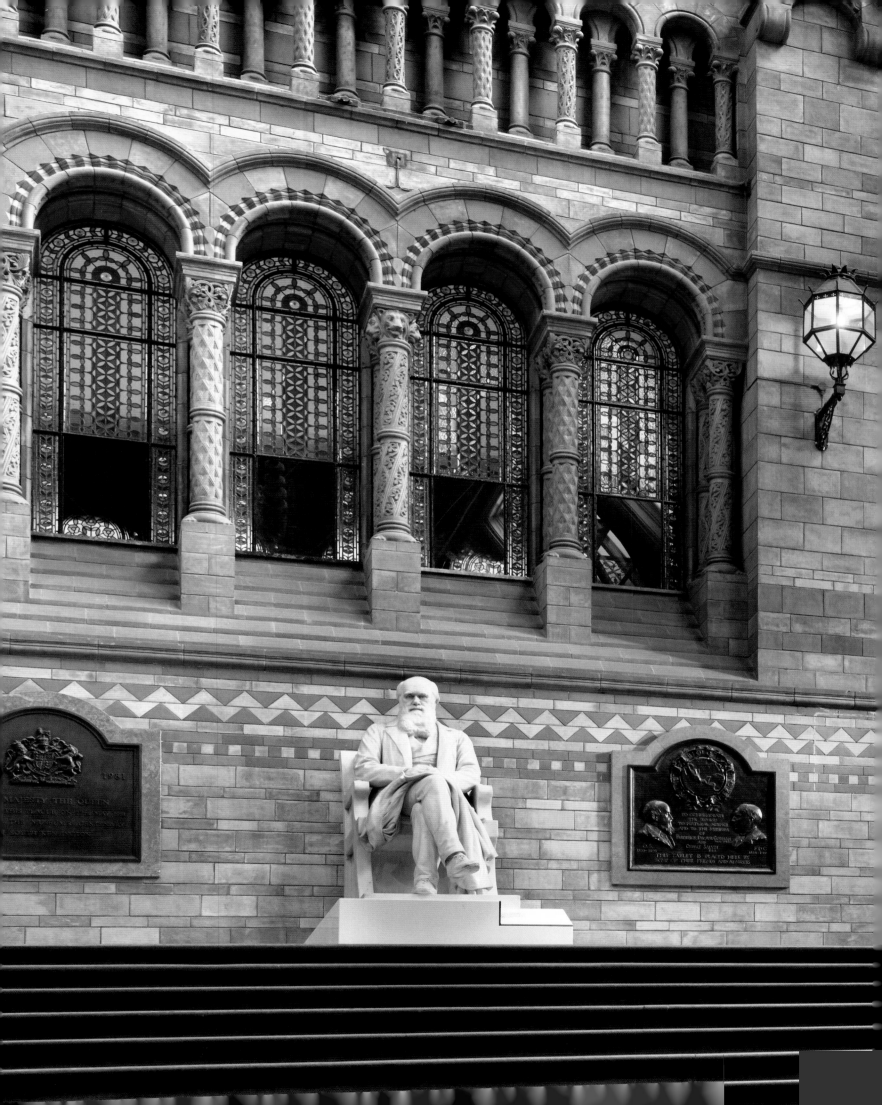

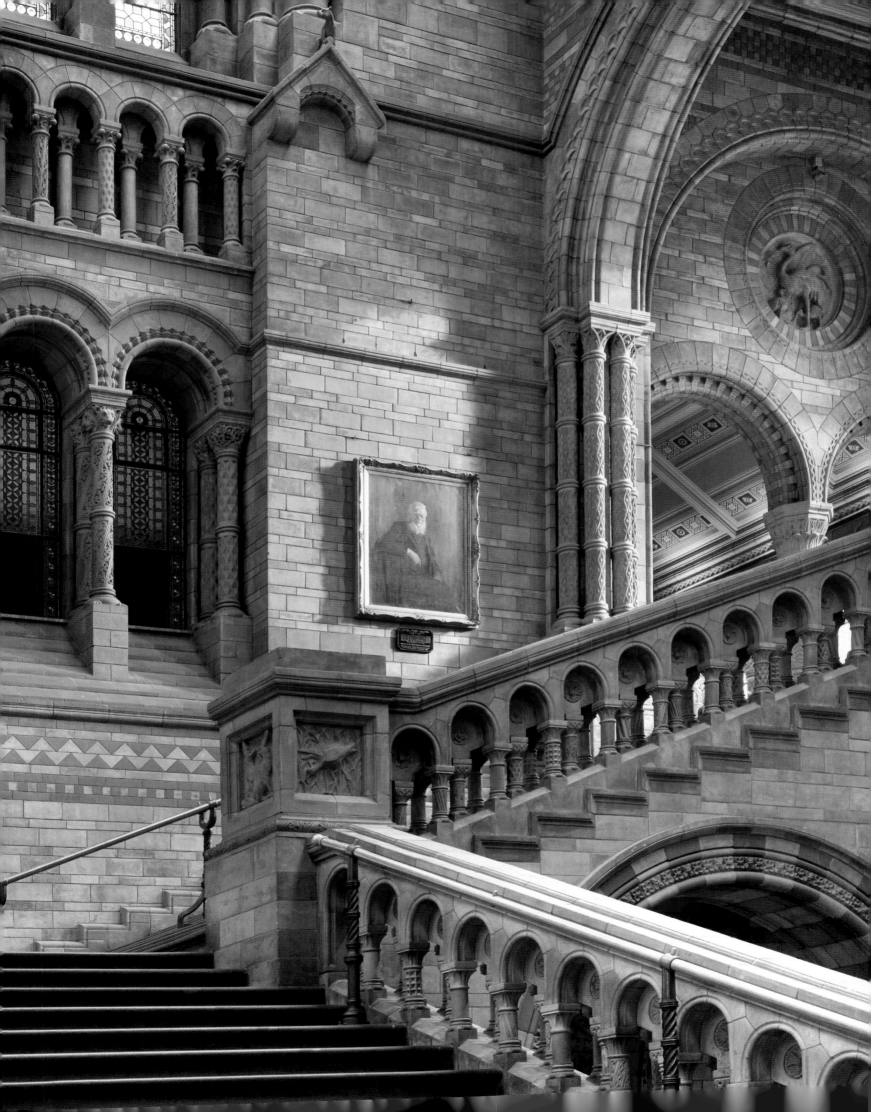

Windrush Car Storage

The location of the Windrush Car Storage facility in west London is not published and it is tempting to describe it as a secret bunker. Its founder and managing director Tim Earnshaw sometimes refers to it as the Batcave.

On the day this picture was taken, four different types of David Brown series Aston Martins were assembled within the space of a few metres and the scene evoked James Bond rather than Bruce Wayne. In neat rows beyond were more than a hundred supercars, hypercars, classic cars and other prestige and rare vehicles valued at millions of pounds, all hidden under tailored covers.

Some of the resident cars may not leave the bunker for five years in certain cases, but this is not a forgotten deep-storage vault. All vehicles are 'on the button' and can be summoned for action at short notice. Batteries are on trickle charge, tyre pressures raised to prevent flat spots, fluid levels checked – all monitored by an attentive staff. At a level equivalent to ten floors below the city streets, the garage provides ideal conditions of temperature and humidity. Tim Earnshaw describes it as a car hotel. He started the company in 2004, first storing cars at a facility on the Cotswold farm where he grew up, close to where the River Windrush flows. Now there are up to 150 cars in London in this location, opened in 2015, in addition to 200 cars at the Gloucestershire base.

The operator is discreet and will not permit many cars to be viewed or photographed, so the covers mostly stay on. Therefore Windrush poses a thrilling tease for any lucky person granted admittance. A knowledgeable visitor might glimpse beneath a cover just a fraction of a gleaming wire-spoked triple-laced wheel. This being in the unmistakeable style of Borrani, coupled to the silhouette, suggests that a certain classic Ferrari of breathtaking rarity lies beneath. In London the resident vehicles are split roughly 60–40 modern to classic, including Bugatti Veyron, McLaren, Lamborghini and high-end Porsche.

The idea of keeping any kind of great car in casual everyday use in London has become increasingly difficult. Here, the solution for owners who want to return their cars at any time of day or night is the provision of a separate garage area adjacent to the main vault, accessed through a door opened by key code. The facility is staffed around the clock. A typical Windrush user is described as being high net worth and time poor.

—

Windrush Car Storage

Holland Park, London W12 7GF

A McLaren 720S, ready for its owner.

Crosby Moran Hall

A grand palace by the River Thames in Chelsea, Crosby Moran Hall has been described by English Heritage as 'The most important surviving secular domestic medieval building in London.'

It is the thirty-year achievement of businessman and philanthropist Dr Christopher Moran, chairman of Co-operation Ireland, who has made it his life's work to put London's only domestic medieval building to have survived the Great Fire of 1666, Crosby Moran Hall, back into its historical context in terms of architecture. As a passionate and knowledgeable enthusiast of the Tudor, Elizabethan and early Stuart periods and a collector of Old Master pictures, high-status furniture, silver and gold, arms and armour, and tapestry of these ages, he launched a project unlike any other restoration programme in London – the final aim being to reinstate the art and architecture of the Tudor, Elizabethan and early Stuart periods here. This rebuilding and restoration of Crosby Moran Hall incorporates a Tudor and Elizabethan mansion constructed over a period of 150 years. Its true history spans 500 years and started in the City of London.

A wealthy merchant, Sir John Crosby, commissioned at Bishopsgate his great house, Crosby Place, between 1466 and 1475. It was afterwards occupied by Richard Plantagenet, Duke of Gloucester – later Richard III – at the time of the disappearance of the princes in the Tower. With this connection, Crosby Place generates several mentions in Shakespeare's *Richard III*. Sir Thomas More owned the house, by that time a palace, while he served Henry VIII. It was described by Stowe in his Survey of London in 1603 as 'of stone and timber, very large and beautiful, and the highest at that time in London'. Catherine of Aragon, Henry VIII, Elizabeth I, Sir Walter Raleigh, the poet Mary Sidney and Shakespeare have all dined, lodged or visited there. Lord

The Elizabethan Garden at Crosby Moran Hall was designed by the Marchioness of Salisbury. One of its features is an ornamental fountain of Diana by Neil Simmons, derived from one at Nonsuch Palace in Surrey.

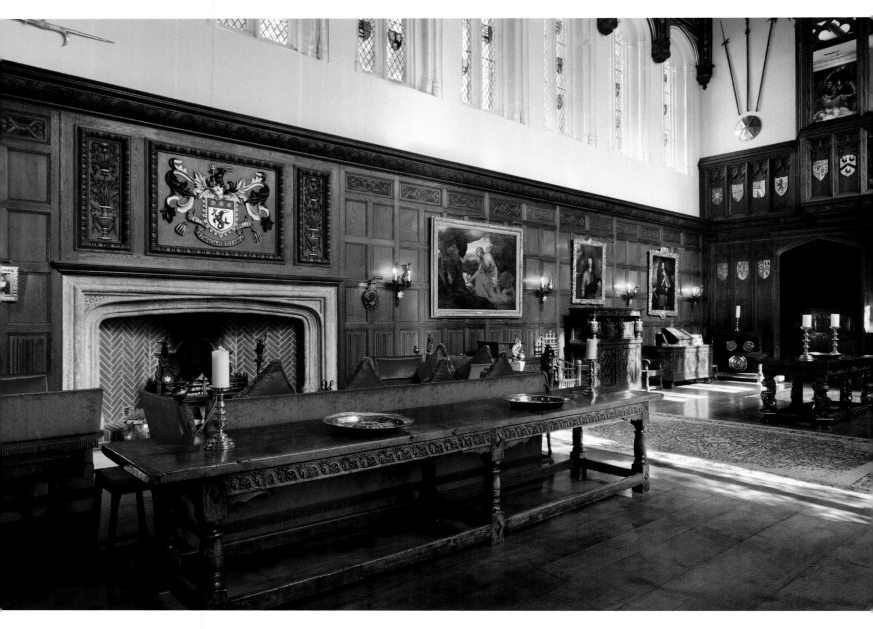

ABOVE *The original Great Hall at Crosby Moran Hall.* OPPOSITE *A sea stag newell post (above left); a statue of Sir Thomas More outside Chelsea Old Church, close to Crosby Moran Hall (above right); the centrepiece of the dining hall is a massive oak dining table hewn, from a single 17-metre/55-foot length of timber (below).*

Mayor Sir John Spencer further beautified the grand rooms while Crosby Hall served as his Mansion House. It operated as head office of the East India Company from 1621 to 1638. At that time, the hall served as a meeting place and warehouse, and by Victorian times, it had become a cavernous restaurant.

In 1908 the Chartered Bank of India, Australia and China bought the Bishopsgate site to build a new London headquarters, which put the hall under threat of demolition. Crosby Hall was saved on an early wave of preservation and conservationism awareness and, in a remarkable feat of engineering, it was dismantled, its parts numbered and re-erected in 1910 on a plot in Chelsea owned by the London County Council, the site of Thomas More's country manor of the 1520s. The Queen Mother opened Crosby Hall here in 1926.

This was the Crosby Hall in Chelsea that Christopher Moran was able to acquire out of public ownership in 1988. After purchasing the renamed Crosby Moran Hall and its attendant buildings, Moran commenced eight years of planning, design and expert consultation with Britain's leading architectural historians and scholars. Moran initially invested over £1 million to stabilize the hall's fifteenth-century Reigate stone, which had begun to crumble. Since then, he has invested more than £50 million into the restoration effort alone. The west of the courtyard is a dining room constructed entirely of stone in the Tudor and Elizabethan style. The quadrangle was completed with a red-brick wing facing the river on Cheyne Walk, inspired by elements of Hampton Court Palace and Hengrave Hall and advised by English Heritage.

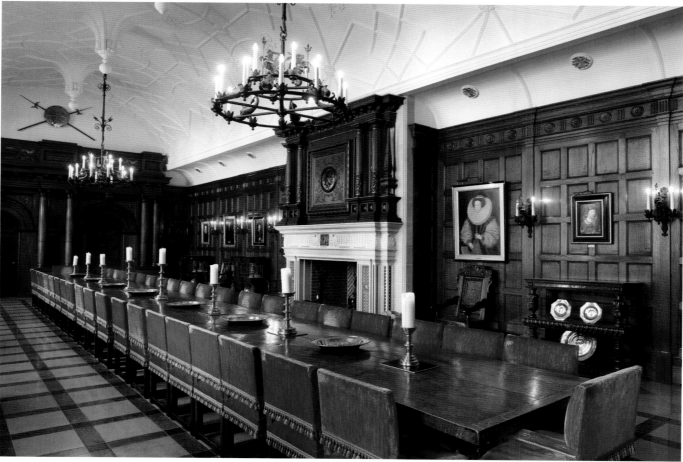

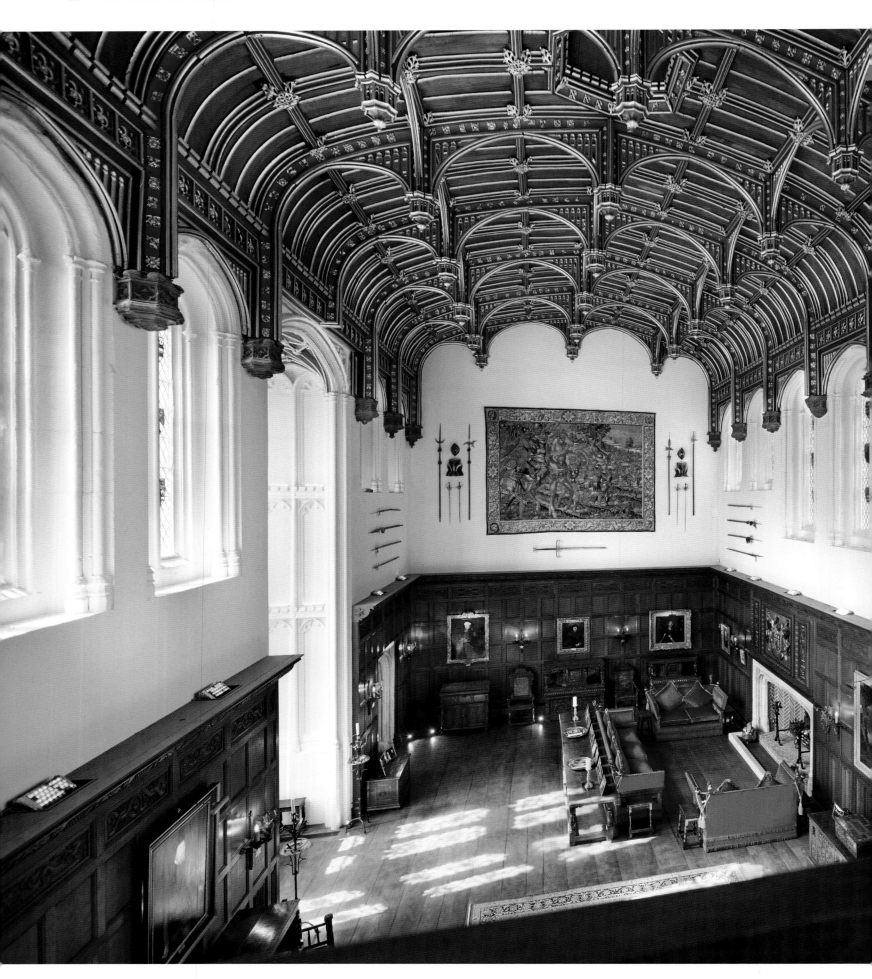

Fitting out required the commissioning of stained glass, the application of wood and stone carving, marquetry, the making of fireplaces and fine detailing, such as the recreation of embellished bronze door locks. For the dining chamber, a 17-metre/55-foot long table was cut from a single piece of oak and seats forty-four people. Each of the five floors are furnished with Moran's impressive collection of fifteenth, sixteenth and early seventeenth-century high-status English furniture, arms and armour, tapestries and paintings by artists Van Dyck, Dobson, Eworth, Gheeraerts, Hilliard, Cranach and Holbein. The main rooms are the council chamber (where the king would have held his council), long gallery above, dining chamber, libraries, chapel, billiard room, museum, and most impressively the Great Hall with its original, magnificent ceiling and soaring, gilded oriel window.

The completed courtyard encloses an Elizabethan knot garden designed by the Dowager Marchioness of Salisbury and is authentic with its plants, trees and layout matching those that had existed in the sixteenth century. Its fountain, bearing a statue of the goddess Diana, is based on the fountain design for the lost Nonsuch Palace of Henry VIII in Surrey. The terrace over the garden, inspired by Rushton, received a stone balustrade carved in the shape of Moran's motto: *Meritum Pertinacia Fortitudo Fidelitas*.

Following medieval tradition, the chapel, with a side Lady Chapel and Mortuary Chapel, is being completed under the Great Hall, with a fan-vaulted ceiling. Under guidance from Westminster Abbey, the chapel will include a rare Cosmati floor, including appropriate stones sourced from Italy in the pattern that was last used 500 years ago. It will also include stained-glass windows to the east and west, and the Lady Chapel will include a window looking across the roses of the knot garden. Several reports have said that Christopher Moran's intention is to leave the house to a charitable trust for cultural or educational use.

—

Crosby Moran Hall

Cheyne Walk, Chelsea

London SW3 5AZ

A view over the original Great Hall from the balcony.

Albert Memorial

In a city loaded with statuary, the Albert Memorial stands out as a colossus in both scale and in the number of figures it depicts. Queen Victoria commissioned the memorial to her consort in 1862, just one month after his death. It was to take until July 1872 to build the monument and the Prince's statue was not installed until 1875. Years had been filled with committee work, consultation and false starts. The Albert Memorial is epic in all senses.

Architect Sir George Gilbert Scott provided the overarching plan for the structure and headed a team of sculptors, mosaicists and craftsmen to decorate it. His inspiration was the canopy covering altars in old churches, reimagined as a bejewelled object, and then scaled up. The Albert Memorial is polychromatic, studded with coloured enamels, polished stone, agate, onyx and much gilding. Building stones were sourced from around the UK, granite, sandstone and limestone, and marble from abroad. Concealed over the columns is a large cross-shaped riveted girder to support the canopy and the iron-cored spire. Hidden below is a vast brick-arched undercroft foundation.

The visible features are bewildering. Gilded angels adorn the spire and more statues below depict the Virtues. Mosaics on the canopy represent four Arts, statues on the pillars and niches more arts and sciences. On the corners are four groups: Agriculture, Manufacturing, Commerce and Engineering. The heart of the memorial is the long Frieze of Parnassus, high-relief and shallow-relief sculptures numbering 169 figures, representing sculptors, painters, poets and musicians. The world's continents are represented by statues at the corners. In places it seems to trip over itself. At least one person (Michelangelo) features twice on the frieze and again on the mosaic above. The allegorical figure of Architecture on the mosaic holds an image of the design of the Albert Memorial itself and architect Scott appears on the frieze. Memorials cannot escape the consequences of being anchored at a point in time, and this monument has been particularly vulnerable to criticism. Its categories of arts and sciences quickly became anachronistic. Women appear only as allegorical figures; there is not one woman depicted on the frieze. There is no Australian continent.

There are so many facets, architectural, philosophical and historical, that are impossible to list and hard to see, but it is sometimes possible by application to go beyond the railing and take a closer look at the Frieze of Parnassus and other details.

—

Albert Memorial, Kensington Gardens, London W2 2UH

Statues representing Geology and Geometry stand over the corner groups of Engineering and Agriculture, overlooking the Frieze showing sculptors through the ages, including Michelangelo in the centre.

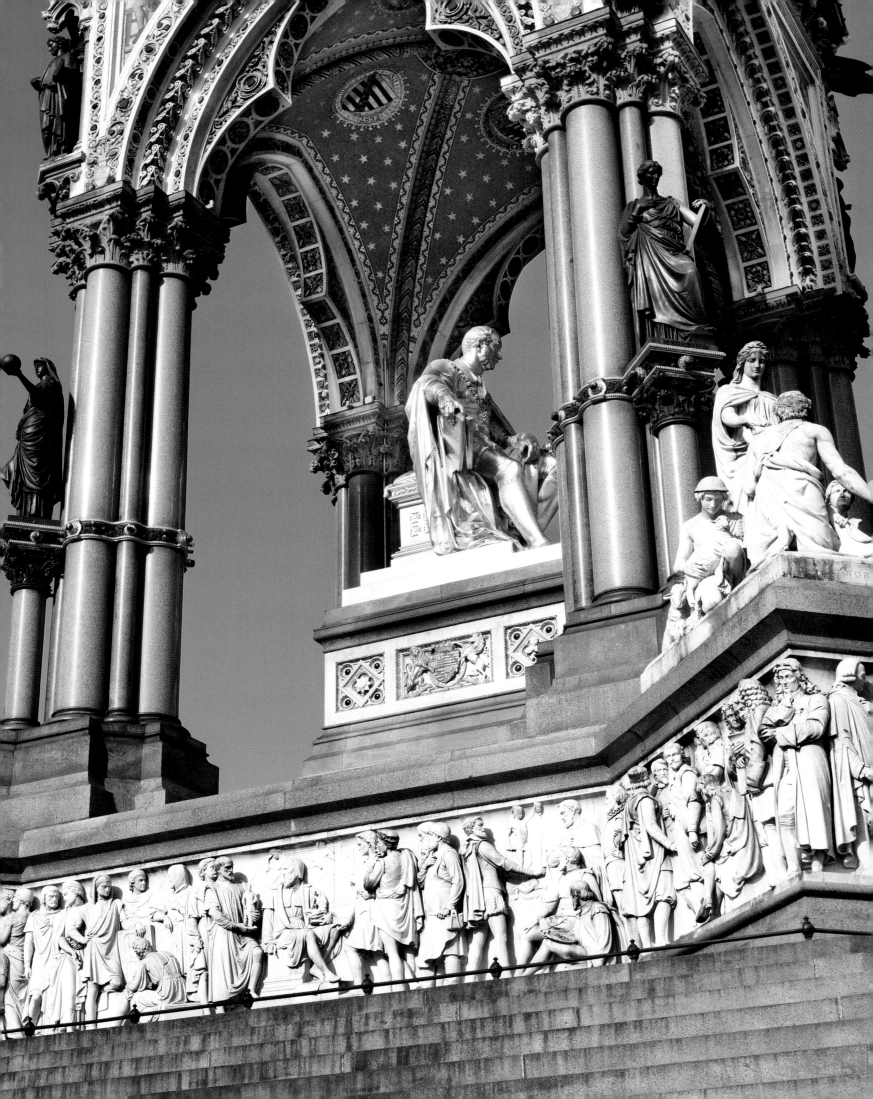

Fuller's Griffin Brewery

At Chiswick under the sign of the Griffin is Fuller's Brewery, the place where London Pride best bitter is made. Fuller's Griffin Brewery operates under the ownership of Asahi Group, which acquired the brewery from London's last big independent, Fuller, Smith & Turner, in 2019. It is London's oldest brewery in continuous production. Fuller's now separately runs its estate of nearly 400 pubs and hotels across London and the south of England.

'Beside the Thames since 1845' is the slogan, although this riverside site can be traced back to a domestic brewery in the garden of the stately home Bedford House on Chiswick Mall when it was common for large households to brew their own beer. Close by, a cottage brewhouse was operated by the local Urlin family, both of these places being active in the 1660s. They were acquired and brought together as a commercial operation by Thomas Mawson in 1701. Thomas Mawson is still honoured today in the shape of the Mawson Arms, the pub located on the brewery site.

The Fuller family started to take a share in the brewery in 1829 and the partnership of John Bird Fuller, Henry Smith and John Turner took over in 1845. Descendants of these partners continued to manage and direct beer production until the Asahi acquisition of the brewery. The name Griffin, a mythical lion-eagle which is a guardian of treasure, was first applied to the brewery at Chiswick in 1816 and officially trademarked in 1892. Chiswick was once a village and the Griffin brewery was first supplied from boats on the Thames, with much of its output transported away by river. Later, a fleet of steam wagons was introduced. Unlike many breweries, the Griffin was never rail connected. By the late 1950s, London's road system and traffic levels had grown to the point that the major A4 arterial road had been cut through yards from the brewery gates. Fuller's Griffin Brewery became a prominent London landmark glimpsed by thousands of travellers.

The old mash tun used for mixing ground malt with water for 125 years until 1993.

The pilot brewery for development and small-scale brewing.

The brewhouse at Chiswick holds gleaming stainless steel fermenters and twin mash tuns with a production capacity of more than 63 million pints each year, largely computer controlled with robots handling the sorting and stacking of casks. In places, however, legacies from the old brewery remain – an ancient mash tun and an old London copper dating from the nineteenth century can still be seen and across the cobbled yard is the former brewer's house, famous for its covering of wisteria, grown from the first plant of its type in England in 1816. The hock cellar, named after a style of harvest ale, also dates from this period. It is an old storeroom, which now serves as a showcase for Fuller's memorabilia and is a highlight on guided tours of the brewery.

In the early 1970s, when a time came to choose between new and old, Fuller's made a crucial decision about its brewing operations as consumer taste was approaching a turning point. The British market had been dominated by keg beers of increasing blandness made by filtration and pasteurization and pumped by carbon dioxide. This gave a stable, transportable product and led to the domination of the big seven brewers: Bass, Allied Whitbread, Watney, Scottish & Newcastle, Courage and Guinness. Fuller's were poised to renew their worn-out plant at that time and considered switching entirely to keg and bottled beer. Against this notion came the Campaign for Real Ale, which tapped a growing public desire for a change in taste and supported smaller brewers. Fuller's decided to re-equip to efficiently brew mainly draught

A heating element in the old London copper.

cask beers and increased their home market and export sales. Between 1975 and 1986 much of the brewery was demolished, the landmark brick chimney removed and a new brewhouse and warehouse added.

In 1989 the big brewers were forced by counter-monopoly legislation to divest themselves of some of their pubs and at the same time permit their tenants to buy cask-conditioned ale from an outside source. This again favoured brewers such as Fuller's, which received an increase in orders and was able to more easily expand its own portfolio of pubs. Fuller's reputation as an authentic brewer for the real beer enthusiast has grown and its range comprises 75 per cent cask ale, a lager and some keg beer, now produced by much-improved processes. London Pride,

named for the hardy flower that grew in the rubble left by the Blitz, remains the flagship ale.

Fuller's launched a pilot brewery in its shop at the Griffin Brewery in 2018 to make some experimental beers in smaller quantities, about ten barrels per brew, which can be cask or keg or packaged in bottles. The first of these was dubbed Beer One, a particularly strong ale at 7 per cent alcohol by volume.

—

Fuller's Griffin Brewery
Chiswick Lane
London W4 2QB

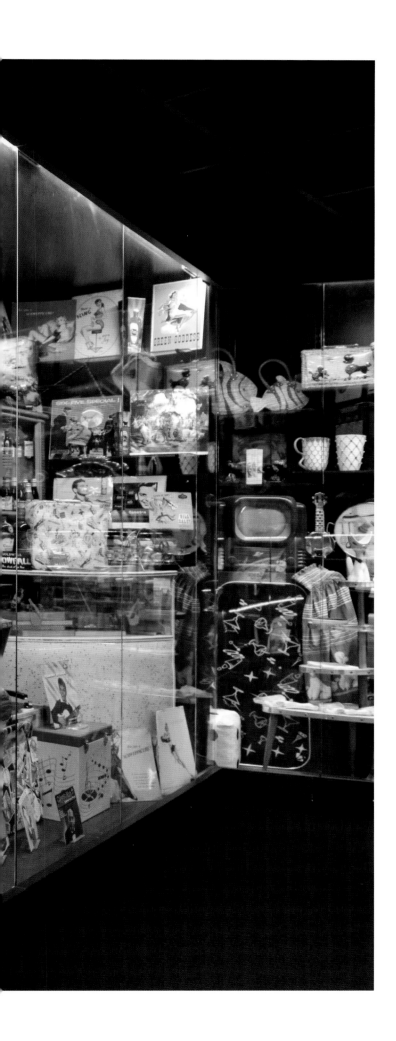

Museum of Brands

The Museum of Brands is a mosaic of many things: tins, toys and games, packets, paper, products and puzzles, all assembled across a long timeline. The man who brought it all together, consumer historian Robert Opie, once identified the supermarket as the true gallery of commercial art, a place where thousands of designs are on display at any moment. Given such widespread exposure, there may have seemed little scope for a museum devoted to everyday consumer items, but the Robert Opie collection soon gained a special fascination. 'I was struck by the idea that I should save the packaging which would otherwise surely disappear forever,' writes Opie. 'The collection offers evidence of a dynamic commercial system that delivers thousands of desirable items from all corners of the world. It is a feat arguably more complex than sending man to the Moon, but one still taken for granted.'

The museum does not give much space to exploring cerebral notions of the crossover of advertising into art but plays it straight with a collection of more than 12,000 products, and specifically of the packaging that encloses them. There is a twist, however, as the result turns out to be a very cleverly curated social history of Britain.

A visitor is invited to enter the 'Time Tunnel', a corridor of cabinets, and experience the first blossoming of advertising and branding during the Victorian age. There are mugs illustrated with images of Florence Nightingale and even of Crimea, as well as plates with images of Queen Victoria and her consort, Albert. The arrival of colour printing provided the impact for the labelling and branding seen in Colman's mustard and Bird's custard packages. Newspapers and magazines were proliferating, and the Valentine's card arrived alongside the first jigsaw puzzles,

1950s-era packaging and products on display at the Museum of Brands.

then known as dissected puzzles. A milestone was the Great Exhibition of 1851, a monument to the very promotion of Britain itself. Chocolate boxes and matchboxes became canvases for a growing art form, and there is a reminder that the packaging for household soaps and cleaning products might have been designed to appeal to servants as much as masters.

Robert Opie, who had collected packaging since childhood, was working as a market researcher in the 1970s and gaining a special awareness of products. He created an exhibition at the Victoria & Albert Museum in 1975 – 'The Pack Age: A Century of Wrapping It Up' – with around 3,000 items, and the exhibition drew an attendance of 80,000 people in a few weeks. He later said that he resisted the word 'museum' for what he had assembled, but the collection went on to form the basis of the first Museum of Brands, Packaging and Advertising, which opened at Gloucester Docks in 1984. The ever-growing collection was moved to London in 2005 and to its present location on Lancaster Road in 2015, with space quadrupled.

The space has enabled a historical continuity that spans 170 years. The 'Time Tunnel' continues through the Edwardian years, charting the fads of roller skating and table tennis, the first era of motoring and designs in the Art Noveau style of the times.

The cleverness of the exhibition lies in taking threads and themes through the ages, especially in printed ephemera. Jigsaw puzzles and board games are punctuation marks for a whole century, one example being an astonishing game called Sanctions, released just after the end of the First World War with a nod to the post-armistice arrangements. There are also later games based on TV series of the 1960s, such as *Doctor Who* and *The Flintstones*. One display is completely devoted to Dan Dare and another to *Thunderbirds*.

A selection of toys and games, including beloved cartoon characters from the 1930s.

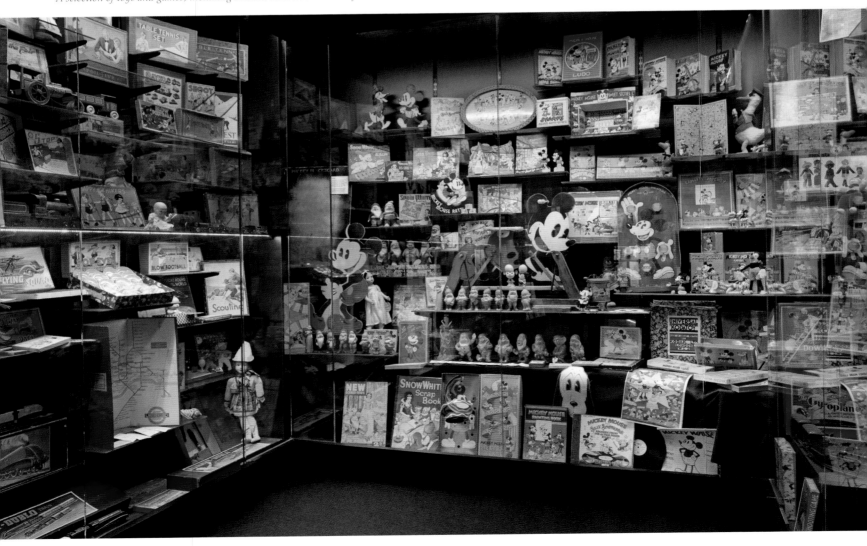

Shredded Wheat, promoted with the slogan 'Busy folk prefer this breakfast', was colourfully packaged with an illustration of the Art Deco factory at Welwyn Garden City where it was produced on the box. Food products and brands are the most recognizable packages in the collection and the word 'iconic', overused but unavoidable, must be applied to thousands of these exhibits.

The evolution of toy packaging is likewise traced across time, particularly well represented during the 1930s, but it is not all kids' stuff. One of the most important platforms for branding was clearly cigarette sales, here unflinchingly explored, from a case designed to sell cigarettes by weight through the coming of the filter tip to the marketable virtues of the king-size cigarettes of the 1950s, and finishing with a rare pack of Three Castles.

Historical events are placed as markers throughout to provide perspective, particularly the dates of wars, the Festival of Britain, coronations, jubilees and regal weddings, and there is a strong impression that the Royal Family are sometimes consumed as a brand through memorabilia.

There is even a nod to the notion of the medium becoming the message in the shape of a bank of TV sets and in a display of transistor radios, which opened another pathway for advertising through sound and vision. The 'Time Tunnel' continues into the 1980s and beyond with electronic games displacing cardboard and counters.

The museum inevitably harnesses nostalgia and self-identification on the part of the visitors, who are invited to share their thoughts with the museum under the Brand Memories programme. The museum has a garden, a café and a gift shop.

—

Museum of Brands

111–117 Lancaster Road

Notting Hill, London W11 1QT

Victorian-era technology on display, as well as a case for selling cigarettes by weight.

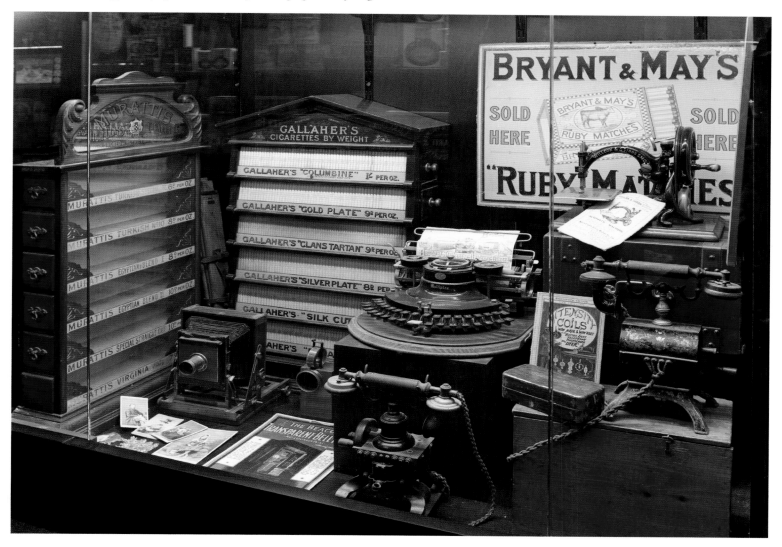

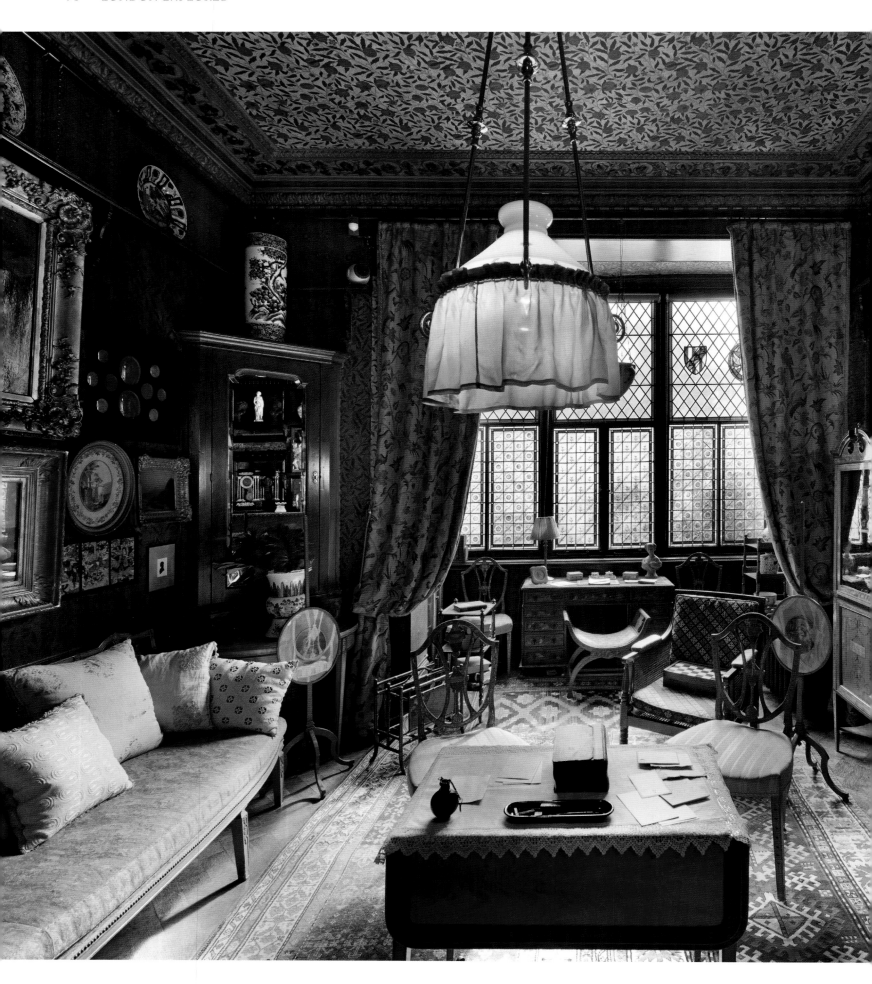

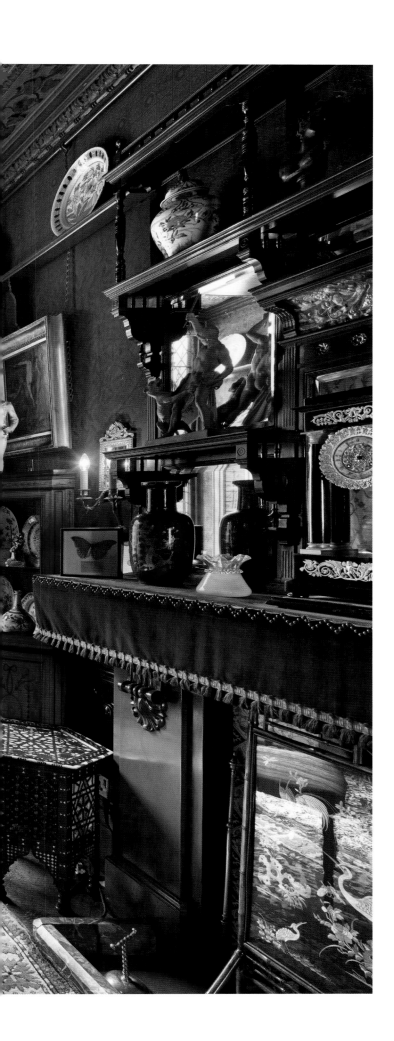

18 Stafford Terrace

A truly historic meeting was held at 18 Stafford Terrace, Kensington, on Guy Fawkes night in 1957, hosted by Lady Anne Rosse and attended by the poet John Betjeman, the artist John Piper and thirty others. That evening it was agreed to launch a society dedicated to the protection and appreciation of Victorian architecture and arts and the first meeting of the newly formed Victorian Society followed in February 1958 in the drawing room of the same house.

The house itself was a reflection of the movement and an inspiration. Lady Rosse had taken charge of 18 Stafford Terrace from her mother, who had acquired the family home after the death of her bachelor brother Roy in 1946. He had lived there for most of his life and continuously since the death of his mother in 1914. Roy Sambourne, a man of some inertia, had thrown nothing away. The reach-back across time had enabled the almost miraculous preservation of a house that had first been decorated in the style of the Victorian Aesthetic Movement in the 1870s and updated in the 1890s.

Lady Rosse, who used 18 Stafford Terrace as an occasional townhouse and for entertaining, had done much to repair bomb damage to the building and preserve the decorative schemes at a time in the 1950s when Victorian things were generally despised. Unmodernized Victorian houses were particularly out of favour. The furniture and effects of the house had next to no value at the time. The Victorian Society was fighting against the tide in its early years, failing to prevent the demolition of Euston Arch and the London Coal Exchange, but eventually through its efforts many buildings which had previously been scorned started to gain respect.

Lady Rosse's ancestors, Linley and Marion Sambourne, had come to 18 Stafford Terrace in 1875. It was one of a recently

The morning room where Marion Sambourne wrote letters and entertained during the day.

OPPOSITE *The studio in which Linley Sambourne worked from 1899 (above); the master bedroom features an impressive fireplace that was installed in 1887 – it contains antique Dutch tiles and is topped with a classical bust and two small reproductions of Michelangelo's* Night *and* Day *(below).*
OVERLEAF *The opulent drawing room, which occupies the whole of the first floor of the house.*

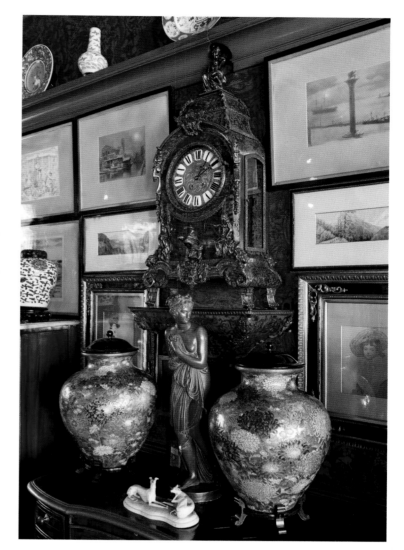

An Andre-Charles Boulle clock in the style of Louis XIV.

completed street of three-storey terrace townhouses developed on the Phillimore estate to the north of Kensington High Street, at that time on the edge of London. Linley Sambourne was an illustrator and cartoonist working for the satirical magazine *Punch*, starting as junior to Sir John Tenniel. He also illustrated several books including an edition of Charles Kingsley's *The Water-Babies* and Hans Christian Andersen fairy tales. Linley was also a photographer. Many of his pictures and photographs are hung at 18 Stafford Terrace. His wife Marion was the daughter of a stockbroker and the couple had two children. The style and decorative ideas for the house are believed to have come from Linley, who was aware of the Aesthetic Movement and the relatively avant-garde trend it represented, taking objects from Japan, China and the Middle East. The house was generously decorated with stained glass in some windows, William Morris wallpaper and crowded with a great deal of furniture and ornaments. It seemed that every wall was covered with pictures. An inventory recorded that 225 framed pictures were hung on the walls and that there were 66 upright chairs in the house.

Diaries kept by Marion Sambourne have left a detailed account of life in the house between 1881 and 1914. The diaries describe a classic social life of the Victorian middle class, with four indoor servants and a groom employed. There were trips to the theatre to see Henry Irving and Ellen Terry in *Macbeth*, and Gilbert and Sullivan operettas, a journey to Paris to see the newly built Eiffel Tower, holidays in Ramsgate, musical evenings, a growing interest in the new art of photography and the coming of the bicycle.

It would be misleading to call 18 Stafford Place a perfect time capsule of 1875 because some of the house had been modernized before the century turned. Electricity had started to replace gas lighting inside the house in 1896 and the Sambournes had updated much of the decoration in the 1890s. Later, Lord and Lady Rosse had installed modern plumbing and redecorated some parts of the house. Yet much of the fabric of the original place has remained intact. It has served as a setting for several films, including the 1985 feature *A Room with a View*.

After the death of Lord Rosse in 1979, it was decided to open 18 Stafford Terrace to public view. It was first run as the Linley Sambourne Museum by the Victorian Society and is now under the ownership of the Royal Borough of Kensington and Chelsea. The Victorian Society continues to work to save Victorian and Edwardian buildings from needless destruction or disfigurement and has a formal role in the planning system through the Secretary of State's arrangements for handling heritage applications under Direction 2015.

Number 18 Stafford Terrace is normally open to the public on Wednesdays, Saturdays and Sundays.

—

18 Stafford Terrace
Kensington
London W8 7BH

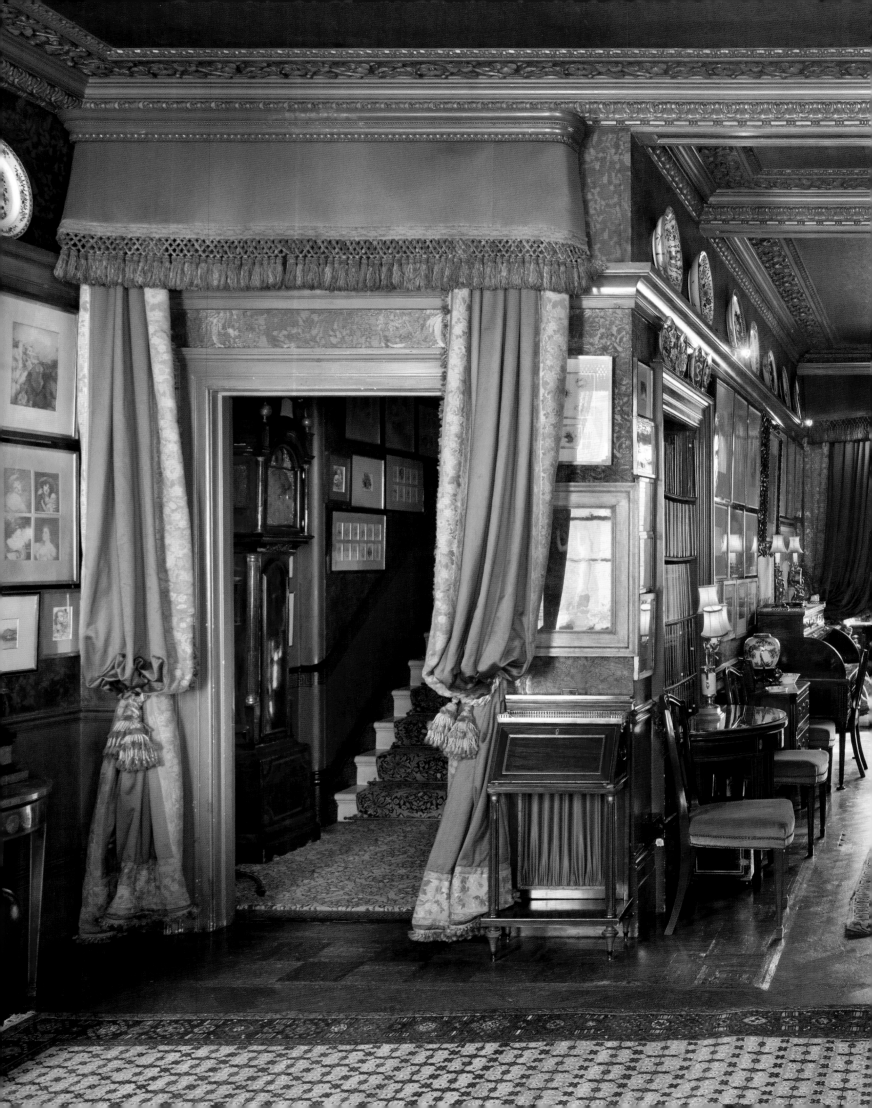

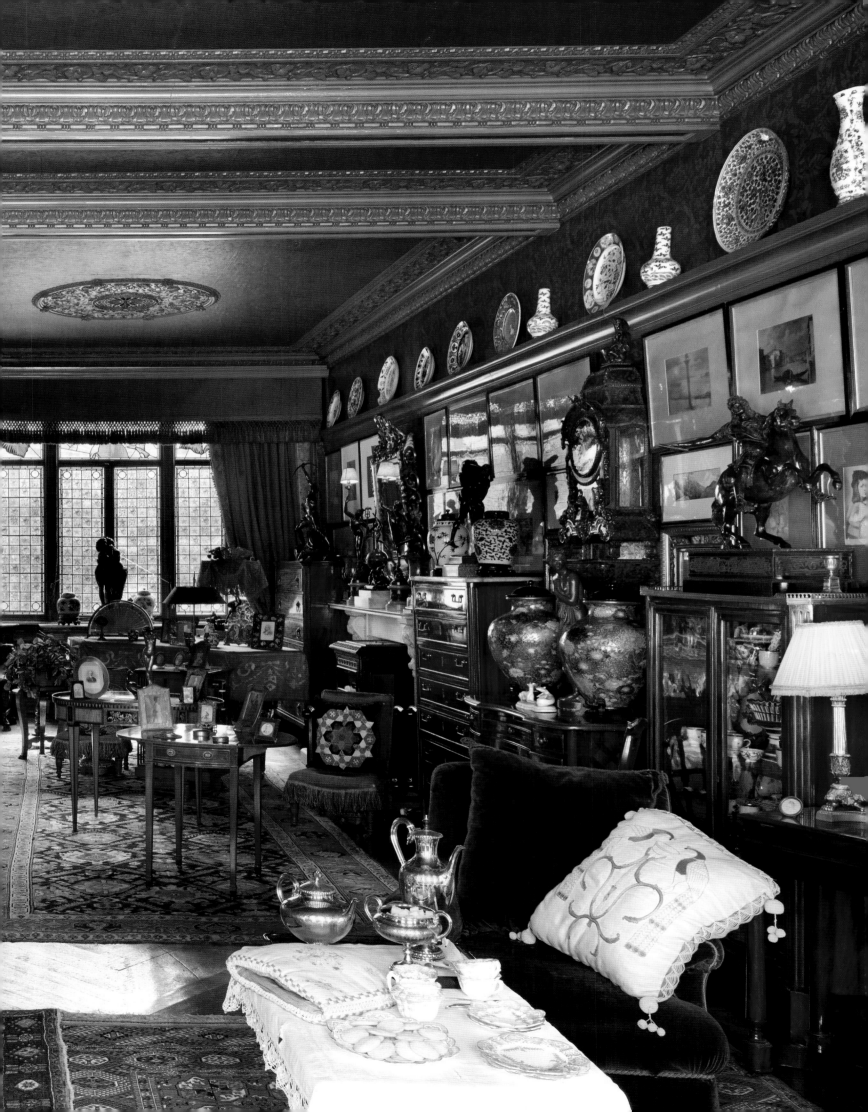

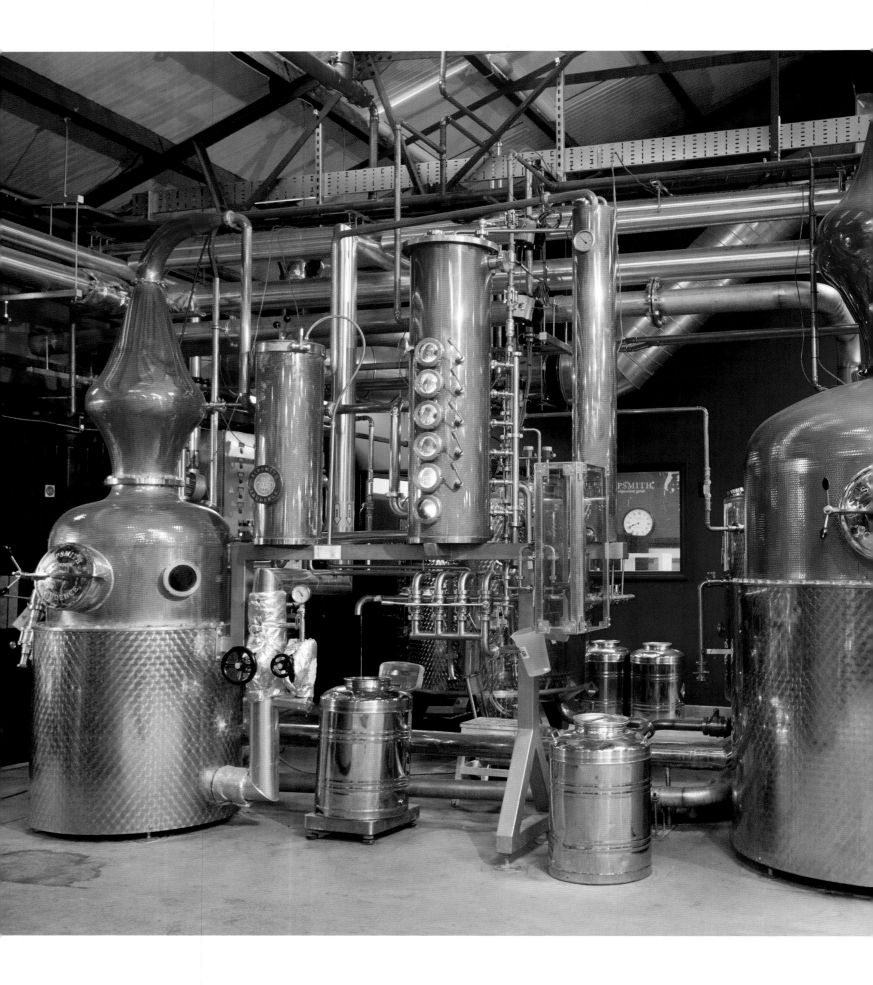

Two of the copper pot stills, named Patience (left) and Verity (right).

Sipsmith Distillery

The first copper pot distillery opened in London after a gap of 190 years under the banner of Sipsmith in 2009. In Chiswick, the gleaming stills christened Prudence, Patience and Verity produce London Dry Gin and other spirits in handcrafted batches.

The company was founded by Sam Galsworthy and Fairfax Hall, friends since childhood, both employed in the drinks industry in the early 2000s. Galsworthy was working in the US, where he saw the craft beer brewing movement and the growing interest in artisan drinks. His thoughts turned to applying the same principles to the distilling and marketing of gin for a more discerning taste through small-scale production in London. Sipsmith was launched with Fairfax Hall and drinks-and-spirits historian Jared Brown, who was appointed master distiller. The intention was to make handcrafted gin in small-scale batches, but there was a legal obstacle to overcome. At that time, it seemed that Her Majesty's Revenue and Customs would not grant a licence for distillation from a still of less than 1,800 litres, a distant legacy of the eighteenth-century legislation that aimed to control bootleg operations.

It took nearly two years of negotiation, with lobbying of Parliament, directly and through trade bodies, before small-scale production was accepted. The first still, Prudence (inspired by a word favoured by then-Prime Minister Gordon Brown) with a capacity of 300 litres, went into production in a converted garage in Nasmyth Street, Hammersmith. By 2014, demand had required the commissioning of another 300-litre still, Patience, and the move to the current site, and later the addition of the 1,500-litre capacity Verity. All stills resemble swans' necks in shape and a smaller still named Cygnet came to handle test and development batches and smaller runs. Distillery tours are available.

—

Sipsmith, 83 Cranbrook Road, Chiswick, London W4 2LJ

Pitzhanger Manor & Gallery

Sir John Soane is acclaimed as one of the greatest of British architects, although his legacy in bricks and mortar is relatively meagre, as many of his finest buildings have been lost. Pitzhanger Manor in Ealing, once his country home, survived largely intact and relatively unmolested but with much hidden away and forgotten for years under layers of paint and ugly Victorian additions. It served in obscurity as a public library, museum and cultural centre until it fully re-emerged after restoration in 2019 with several Soane features reinstated and the Victorian wing removed. With layers of paint unpeeled, and an analysis of the original finishes, the rooms have regained Soane's original striking colour schemes and decoration.

Ealing was a village separated from London by more than 13 kilometres/8 miles of countryside in 1800, when John Soane was well established as a leading architect. He had been appointed architect and surveyor of the Bank of England and had designed several country houses across England. Soane purchased the house known as Pitzhanger Manor with the intention of making it a showcase for his collection of antiquities and to exhibit his abilities as a designer. He had most of the original house demolished and made a new main block with a façade inspired by the Arch of Constantine in Rome, built of yellow London brick and Portland stone. Four Ionic columns are topped with statuary of draped female figures. The design is informed throughout by Soane's sometimes idiosyncratic take on classicism and clever arrangement of light and space to make the house seem larger than it really is. There are ceramic statues painted to take on the appearance of bronze and areas of plasterwork that are painted as veined marble.

The house is entered by a dark vestibule resembling a vaulted tunnel, which emerges into a tall naturally lighted hall. The walls

The breakfast room is decorated with Greek key designs on the ceiling and the fireplace.

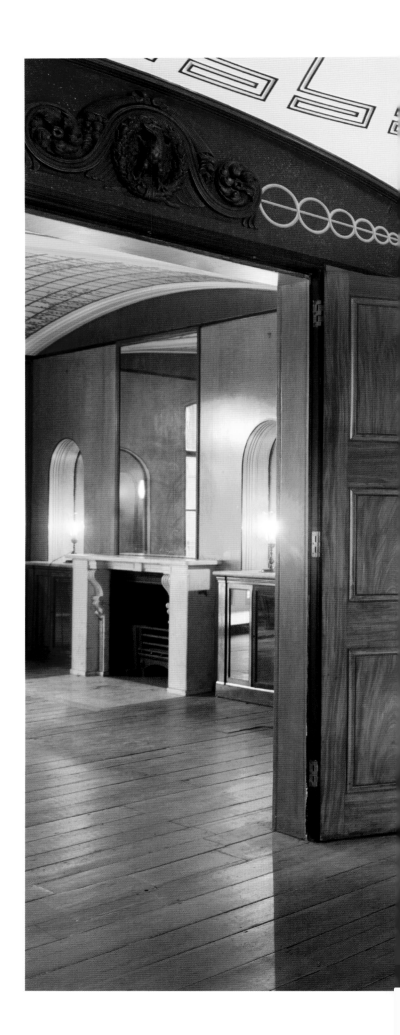

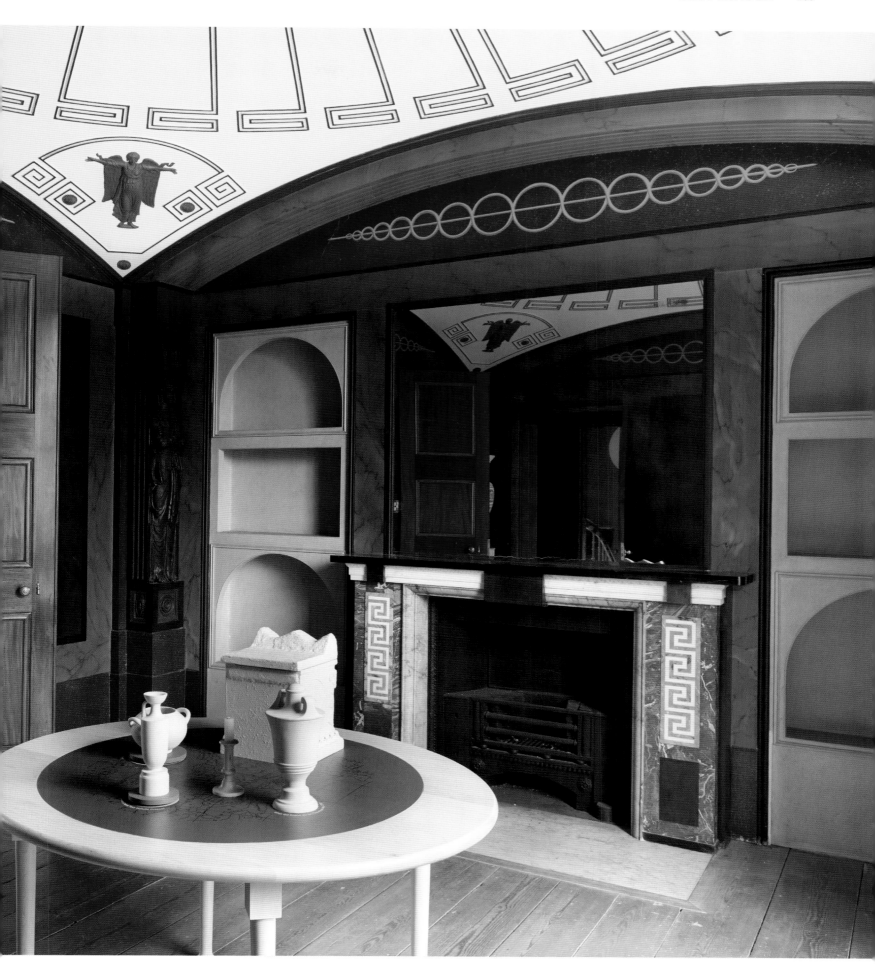

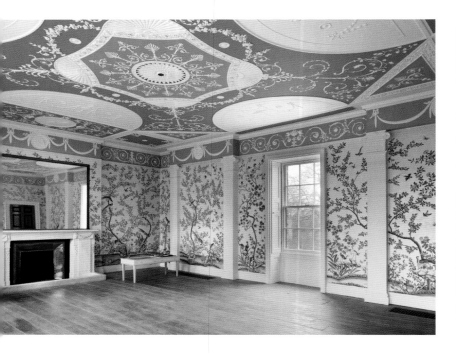

ABOVE *The upper drawing room, decorated with hand-painted Chinese wallpaper.*

ABOVE *The staircase viewed from the upper landing.*

OPPOSITE *The ceiling of the impressive marbled entrance hall.*

are marbled, and the light takes on the warmth of the amber glass of the internal windows on the landing above. The light comes from the top of the house where there is a large glass-sided roof lantern. The breakfast room presents itself with an almost theatrical flourish with a ceiling resembling a draped canopy decorated with Greek key designs, which are repeated around the fireplace.

The only part of the house that Soane had retained from the original manor building was a wing designed by architect George Dance, a neoclassical pioneer, whom Soane had worked for as an apprentice aged fifteen in 1768. This wing held some special significant for Soane, possibly because as a pupil he may have worked on it, and for his own house he transformed it into the eating room and upper drawing room. Soane's choice of decoration for the upper drawing room was a vivid Chinese wallpaper and he repainted the Dance-designed ceiling in a matching palette. The wallpaper and colours were recreated after analysis in the restoration.

Soane was a bright boy who rose spectacularly from a modest background, his father being described as a either a bricklayer or a builder. Soane himself is said to have worked as a hod carrier for his older brother as a thirteen-year-old. The honours and acclaim he later won did not prevent a great disappointment for Soane and Pitzhanger Manor itself tells the story of an unfulfilled dream. As well as making a showcase for his architectural skills and his collection of art and antiquities, he planned that Pitzhanger would become home to an architectural dynasty by way of his two sons.

It was soon clear that neither had any interest in following their father's profession and a rift developed between Soane and his sons. Soane's wife Eliza found Pitzhanger Manor isolated and exhausting to manage alongside a London home. The house was subsequently sold on by Soane in 1812. He already owned a house in Lincoln's Inn when he bought Pitzhanger Manor and he transferred his extensive collection of artefacts to London and expanded the house there.

The contrast today between the interior of the two houses is compelling: Pitzhanger with empty niches and devoid of ornament and furniture, and 13 Lincoln's Inn Fields, known as the Sir John Soane Museum, with densely packed and some seemingly chaotic rooms overflowing with exhibits. It might have been different. Eliza Soane had bought a series of eight paintings by William Hogarth, *The Rakes Progress*, in 1802 and the intention was to display them at Pitzhanger. The small drawing room with its plain red wall was designed to show off paintings, although this might not seem to be a good setting for scenes of Hogarthian debauchery. The Hogarths migrated to Lincoln's Inn, where they can be seen today in the picture room along with a hundred other paintings. At Pitzhanger Manor, the carefully calibrated restoration offers a clear, uncluttered look at the essence of Soane's style.

—

Pitzhanger Manor & Gallery

Mattock Lane

London W5 5EQ

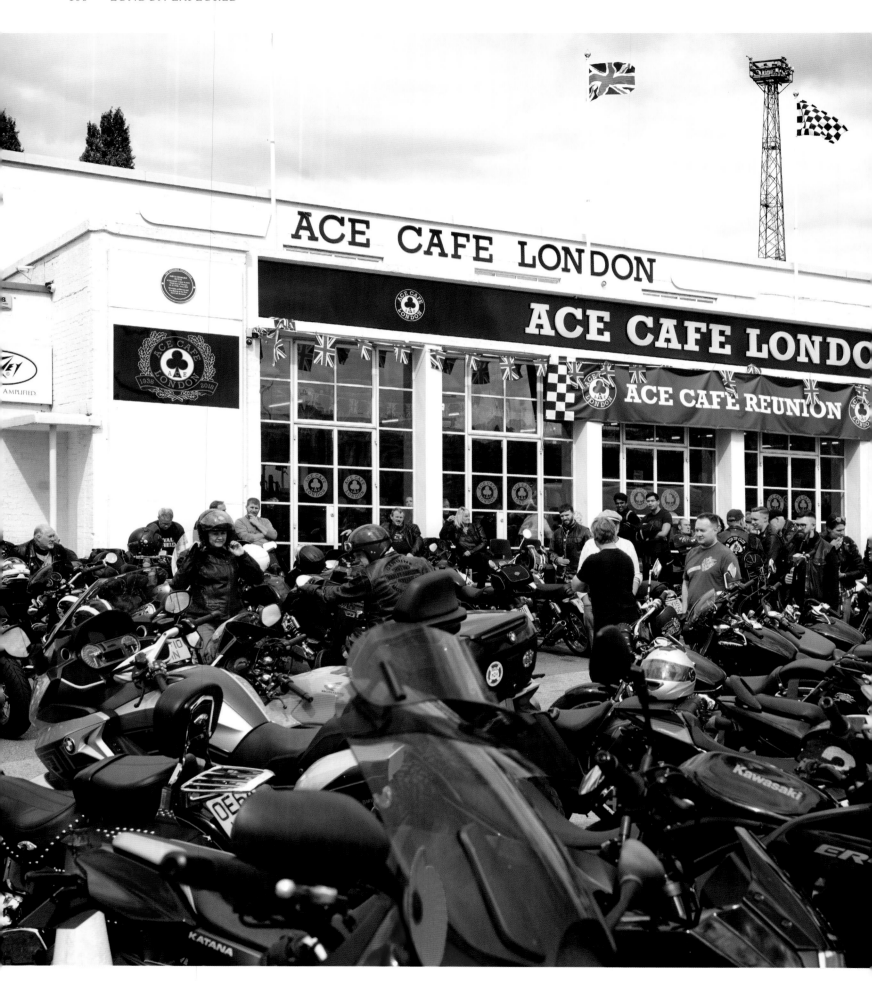

Ace Café

Motorcyclists gather today at the Ace Café on the old North Circular Road at Stonebridge, and so do classic car owners, rock 'n' rollers and film crews in search of a good background. In its latest form, the Ace Café has been described as a heritage site, a retro-culture theme bar and a restaurant licenced for music, dancing and even wedding ceremonies. All this builds on the once-notorious original Ace Café and its lively history.

The first Ace arrived in 1938 alongside the recently completed North Circular as an ultra-modern roadhouse establishment. It was joined by a filling station with garage workshops adjacent and business was brisk in the months before the outbreak of war. The café was badly damaged by bombing in 1940 and replaced by a larger building completed in 1948, and by the early 1950s, some 2,000 meals were being served each day. In the busy location trade was good and road transport was growing on the main route that skirted central London in the years before the motorway. The Ace operated as a twenty-four-hour transport café in an area of west London where industry was strong. Alongside lorry drivers, mechanics and workmen, motorcyclists in their protective clothing were not unwelcome.

The phenomena of what followed has long fascinated social historians. Motorcycles were cheap transport in the 1950s and the Teddy Boy subculture that emerged after the war quickly picked up on this, and on the rock 'n' roll music coming from the US. The confluence of these elements, and a dash of spirit of rebellion, led to the emergence of the riders described as ton-up boys going in search of 100 mph on the roads of Britain. These were later known as rockers, and the Ace Café was an adopted home for many of them. The A406, the North Circular Road, was their sphere of operations.

The Ace Café Reunion Weekend, on the North Circular Road, London NW10. A popular hangout for rockers, bikers and petrolheads.

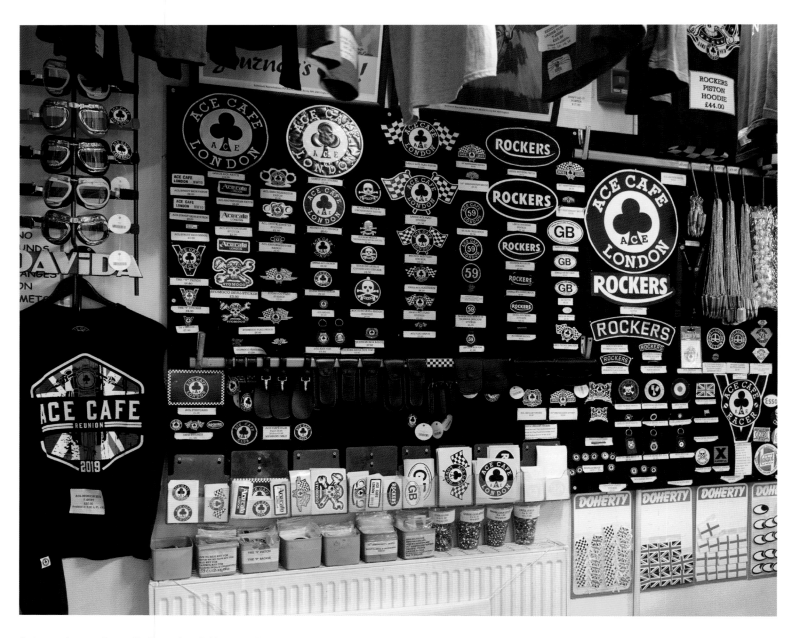

Badges and souvenirs on display and available to purchase.

It is best to imagine the Ace in its peak years, which, measured by motorcycle sales and registrations, were 1959 and 1960. With 'Apache' or 'Shaking All Over' playing on the café jukebox, the leather-clad regulars would stir their cups of tea (with the spoons that were reputedly chained to the tables) while considering their next step and examining the machinery standing outside. This would have typically been a collection of larger-capacity Triumphs, BSAs or Nortons, some modified to single-seat café racers. What followed sometimes was a racing blast by two or ten or twenty riders, often to the Busy Bee Café 13 kilometres / 8 miles around the North Circular on to the Watford bypass.

According to several veterans of the old Ace Café, there was another tradition: insert sixpence in the jukebox, select record, then sprint to the bike for a burst out to the Iron Bridge bends, about a mile and half east of the Ace at Neasden, turn at the roundabout, and aim to return before the record finished playing.

The Ace Café became the destination for thousands of motorcyclists in the 1960s, the point of meeting and departure for countless roads runs. Attrition was high during those years and the accident rate and wildness of rocker culture generated much critical comment in newspapers. Later headlines condemned the conflict between rockers and scooter-borne mods at seaside towns in 1964, but the age of the rocker was soon to fade. The year 1969 marked three key events: the introduction of the Honda CB750 four-cylinder, the Japanese motorcycle that toppled the ascendancy of the big British bike, and the release of the feature

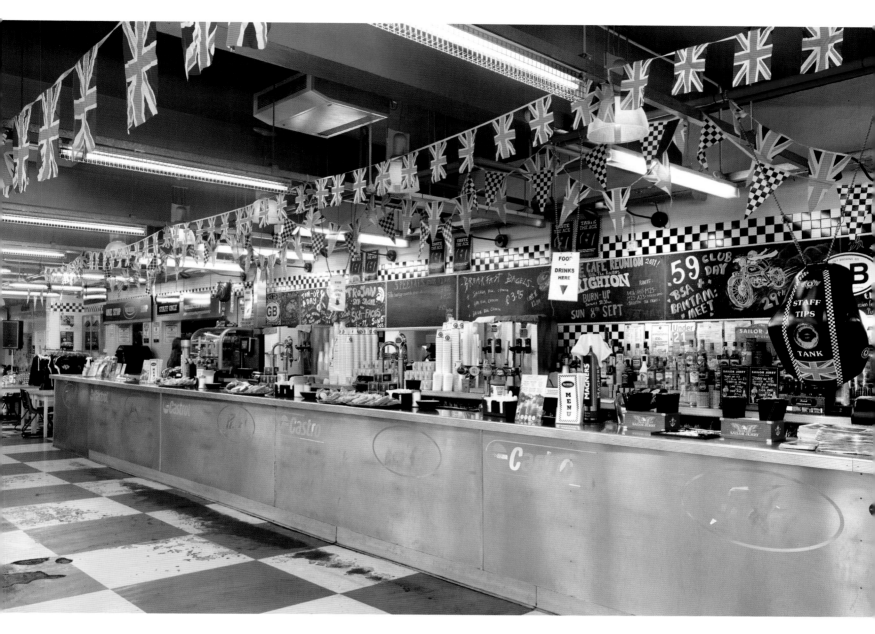

The main bar of the Ace Café London.

film *Easy Rider*, which charted quite another direction in the culture. In a changing world, the rockers had undeniably lost the juice. The Ace Café closed that November.

The building remained intact and served at times as a bookmakers' office, workshop for a tyre depot and vehicle delivery centre. The position of the North Circular shifted into a multi-lane realignment to relieve traffic congestion between Hanger Lane and Neasden, leaving the Ace on the old A406 in a quieter place with some grassy space in front and the River Brent behind.

A new breed of motorcyclist emerged, some old rockers returned to their roots, and the Ace Café was not forgotten. A revival reunion meeting on the site in September 1994 was attended by thousands and further reunions were held in the

1990s. In 2000 a restoration started and the café was reopened in August 2001 in the shape of a bar restaurant, the One-Stop Rockers Shop and stage and dancefloor. It was licenced for the first time. The strength of the Ace Café legend has translated into a brand, and cafés have been opened in China, Finland, Spain, Switzerland and the US.

The Ace Café London opens throughout the week at 7.30 a.m., closing times vary, generally 22.30 p.m., sometimes later.

—

Ace Café London

Ace Corner, North Circular Road

Stonebridge

London NW10 7UD

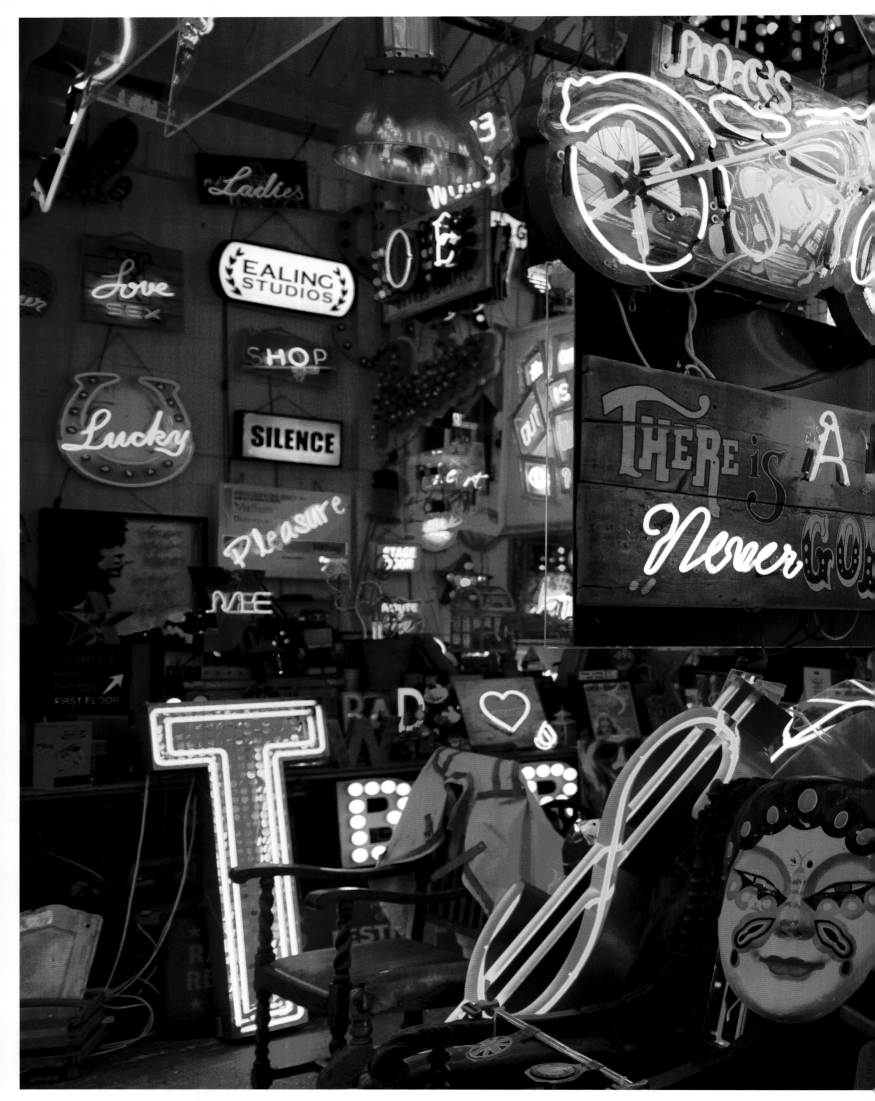

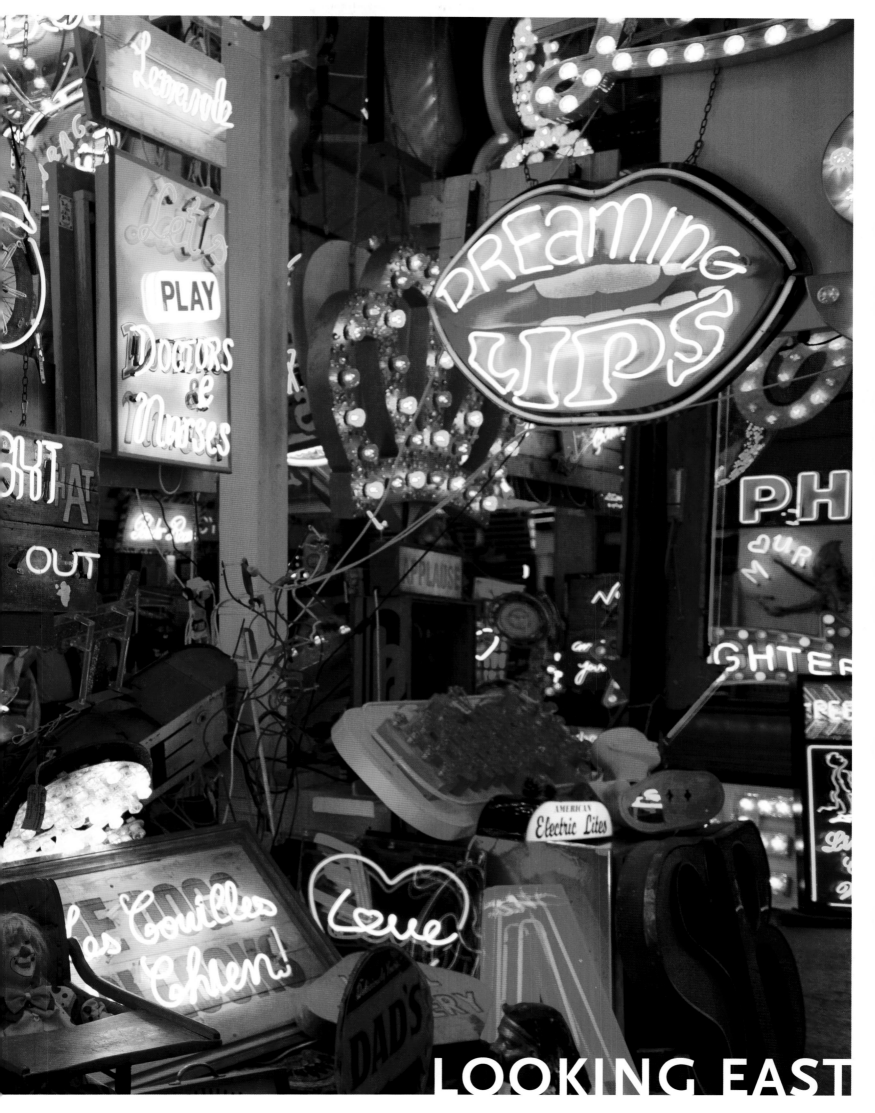

LOOKING EAST

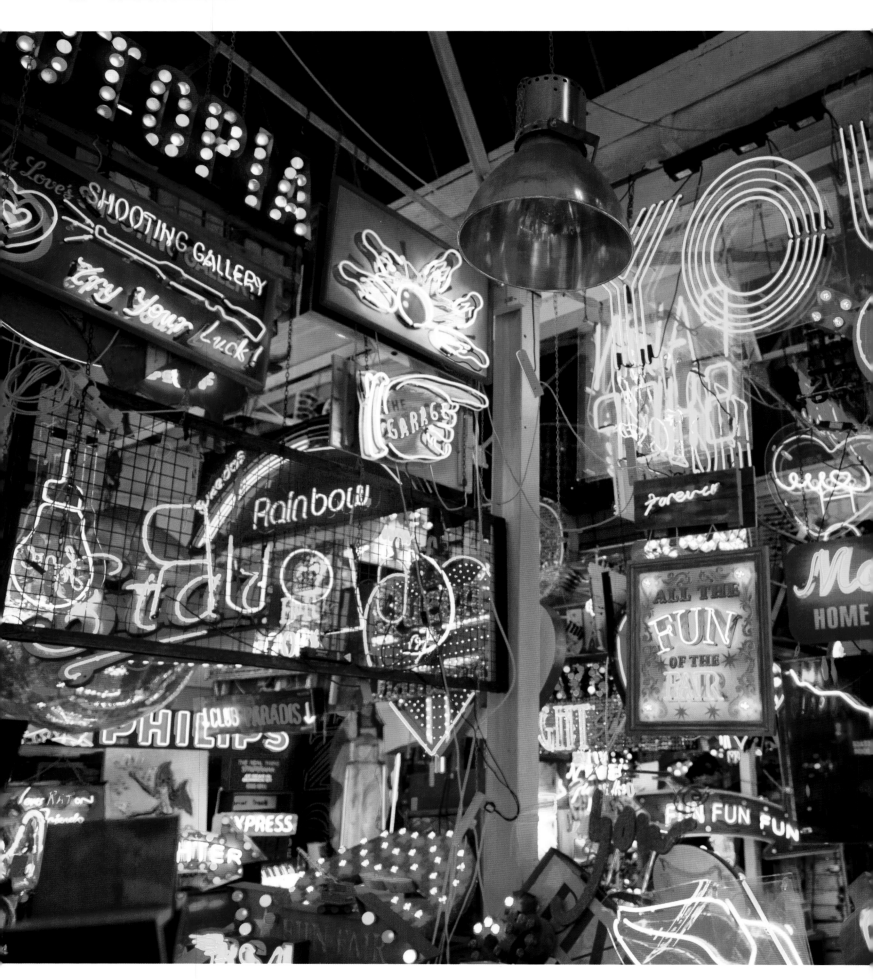

God's Own Junkyard

God's Own Junkyard is a gallery-museum and showroom operated by the Bracey family, which can be described as a neon dynasty. The family-owned company Electro Signs is based nearby and is a major supplier and manufacturer of neon signs, LEDs and bulb signs, electro props, architectural signs, awnings and banners. God's Own Junkyard is believed to be the largest collection anywhere of illuminated graphic systems of all types, some sculptures, mirror balls and the like, but mostly hundreds of neon signs, many of them salvaged, of which 80 per cent are offered for sale at any time.

Neon happened first in London. 'The blaze of crimson light from the tube told its own story and was a sight to dwell on and never forget,' said University College London chemist Morris Travers when the gas was first isolated by him and Sir William Ramsay in a UCL laboratory in Bloomsbury in 1898. Its first application was advertising signage, celebrated in God's Own Junkyard in Walthamstow today.

Signage started with Richard Bracey, a Welsh coal miner who came to London after the Second World War, trained as an electrician and started work with a company called Power Neon, an established maker of neon signs. He lived in the East End and worked on installations across London, including helping to maintain the array of neon at Piccadilly Circus. In 1952 he started Electro Signs, a workshop supplying neon to circuses, entertainment arcades and funfairs around London, in the south-east and at seaside towns along the east coast. One of the early Bracey signs was for Bar Italia on Frith Street, its neon incorporating a clock with the glowing words Caffe Espresso and Universal, a classic sign of its time that survives today. It was an early example of the company's work in Soho, which was soon to become a dominant market. In 1958 the famous Paul Raymond Revuebar opened at

This neon wonderland contains an enormous collection of vintage signs.

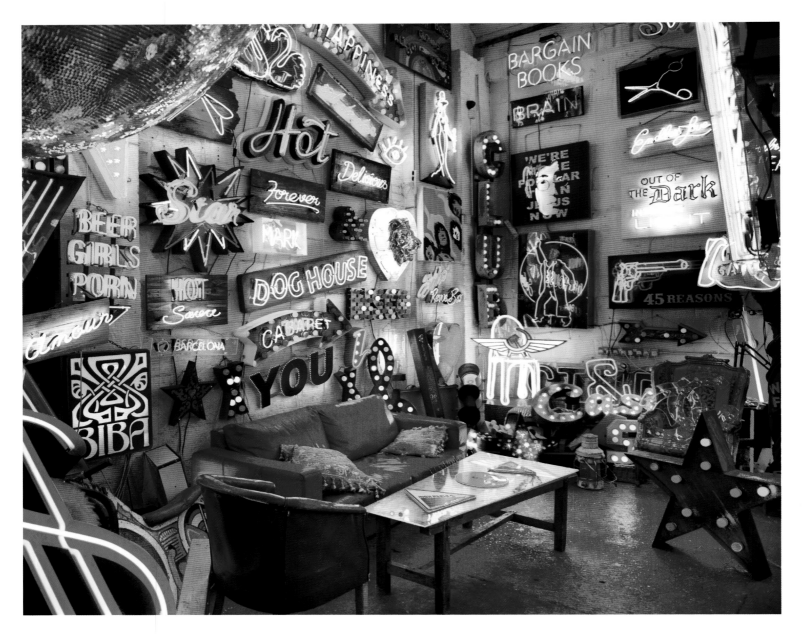

The neon signs are mostly available for sale or for hire.

11 Walkers Court, highlighting its striptease with a towering Richard Bracey designed and constructed sign. Soho, a colourful place in every respect, continued to be a rewarding but sometimes tough environment for Electro Signs through the 1960s and 1970s.

From 1972 Richard's son Chris Bracey, knowledgeable in graphics and design, increasingly guided the company. He was to become a creator of fluorescent tube artworks and a collector of signs. A turning point came in 1986 when a film art-department assistant asked for Chris Bracey's help in gaining access to a Soho club location for a forthcoming feature. The film was *Mona Lisa* with Neil Jordan directing and Bob Hoskins starring. It required authentic London backdrops and also some neon signs to dress the set. A deal was done. More neon work for film followed with

Batman, *Eyes Wide Shut*, *Charlie and the Chocolate Factory*, *Judge Dredd*, *Tomb Raider* and *Mission Impossible*. On Chris Bracey's death in 2014, his son Matthew came to head the company with his mother and brothers.

The film connection and TV connections continue with either custom pieces or examples drawn from GOJ, and Matthew Bracey is an established neon-light artist. The company has traditionally created a Christmas exhibition for Selfridges' windows.

Neon has largely been displaced by liquid crystal displays and LEDs for mainstream advertising purposes. For example, the last big sign at Piccadilly Circus illuminated by neon, owned by Sanyo, was shut down and removed in 2011, while at the same time there is a growing appreciation of neon as an artform. GOJ has sold

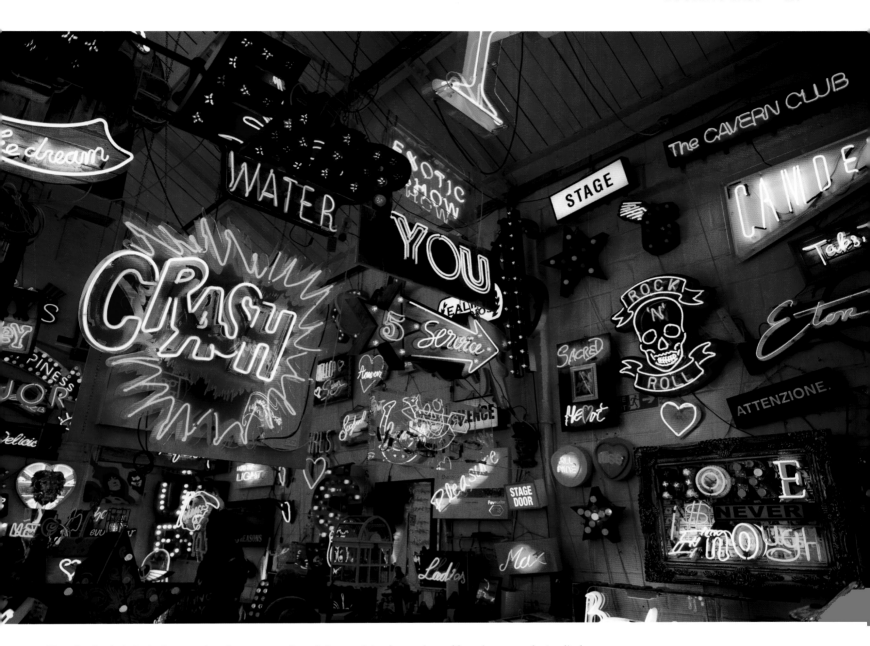

The collection includes both new and used – some are salvaged signs, reclaimed neon signs, old movie props and retro displays.

pieces to Grayson Perry, Kate Moss, Damien Hirst, Vivienne Westwood and Lady Gaga. Eighty per cent of commissioned works are for display in homes.

Soho changed. The Raymond Revuebar sign was restored, rehabilitated and reinstalled in 2014. It reads 'personal appearances of the world's greatest names in striptease – lavish revue – licenced bars', but the show has long gone. Fawn and India James, granddaughters of Paul Raymond, commissioned it as a tribute to their grandfather and as a piece of public art for Soho. The sign was remade by the Braceys.

Regarding the name of the collection, Chris Bracey, who had been actively collecting neon signs from the 1970s, may have been stirred by a visit to the Neon Boneyard in Las Vegas, a storage facility for old signs, or inspired by the words God's Own Junkyard from architectural writer Peter Blake's 1963 book about the visual ruination of America. That may be ironic, because Blake identified the proliferation of signs and billboards as a major damaging force. In any case, GOJ at Walthamstow is informed throughout by a kind of rock 'n' roll sensibility; the words hip, funky and retro apply, it is high in kitsch, sometimes lower in tone and always exciting.

—

God's Own Junkyard

Unit 12, Ravenswood Industrial Estate

Shernhall Street

London E17 9HQ

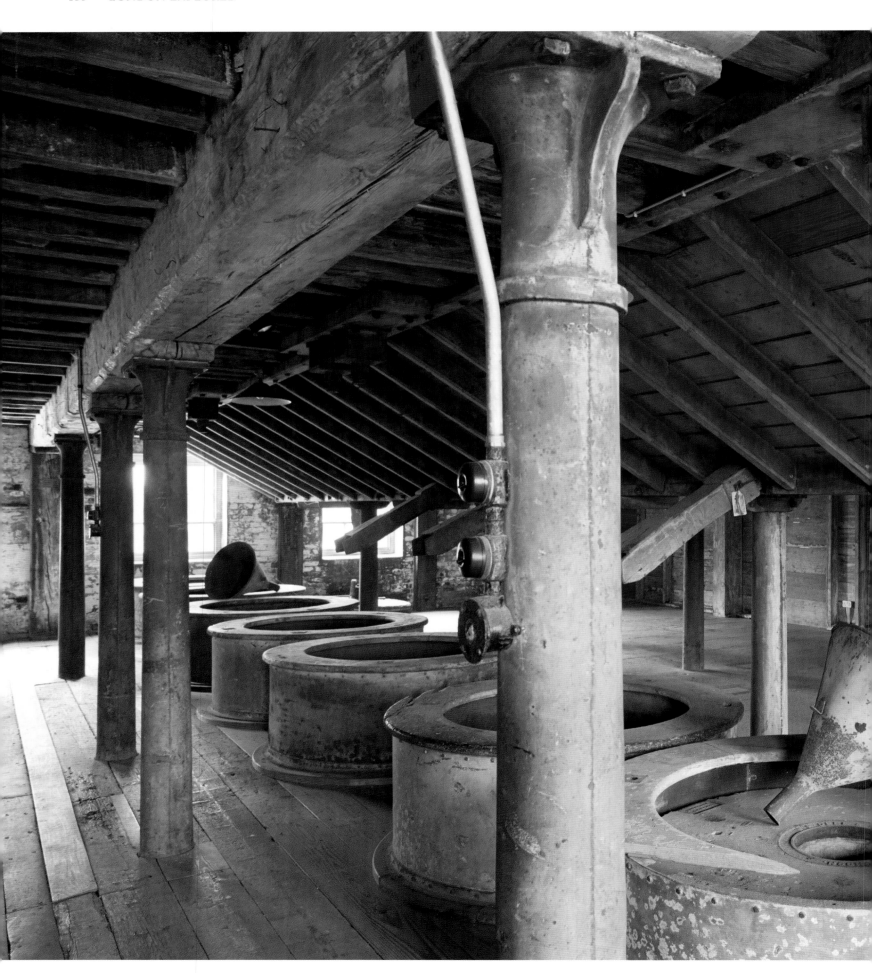

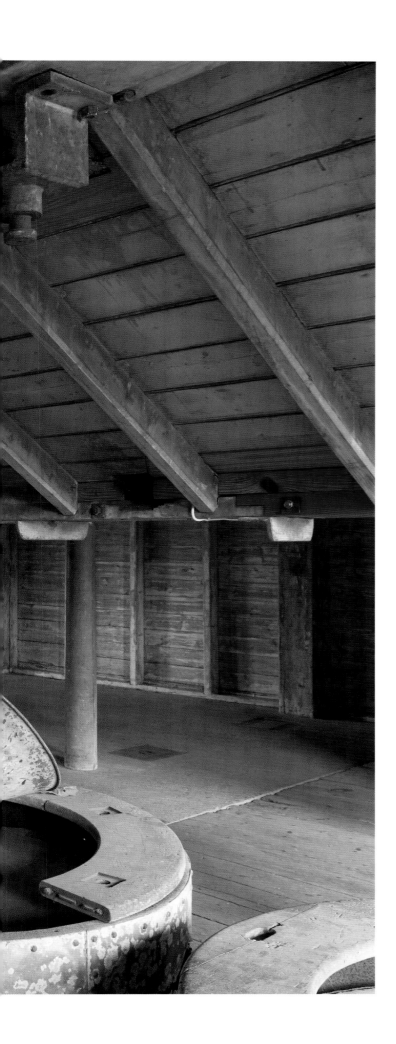

House Mill

House Mill at Bromley-by-Bow is the oldest and largest surviving tide mill in the UK. Tide mills, which capture high water behind a sluice and then release it to drive mill wheels, represented state-of-the-art power generation for hundreds of years before the steam age.

House Mill lies on an old artificial island known as Three Mills Island, which was partially created by driven oak piles. The island builders may have been Cistercian monks. A complex of watercourses called the Bow Back rivers, derived from the River Lea, surround the island and flow into the Thames at Blackwall. Over centuries more channels were created and some canalized, fitted with locks and weirs to aid navigation, while still harnessing the upriver push of the tidal Thames to Three Mills Island.

The main purpose of the first mills here was to grind corn for flour, and briefly for gunpowder and linseed oil. Flour production continued until the early 1700s when the site was acquired by a partnership to launch distilling of spirits. The mills working on the island were supplemented by distillery sheds, granaries, a bonded warehouse and a windmill. Business boomed during the gin-craze years. House Mill was a replacement built in 1776 on arches straddling the tidal Three Mills Wall River. It was gutted by fire in 1802, rebuilt with a timber frame behind the surviving brick front wall and fitted out with four waterwheels, each driving two pairs of millstones through multiple gearing. Two of these wheels remain today, one of them cast-iron with wooden paddles. House Mill came under the ownership of gin magnate William Nicholson and was upgraded again between 1886 and 1900 with the addition of two more large waterwheels, undershot and breast-shot. These wheels also survive. At this time much of the surrounding timber work was replaced by cast-iron columns and joists.

Pairs of surviving millstones beneath the grain hopper, using an advanced Fairbairn system introduced in the late nineteenth century.

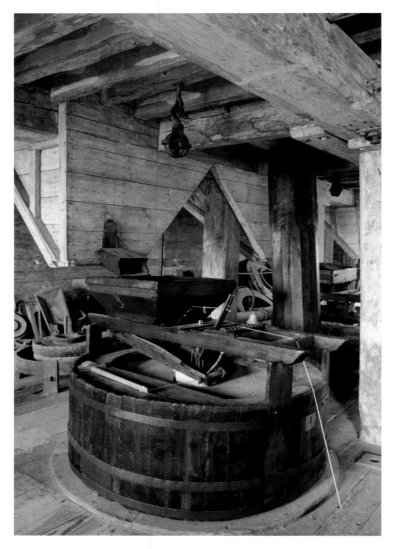

OPPOSITE *A sack hoist on the fourth floor – it has a top-down operation with a wooden frame construction (above); wooden patterns are retained to enable sand-blasting of broken and damaged cast-iron machinery on site (below).*

Some restored traditional mill machinery on the first floor. This part of the mill retains its original wooden framing.

Clock Mill was built in 1817, incorporating part of on older building with an elegant clock tower. The main process buildings of the distillery lay behind. Clock Mill, with its conical roofs and cowls, and the tall dignified House Mill, with its many windows, formed an attractive visual partnership. Three Mills, meanwhile, was drawn into a jagged industrial landscape as London spread eastwards, with railways, pumping stations, factories, gasworks and dock systems. In post-industrial times, this is an extraordinary background of Olympic Park sports stadia, Eurostar and Docklands Light Railway stations, distribution warehouses, flyovers and waterways.

Part of the distillery was commandeered during the First World War to assist the British war effort when production of cordite, the propellant powering the guns of the army and navy, was collapsing through the shortage of the solvent acetone. Acetone was irreplaceable in explosive production. Biochemist Chaim Weizmann had discovered a laboratory method of converting maize into acetone by applying a bacillus. There was a need to scale up the process from test tube to large-scale production. At Three Mills the fermentation plant was used to prove that acetone in large volumes could be produced this way. Weizmann, a pioneering Zionist, had won the respect and attention of ministers Lloyd George and Churchill, and gained influence on the Balfour Declaration of 1917 in favour of 'the establishment in Palestine of a national home for the Jewish people'. The same Chaim Weizmann became the first president of the new state of Israel in 1948.

Historians with expertise in the study of mills estimate that in medieval times the mills here operated for three to four hours per tide. By the early twentieth century, better technology and improved water flow extended the operation of House Mill to up to eight hours per tide and the operation remained viable. Steam power had been introduced for certain operations. The mills survived the Blitz, but much damage was inflicted around the island and the bonded warehouse and houses were destroyed. House Mill operated until 1940, Clock Mill until 1951. Clock Mill has recently housed a school and the distillery site is now 3 Mills Studios for film and television.

The Three Mills Conservation Area was established by the London Borough of Newham in 1971, and ownership of the House Mill building was assigned to the River Lea Tidal Mill Trust. The Miller's House, badly damaged during the Blitz and demolished in the late 1950s, was reconstructed to house a visitors' information and education centre. Restoration of the House Mill building was completed in 1997; restoration of the machinery to working order is planned. House Mill is regularly opened to visitors; all tours are guided.

—

The House Mill

The Miller's House

Three Mill Lane, Bromley-by-Bow

London E3 3DU

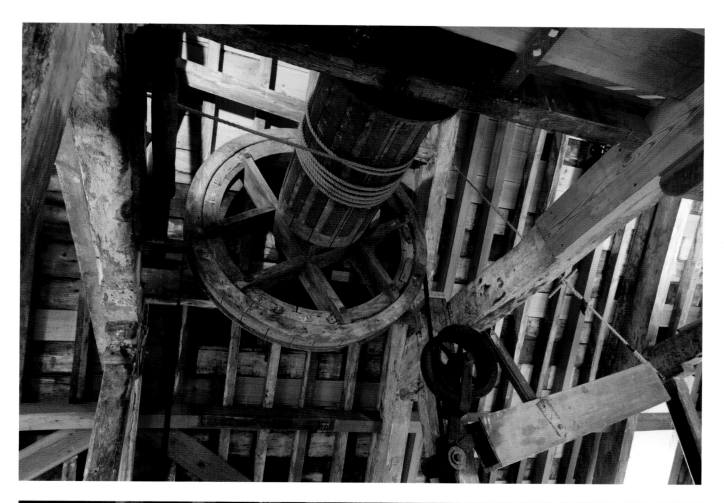

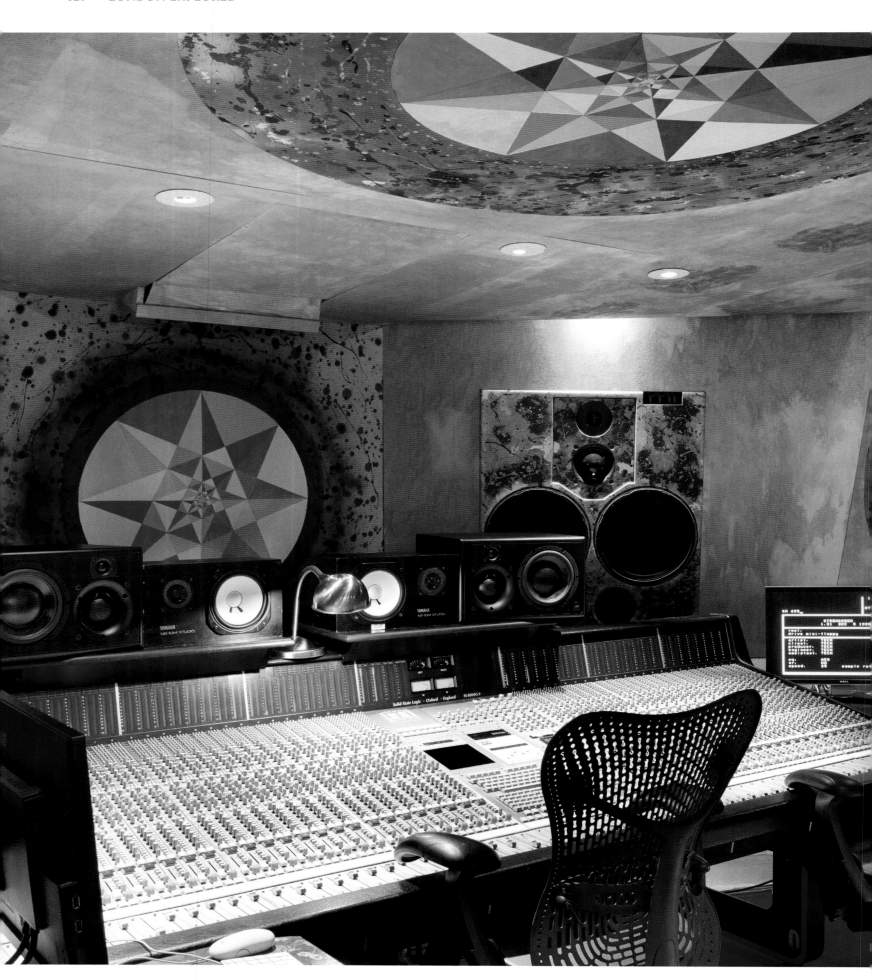

Strongroom Studios

Strongroom Studios is located in a courtyard off Curtain Road in EC2, a suite of recording rooms and a bar restaurant, music venue and home for several creative enterprises, a vibrant hub in a well-established hip enclave. It was not always that way: Strongroom blazed trails in both music recording and choice of location when it started in Shoreditch.

It was a run-down area of desolate Victorian warehouses and workshops, many of which were boarded up, when Strongroom took over some empty space in a disused building and opened a recording studio. The year was 1984 and soon the artists started to come in numbers. The first albums made here were an interesting cross-section of musical styles: the Proclaimers' *This Is the Story*, *London 0 Hull 4* by the Housemartins, and two from Velvet Underground veterans – John Cale's self-produced *Artificial Intelligence* and Nico's last album *Camera Obscura*.

The founder of the studio was Richard Boote, whose entry into the music business came as truck driver for tours of the Rolling Stones, Rick Wakeman, the Who and David Bowie. Tour management and later band management followed, but after losing his office at the heart of the music business in Denmark Street, he cast around for a new base with the idea of making a studio for recording demos. He came to Shoreditch, once London's furniture-making quarter, and found a place through an archway on Curtain Street. Many businesses in the area had closed; the single survivor still operational nearby sold old-fashioned furniture ironmongery. The space available around the courtyard in Curtain Street had once been a veneer store and wood yard for the James Latham company, one of the largest timber merchants in the world. Its last purpose in the trade had been a furniture distribution warehouse. Richard Boote built a studio room with equipment that was more advanced than state of the art.

The desk and interior of Studio 3.

Strongroom tapped a changing creative wave coupled to emerging technology, computers and digital audio. The Musical Instrument Digital Interface (MIDI) protocol introduced in 1983 allowed the interconnection of electronic instruments from different manufacturers. Other connection protocols were developed that enabled the linking of digital and analogue devices. An early Apple Mac computer was acquired.

At the same time, music in Britain was evolving independently of traditional labels and developing in a rush of post-punk directions. Strongroom embraced electronic music with synths and samplers and drum machines. It is traditional to claim that a special sonic quality is embedded in every recording studio (such as the near-mythical reverb in Abbey Road Studio 2); Strongroom has a reputation for fine drum sounds and what a producer has described as 'good vibes in a free environment'. The creative director behind the artwork in the studios was Jamie

Read, whose ransom-note designs had set a style in the 1970s for The Sex Pistols. In the studios, Read's unique colourful designs carry motifs from Druidism and Shamanism, intended to generate creativity and calm, according to the studio's own publicity.

A music trend helped along by Strongroom was the first dance remixes from DJs; a long run of these were handled in Studio 2. A number of programming rooms and smaller studios followed. Some of these were let to independent producers. Strongroom expanded into all areas of the former warehouse. Office spaces were let to publicists, record labels, publishers and design agencies. In 1997, the alternative Strongroom late-night bar and restaurant opened in a former timber seasoning shed on the side of the vine-covered courtyard across from the recording rooms. Its first aim had been to provide a place to eat and drink for people based at Strongroom. By the end of the 1990s, the world had caught on about Shoreditch – it was now increasingly popular

Studio 1, with ribbon valve condenser microphones – a mixture of vintage and new – and a Fender Bassman amplifier.

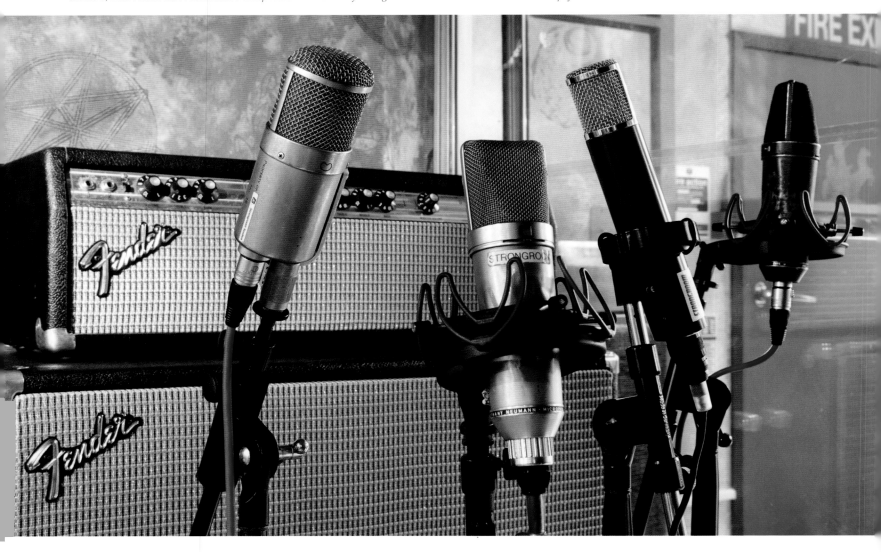

and fashionable, and bars, restaurants and coffee shops came to Curtain Road. In 2006, Richard Boote received the Mayor of Hackney's Businessman of the Year award, recognizing the contribution of Strongroom to the wider area.

Strongroom's studios number one to four. The original Studio 1 has capacity for a full line-up band, classic or jazz ensembles, drum recording, piano or vocal sessions, and additional booth and isolation areas. Studio 2 is a smaller space relaunched in 2018 with a minimalist look, said by Strongroom to give a contemporary feel with greater environmental control. Studio 3 is another spacious room with a reputation as an accurate-sounding mix room. Studio 4 is based around an ex-BBC console. It is said to be good for production, recording and overdubbing and is renowned for producing an intimate drum sound.

The roll call of artists after the first recordings of 1984 includes: Depeche Mode, Nick Cave and the Bad Seeds, the first albums of Jamiroquai and the Prodigy, and in 1995, the Spice Girls started recording at Strongroom. Later came Radiohead, Bjork, the Arctic Monkeys, the Chemical Brothers, Tom Odell, FKA Twigs and Rex Orange County.

—

Strongroom

120–124 Curtain Road

Hackney

London EC2A 3SQ

The Dalcon desk in Studio 2.

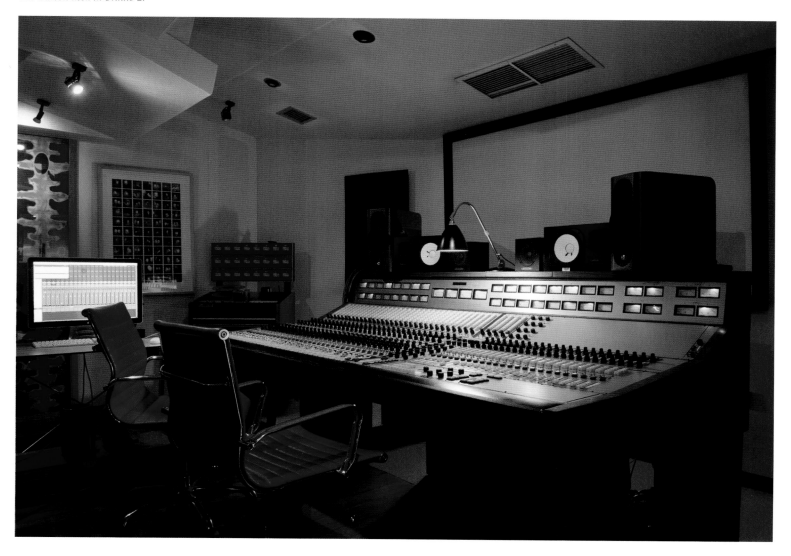

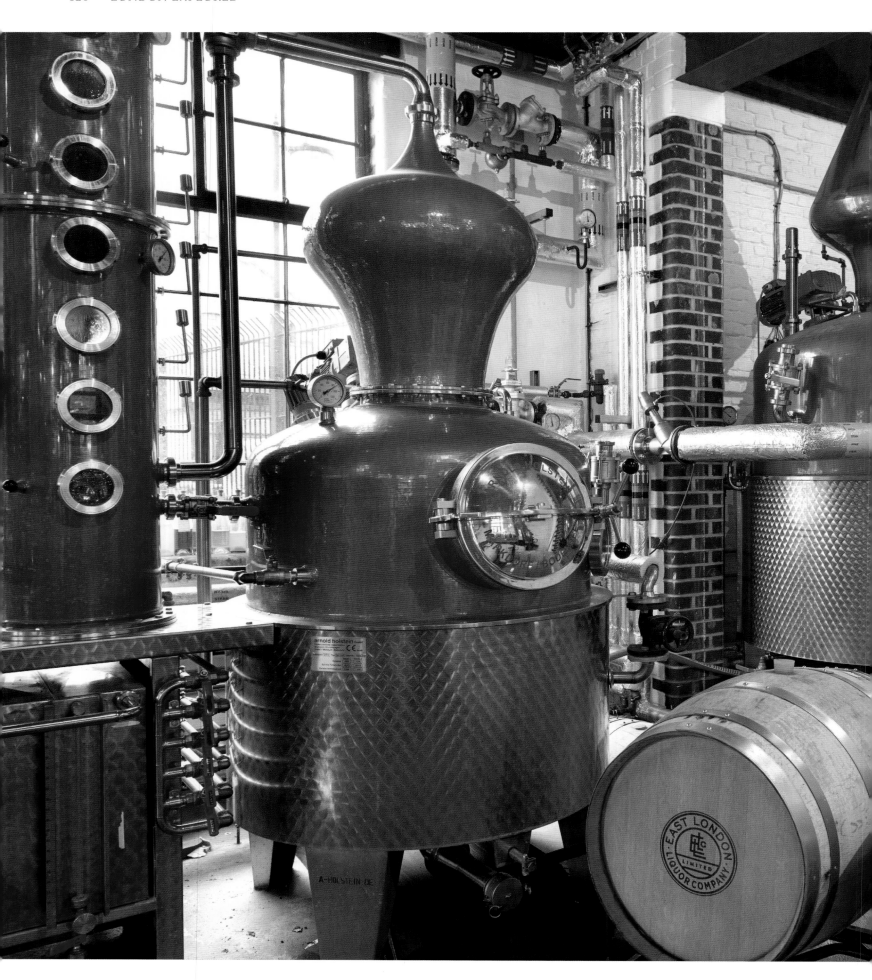

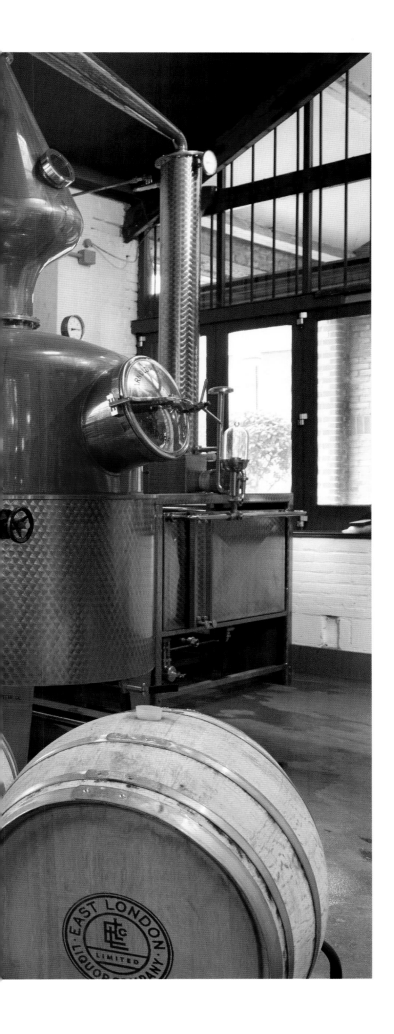

East London Liquor Company

London waited 300 years for a second wave of the gin craze. This emerged in a more civilized way in the 2000s, in clear contrast to when 'mother's ruin' ran riot in the 1700s. The second coming saw the opening of a range of smooth gin-themed bars in London, the resurgence of cocktails and the emergence of micro distilleries and ginsmiths producing more subtle varieties of the spirit.

Gin had sunk to a low ebb in the 1990s after the drink had fallen out of fashion and, for a time, there was just one working gin distillery in London, but by 2012 this had grown to four and, with more micro distilleries opening, to as many as fifteen or more by 2020. While the major international gin-maker working in London remains Beefeater's monumental operation in Kennington producing millions of bottles annually, smaller new distilleries (see Sipsmith Distillery, pages 100–101) have set a different style. The East London Liquor Company has carved out a distinct identity, claiming to be the first gin, vodka and whisky distillery established in East London in over 114 years and, at the same time, a place that serves and sells drinks and offers food.

Gordon's and Booth's Gin were established at Clerkenwell to the west, but the East End of London is also an historic home of all types of distilling. At Bow, Three Mills Island under the ownership of Nicholson gin dynasty (see House Mill, pages 116–19) produced both neat spirit and Lamplighter gin until its closure in 1966. The Lea Valley Distillery Company at Stratford, operating between 1882 and 1904, was a rare example of a whisky distillery once working in England. Reviving these traditions, the East London Liquor Company started production of gin and vodka in 2014 and in November 2018 came whisky.

The founder and managing director of the East London Liquor Company is Alex Wolpert. With a background in restaurant

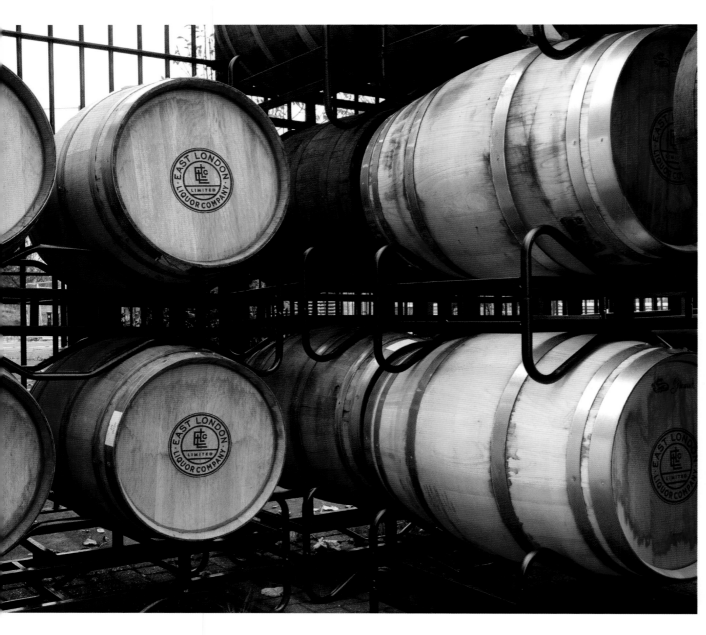

ABOVE *Empty barrels made of French oak.*

and gastropub management in London, he progressed through organizing private tasting events and developed an interest in cocktails and distilling. Seeing that many of the new generation gins were tending to be expensive super-premium products, he set out to produce spirits of high quality yet accessible in price with a young market in mind.

In 2013, the East London Liquor Company was founded and the business opened in 2014 at Bow Wharf in a converted building that was home at various times to a steam-driven sawmill, a paint factory, possibly a glue works and later a pub. The location is alongside the Hertford Union Canal near to where it joins the Regent's Canal and close to Victoria Park, a prime East End position. Two copper stills of 450 litre and 650 litre capacities were commissioned from German maker Arnold Holstein and a third still was added in 2017. With transparency and accessibility being one of the aims of the ELLC, the stills were arranged to be visible behind a glass screen from the cocktail bar to show the production process. The interior style is industrial brick walls and wooden floors. From the start, it served cocktails alongside craft beers and grilled sandwiches, and by 2016, a restaurant serving Italian-style dishes had been added. There is a bottle shop here and also an ELLC shop at Borough Market.

On the label of some of ELLC's bottles is a picture of an inverted horse, a sly reference to the horses' hooves that once provided raw material for the glue reputedly once made in the building alongside the canal.

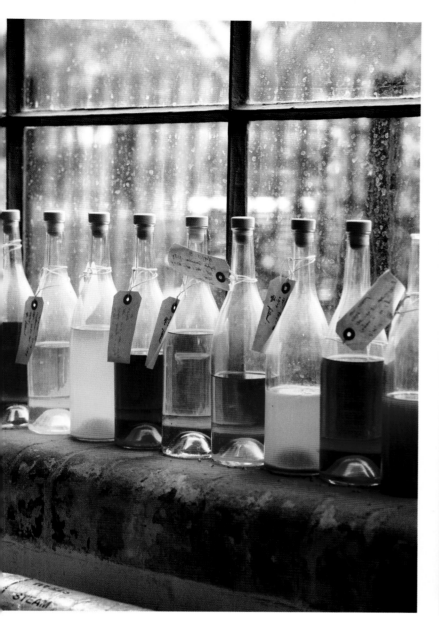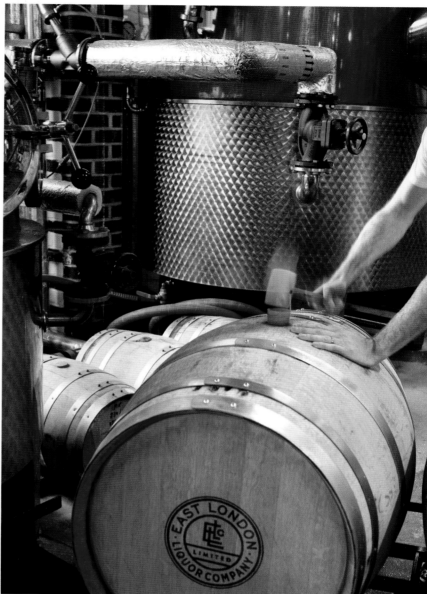

ABOVE *Bottles of macerates lined up on window sill show experiments with soaking different flavour elements in alcohol (left); the ageing process begins (right).*

Gin was the first into production. A London dry gin is, by definition, distilled alcohol flavoured by infusion alone. It can be, and is, made in other parts of Britain, on the continent of Europe and in the US. The predominant flavour of gin must be juniper, otherwise there is no limit on the number and type of flavourings, which must be natural and are called botanicals, that can be used in its production. The original ELLC's product was a classic London dry gin; its Premium Batch No. 1 gin with flavourings of cassia bark, darjeeling tea, pink grapefruit peel and cubeb berries is said to suit dry martinis well; Premium Batch No. 2 with orris root, lemon peel, thyme, winter savoury, fennel seeds, sage, bay leaf and lavender is described as making a good negroni. The first whisky from ELLC was started in April 2015

– London Rye, distilled and aged on-site in casks for three years before release. A single malt whisky followed the next year. Oak casks are stipulated for traditional Scotch and American whiskies, and the ELLC is able to use oak and also other varieties of casks, such as chestnut, former sherry casks and ex-bourbon casks, for its specialized spirits. Barrel-aged gins have been produced.

—

East London Liquor Company
Unit GF1, 221 Grove Road
Bow Wharf
London E3 5SN

Old Royal Naval College

The Old Royal Naval College, standing beside the Thames at Greenwich in south London, is among the grandest architectural collections in England. It comprises four large buildings, all with a central courtyard, and since 1997 has been the centrepiece of the Maritime Greenwich Unesco World Heritage Site. Perhaps the grandest of the gems at Greenwich is the Painted Hall, in the King William block, where a two-year restoration in 2019 revealed elements of its decoration that had long been lost in the riverside murk. The building is both simple and magnificent. It is, as its name suggests, a painted hall, but it is the size of the hall and the richness of the painting which writhes across the walls and ceilings that confirm it as a Baroque masterpiece. The interior is readily described: it is a simple rectangular space on two levels, designed by Sir Christopher Wren. Yet its decoration is something else entirely. This was the work of Sir James Thornhill, who spent nineteen years from 1707 to 1726 producing riotous images of national self-aggrandizement and maritime power.

The Painted Hall is conventionally described as the 'UK's Sistine Chapel', which suggests, correctly, superlative architectural decoration. Yet where the chapel in the Vatican explores themes from the Bible, at Greenwich the narrative is far more martial. It has been said that Thornhill secured the commission because he was, in order of importance, Protestant, English and cheap, and it is the triumph of a Protestant monarchy in securing peace and prosperity for England that is the great theme of the work. So we have William and Mary at the climax of the ceiling with a splendid George I on the rear wall, plus a grovelling Louis XIV of France and figures of Peace, Truth and Piety. Thornhill covered around 2,700 square metres/3,200 square yards in all, earning £3 per square yard on the ceiling, £1 on the walls. He may have then felt under-valued, but during

Undertaking the restoration of the ceiling of the Painted Hall.

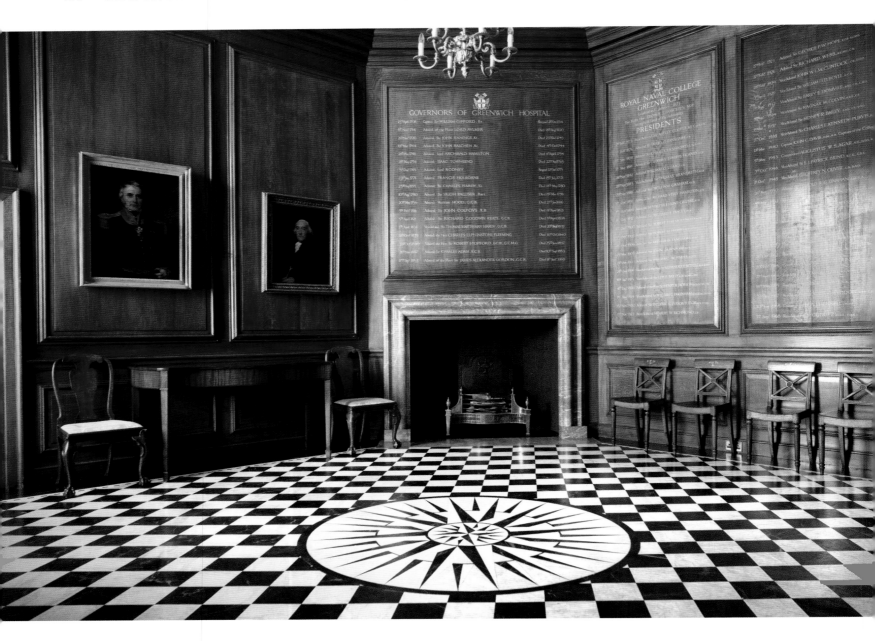

A wood-panelled room in the Admiral's House.

the restoration 85,000 visitors climbed scaffolding to around 20 metres / 65 feet above the hall floor to admire his ceiling.

The exterior of the Painted Hall has a classical façade beneath one of a pair of domes. Under the second is another of the Old Royal Naval College's gems: the chapel, located in the Queen Mary block. The whole complex at Greenwich was designed by Wren as a Royal Hospital, or refuge, for disabled seamen and there are clear nautical motifs of ropes, anchors and a mariner's compass in the chapel's marble floor. Everything else would come as a surprise to Wren as the chapel interior dates from 1789, ten years after fire gutted the original. The present chapel and Painted Hall are separated only by sixty-odd years but their styles move rapidly from English Baroque to a more refined classicism. For

all the exuberance of Thornhill's painting, it has to be admitted that the hall's interior has a sombre brown tone, yet the chapel sparkles with colour and light. It was redesigned by James 'Athenian' Stuart, a key figure in the Greek Revival in English architecture and Greenwich is an example of his finest work. The visitor to the chapel passes between a pair of Ionic pillars at the entrance to the nave and finds twinned Corinthian pilasters framing the altar. On either side of the nave are elegant balconies, effortlessly held aloft on carved cantilevers. Yet it is the ceiling, as at the Painted Hall, that commands most admiration, though a stronger contrast to Thornhill's work is hard to imagine. Stuart divided the ceiling into three panels, with ornate rosettes at the centre of each, introducing a blaze of azure decoration.

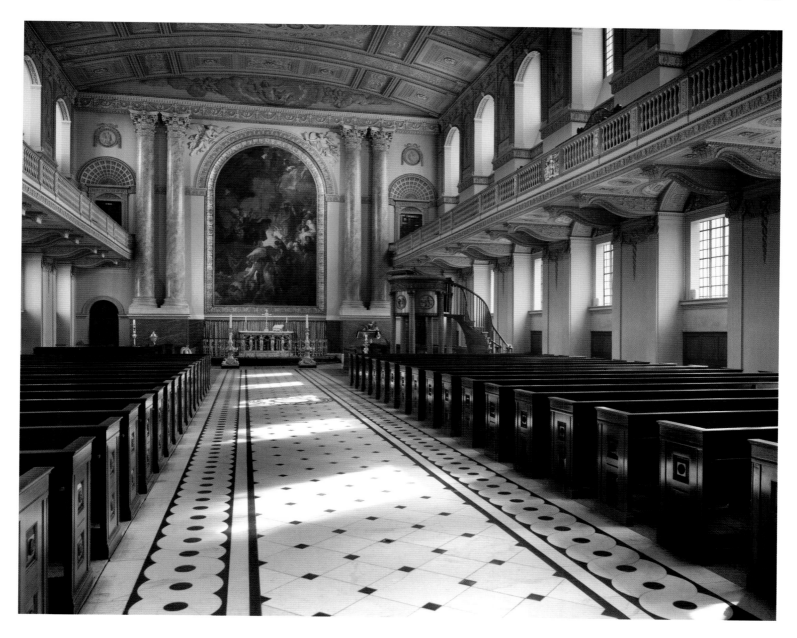

ABOVE *The Chapel of St Peter and St Paul, a neoclassical masterpiece.*
OVERLEAF *The Painted Hall, which has been dubbed the 'UK's Sistine Chapel'.*

The Admiral's House at Greenwich is an architectural survivor on a smaller scale. It is located in the King Charles block, dating from 1669 and the oldest building at the complex. After losing his right arm in 1797, Horatio Nelson recuperated in the Admiral's House and there sat for one of his most celebrated portraits. The house was badly damaged by bombing in 1943 but its key features of lavish panelling and ornate tiled floors were successfully restored.

The house originally accommodated the governor of the seamen's hospital but this function ended in 1873 when the complex of buildings found a new role as the Royal Naval College, the navy's university, where officers were educated. The college operated mostly away from the public gaze, though there was significant controversy when it emerged, in the 1980s, that a small nuclear reactor named JASON had, in 1961, been installed under the King William block. The reactor stood 14 metres / 2 feet high and was surrounded by 300 tonnes of steel and concrete cladding. JASON was used for training engineering officers destined to serve on nuclear-powered submarines but was dismantled when the navy departed in 1997 to make way for the University of Greenwich, the present occupants of the site.

—

Old Royal Naval College

King William Walk, Greenwich Peninsula

London SE10 9NN

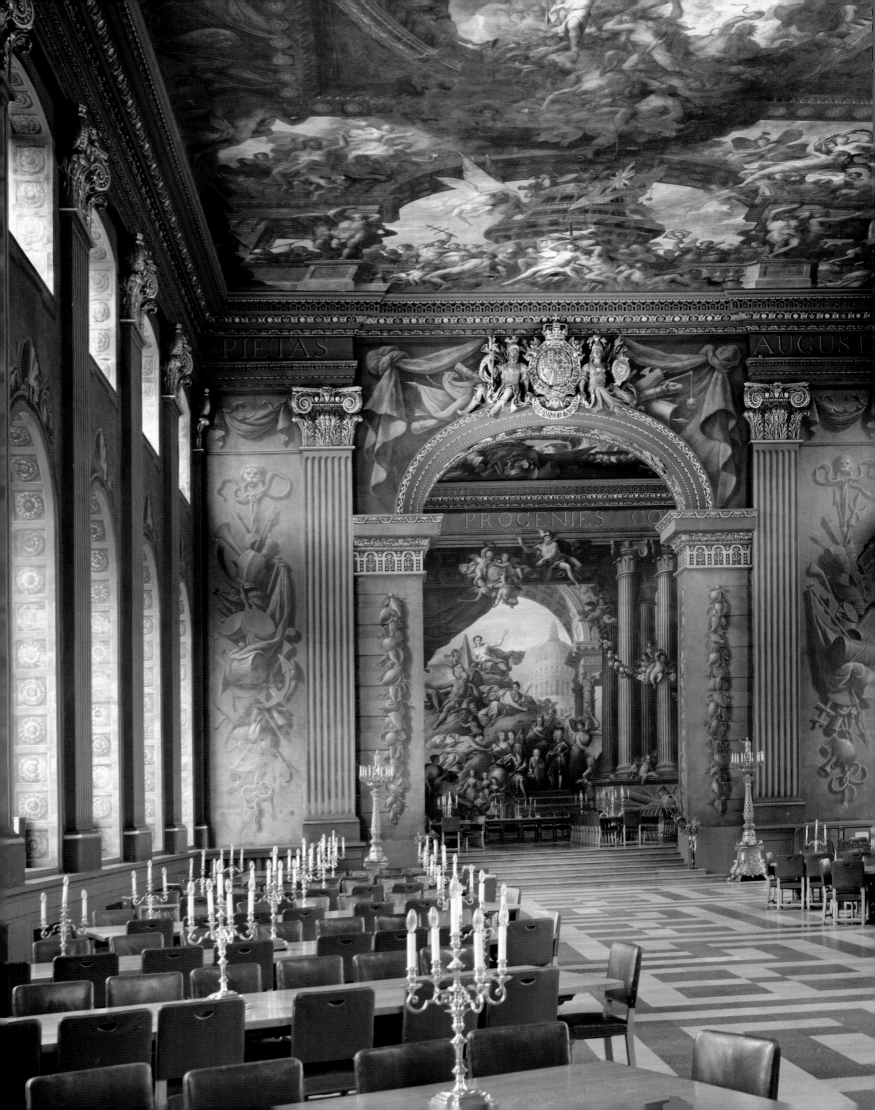

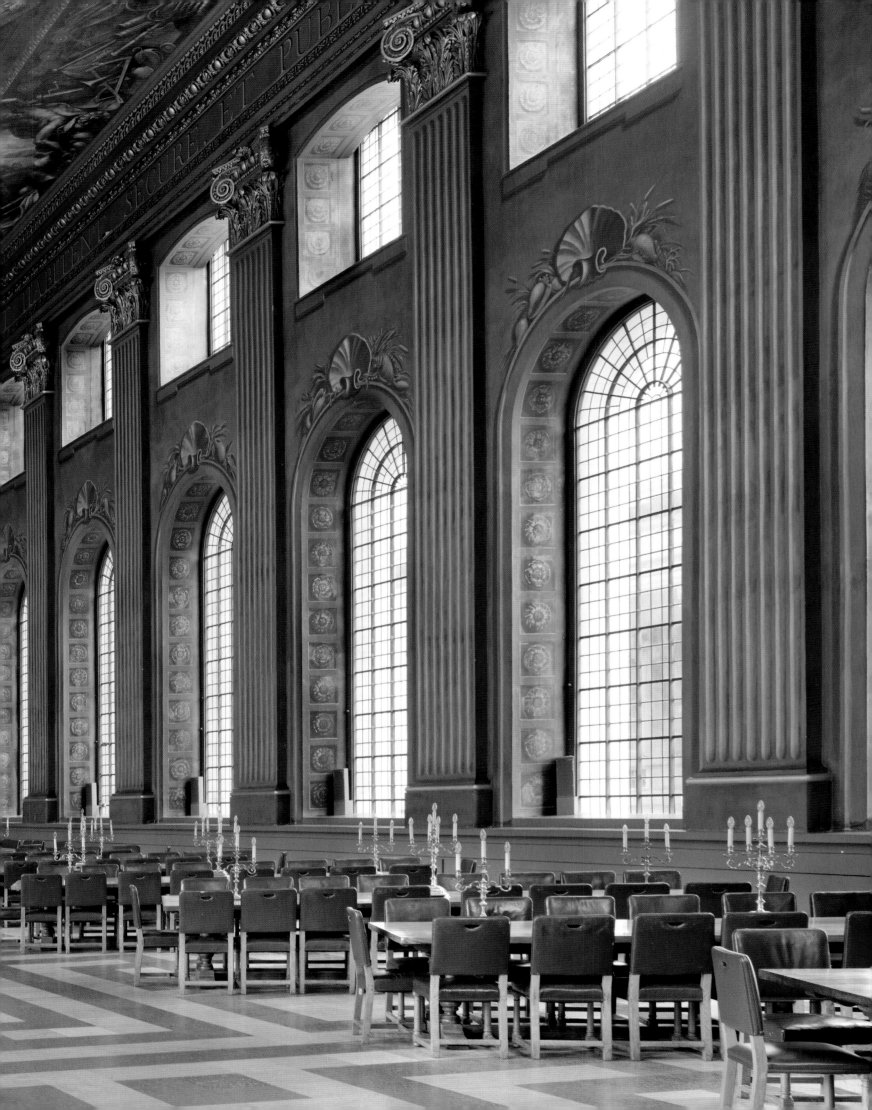

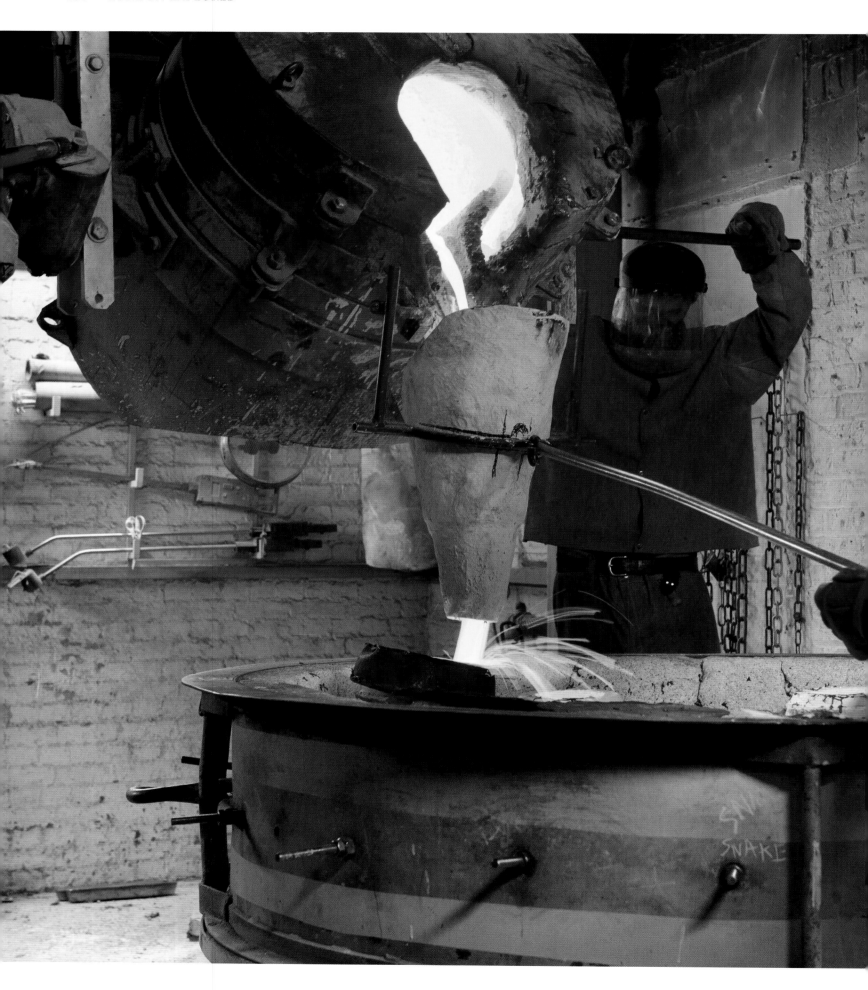

Bronze Age London

The process of translating statuary into bronze is a specialized craft limited to a handful of practitioners in London, one of the largest and busiest being the Bronze Age sculpture casting foundry in Limehouse. This art foundry set up by the sculptor Mark Kennedy to cast his own work was steadily expanded to offer casting services in bronze and aluminium to other artists and companies for public and private sculptures. It specializes in lost-wax casting of bronze and aluminium and has the capacity to pour and cast a half-tonne of bronze at a time for monumental large sculptures, with separate techniques for pouring small and detailed sculptures and medals. The foundry is in East London's Docklands, close to Canary Wharf.

Bronze Age has worked with over 1,500 artists and statues cast at Limehouse can be seen all over London. A figurative public sculpture in the City – a wall depicting students from Christ's Hospital School – by Andrew Brown is one of the latest from the Bronze Age foundry. At Kings Cross railway station is the bronze statue of Sir Nigel Gresley by Hazel Reeves. At Royal Victoria Dock, outside the ExCel, the three figures comprising the massive *Dockers* statue by Les Johnson is one of the largest sculptures handled by the foundry. Close by, at Canada Square, are two lion sculptures standing at the HSBC headquarters building, which are replicas of two original sculptures at the Hong Kong (China) office. The originals were moulded on site in China mainland by Bronze Age and reproduced at Limehouse. More delicate is *The Tree of Life* frieze on the façade of the Whitechapel Gallery by Rachel Whiteread, her first permanent public commission – clusters of leaves cast in bronze and finished in gold leaf. Further afield in Britain are Nigel Boonham's statue of Martin Luther King Jr at Newcastle University, unveiled in 2019, as well as Hazel Reeves'

The crew pouring molten bronze of 1,170 degrees centigrade into the ceramic shells.

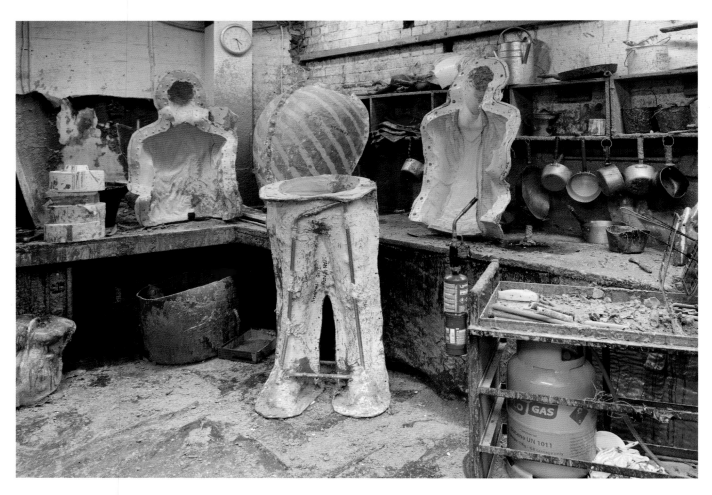

OPPOSITE *Moulds being cleaned and prepared for use in the wax room (above); the ceramic shell department (below).*

statue of Emmeline Pankhurst, the political activist and leader of the Suffragette movement, in St Peter's Square, Manchester.

In Britain, the method of casting sculpture and statuary in bronze started to develop in early Victorian times. In the 1880s, bronze was coupled to the revival of lost-wax casting, a technique that dated back thousands of years for smaller statues, but was this time being applied to large statues. Lost-wax casting can reproduce intricate detail and make a strong, long-lasting work, although this is achieved by an arduous and time-consuming process. The processes used by Bronze Age have evolved with the introduction of some more modern materials but are based on the following long-established rituals. The first stage is mould-making, which requires the entire surface of the original sculpture to be coated with silicone rubber before resin and fibreglass are added. Detail as fine as a fingerprint can be picked up. The mould is used to make a wax positive, which is hollow, as the final bronze

must be. A ceramic shell is made in layers surrounding the wax, incorporating channels for the bronze to flow. The inside cavity of the hollow wax is filled with a plaster-based mixture called Core. When the wax is melted away by a propane burner, the hollow ceramic shell remains. This is placed in a supporting bed of sand, with a cup mounted to receive the molten bronze. Next comes the pour. Bronze ingots are heated to 1,170 degrees centigrade in a crucible and poured through the cup into the void. After cooling overnight, the ceramic shell and feeder system is removed by high-power water-blasting. All that was once wax is now bronze.

For large sculptures cast in sections, fabrication by welding follows. The welds are chased back before a surface finish is applied. The finishing of bronzes by applying a patina is mostly achieved using various combinations of different layers of chemicals with heat. Bronze Age say this is a crucial stage, transforming the casting, enhancing and enriching the sculpture and bringing the sculpture to life.

The bronze of William Shakespeare pictured here in the metal workshop at the foundry is a collaboration between Raphael Maklouf and Hayley Gibbs for a new building and exhibition space on an historic site at Shoreditch, where a theatre dating from 1576 existed. Another noted literary figure memorialized in bronze is Agatha Christie by Ben Twiston-Davies in Covent Garden.

Tours of the Bronze Age foundry can be made by booking in advance.

—

Bronze Age London
Gallery Building
Basin Approach, Limehouse
London E14 7JG

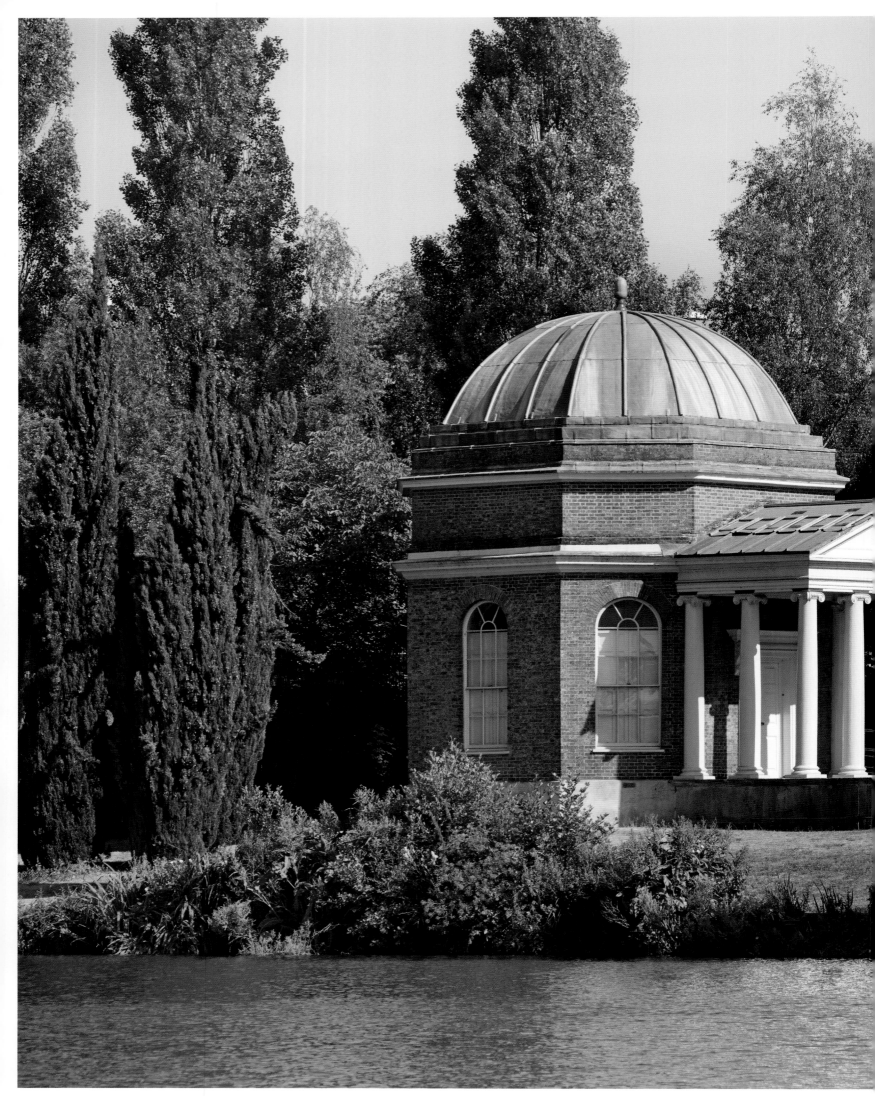

FURTHER AFIELD

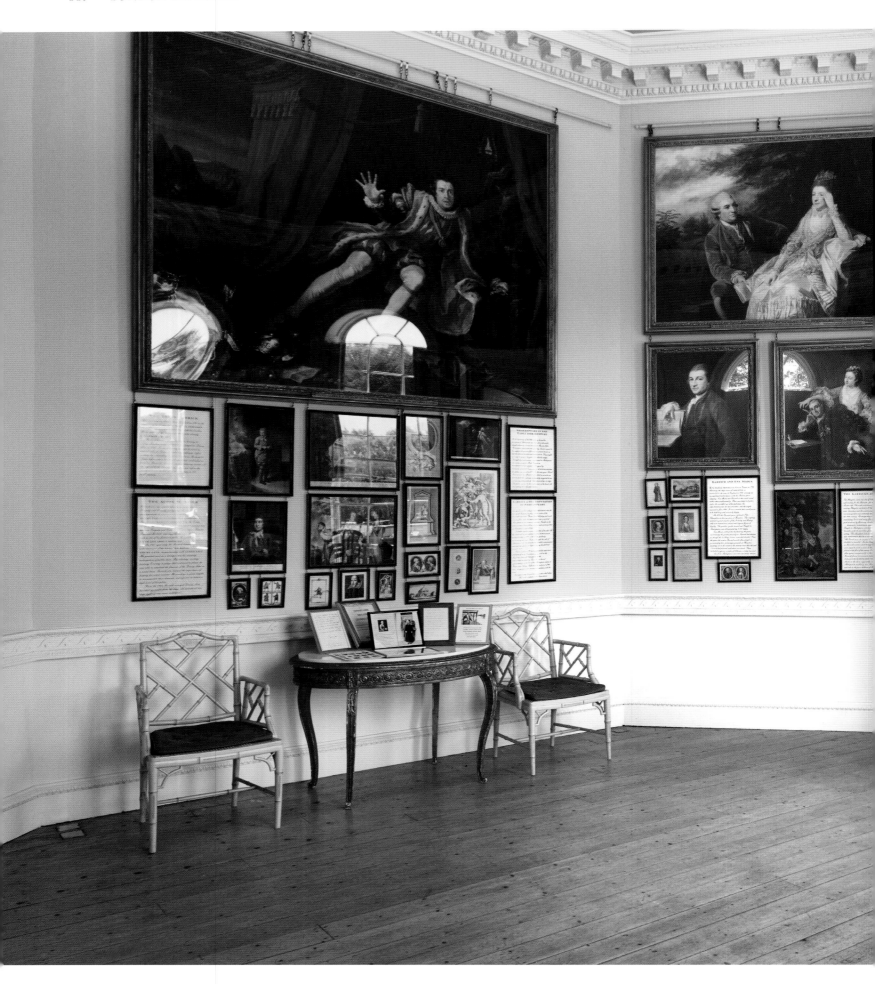

Garrick's Temple to Shakespeare

Two phenomena of the mid-eighteenth century are represented on the riverside at Hampton: an architectural folly and the resurrection of William Shakespeare. David Garrick, actor, theatre manager and pioneering restorer of the plays of Shakespeare, commissioned an octagonal temple for the garden of his villa overlooking the Thames. He filled the temple with his collection of Shakespearean relics, creating a secular shrine for entertaining friends and family.

Through the years of the Restoration, the plays of Shakespeare had fallen into relative obscurity. David Garrick, who was born 100 years after Shakespeare's death, restored much of the original texts of the plays and staged them. His performances as King Lear, Hamlet and Macbeth in a naturalistic style made his reputation as the greatest actor of the age and contributed to establishing Shakespeare as the towering figure of English literature.

After Garrick's death in 1779, the temple passed through a succession of owners until 1932 when it was purchased by Hampton Urban District Council. It was restored in the late 1990s and reopened to the public. It usually opens on certain Sunday afternoons between late March and October and also hosts educational visits and cultural events.

Garrick commissioned a life-sized marble statue of Shakespeare from the sculptor Louis François Roubiliac, which is now in the British Library but a copy can be seen in the temple. Garrick seems to have posed for the statue himself. There are several pictures of Garrick in the temple, which has become a museum of the actor rather than a monument to the playwright. Historical cataloguing records that there are over 250 known portraits of Garrick, off-duty and in stage character, original and engraved, more than those of any other actor of his day. There are likely only two known faithful representations of William Shakespeare.

—

Garrick's Temple, Hampton Court Road, TW12 2EJ

Garrick's Temple is a museum, concert venue, education facility and theatre.

Keats House

John Keats, arguably the greatest of English Romantic poets, drew inspiration from classical mythology, from nature, from notions of love and mortality. His time as a poet spanned less than six years, during which he produced no fewer than sixty poems, some of them remarkable in richness of imagery, sensuality of language and mastery of verse form. In the background lay the northern suburbs of London 'where Keats' life as a poet began and where much of his greatest poetry would be written' in the words of biographer Nicholas Rowe. It was an area he knew well, and a house in Hampstead was John Keats' last real home, now restored as Keats House, a memorial and museum.

A Londoner by birth, he was raised in Moorgate where his family operated a livery stable attached to the Swan and Hoop pub. At the start of the 1800s, the city was beginning to edge northwards into the countryside and John Keats was sent to Enfield for his schooling. He became a medical apprentice in Edmonton before going to Guy's Hospital to study to be an apothecary surgeon.

In 1816, he turned away from his medical career and the following year, as his first poems were published, he moved with his brothers to lodgings at Well Walk in Hampstead. The move was most likely prompted by a search for a healthier environment; his brother Tom was beginning to show signs of tuberculosis, a disease which dogged the Keats family. Hampstead was a village yet to be connected to London on its southern side, while open to the heath to the north. At that time it was starting to become a fashionable place and several houses were being built along the country lanes of Hampstead. One of these was Wentworth Place, a house divided into two residences, one part owned by Charles Brown, a merchant and supporter of the arts. When Tom

The Chester Room, which was used for entertaining, was an 1839 addition to the original house.

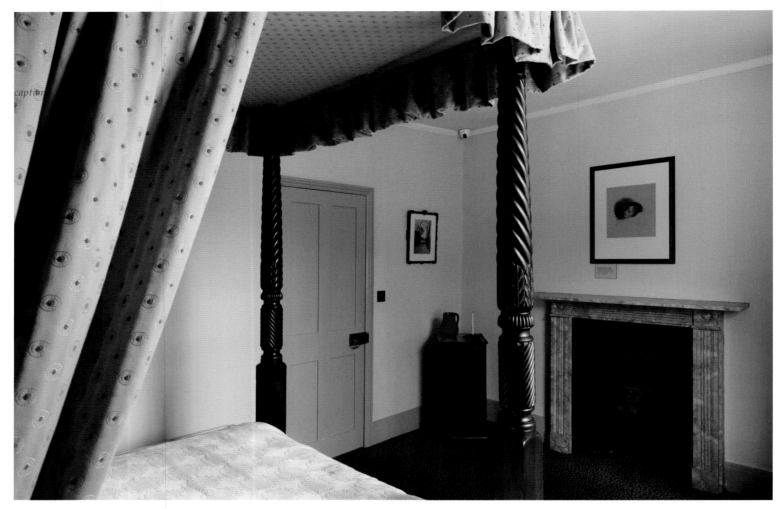

caption

ABOVE *Keats' bedroom where he first realized he had consumption (tuberculosis), the illness that he died from in 1821.*
OPPOSITE *The cellar and wine store.*

Keats died, Brown invited John Keats to share the rooms at Wentworth Place. This is the building now known as Keats House.

In 1819, the house was surrounded by a garden planted with fruit trees and vegetables, with open fields lying beyond. Tradition says that 'Ode to a Nightingale' was composed under a plum tree here in April or May when Keats was inspired by birdsong; this is based on an account by Charles Brown.

More certain is the fact that the Brawne family had moved into the house that comprised the other side of Wentworth Place around this time. The eldest daughter, Fanny Brawne, met Keats in the garden, a friendship developed and an engagement was arranged between them.

Keats did not come from an aristocratic, prosperous or landed family, which set him apart from other poets of the time, but neither was he born into

poverty as sometimes suggested. He enjoyed no particular privilege, yet received a good education in a progressive environment and he travelled quite widely in Britain during his short life. For him there was to be no Grand Tour or European sojourns as there were for Byron, Shelley and Wordsworth, although his last weeks were spent in Italy for the sake of his health. He died there aged twenty-five in 1821. There had been little positive recognition by critics during his lifetime and there was little sense of preciousness attached to Wentworth Place for years after his death.

Wentworth Place was bought by the actress Eliza Jane Chester in 1838, who ordered the combining of the two houses into a single dwelling and added a drawing room to the eastern side of the building. The house continued as a residence into the twentieth century until it was proposed to demolish it to make way for the development of a row of flats. A growing

OPPOSITE *Keats' incredibly neat medical notebook dated 1816, the year he finished his studies and dedicated himself to poetry (above); the parlour, where Keats wrote his greatest and most enduring poetry (below).*

ABOVE *The house was divided into two residences, this was the basement kitchen of the Brawne family.*

appreciation of the quality of Keats' poetry had come during the late nineteenth century and a memorial committee was formed to save the house. Fundraising of £10,000, much of it coming from the US where Keats' reputation was high, saved the house, which subsequently became a museum. A building was added to the side to contain a collection of books, letters and artefacts related to the poet, and part of this was used as a Hampstead branch library. The house was restored by the London Borough of Camden in the 1970s. In 1998, the City of London took over responsibility for Keats House and completed a programme of conservation and internal restoration. The result is a homely series of rooms describing the time in 1819 when Keats and Charles Brown shared one side of the house and the Brawne family lived next door.

By far the grandest room is the Chester entertaining room, the drawing room added by Eliza Jane Chester. The cosy bedroom with pale pink walls is poignant because it is the place where Keats was first seized by a tubercular cough and immediately made his own prognosis.

—

Keats House
10 Keats Grove
Hampstead
London NW3 2RR

Southside House

Eccentric, enchanting and charming are the words most often used to describe Southside House, an old, much reworked Tudor-Georgian residence on a corner of Wimbledon Common. Its rooms house whimsical collections and its garden carries a series of curiosities.

The origins of the house are obscure, possibly based on the amalgamation of a country manor house and a Tudor farmhouse lodge by Robert Pennington, a legal clerk of the Court of Chancery, who wanted to escape the London plague epidemics in the 1600s. The building was further developed in the 1750s with the addition of a wing and a combining frontage of brick façade. The result is a house that has a unified front with a central doorway under a clock tower and a rear aspect that resembles two or three houses joined together. Inside is a collection of family possessions reflecting the history of the house, and possibly some legends.

A descendant of Pennington, Hilda Pennington Mellor, married the Swedish-born writer Dr Axel Munthe, author of *The Story of San Michele*, the sometimes fanciful biography, which became a bestseller in the 1930s. Their youngest son was Malcolm Munthe, who as a British Army liaison officer and Special Operations Executive representative, served during the Second World War in Finland, Norway and Sweden and later in Italy. Influenced by the experiences of war, Major Malcolm Munthe resolved to restore the bomb-damaged Southside House and bring together its history and his family history. The highly personal result has been described as a psychological landscape by a curator of Southside House.

The scope of the post-war refurbishment was limited by the money available and the result is not a shining example of restored surfaces, but a collection of pictures, mementos and furnishings making associations with history. Some of the pieces come from the family's home in Biarritz, south of France, including paintings,

The entrance hall.

OPPOSITE *The entrance hall from the upper gallery (above left); the folly in the garden (above right); the library, which houses a writing desk and a rare circular Hammond typewriter (below).*

OVERLEAF *The ornately decorated breakfast room.*

The atmospheric music room is still used for a variety of musical events.

chandeliers and some statuary. Southside House was first opened to visitors in 1982.

A visitor enters Southside House from the rear through the garden hall, which has traces of faux windows in the technique called *trompe l'oeil* and walls hung with family portraits. The old rocking horse which stands here once belonged to Horatia, daughter of Lord Nelson and Lady Hamilton. Lord Nelson, Sir William Hamilton and Lady Hamilton were guests of John Pennington at Southside when they were living at nearby Merton Place. Lady Emma Hamilton, it is claimed, performed attitudes – choreographed poses in imitation of shapes in classical artworks - in the music room. The room has a portrait of Emma Hamilton and the table where they all played cards.

Earlier, Frederick, Prince of Wales, is said to have stayed at Southside House after attending a military review on the Common in 1750. The recreated room is decorated with yellow silk wallhangings and a bed with scarlet headboard and embroidered

Prince of Wales' feathers in silver thread. Some accounts say this bedhead refers to a later Prince of Wales, Edward VII, who visited the Pennington home in Biarritz. A display case contains what is reputed to be a string of pearls worn by Marie Antoinette on the day of her execution, presented to a member of the Pennington family by Empress Josephine. There are other precious objects including an emerald and gold ring, gifted to Hilda Pennington by the former Queen Natalie of Serbia. Hilda had been courted as a teenager by Alexander I of Serbia, and his mother Natalie, hearing of her impending marriage to Axel Munthe, presented her with some of her then late son's heirlooms.

The library is furnished in a later style with items including busts, books, a rare circular Hammond typewriter from the nineteenth century and somewhere there is said to be a painter's palette belonging to Sir Joshua Reynolds.

One of the strangest legacies of Southside House is not on display – a stash of weapons discovered under the dining room in 2011. After a fire the previous year, clean-up work uncovered steps under the hearthstone to a room containing a chest. Inside were found a Sten submachine gun and .45 automatic Colt pistol, magazines for the M1 Garand rifle and some rounds of ammunition. The weapons, which were removed by police officers, were believed to have been hidden by Malcolm Munthe, who died in 1995. The arms cache has never been explained.

Behind the house, the garden is spread over almost a hectare (two acres) and was once occupied by wartime allotments. Restored, again by Malcolm Munthe, there are few flowers but a shell grotto, an orchard, grassy pathways, box hedges, a stream enclosing an island and two classical temples, all in a landscape that is rather wild in places.

Southside House has served as a backdrop in several films, including *Mr Turner*, *The Invisible Woman* and *Gormenghast*. It is run by the Pennington-Mellor-Munthe Charity Trust and hosts tours during part of the year.

—

Southside House

3-4 Woodhayes Road, Wimbledon

London SW19 4RJ

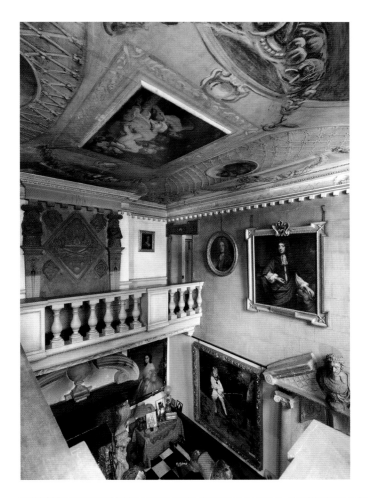

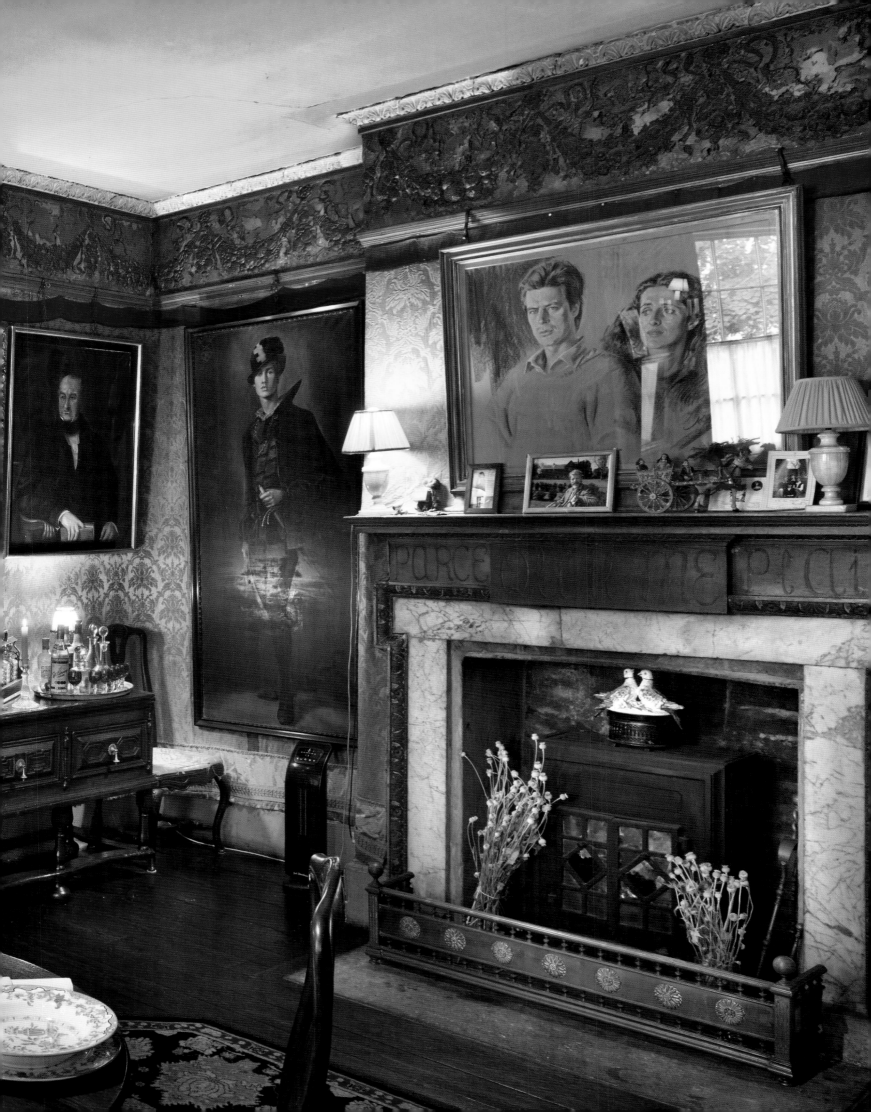

Bentley Priory Museum

Plainly described, Bentley Priory was the Royal Air Force headquarters for the air defence of the UK from 1936 until 2000. In history it occupies a legendary position as the place from where the Battle of Britain was won, which is the narrative of the museum in this restored eighteenth-century mansion.

It was once a modest villa on the site of an ancient Augustinian priory before being extensively reworked to the design of architect Sir John Soane from 1789 for the 1st Marquis of Abercorn. By 1853 the house and surrounding estate had been sold. The mansion served as a hotel and then housed a girls' school before being purchased by the Air Ministry in 1926.

Bentley Priory became headquarters of the newly formed RAF Fighter Command in July 1936, with its first Air Officer Commanding Air Chief Marshal, Sir Hugh Dowding. It was one of a cluster of key RAF stations on the western fringe of London: Uxbridge, Northolt, Hendon, Stanmore and later High Wycombe, Eastcote and Ruislip, only two of which were operational airfields.

The rooms and spaces of Bentley Priory Museum tell a story of the technology, organization and people behind the Hurricane and Spitfire fighter squadrons. The leading exhibit is the Filter Room, a recreation of the facility which was first assembled in Bentley Priory in 1937. It built on experimental work completed at a research site at Bawdsey on the Suffolk coast. While the tremendous potential of radar was being recognized and perfected, there was an equal need to develop a system to exploit the information provided by sensors.

As the first radars were coastal based and could only detect incoming aircraft over the sea, the eyes and ears of human observers inland needed to be linked to the detection and tracking system. Telecommunications were required to connect radar stations and observers to a Filter Room, where courses or

The exterior of the house, viewed from the Italian garden.

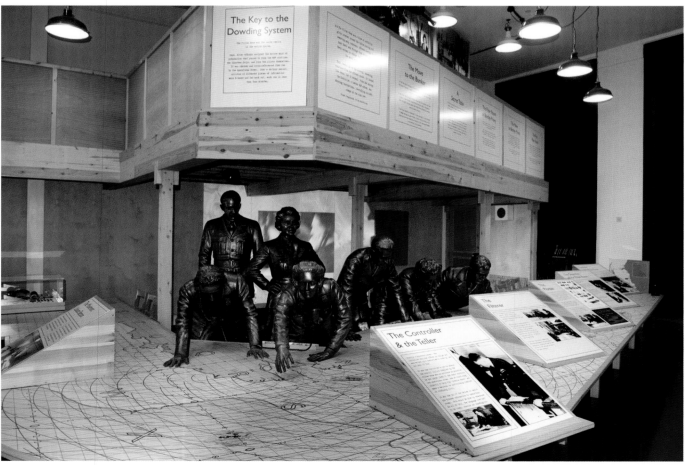

OPPOSITE *A Spitfire on the lawn in front of the museum (above); the Filter Room, where the movement liaison section on the balcony receive information on friendly aircraft movements, which are passed on to the controller (below).* ABOVE *The Hurricane window, commissioned in 1990, along with the Spitfire window directly opposite, to commemorate the 50th anniversary of the Battle of Britain and installed in 1991.*

'tracks' of attacking aircraft and friendly aircraft would need to be calculated and plotted on a master map. This information would be distributed to operations rooms and fighter stations and by radio to the Hurricanes and Spitfires.

Later known as the Dowding System, it encompassed the first Chain Home radars, connected by telephone to the operators at Bentley Priory, known as filterer, plotters (mostly Women's Auxiliary Air Force), controller and tellers, and then down to the simple counters and arrows on the map board. Together it represented the first integrated system of air defence anywhere in the world.

Dowding's office has been restored and developed into the backdrop for an audio-visual display, a film entitled *The One*

Behind the Few. From this office came his powerful letter dated 16 May 1940 warning that no more RAF fighter squadrons should be deployed to France, a message intended for Prime Minister Churchill. Over the following four months, the Battle of Britain was fought in the skies over southern England, with Bentley Priory the nerve centre of defence.

Most of its critical functions, including the Filter Room and Operations Room, were transferred into an underground bunker alongside the house in 1940. Later this was home to the planning headquarters for the Allied Expeditionary Air Force (AEAF), the air element of the invasion of Europe. On D-Day, the landings were monitored by King George VI, Winston Churchill and General Dwight D. Eisenhower in the AEAF war room.

There are places were the former life of Bentley Priory and the museum function merge. A domed rotunda close to the centre of the house is a signature feature of architect Soane, with domes much used in his masterpiece, the old Bank of England. Here it was created to display pictures and objects of virtue for the 1st Marquess of Abercorn. Now, it is covered with paintings and furnished with artefacts from medals to logbooks from the RAF collection. The painted sky ceiling in the ballroom, an authentic fashionable decoration in grand houses of the Georgian period, now includes condensation trails of aircraft at high altitude. Some of the original window openings are filled with modern stained glass depicting the Royal Observer Corps, aircraft and radar systems. Several Soane fireplaces survive.

One part of the house has been restored entirely in period, the room from an apartment for the Dowager Queen Adelaide, widow of King William IV, who lived here for a year before her death in 1849. She was visited here by Queen Victoria and Prince Albert.

Under the ownership of the 1st Marquis of Abercorn in the early 1800s, the house had been a social hub where Wellington and Pitt, Wordsworth and Sir Walter Scott were visitors. The building was already almost 130 years old when the RAF took it over and the changes imposed over time have been profound. The house was never attacked but was damaged by two fires. The RAF were in possession for eighty years until the final element left in 2008. It was headquarters of the Royal Observer Corps for much of that organization's period of existence. Fighter Command became Strike Command in 1968 and Bentley Priory's headquarters role for air defence continued before declining in the 1990s. The bunker, which was nuclear hardened in 1982, was filled in during 2010. RAF Bentley Priory was latterly home to the Defence Aviation Safety Centre, Air Historical Branch and RAF Ceremonial.

—

Bentley Priory Museum

Mansion House Drive

Stanmore HA7 3FB

Sir John Soane's spectacular Neoclassical rotunda, where the Battle of Britain's pilots' database can be accessed.

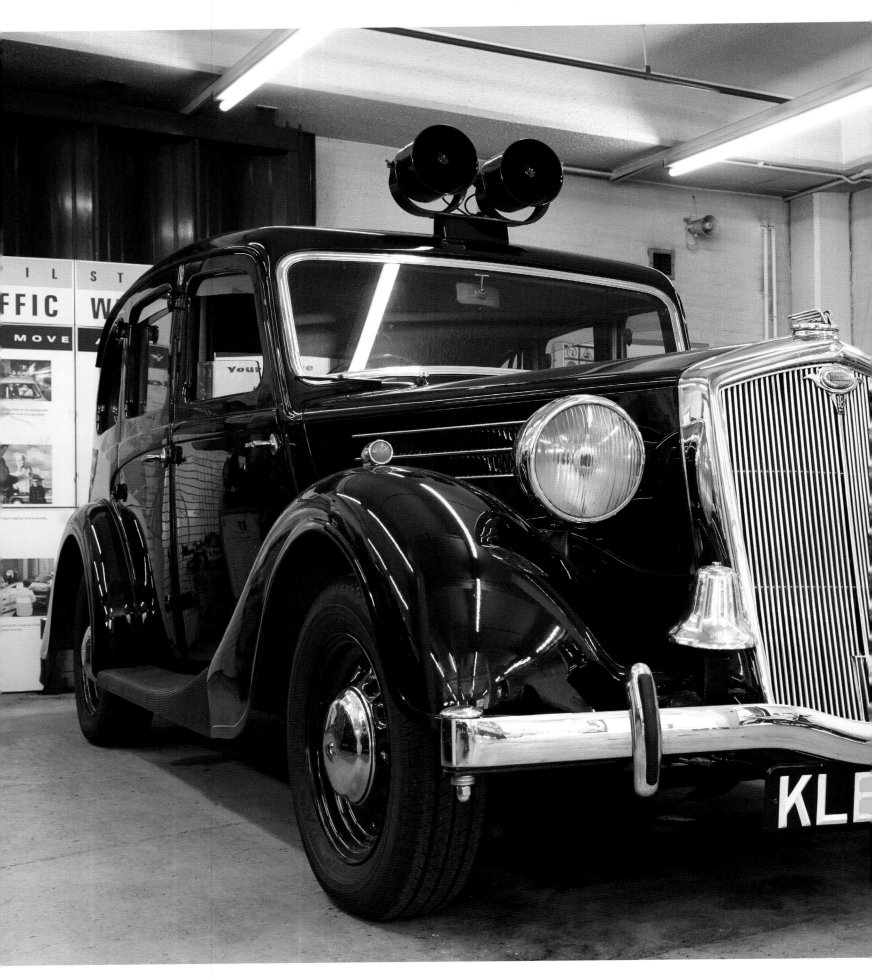

The Metropolitan Police Historic Vehicle Collection

Police cars at street level have long been part of London's shifting social-historical background, changing decade by decade. Old crime films depict black Wolseley saloons traversing the mean streetscape of post-war Soho, and later thrillers depict police Jaguars in pursuit of East End bad men, who are generally equipped with precisely the same kind of motor. More recent and memorable for some is the reality of sleek Rovers rushing to explosive or riotous incidents in the London of the 1970s and 1980s.

When the Metropolitan Police Historic Vehicle Collection moved in convoy from Hampton Court Traffic Garage to its current home at Hendon in 2014, there were reports that it caused other traffic in the vicinity to slow to a stop, with many drivers experiencing a double take as a fourteen-vehicle slice of history passed by in a kind of time warp. This collection now resides in the garage of the police operational and training centre at Hendon and it is not open to public view. However, its cars can be frequently seen when they are deployed on displays at 300 public events across the thirty-two boroughs of the Metropolitan Police district each year.

The oldest car in the collection is a Wolseley 18/85, dated 1948. With a top speed of 43 mph, it is unmistakeably a police vehicle, marked by the bell behind the bumper and colossal public address equipment on the roof. It is marked as a Wolseley because this was the only vehicle carrying an illuminated maker's badge on the grille, popularly known as the ghost light. The Metropolitan Police later went on to operate many 6/80, 6/99 and 6/110 models and wrongdoers had reason to fear the ghost light in their rear-view mirrors until the last police Wolseley was withdrawn in 1972.

Two particular cars are said to be regarded with a special warmth by the public whenever they are shown. These are the Morris Minor 1000 of 1969 and Austin 1100 Mk 3 from 1973, immediately recognizable as 'panda' cars. One of the mysteries

A Wolseley 18/85 dated 1948, the oldest car in the collection.

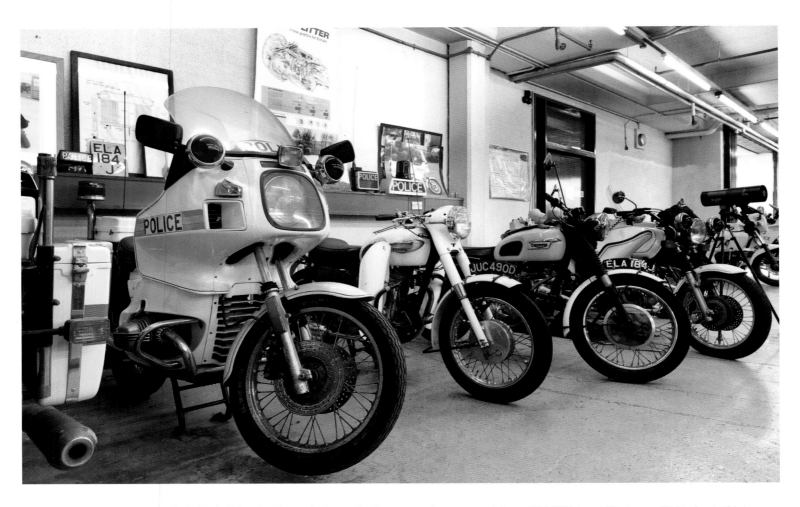

ABOVE *Long before the BMW R80/7 (left), the Triumph 650 was the favoured police motorcycle.* OPPOSITE *A Rover SD1 3500 from 1983, two roof lights denote this is a traffic car rather than area crime car, the classic law enforcement vehicle of its time (above); a Morris Minor 1000 of 1969 and Austin 1100, 1973, always known as panda cars despite blue-and-white livery, licence plates from the first cars officially purchased by the Metropolitan Police and two Wolseley wagonettes of 1903 (below).*

connected to them is how the name panda came to be applied to vehicles in blue and white livery. There are several theories, one of which is that the first pictures released of these cars were published in newspapers during the monochrome era and an assumption of a black-and-white scheme was made. Panda cars represent a concept properly known as unit beat policing, which was adopted by the Metropolitan Police in 1970. The idea was to extend the range of the foot patrol officer, who was also issued with some of the first handheld pocket radios and was still required to don helmet, walk and be a visible presence over a wider area. Any high-performance specification and special equipment were not required, except for a roof sign in the case of the 1000 and 1100. Generally, the lowest-specification, smallest-capacity vehicles fitted the bill. The concept of unit beat policing faded at the start of the 1980s, although nostalgia for the cuteness of the cars has prevailed.

A car that requires a second look to appreciate is a Corsica blue Rover P6 3500, dating from 1973, built for the Metropolitan Police Special Branch as a royalty and prime ministerial protection vehicle. The 2-tonne car is armoured on its floor, doors, bulkheads and transparencies. The contents of the boot are an enormous radio transceiver necessary for nationwide communications at that time, alongside the so-called Kojak lamp for slapping on the roof to show the true colours of this unmarked car in an emergency.

The Rover connection continues with an SD1 3500 traffic car from 1983, a classic law-enforcement vehicle of its time, and is completed by the Met's last Rover, an 827 V6 of 1995. Traffic cars are marked by twin blue roof lights; area crime cars have a single light.

Prince Charles' escort car, a Bentley Turbo R of 1998, operated by the Metropolitan Police Service's Royalty and Specialist Protection unit, was donated to the historic fleet in 2012 and was still stored at Hendon in 2019. Heavily armoured on the roof, floor and sides and with thick armoured glass, the interior is far less spacious than any other Bentley. It is said that this vehicle would never be sold; a possible fate is that it will one day be experimentally tested to destruction on a firing range.

On two wheels, a range of twin-cylinder Triumphs, a Velocette LE and other bikes up to the BMW R80/7 complete the collection.

—

The Metropolitan Police Historic Vehicle Collection

Peel Centre, Aerodrome Road, London NW9 5JE

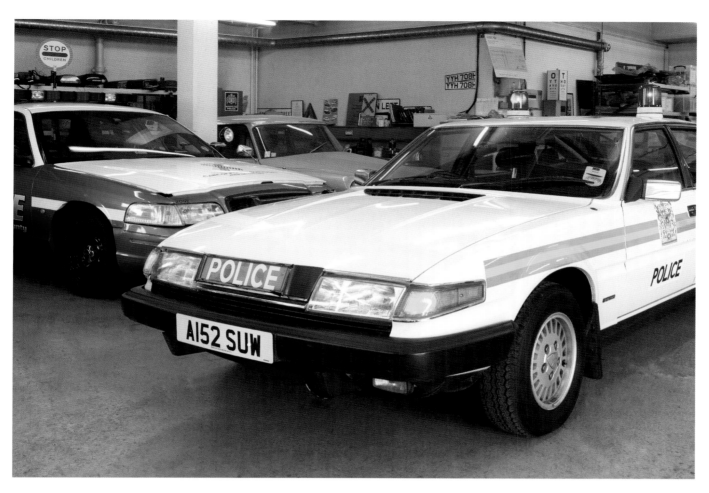

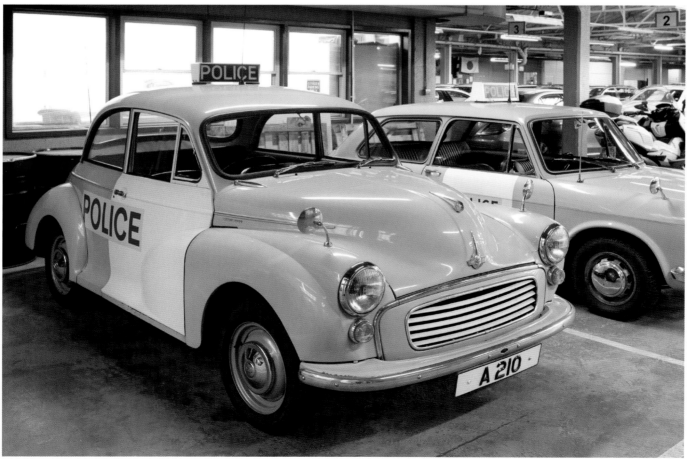

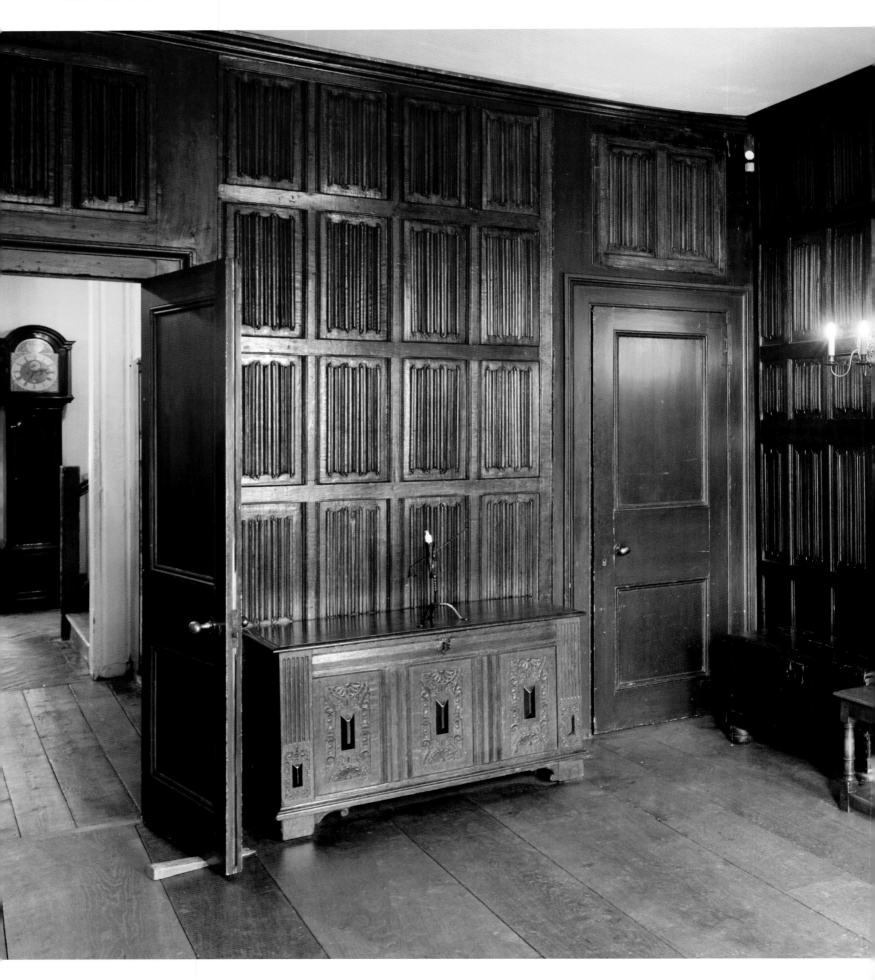

Sutton House

Sutton House in Hackney is one of London's oldest houses, and a National Trust guide has claimed it to be the oldest domestic building in the East End. That is partly a product of geographical and historical definition, as relatively few London houses survive from before 1666 and rural Hackney village came slowly into the embrace of the city after the Great Fire. When the process of urban absorption was complete by around 1870, Sutton House was already almost 340 years old. Dendrochronology, the science of wood dating, places the years of its construction as 1534–5.

The house was built for a Tudor courtier, Ralph Sadleir, who worked closely with the statesman Thomas Cromwell, serving as his secretary. Cromwell had been gifted one hundred oak trees from the royal forest at Enfield by King Henry VIII and some of these may have been used in construction of the house. However, it was the use of brick as the principal material that was unusual, found only in the grandest houses of the time, when wattle and daub construction around a timber frame prevailed; its original name, Bryk Place, reflected its notable status. It was not a palace, but a substantial three-storey house built on an H ground plan with two wings joined by a central hall. One of the outstanding rooms was the linenfold parlour, the name describing the resemblance of the carved oak panelling to gathered fabric. On the top floor were rooms for servants, under the wings two cellars for storing ale and wine and, in between, a great chamber and great hall, also finely panelled.

Sadleir rose swiftly, gaining a knighthood and becoming principal secretary to King Henry himself, and by 1546 had built a grander mansion in Hertfordshire. Bryk Place was sold to a wool merchant, then to a silk merchant, and it was leased to become a girls' school between 1657 and 1741. At this point, the house came into the possession of a builder, who updated it with larger sash

Rare oak-panelling in the linenfold parlour.

ABOVE *The Tudor kitchen (left) and the cellar (centre).*

windows replacing the vertically barred mullions, with many of the Tudor features covered. Its next occupiers were of Huguenot descent, when French Protestant merchants came to England to escape persecution and typically settled in places on the north-eastern side of London. The house was much altered and divided into two self-contained residences, known as Milford House and Picton House, with one side occupied by a solicitor who was Hackney's chief clerk and the other part becoming a school again.

In the late nineteenth century, the house was influenced by change as the village merged into London and became more occupied with workshops and factories. As the more prosperous families moved outwards, many larger houses were further divided and multi-occupied, some becoming industrial places.

Against the trend, Milford House and Picton House were reunited under the possession of the rector of St John at Hackney as the St John's Institute, a social and recreation centre, but by this time the building was in a state of disrepair, having lost some of its outbuildings and gardens. After an appeal, the St John's Institute was re-opened with a grand ceremony in 1904, with some of the Tudor features restored, including the panelling and two fireplaces, and with a new annexe called the Wenlock Barn in Arts and Crafts style in the courtyard behind.

When the church relinquished the Institute, it came into the possession of the National Trust. It was not opened to the public but leased to organizations, including charities and public services. Surviving the Blitz undamaged, it become the headquarters of

ABOVE *The entrance to one of London's last remaining Tudor houses, Sutton House, which was originally built in 1535 by Sir Ralph Sadleir, Secretary of State to Henry VIII, as his family home.*

Hackney Social Services until the tenancy passed to the trade union, which stayed until 1982. It had continued to be called the Institute until 1953 when it was mistakenly named Sutton House in the belief that it was once the home of Thomas Sutton, a wealthy Hackney-based businessman who had founded Charterhouse Hospital and School in the 1600s; this ownership was disproved by subsequent research but the name has remained.

The house continued to mirror the changing character of Hackney, which by the 1980s was a cosmopolitan inner-city suburb with little industry and a distinctly alternative subculture developing at street level. After the union left, the National Trust struggled to find tenants, and the house was occupied by squatters and became known as the Blue House, a home for some, and also a social centre. The barn was a music venue for a few years. A car breaker's yard squeezed alongside in a garden. When the squatters were evicted, thieves and vandals came to steal the panelling and fireplaces, which were recovered. A group of Hackney residents formed the Sutton House Society, which worked with the National Trust to restore the house. It was opened by the National Trust in 1994 as a house-museum and a focus for cultural and social events. All its archetypal timeline has been celebrated, from Tudor to punk. There is a restored squatter's bedroom in the attic, with a graffiti mural, and the space where the breaker's yard operated is now a garden.

—

Sutton House, Homerton High Street, London E9 6JQ

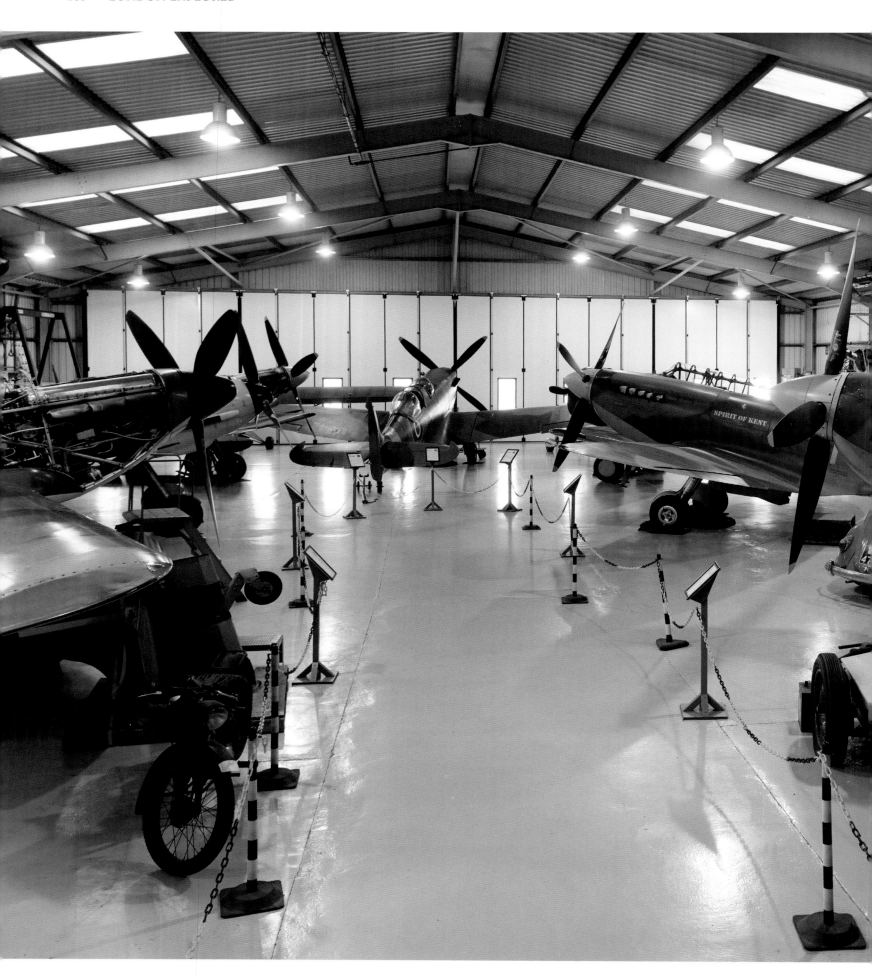

Biggin Hill Heritage Hangar

Biggin Hill is an evocative place name that has great significance for London. It was home to the RAF fighter station that stood on the front line of defence of the capital during the Battle of Britain in 1940. Biggin Hill airfield lies high on the North Downs overlooking the Weald of Kent, with London spread out beyond. As the pivotal station defending against aircraft attacking from across the Channel, it was home to No. 11 Group C Sector Headquarters Fighter Command, and it has an enduring connection with the classic Vickers Supermarine Spitfire fighter.

Now a commercial airport specializing in business jet and private flying, it is home to the Biggin Hill Heritage Hangar, housing a fleet of airworthy Spitfires. The operators of the Heritage Hangar say that 'there is nowhere else in the world that you can see a squadron's worth of Spitfires up close all year round'. It claims to have the greatest concentration of Spitfires in the world. Most visitors opt for a hangar tour, although for those with a fair sum of money to spend there is a thrilling alternative – the opportunity to fly as a passenger in a genuine Rolls-Royce Merlin-powered Spitfire. Taking off in the classic fighter from arguably the world's most illustrious fighter base makes authentic connections.

First at Biggin Hill with Spitfires was No. 610 Squadron, in July 1940, and five more Spitfire squadrons and Hurricane fighters flew from the station during 1940. It was right in the thick of the Battle of Britain and they were badly damaged in a series of attacks, heavily bombed in six raids over three days as the battle approached the decisive phase. The airfield was almost put out of operation, but the fighters continued to operate. The following year it went on to mount offensive operations over occupied Europe. In 1943, a corner of the veil of secrecy generally applied to RAF bases in wartime was lifted to announce that 1,000 enemy

Four Spitfires, a yellow-nosed Messerschimdt and a Harvard in the operational bay of the Heritage Hangar.

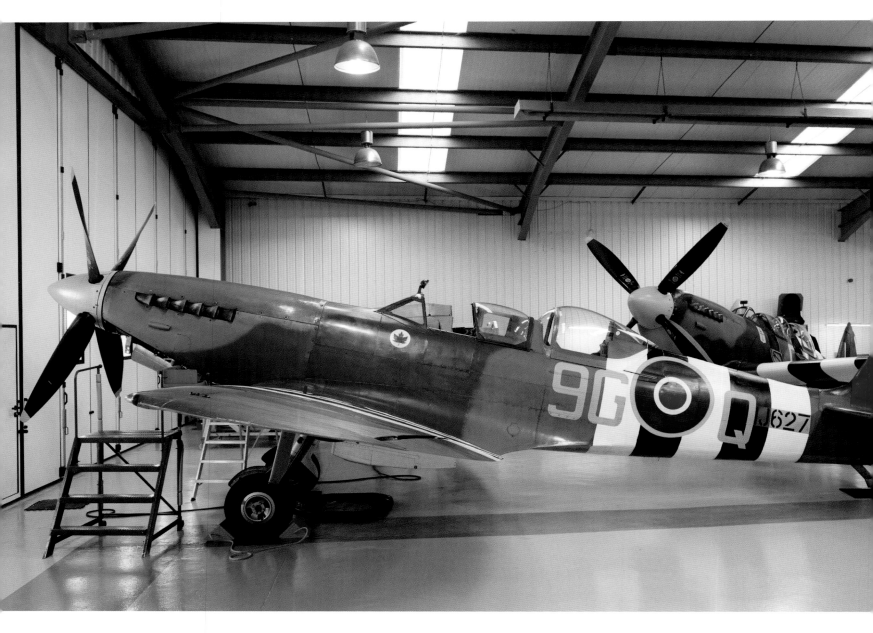

Spitfire two-seater MJ627, once a fighter and later converted to a trainer, available for passenger flights.

aircraft had been shot down by fighters based at the station, a rare disclosure that started to establish Biggin Hill's reputation in national awareness. Spitfires continued to fly from Biggin Hill throughout the war and beyond. During the 1950s, the RAF's piston-engine fighters quickly succumbed to scrap. In 1957, three late-type Griffon-engine Spitfires and a single Hurricane were briefly collected together at Biggin Hill for ceremonial purposes to become what was known as the Historic Aircraft Flight, but these were soon moved away to other stations. The RAF remained but ceased flying operations on the airfield in 1959.

At that time, flyable Spitfires were nearing extinction, with the RAF barely holding on to its ceremonial examples. The last Spitfires in operational military use anywhere were found in

Ireland, with the Irish Air Corps, which flew six of the two-seat Mk T9, a rare variant converted for training. The last of these was withdrawn in 1961. A large-scale rehabilitation to airworthiness of Spitfires came for the 1969 feature film *Battle of Britain,* including the two former Irish aircraft, which are now based at the Biggin Hill Heritage Hangar. From 2015, the relaxing of certain Civil Aviation Authority rules allowed the public to fly as passengers in these two-seater Spitfires.

The firm operating all this was founded first as the Spitfire Company Limited at Biggin Hill in 2011 by Peter Monk, a former airline pilot, as an engineering organization. It was then dedicated to restoring a single Spitfire. Over time it moved across the airfield to a large hangar on the western side and took on the

Now undergoing a comprehensive restoration with its fuselage in the jig and wings detached, Spitfire MJ755 last flew in 1953.

restoration of further aircraft. One hangar bay keeps mainly the airworthy aeroplanes and the neighbouring side and adjoining workshop is dedicated to restorations and maintenance. A visitor can expect to see between ten and thirteen Spitfires, constantly changing, either airworthy or undergoing restoration. Alongside, in 2019, was a single Hurricane, a Harvard, a Piper Cub and, exceptionally, a Messerschmitt Bf 109 housed as a guest. For the enthusiast, the opportunity to see secrets of the Spitfire exposed close up is unique. There is the chance to examine the signature elliptical wing shape, while understanding that the thinness and hollow-ground section of the wing enabled the true magic of the Spitfire's high performance. Classic aircraft are stripped back to major assemblies and held in jigs, with wings detached from

fuselage, all described by a knowledgeable guide. Photography is not restricted. All the Spitfires in the Heritage Hangar are Merlin-engine aircraft; later Griffon-engine types are expected to follow.

Hangar tours for small groups are available on weekdays and Saturdays. Those that wish to take the opportunity can also sit in a Spitfire for an additional charge.

—

Biggin Hill Heritage Hangar

Building 204, Churchill Way

Biggin Hill Airport

Westerham TN16 3BN

Pope's Grotto

Alexander Pope, eighteenth-century poet, essayist, satirist, translator and pioneering garden designer, created a mysterious encrusted grotto, which survives under the site of his long-demolished house in Twickenham. Today a school stands above the grotto, which is not open for casual visiting but can be explored on certain scheduled days.

Pope came to Twickenham in 1719. Made prosperous by rewards from his translation of Homer's *Iliad*, he was able to build a substantial three-storey house facing the Thames. Across a roadway, he rented several acres of land to create an early landscaped garden. House and garden were linked by a tunnel he commissioned, which remains under the A310 road to Richmond. By 1725, a grotto had been created in the brick basement of the house, forming the entrance of the tunnel. Pope had embellishments added until his death in 1744. Flints, quartz, shells, ammonite, coral, a slab of basalt taken from the Giant's Causeway in Ireland all line the walls. There are glass pieces, minerals, ceramics and religious and secular imagery. Remains of rustic arcades and columns can be glimpsed and there were once mirrors and a lens working as a camera obscura to illuminate the vaults.

Pope is recognized as a master of rhyming couplets in iambic pentameters. His most famous work is *The Rape of the Lock* and his poetry is most widely recognized in proverbs. 'Fools rush in where angels fear to tread', 'A little learning is a dangerous thing' and 'To err is human, to forgive divine' all come from one poem, *An Essay on Criticism*. The notion 'eternal sunshine of the spotless mind' belongs to Pope.

The sheer curiosity of the grotto is made stranger by the challenge of understanding its inspiration, partly lost across time. Pope may have seen grottoes in travels to Italy or, if not, was aware of decorated chambers through his aesthetic interests stemming from ancient Rome. Pope described later additions to the grotto as forming a museum of mining and geology. A further complication is that some statuary was added after Pope's death by the subsequent owner. Extensive study is needed to uncover the true context for the creation of the chambers. A symposium exploring the links between the grotto, garden design and eighteenth-century literature has been hosted by the Pope's Grotto Preservation Trust, the group responsible for its continuing restoration and for the scheduling of open days.

Pope's Grotto, Radnor House Independent School, 21 Cross Deep, Twickenham TW1 4QG

This statue of unknown origin is one of the grotto's several enigmas, possibly the Roman goddess Pudicitia, representing chastity and modesty.

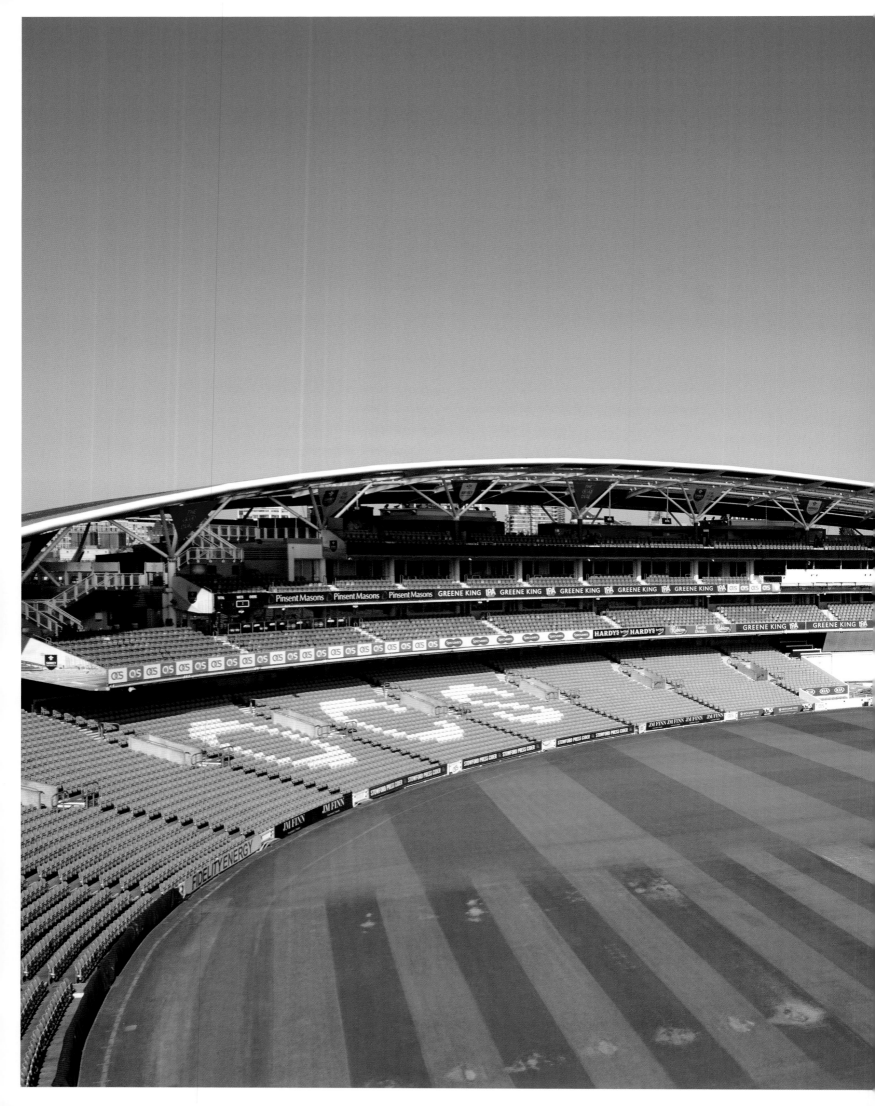

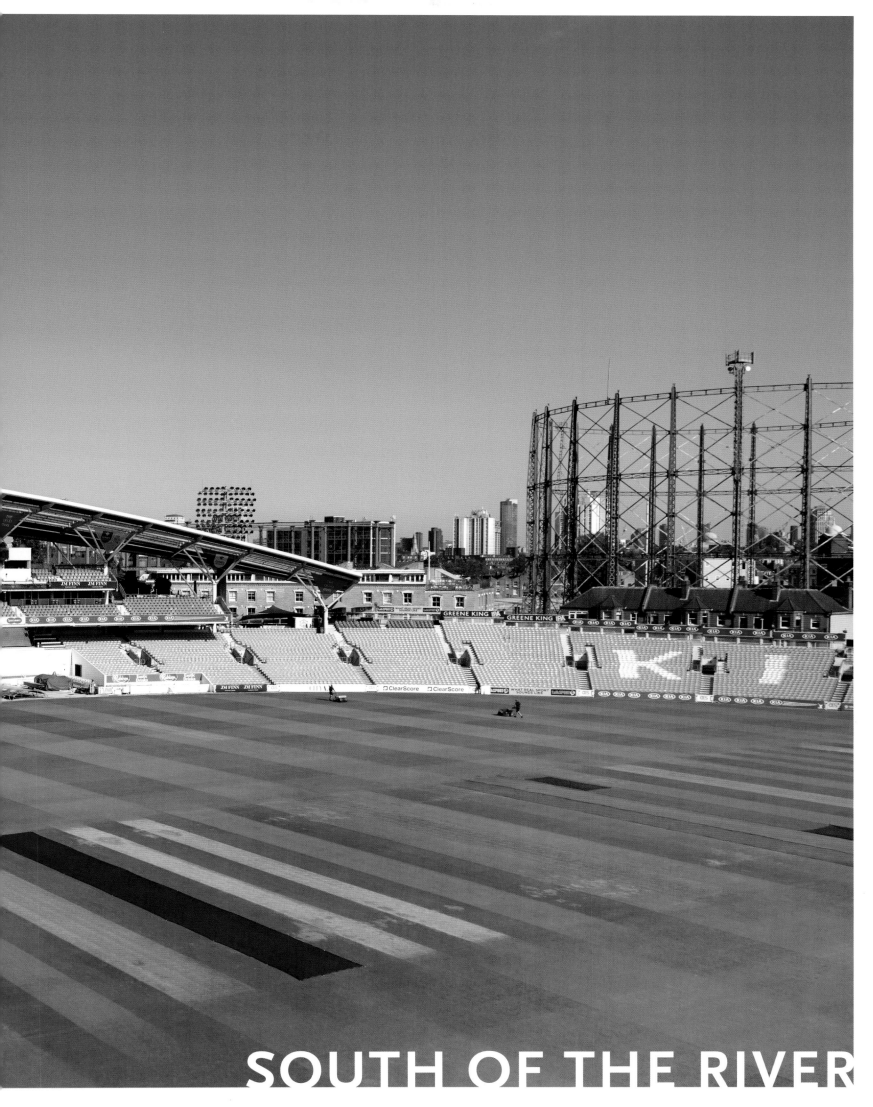

SOUTH OF THE RIVER

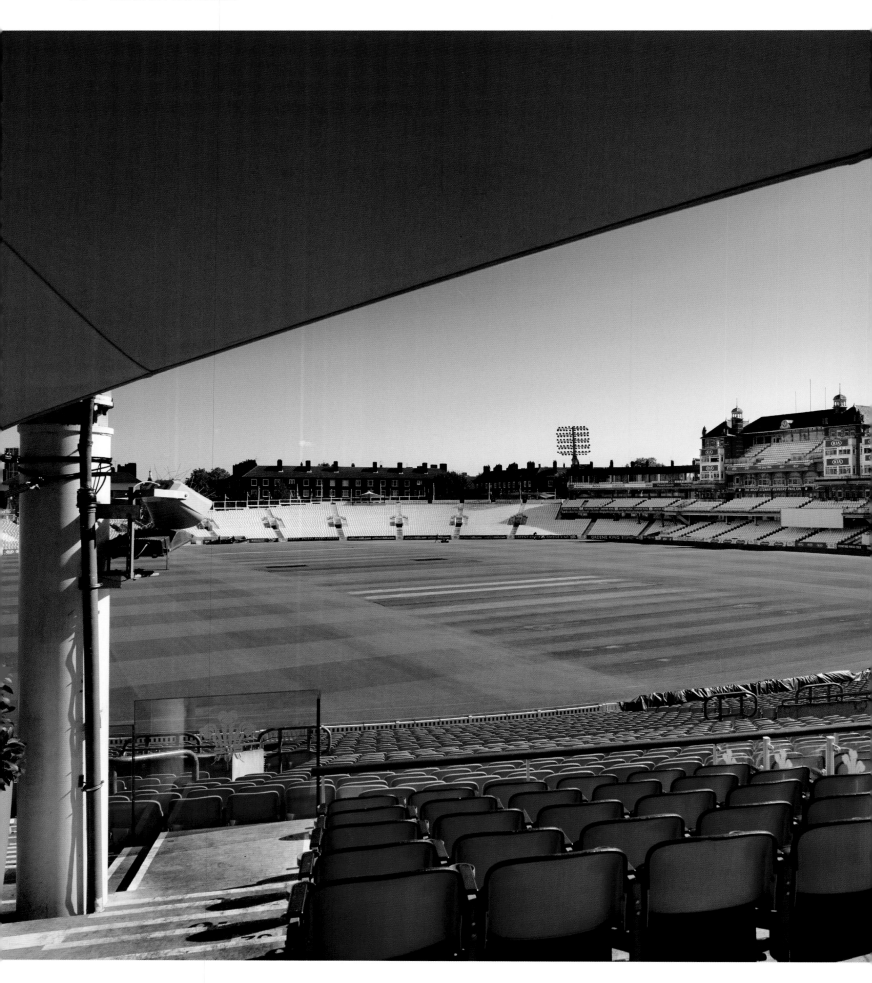

The Kia Oval

Many visitors to this historic ground approach from the Oval tube station and enter through the tall black gates which are a reminder that this is both a test match venue and the home of Surrey County Cricket Club (Surrey CCC).

The gate posts are topped with urns, commemorating the 'death of English cricket' when England was defeated by Australia in a test match played here in August 1882, the first time England had lost at home. These are the Hobbs Gates, which commemorate the great Surrey batsman, Sir John Hobbs, better known as Jack Hobbs, who scored more than 60,000 runs and 199 first-class centuries in first-class cricket, more than any other cricketer of any era.

Beyond the gates is the impressive Micky Stewart Members' Pavilion. This imposing structure also incorporates the urn design as well as giant pictures of Surrey greats – in 2020, it was Surrey and England opener Rory Burns and Surrey Women and England all-rounder Natalie Sciver.

The Oval is loaded with references to Surrey CCC players of today and of the past. Micky Stewart is a Surrey legend, as is his son, Alec, both gifted batsmen who played many tests for England as well as their county. The ground's stands and gates bear the names of other Surrey legends – such as the Bedser Stand, the Peter May Stand and the John Edrich Gate.

Also much in evidence around the ground are the Prince of Wales Feathers, important because the land is owned by the Duchy of Cornwall and the connection with the business remains close. The Feathers form part of the Surrey CCC badge. The land was originally occupied by a market garden enclosed by an oval roadway, the same footprint that exists today.

Large panels on the inner wall on one side of the ground commemorate Surrey CCC player records and County Championship wins; the county's heyday was in the 1950s when

A view of the Pavilion from the stands.

The bell was acquired from the decommissioned aircraft carrier HMS Illustrious. *The bell is rung five minutes before the start of play on each day of a test match.*

it won seven consecutive county titles between 1952 and 1958, but it first won the County Championship back in 1890 and the Oval has been home to Surrey CCC since 1845.

The playing surface was believed to be the largest in England until the Rose Bowl replaced Hampshire's old County Ground in 2001. At the other end of the ground from the Pavilion is the OCS Stand, renamed the 1845 Stand in 2019, a much newer design.

For years its capacity was a little over 25,000, increasing to 28,000 in the 2020s. The One Oval Square development will see the Members' Pavilion extended and more space introduced above the Peter May Stand.

The Oval is unique in many ways. As well as its cricket history – it was the first ground in England to hold an international cricket match, for example (in 1880, versus Australia) – there is no other ground that has also hosted an FA Cup final. This was the first ever FA Cup final, played there in 1872. It can also claim the first international Rugby Union match to be held in England, played between England and Scotland in the same year.

That breadth of sporting coverage was largely the result of efforts by Charles Alcock, the first paid secretary of SCCC and a founding father of the Football Association. As well as having a room in the Pavilion named after him, there are more pictures of Alcock in the ground than of anyone else.

Also in the Pavilion is the Oval's Long Room, perhaps not as famous as its Lord's equivalent, and certainly without the formal dress code, but steeped in history. It dates from 1898.

The famous Long Room in the Pavilion, which dates from 1898.

A feature of the Kia Oval well known to any Surrey CCC member is its museum. As well as numerous bats, gloves and artefacts, autographed by leading cricketers who have played at the ground over the years, there are rare exhibits including the 'Chitty Bat', thought to be the first-ever cricket bat, a chain that was used to mark out the 22-yard wicket and an extensive cricketing library that includes two rare full sets of the *Wisden Cricketer's Almanack*, the Bible of cricket.

Another idiosyncrasy is the bell from the former Royal Navy aircraft carrier HMS *Illustrious*, which was put in place in late 2019 and is used to give the five-minute warning before play.

Finally, around the ground are scenes to which the TV cameras frequently pan when looking for context to their Oval coverage.

The famous gas holder (gasometer) just outside the Oval, originally one of six, is a familiar sight to any Surrey or England cricket fan. It has been scheduled to be taken down to allow houses to be built but, because it is Grade II listed, it will then be rebuilt around the newly constructed housing development.

—

The Kia Oval
Surrey County Cricket Club
Kennington
London SE11 5SS

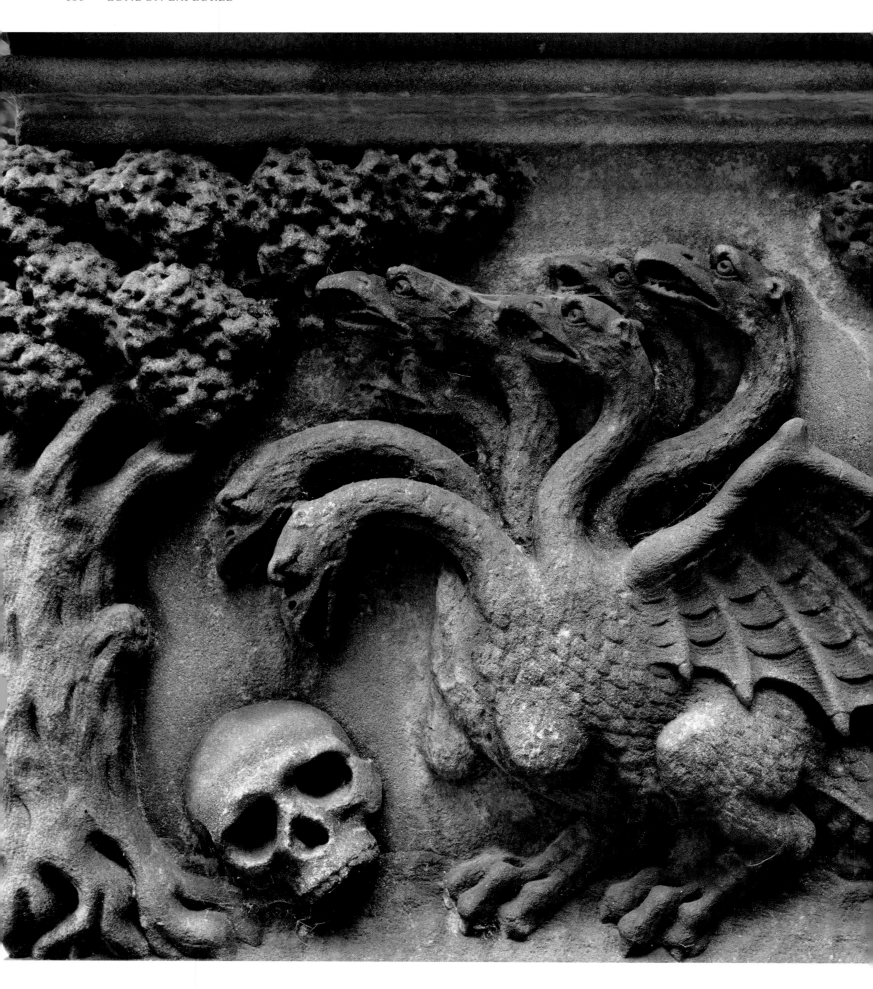

Garden Museum & Lambeth Palace

Two fascinating and contrasting church buildings are found close together by the river at Lambeth. One is the most important religious building in the capital south of the Thames, Lambeth Palace, which serves as the London residence of the Archbishop of Canterbury. By the gatehouse, just outside its walls, lies the church of St Mary, the former parish church of Lambeth, long deconsecrated and home to the Garden Museum.

In the precincts of Lambeth Palace is the library, which was once the Great Hall. It was ransacked and its timbers plundered for building materials by Cromwellian soldiers during the English Civil War. Rebuilt after the Restoration in 1663, the hall was fitted with a gothic hammerbeam roof long after that style of open-timber construction had passed. This caused Samuel Pepys to describe it as the 'new old-fashioned' hall, although some of its decorative features carved in the woodwork and stonework are classical. It became the Lambeth Palace Library in 1829 and is the principal repository of the documentary history of the Church of England, housing just a part of a collection of 200,000 books, including 30,000 printed before 1700. Manuscripts include papers relating to the divorce of King Henry VIII and Catherine of Aragon and the execution warrant for Mary, Queen of Scots. Its collections have been freely available for research since 1610. Each year the library is used by over 2,000 scholars, historians and ecclesiastical students.

The oldest parts of Lambeth Palace are the chapel and the crypt dating from 1220, Lollards' Tower from 1435 and Morton's Tower, the castellated gatehouse unchanged since it was completed in 1486. The most modern part is a new purpose-built eight-storey library and repository, completed at the far end of the palace gardens with an entrance on Lambeth Palace Road, scheduled

The skull and the seven-headed monster carved on the great stone tomb, the resting place of members of the Tradescant family, one of the most important churchyard monuments in London, a masterpiece of funerary architecture and Grade II listed.

This plaque commemorates John and Rosemary Nicholson
who founded this museum in 1977

to open in the 2020s. While the library has always been open to researchers, Lambeth Palace is not open to visitors on a daily basis, although guided tours are sometimes available by booking.

The birth of the Garden Museum at Lambeth and the repurposing of the old church of St Mary can be traced precisely to a convergence of events in 1976. John and Rosemary Nicholson, gardening enthusiasts, with no official responsibilities, were researching two seventeenth-century royal gardeners and plant-hunters, John Tradescant the Elder and the Younger, and traced their graves to the derelict St Mary's churchyard. Rosemary Nicholson later attended a function at Lambeth Palace at which the Archbishop of Canterbury at that time, Donald Coggan, told her that the church she had visited was scheduled for demolition. When she expressed her dismay, Archbishop Coggan suggested that she might try to get the decision reversed, if she could think of some purpose for the site. The Nicholsons appealed to the church commissioners to delay demolition of St Mary's and mounted a campaign to turn the church and churchyard into the Museum of Garden History.

In 1977, the Tradescant Trust was formed and Rosemary Nicholson recruited volunteers and raised funds. The Queen Mother was an early supporter and Prince Charles became its patron. By 1980, funds had been raised to provide a roof for the church and clear the overgrown churchyard. Close to the Tradescant family tomb was found the grave of Captain William Bligh, who had been working for the Royal Botanic Gardens at Kew to gather breadfruit plants from Tahiti during his voyage on the HMS *Bounty* when the mutiny occurred.

By 1981, the museum was fully open with the church building filled with papers, tools and artefacts ranging from lawnmowers to garden designer Gertrude Jekyll's desk. In the churchyard was a reproduction seventeenth-century knot garden with a planting scheme only having species that were known to the Tradescants. In 2008, it was renamed the Garden Museum and it was extended and redeveloped between 2015 and 2017 with a café and a new garden formed around the tombs.

In a museum and garden packed with interest, the Tradescant tomb stands out, noteworthy for its enigmatic embellishment,

The tomb of Captain William Bligh of the Bounty, *buried here 15 December 1817, has become a central feature of the Garden Museum.*

which is said to represent the life and work of the men. The two John Tradescants, father and son, lived close by and as gardeners they both worked for King Charles I and introduced many new exotic species. Between them they visited Russia, the Levant and Algiers and the new colony of Virginia, bringing to England the yucca, Michaelmas daisies and Virginia creeper. They were also collectors of strange objects: a mermaid's hand, a mummy's hand, a sliver of wood from the true cross, all of which were eventually given to the collection which became the Ashmolean. Their tomb is marked with allegorical scenes of ancient ruins and, on one panel, a ferocious multi-headed hydra overlooking part of a skull. The meaning of this has yet to be explained.

—

Garden Museum

5 Lambeth Palace Road

London SE1 7LB

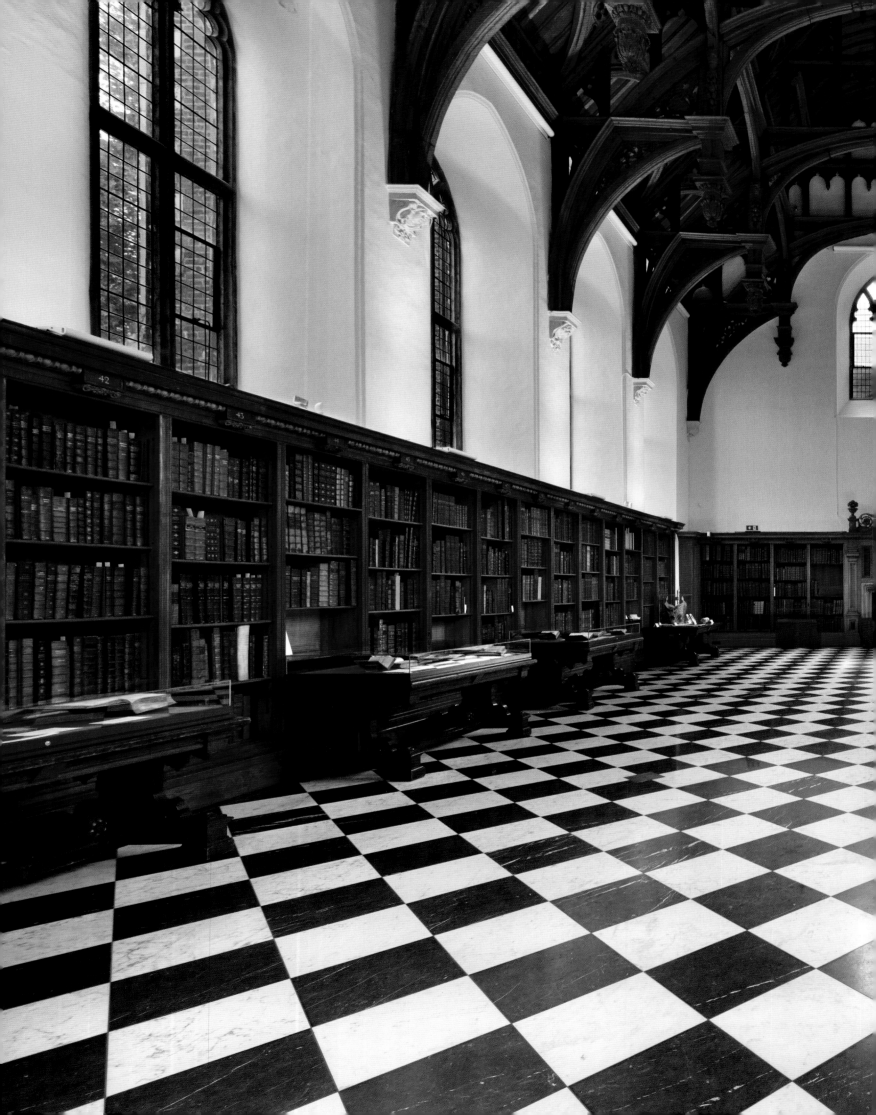

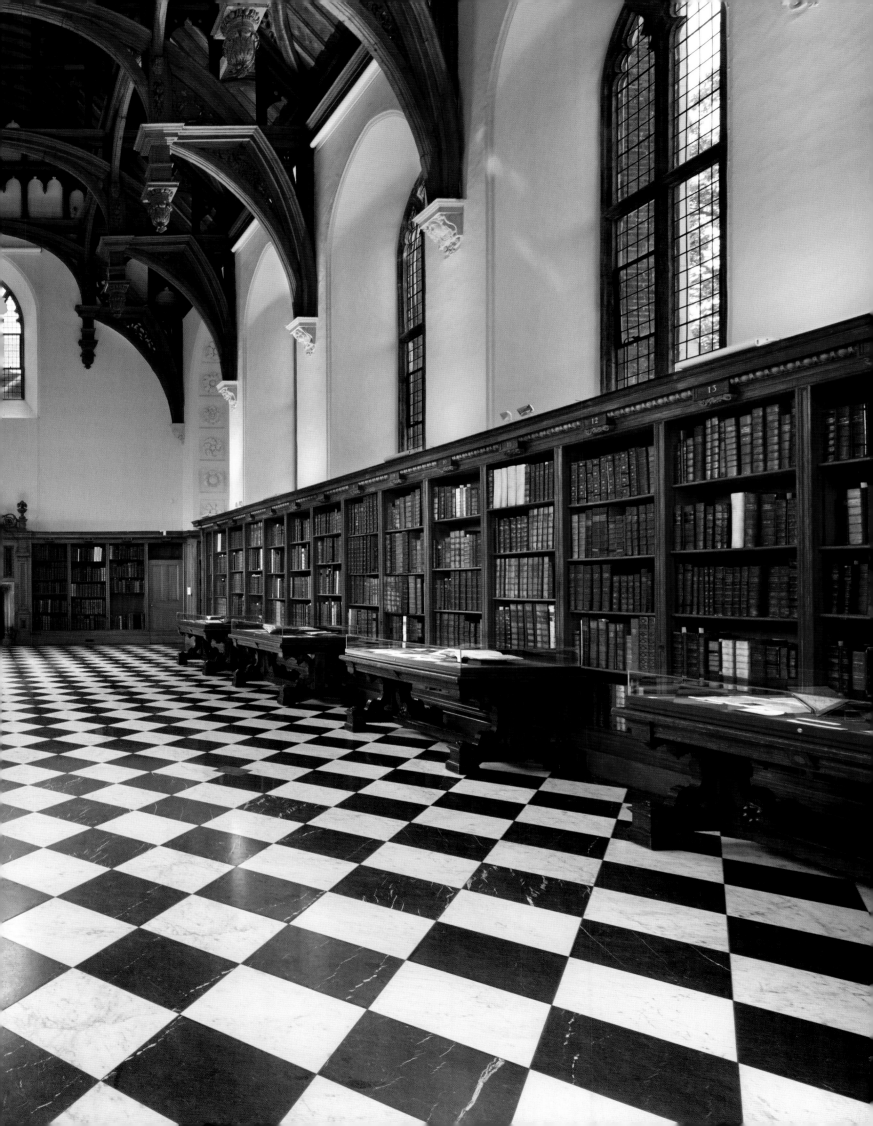

OXO Tower

Advertising has always been powered by applied craftiness and the OXO Tower on the South Bank is craftiness made concrete.

Many London buildings in late Victorian times had been smothered with chaotic advertising signage, including so-called sky signs at roof-top level. Such sky signs were quickly regulated by London County Council and legislated out of existence. In the mid-1920s, Lemco, which produced the OXO cube, was aiming to convert a building on Stamford Wharf in Southwark into a meat processing plant and cold store. Legend goes that the first plan, which included an illuminated advertising sign at high level, was rejected by the LCC, and the company was obliged to rethink.

OXO was always promoted by pioneering ideas, ranging from clever packaging, gift rewards for product loyalty and even 1908 London Olympic Games sponsorship. During the First World War, 100 million OXO cubes were supplied to the armed forces, a fact underlined with advertising. OXO branding was powerful and imaginative and the transformed building that emerged in 1929 included a high concrete tower. Its architect, Albert W. Moore, said his design incorporated windows in 'an elemental geometric form' on all four sides of the tower. When illuminated, the windows spelled OXO, but being integrated with the structure this could not be classified as advertising.

Inside, it is clear that the tower could never claim any dual function, such as chimney or cooling stack; it was designed just to deliver a statement. There are five levels of ascending square spaces circled by spiral staircases. The windows start on the third level and continue to level five, which has a door leading to a parapet and walkway. Above is a cupola and spire. Below is the main building, which the company adapted as a meat-packing warehouse. It was built as the Post Office Central Power Station around 1900, generating electricity exclusively for the Royal Mail. The new owners adapted the former power station while extending its riverside frontage. Meat processing and cold storage continued, declining in the 1960s and ending in 1979. Local group Coin Street Community Builders rescued the tower and warehouse when it was under threat of demolition. Extensively rebuilt, the place is known as Oxo Tower Wharf and it houses co-operative homes, design studios, shops, galleries, restaurants, cafés and bars.

—

OXO Tower Wharf, Barge House Street, South Bank, London SE1 9PH

The interior of the famous Oxo Tower, on the South Bank of the Thames.

London Glassblowing

For explorers of the lively streets close to London Bridge station, this place can be a fascinating chance discovery; for people who admire glass as a creative medium, Bermondsey Street is an essential destination. London Glassblowing is the studio-gallery established by Peter Layton, the British master of the art form known as studio glass, the advanced glassblowing craft which he has taken into a painterly realm.

The glass-fronted exhibition space occupies the front of the building; directly behind is the hot shop, which houses the furnaces and the workbenches, all of which are visible to visitors. London Glassblowing at any time is home for ten or more resident designer-maker artists or student assistants who produce much of the work flowing from the studio. Some works are shaped as vessels and containers, while other pieces are representational; some are abstract or installations. The shapes and colours of Peter Layton's work has sometimes been inspired by the qualities of paintings by great artists including Miró, Picasso and Monet.

All works from the studio by resident or visiting artists employ glass that has been shaped by blowing and other techniques. It is claimed to be the only public-access glassblowing studio in London. Founder Peter Layton, born in 1937, remains the main creative force and guiding hand, and his influence can be traced back almost to the start of the studio glass movement.

Peter Layton began his creative career as a potter with a diploma from the London Central School of Art and Design. As a visiting lecturer in ceramics to the US, he was influenced by the way Professor Harvey Littleton had pioneered the use of small furnaces to readily work glass in a way that an artist might use clay. He enrolled in an early glassblowing workshop at the University of Iowa as the US studio glass movement began to

The gallery featuring pieces from Peter Layton's exhibition Homage: Reflections On My Heroes.

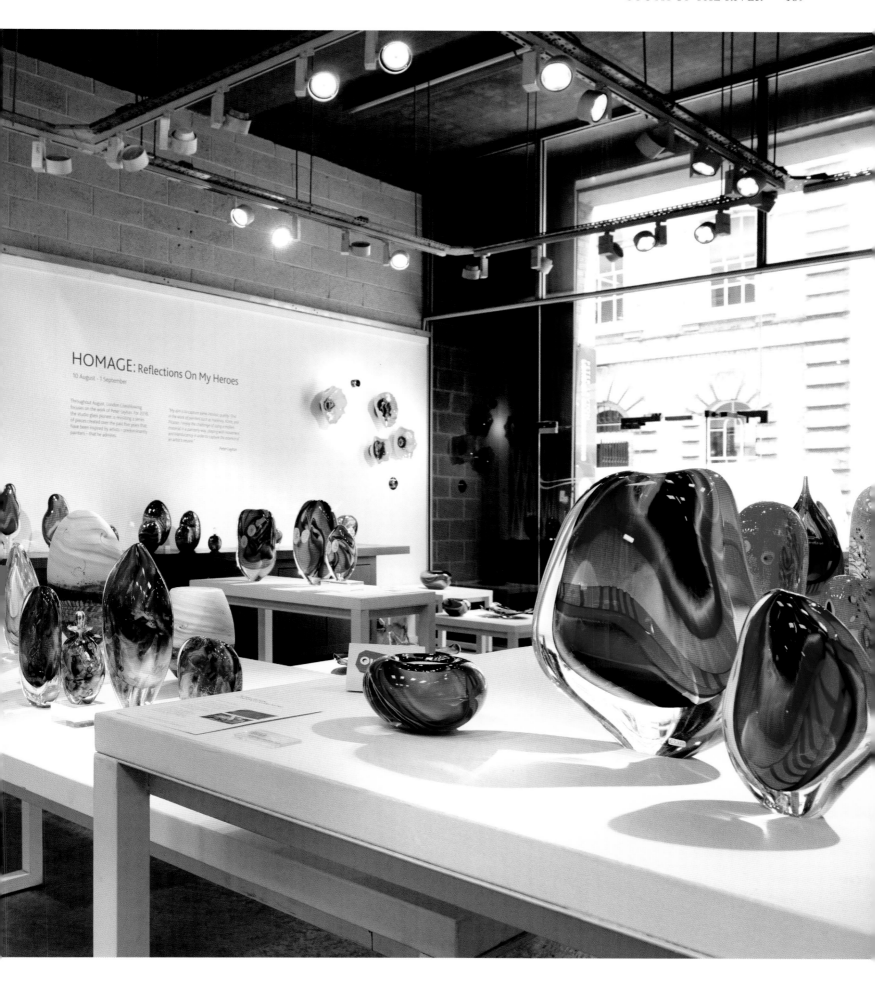

HOMAGE: Reflections On My Heroes

10 August - 1 September

Throughout August, London Glassblowing focuses on the work of Peter Layton. For 2018, the studio glass pioneer is revisiting a series of pieces created over the past five years that have been inspired by artists – predominantly painters – that he admires.

"My aim is to capture some intrinsic quality that is in the work of painters such as Matisse, Klimt, and Picasso. I enjoy the challenge of using a molten material in a painterly way, playing with movement and texture using oil oxides to capture the essence of an artist's oeuvre."

Peter Layton

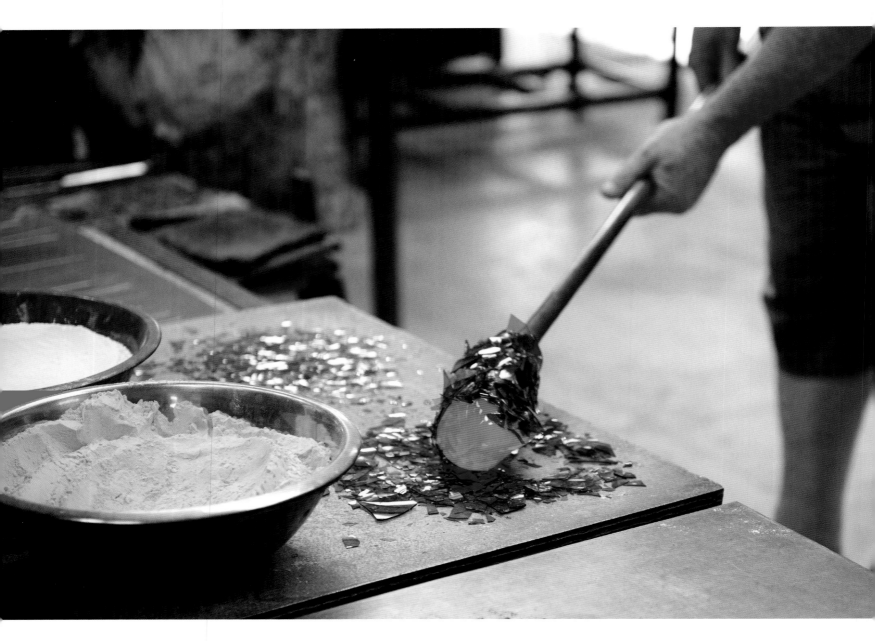

Resident artist Bruce Marks making Peter Layton's Highgrove series, which is inspired by the Royal Gardens at Highgrove.

develop. Returning to the Britain and continuing to both teach and make, he was increasingly drawn to working in glass rather than ceramics. In 1976, he set up a glassblowing workshop by the river at Hope Wharf, Rotherhithe, in a former tug operator's building. One of the principles of the operation was the sharing of space and the sharing of equipment with other artists. London Glassblowing moved to the old Leathermarket near London Bridge in 1995, where it opened a gallery attached to the workshop. It subsequently moved to Bermondsey Street in 2009. London Glassblowing set a trend for locating arts in Southwark, and several other studios and exhibition spaces followed, including the major contemporary art gallery White Cube, which came to Bermondsey Street in 2011.

Glassblowing was once a closely guarded art, and the skilled craftsman of former times who worked in seclusion on the Venetian island of Murano, for instance, were sworn to secrecy in their techniques. For later applications, it continued as a skill unknown outside the factory environment. This required glassblowing techniques to be rediscovered by modern makers. At London Glassblowing, much of the arcane process can be seen by visitors, starting from the furnace holding the crucible of molten glass, which is gathered on to an iron, to the second furnace known as the glory hole, where the piece is reheated, and a final place called the annealer, which is used to slowly control the cooling of the piece to prevent cracking or shattering through thermal stress. There are the special tools involved, such as the

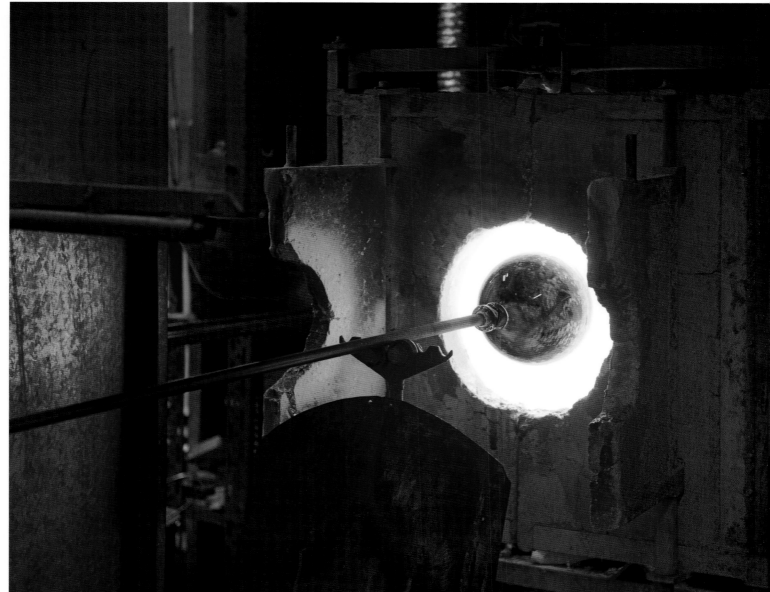

The glory hole is used to reheat a piece of art in between the processing stages.

blowtube and punty rod, and the table called the marver with a polished heat-resistant work surface. A crucial touch comes from the judicious application of pads, simply made from folded newspapers. Sometimes the work requires the actions of two or more people to manipulate a larger piece, and their steps back and forth between the furnace and the workbenches often resemble a kind of choreography. At the heart of the studio is said to be a spirit of collaboration.

The acceptance of glass as a means of artistic expression rather than a functional product was a long time coming, say the artists, ranked below paint and sculpture and rated behind ceramics and jewellery-making, but that has slowly started to change. Visitors to the London Glassblowing studio are welcomed in mornings and afternoons. A glassblowing class, with a day of training, is also offered, and each month a group viewing for twelve people is organized.

—

London Glassblowing

62–66 Bermondsey Street

Bermondsey

London SE1 3UD

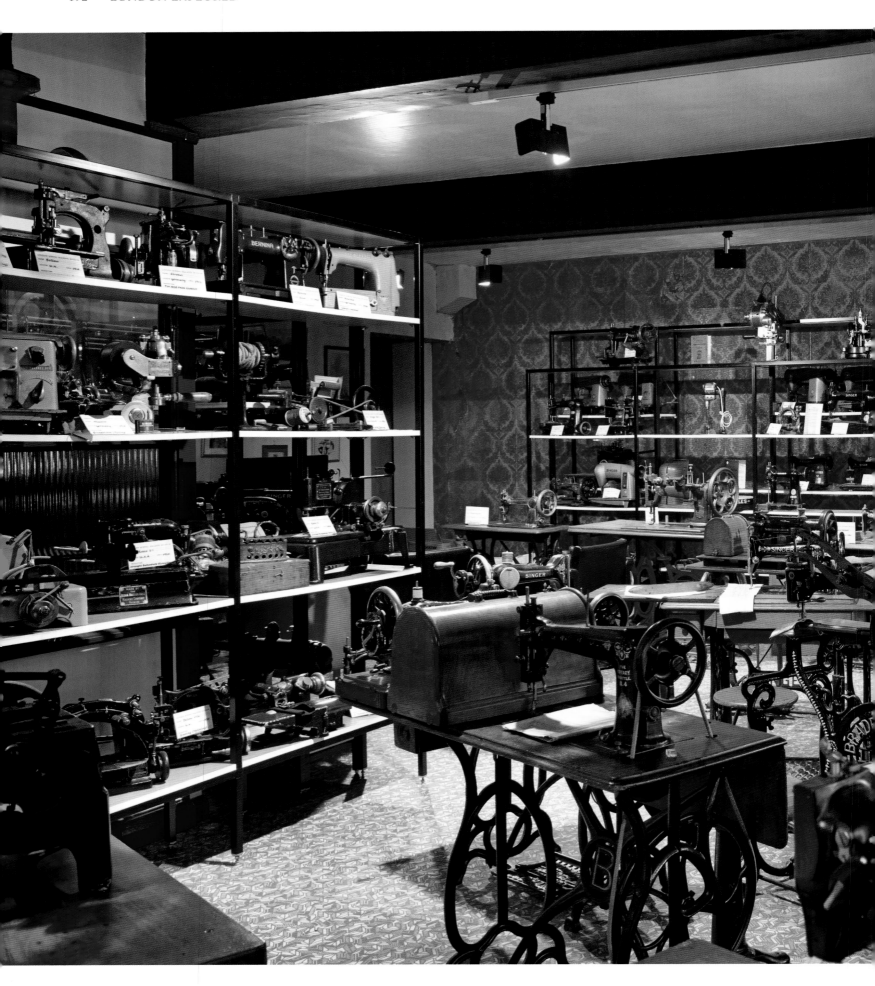

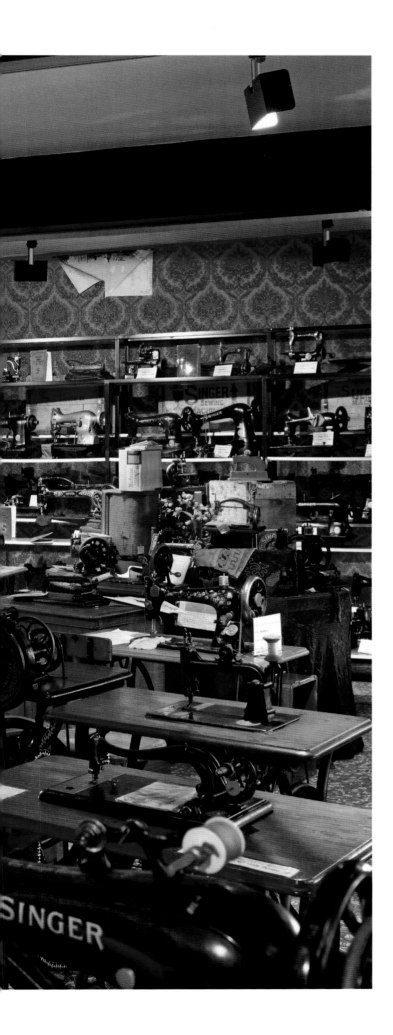

London Sewing Machine Museum

The first sewing machines started operations at a workshop in Paris in 1830 and weeks later the factory was torched by a furious band of tailors. They could not tolerate the idea that any device could replace stitching by hand. The inventor, Barthélemy Thimonnier, fled Paris with a machine he managed to salvage and tried to establish a factory to make more and better machines, but he did not prosper. Soon an eruption of sewing machine activity started in the US with improved designs emerging working on differing principles. An argument raged over patents and marketing between inventors Elias Howe and Isaac Singer and many feared that the machines would force jobless seamstresses and dressmakers on to the streets. The sewing machine underwent a turbulent evolution, yet by the end of the century, there were more than 600 makers worldwide and it could be claimed that the machine had changed the world and gained universal acceptance. It became hard to dislike the sewing machine, especially in the home.

Much of this history is found in hardware at the London Sewing Machine Museum in Tooting, a treasure house telling the story of the sewing machine from 1830 to 1950. It is located at the site of a modern sewing-machine sales company and has restricted opening hours, generally allowing visitors only for a few hours on the first Saturday each month. There are more than 600 sewing machines exhibited, one room for domestic types and another for industrial machines.

The collection was assembled by the managing director of the Wimbledon Sewing Machine Co Ltd, Ray Rushton, and has roots in south London going back over seventy years. After the war, Ray's father, Thomas Ruston, started a business repairing and selling second-hand machines, first from home and then from the T.A. Ruston shop in Merton Road, South Wimbledon, at a time

A range of industrial sewing machines on display.

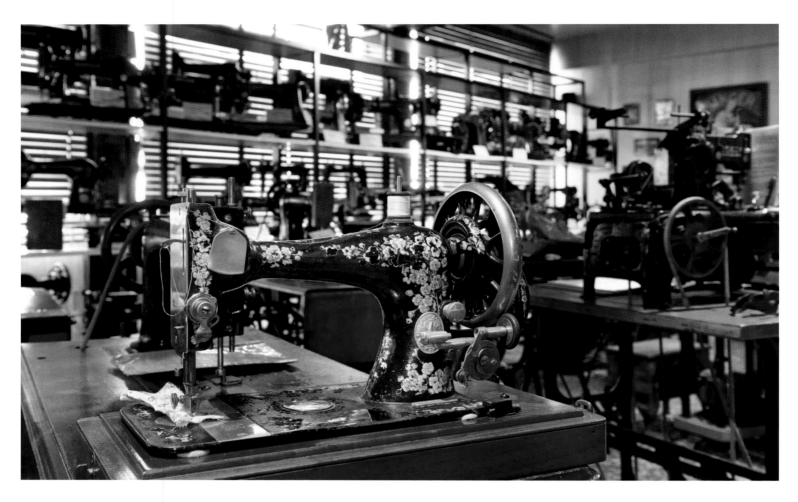

ABOVE *A Singer sewing machine, Model No. 28.* OPPOSITE *Queen Victoria's daughter Vicky's sewing machine, which was made in 1865 by Pollack & Schmidt of Hamburg (above); a collection of domestic sewing machines (below).*

when the average wait for a new machine from the factory was six months. A replica shopfront is an exhibit in the museum. Over time the business developed into the Wimbledon Sewing Machine Company, eventually dispatching machines across the world and marketing its own Wimsew machines. At the same time, a collection of old machines was accumulating, including special types for embroidery and for sewing gloves, shoes, handbags, curtains, leather and fur, for patching boots and for making buttonholes. Knowledgeable enthusiasts recognize four-needle machines for sewing corsets. There are machines for sewing sails, tarpaulins and parachutes. There is a unique machine from a Scottish maker dated 1904 with the head cast in the shape of a lion. Rushton family history says it was bought from a rag-and-bone merchant for £7 in the late 1940s. There are machines with personal history attached, one of which was owned by Charlie Chaplin's mother Hannah, a seamstress, and another owned by the mother of Boy George, who used it to make his stage costumes.

One of the most prized exhibits is the sewing machine given as a present to Queen Victoria's oldest daughter, Victoria Adelaide Mary Louisa, on her wedding to Frederick, Crown Prince of

Prussia, in 1858. The machine has ornamental engraving under a silver gilt finish. The stitch plate is engraved with a view of Windsor Castle and a cut-glass cover carries Prussian and British coats of arms. Accessory boxes and instruction manual are bound in blue velvet with gilt brass monograms. The ivory cotton reels are carved with a crown motif. The machine was bought at auction for £23,500 in 1997, but it is not the most expensive machine in the collection. That is an historic machine made by Barthélemy Thimonnier, the French inventor who had fled Paris in 1831 after attacks by rioters, and dating from that time. The machine, which is treadle operated and made largely of wood, was discovered in the basement of an abandoned sewing factory in Argentina and purchased by the Rushton family for £50,000 and may be one of only two or three survivors.

The London Sewing Machine Museum regularly supplies film-makers with authentic props, and its machines can be seen in *Downton Abbey*, *Call the Midwife* and *Made in Dagenham*.

—

London Sewing Machine Museum

292–312 Balham High Road, London SW17 7AA

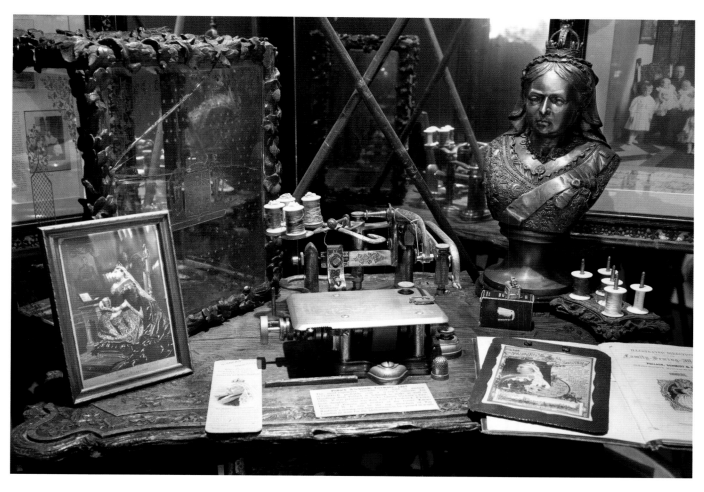

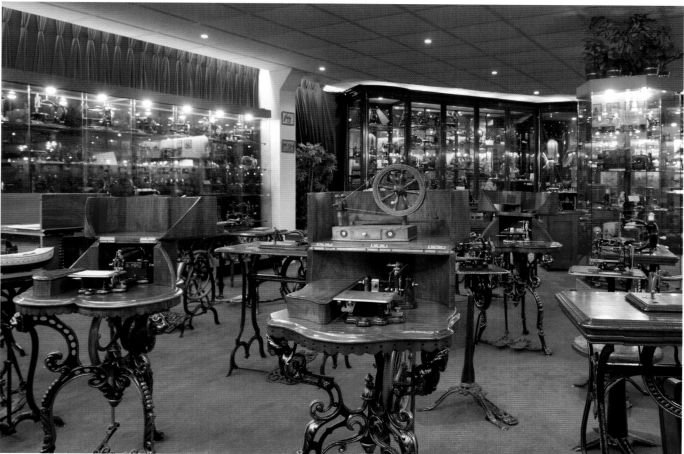

Kirkaldy's Testing Works

Over the doorway of 99 Southwark Street, the legend 'Facts Not Opinions' is carved in stone, the rigorous motto of Scottish engineer David Kirkaldy. Inside is a colossal machine, which is a monument to the first age of scientific materials testing. In full working order, the Kirkaldy Universal Testing machine is a unique technological survivor.

David Kirkaldy gained expertise in the design and testing of boilers and other marine machinery as chief draughtsman at Glasgow engineers Robert Napier & Sons. In 1861, he left the company and devoted the next two years to the design and patenting of a large-scale testing machine. Greenwood & Batley of Leeds were commissioned to construct it. More than 14 metres/47 feet long and weighing 118 tonnes, it was delivered by rail to London in 1865.

The machine is a fixed hydraulic cylinder housing a ram, which drives a carriage exerting load on the test specimens. It was described as capable of pulling, thrusting, twisting, shearing, punching and bulging. Power came from the high-pressure water main of the London Hydraulic Power Company, with the addition of a booster installed inside the works. Kirkaldy claimed that the machine could exert forces up to 450 tonnes.

In the first Industrial Revolution, engineering had swiftly shifted from the era of wood, stone and rope to cast- and wrought-iron and then steel. With this came an often-imperfect understanding of the qualities of the materials. Kirkaldy established the first independent commercial testing house. The machine tested many samples salvaged from the Tay Bridge disaster, and the strengthening links for Albert Bridge and for Hammersmith Bridge, when more than 150 pieces were tested to failure. The world's first major steel bridge, constructed at St Louis in 1874, depended on Kirkaldy testing. German steelmaker Alfred Krupp was a customer, and later components for Wembley Stadium and parts of the framework for Sydney Harbour Bridge were tested. A machine for testing marine chains was installed in the basement, and another for concrete testing by crushing.

The precise occasion when the mighty machine made its last operational commercial test has not been recorded, although Kirkaldy tested the suspension cables for the Skylon sculpture created for the Festival of Britain in 1951 and the works operated until 1974. Preservationists established a museum in 1983. Now the Kirkaldy museum houses a wide collection of testing machines.

—

Kirkaldy's Testing Works, 99 Southwark Street, London SE1 0JF

Most of the ground floor in the Kirkaldy Testing Works is filled by the Universal Testing machine.

Clapham South Deep-Level Shelter

Clapham South Deep-Level Shelter, built for air-raid protection, has been repurposed several times in pursuit of the needs of a changing world.

The decision to construct it did not come until after the Blitz on London had started. Any use of Tube stations as shelters had first been barred by the authorities, who were made to reconsider when thousands forced their way into Liverpool Street Underground station during air raids in September 1940. Within days, many operational Tube stations were officially sanctioned as shelters and in November plans were issued for purpose-built deep shelters. London Transport, with its experience in underground construction, was commissioned to manage the making of the deep shelters by the Ministry of Home Security. Eight locations were eventually worked below existing Tube stations, four of them to the north of the Thames and four to the south: Stockwell, Clapham North, Clapham Common and Clapham South.

The design was for twin tunnels 30 metres/100 feet below street level, each 400 metres/¼ mile long and divided into two decks, with sleeping accommodation for 8,000 people, washing facilities and chemical toilets, medical rooms, canteens and recreation areas.

Clapham South was fitted out in June 1942; the intensive phase of the Blitz had ended in May 1941. This relative lull in bombing persuaded the Ministry to keep the deep shelters on standby, a wary response partly based on the expense of opening and supervising the tunnels, and also on the unpredictable nature of the menace. Instead, areas of the south London shelters were made to accommodate soldiers on leave, and part of the new deep shelter at Goodge Street was given over to General

The Hardy shelter, at one of the secret wartime tunnels.

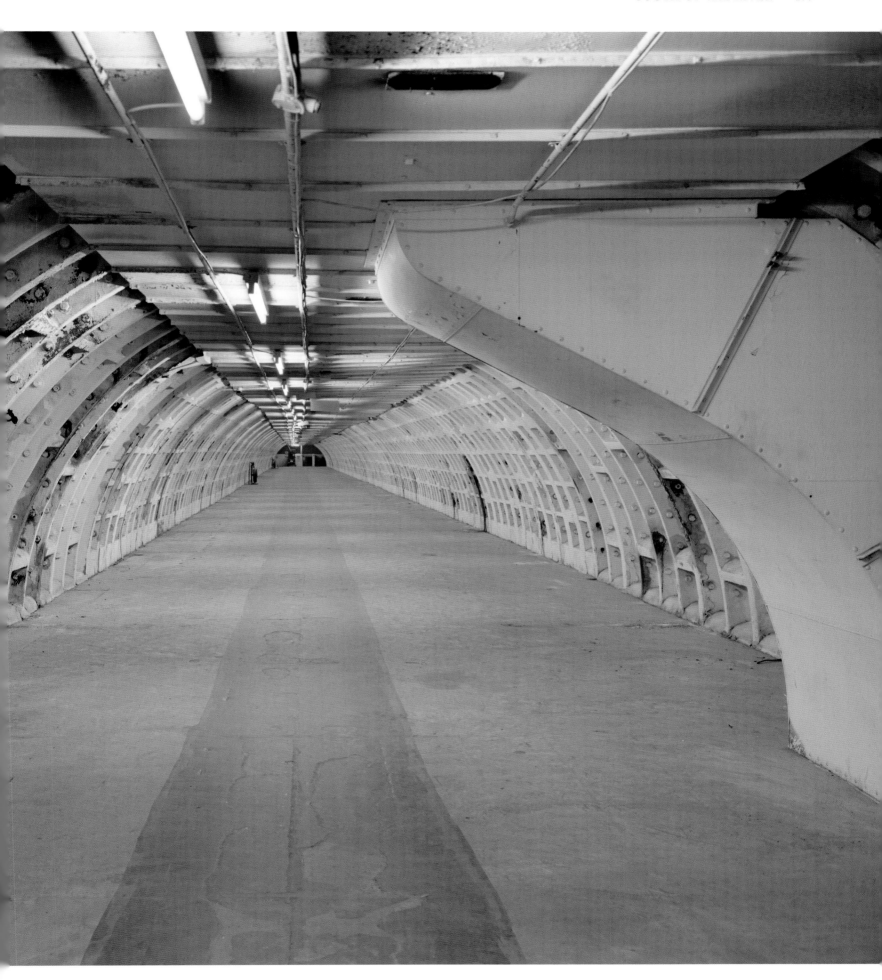

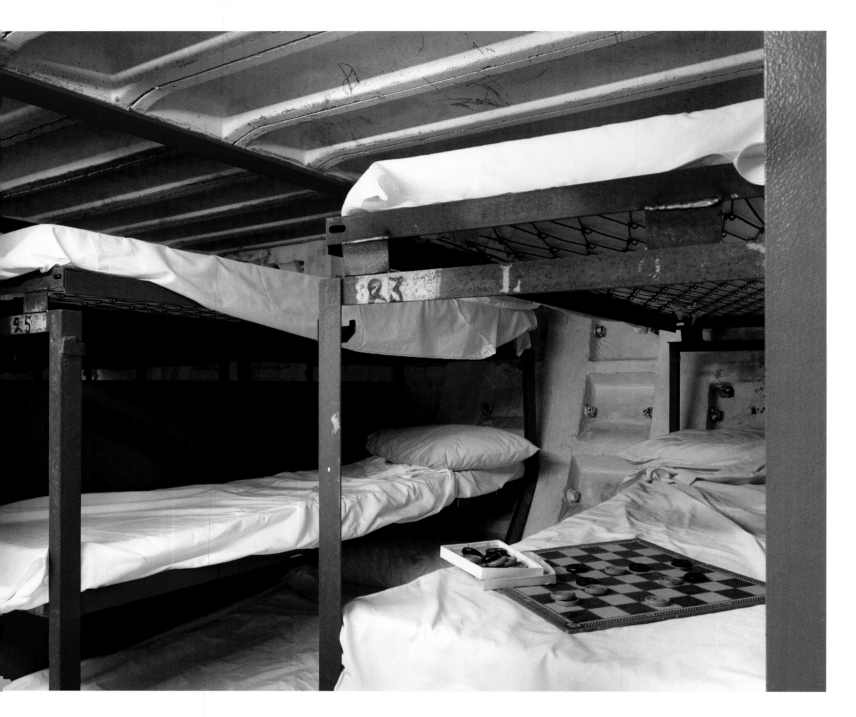

Many bunks remain in place in Ley shelter, which is triple tiered in places. After the Second World War in 1948, these were used to house Caribbean migrants from the Empire Windrush, when the lack of housing meant even temporary accommodation was in short supply. For six shillings and sixpence a week, inhabitants received food and a bed in a shelter underneath Clapham South Tube station.

Eisenhower's headquarters. Only those at the highest level of wartime government could dimly glimpse a forthcoming danger posed by enemy missile technology.

Raids on London resumed with the so-called Little Blitz starting in early 1944; even these attacks did not cause the authorities to open up, but a new threat came with the first V-1 flying bomb to hit London in June 1944. As these attacks intensified, Clapham South was opened on 19 July. The borough of Wandsworth recorded the greatest density of V-1 impacts of

any London district, with 122 hits up to September 1944, and as that threat abated, V-2 ballistic rockets started to fall on the city. The last air-raid warning came in March 1945. The highest occupation of the deep shelters on a single night was 12,297 people, full capacity was never approached.

Post-war purchase of the shelters by London Transport was an option coupled to its participation in the programme, with an eye on conversion to an express Tube route. This influenced the engineering of the shelters and at Clapham South the tunnels

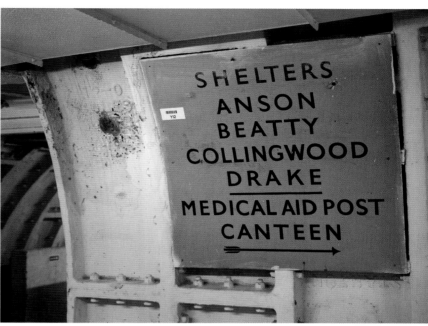

Graffiti on the wall in Grenville shelter. More graffiti can be found on the tunnel segments made by those sheltering, soldiers and, in this case, a workman.

A cross-passage sign at the Balham end of the secret wartime tunnels. Upper-level tunnels were divided into sub-shelters named after alphabetically listed admirals of the Royal Navy, with the intention of helping shelterers to remember their locations.

were built in a long curve aligning with the other deep shelters at Clapham Common and Stockwell. The diameter of all the main tunnels was more than 5 metres/16 feet, possibly capable of taking full-sized rolling stock but not big enough to provide any deep platforms for passengers at Clapham South. Although there was, and is, a connecting stairway to the existing Tube station, the intention was to develop non-stop or limited stop services from central London to the end of the Northern line at Morden and beyond. This had been mooted pre-war, again in 1940 and in the London Transport annual report of 1945, but the tunnels were never destined to be joined and several historians and chroniclers of the Tube doubt if the fast-track idea was realistic or desirable. As the plan melted away and the option lapsed, there were other uses.

The shelter became a leave hostel for military personnel and, in 1948, temporary home to over 200 migrants from Jamaica arriving on the HMT *Empire Windrush*. The nearest labour exchange was in Brixton, and the location of Clapham South can claim to have shaped the future influence of West Indians on south London. The Festival of Britain of 1951 brought thousands to London, and the shelter became the low-cost Festival Hotel for visitors. The following year, troops were accommodated again for ceremonial duties during the funeral of King George VI, and visitors for Queen Elizabeth II's coronation were housed here in 1953. A fire at Goodge Street in 1956 highlighted the vulnerability of shelter habitation, and further use for accommodation was barred.

A long twilight spell under mothballing and use as a storage facility followed.

Remaining in the ownership of the Ministry of Works and its successors, the property arm of the government eventually sold seven deep shelters to Transport for London in the late 1990s. It may have seemed like a delayed fulfilment of destiny, but the focus was now on property management rather than rail transport, the shelters now mostly serving as commercial secure archives and, in one case, a salad farm. Clapham South has been leased to the London Transport Museum and is open to visitors at certain times.

—

Clapham South Deep-Level Shelter
Clapham Common
London SW12 9DU

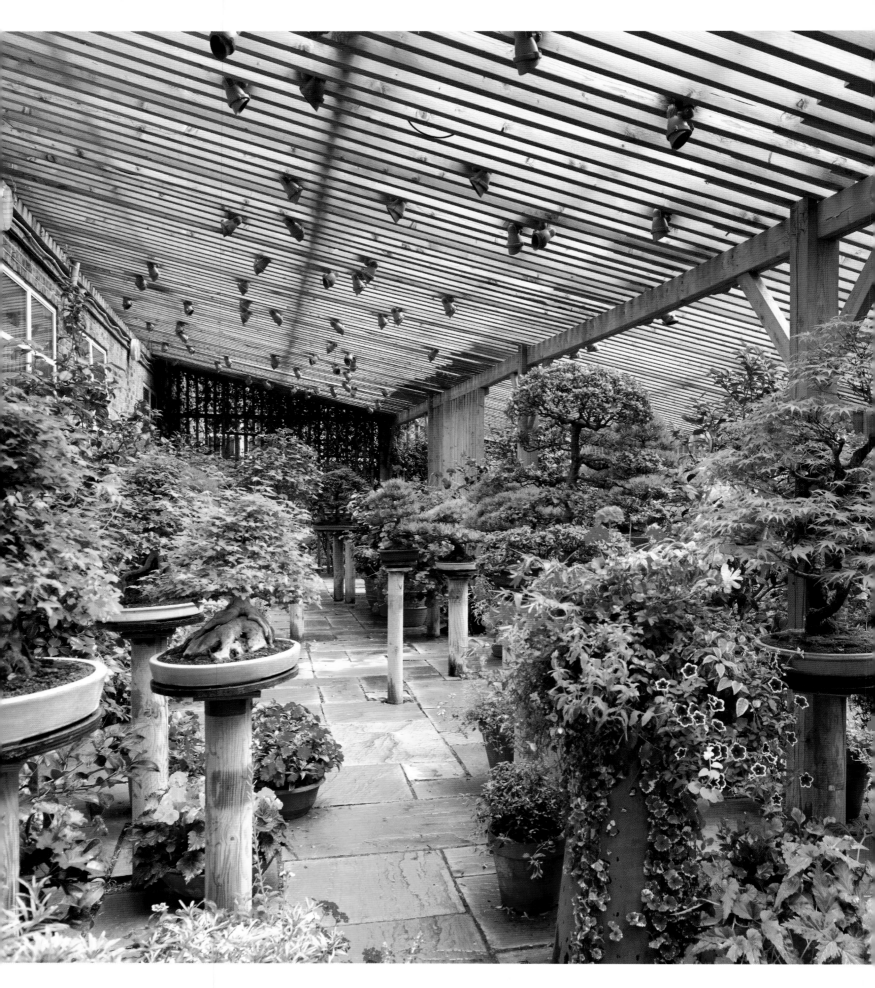

Raqib Shaw's Sausage Factory

Extravagant and extraordinary, the studio and home of the artist Raqib Shaw in Peckham defies classification, just like his intricate and audacious paintings of fantastical worlds. His pictures have taken figures and scenes inspired by Northern Renaissance paintings and placed them in worlds filled with mystical Eastern imagery, seemingly laden with secret meanings. His house is a similarly colourful environment of dense foliage and eclectic decoration. It is tempting to make a connection between the intricate paintings and the lavish apartment; it is safe to say that in both places Raqib Shaw favours flowers, plants and trees.

The studio and house was previously a sausage-making factory operated by the Kennedy company. Widely known for pies and sausages, the firm was a well-regarded south London institution with more than a dozen butcher shops from Deptford to Orpington. The last of these closed by 2007, including the factory on the west side of Peckham, a functional building of brick and concrete with no visible concession to art or elegance. This lay empty and increasingly derelict until Raqib Shaw bought it in 2011 and transformed part of the interior with the aid of the McCrum interior design company. The artist sometimes refers to it still as the sausage factory, otherwise calling it his atelier, meaning a studio and workshop in the Renaissance sense.

Raqib Shaw was born in India and spent his early years in Kashmir, coming to London in 1998 to study art at Central Saint Martins. His early series of paintings *Garden of Earthly Delights* took inspiration from the gruesome fifteenth-century Hieronymus Bosch triptych. In Shaw's universe, groups of hybrid anthropomorphic creatures occupy a world of dazzling colour. From 2004, his exhibitions in London and New York created a stir. In 2007, *Garden of Earthly Delights III* was sold at Sotheby's in

The exquisite bonsai garden in the wooden-slatted loggia at the rear of the building.

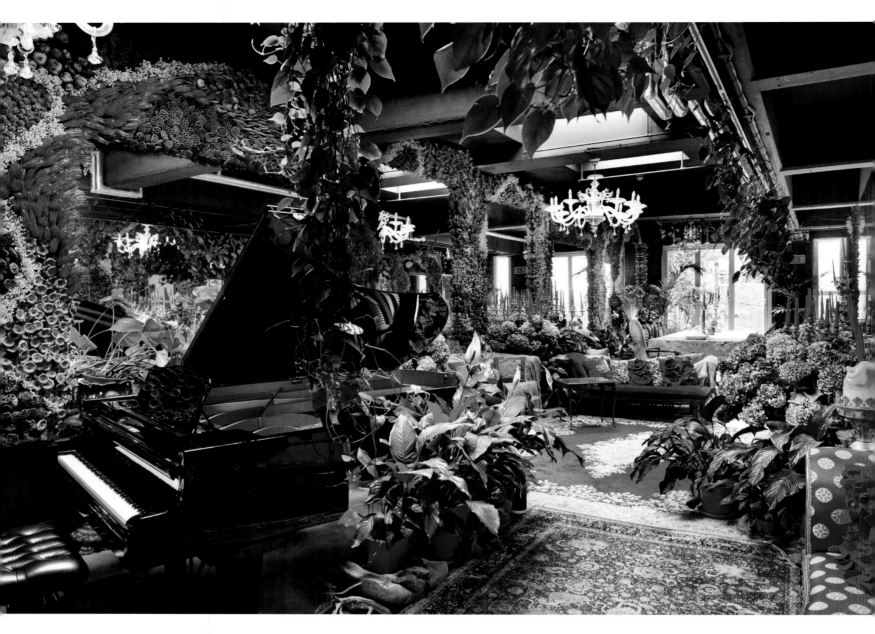

The soirée room, with a grand piano and an eclectic mix of real and faux flowers and foliage.

New York for $5.5 million. A series of extravagant paintings has come from the Peckham studio, with the surfaces often traced with glitter and encrusted with stones, where images of Hindu mythology may be glimpsed, together with the influence of Persian carpet design and Japanese prints. Highly detailed, super realistic and at the same time phantasmagorical, they are often populated with images of strange fauna and always much flora.

The three-bay factory building is set back from the Peckham Road behind a wall of London brick, with a garden added to the front and a loggia to the back. Much of the former production area of the factory is now white-painted workspace for Rabiq Shaw's team of assistants, who help him apply the finishes to his large-scale works, each of which takes months to complete.

The technique Shaw devised is space and labour intensive, starting with the tracing, or optical projection, of the design on to the birchwood board, which is laid flat, and then the tracing of outlines in gold paint of the type used in stained-glass windows. Fine-detail enamel pigmentation is applied and manipulated into place with a porcupine quill. One piece of special equipment is a commercial paint-mixing machine for the heavy enamel paints, operated alongside the trestles and workbenches.

Beyond a door in the workshop are the rooms of Raqib Shaw's apartment. The main space of this is called the soirée room, an environment of flowers and foliage, real and faux. Here is a grand piano, oriental carpets, tapestry, upholstered couches, chandeliers, candles; the colours red and green dominate throughout. The

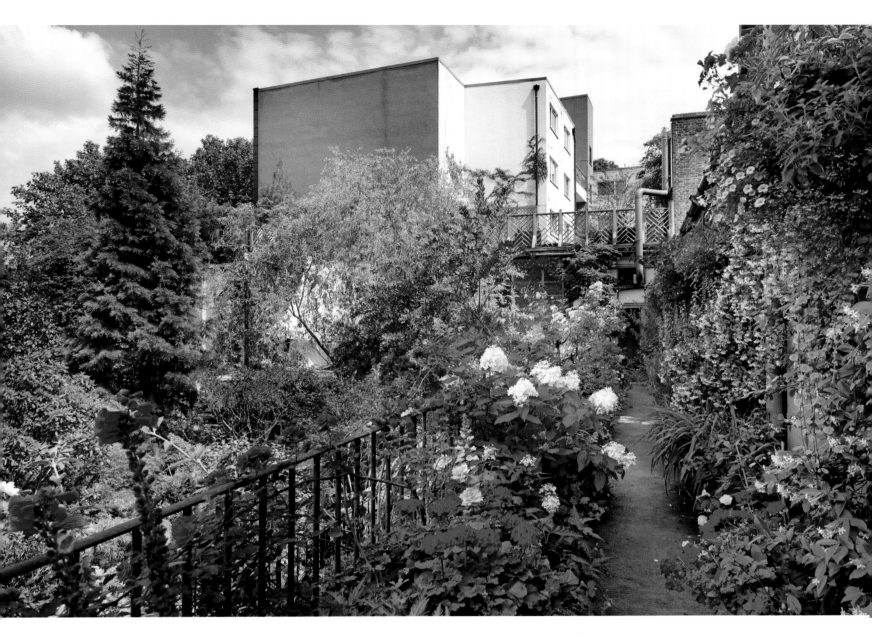

The garden balcony at the front of the building is planted with beautiful flora, including azaleas, begonias, magnolias and ferns.

effect is of an exotic salon from another age transplanted into a garden, with the functional concrete surfaces of the old factory interior just visible beyond. A balcony running across the front of the building at an upper level is laden with plantings of azaleas, begonias, magnolias and ferns. At the rear, an addition to the factory building, a wooden-slatted loggia, encloses a collection of bonsai, dwarfed varieties of maple, pine, elm, juniper and gingko arrayed on pedestals.

The flow of extraordinary paintings from Raqib Shaw's atelier continues, managing to span Old Master compositions and Eastern imagery, and more recently the re-imagined landscapes of Kashmir. *From Narcissus to Icarus* credits the influence of *Le Déjeuner sur L'herbe* by Manet. It is hard to provide any example

that can be described as typical, although *Self Portrait in the Studio at Peckham (After Steenwyck the Younger) II*, is a fusion of elements, some of which can be recognized. It takes the precise composition of a Flemish painting of Greek mythology and populates it with animate skeletons and nameless creatures. Elements of Shaw's studio can be seen, including an array of flowers, champagne bottles and bonsai tree, and the artist shows as a face on a skeleton in the centre foreground. Behind, the sky can be glimpsed with an airliner climbing above the London Shard, a realistic everyday view from the balcony at the sausage factory in Peckham.

—

Raqib Shaw's Sausage Factory

Peckham Road, London SE15

Crystal Palace Subway

London's vast and intricate rail system has lost hardly any of its passenger-carrying tracks since the first lines opened in the 1830s. An ornate subway at Crystal Palace marks a rare exception: a beautiful isolated relic of a vanished branch line and a reminder of the huge exhibition hall it once served.

The vaulted subway of octagonal columns provided a pedestrian link from a lost terminus station. It was intended to channel passengers – first-class only – direct from the platforms to the main floor of the Palace through a courtyard and entrance steps. A 6.4-kilometre/4-mile branch had been built from the main line at Nunhead, providing trains to central London every half hour. Although there were three intermediate stations, the main justification for construction was the Crystal Palace itself. This Victorian showpiece built for the Great Exhibition at Hyde Park in 1851 had been re-erected on Sydenham Hill. Here, the prefabricated plate-glass, cast-iron and timber structure was enlarged as a tourist attraction housing a theatre and concert hall, shops and exhibitions.

The nearby Dulwich College estate exerted influence on the high-concept design of the subway and station, which became known as Crystal Palace High Level. The subway has fan vaults resembling church architecture, although here the vaults have no ribs. Patterns on the vaulting are picked out in red and cream bricks. On the ceiling, circular roundels in stone enclose more decorative brickwork and iron gaslight fittings. The subway was well lit. Overall it was 'designed to intrigue and excite, acting as a precursor to the treasures to be found in the Crystal Palace' in the words of conservators.

Crystal Palace was destroyed by fire on 30 November 1936, and the subway lost its purpose overnight. It entered a long twilight, becoming an air-raid shelter during the war. The branch line and High Level station closed in 1954 and the terminus was demolished seven years later.

Although locked away in recent years, it has attracted thousands of visitors on rare openings during heritage and festival days and Open House weekends. Paving has been replaced and grilles and gates fitted, and repairs to the flank walls authorized. In 2020, with funding in place for restoration and work underway, there are signs it is poised for rebirth, possibly as an event or exhibition space.

Crystal Palace Subway, Crystal Palace Parade, Dulwich, London SE19 1XX

The Crystal Palace Subway survives in ornate isolation.

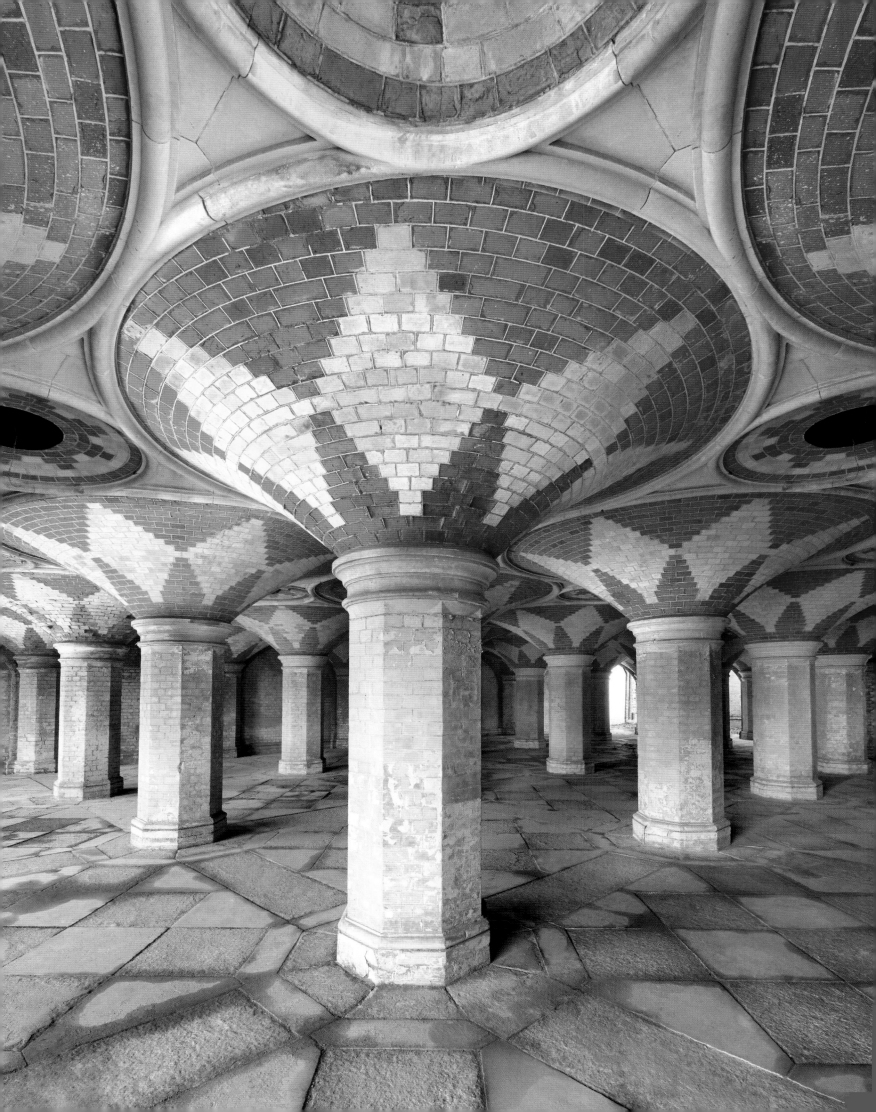

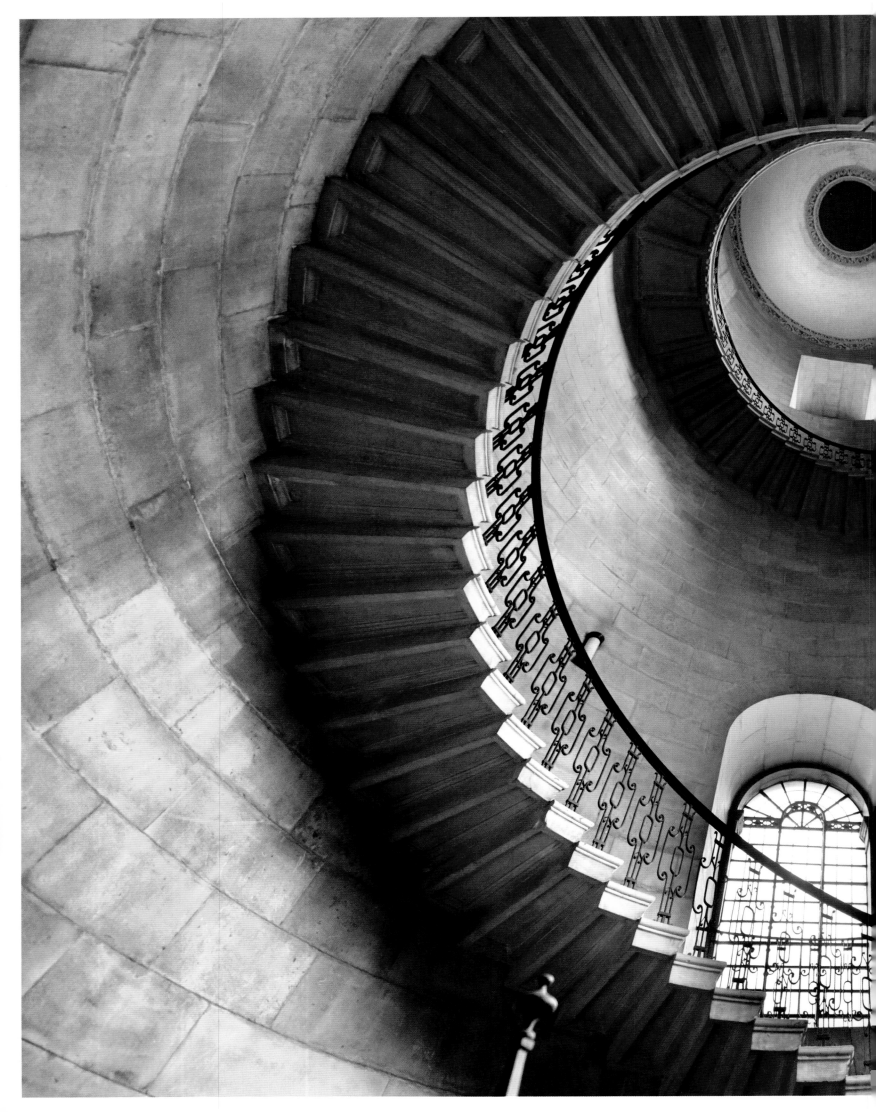

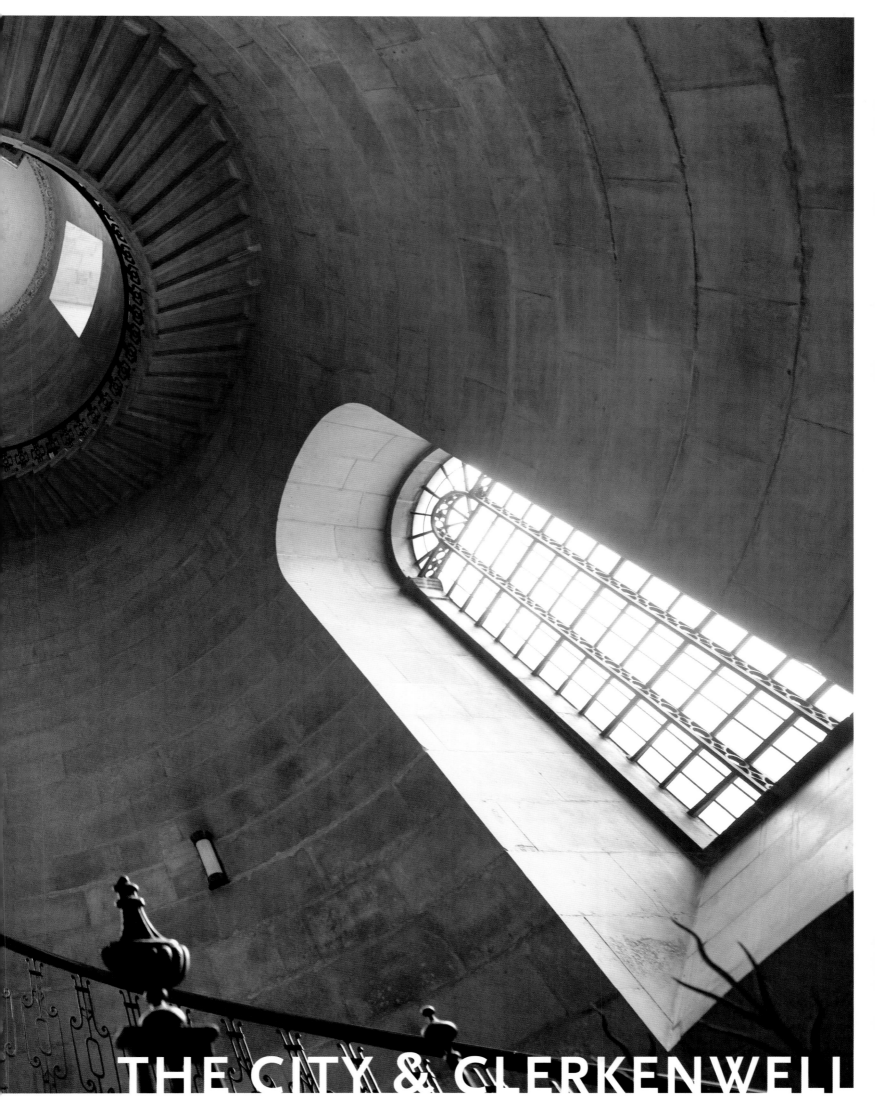

THE CITY & CLERKENWELL

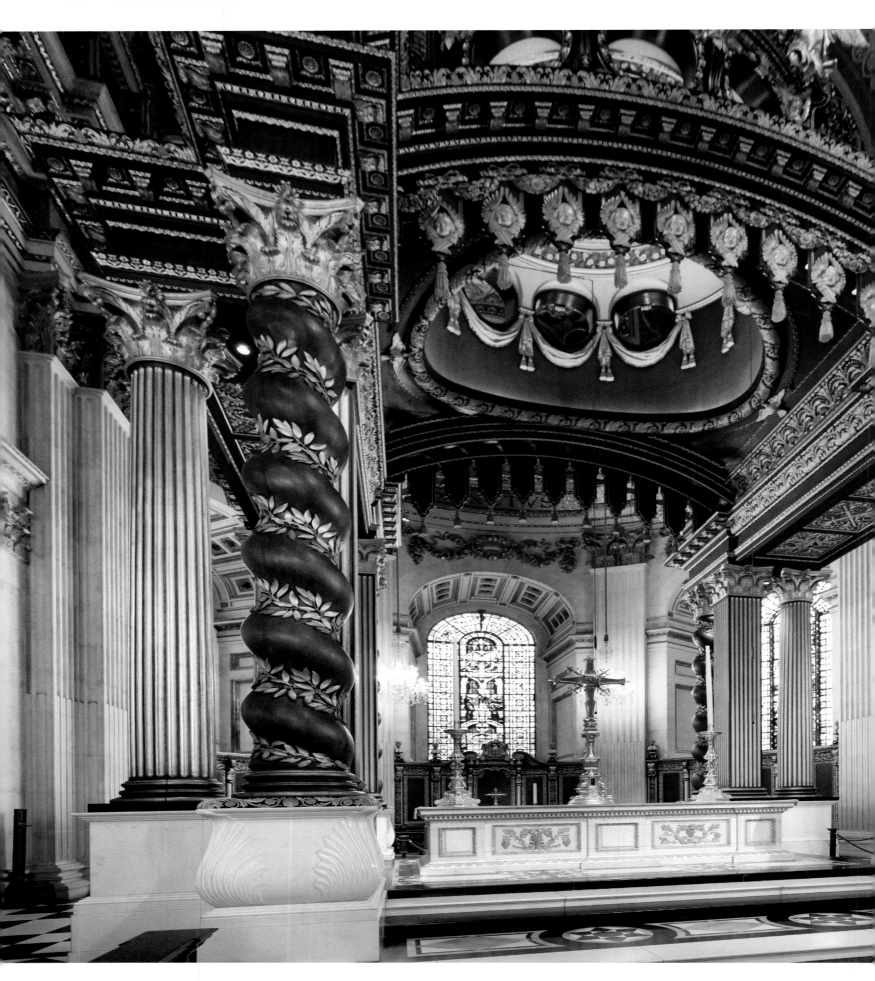

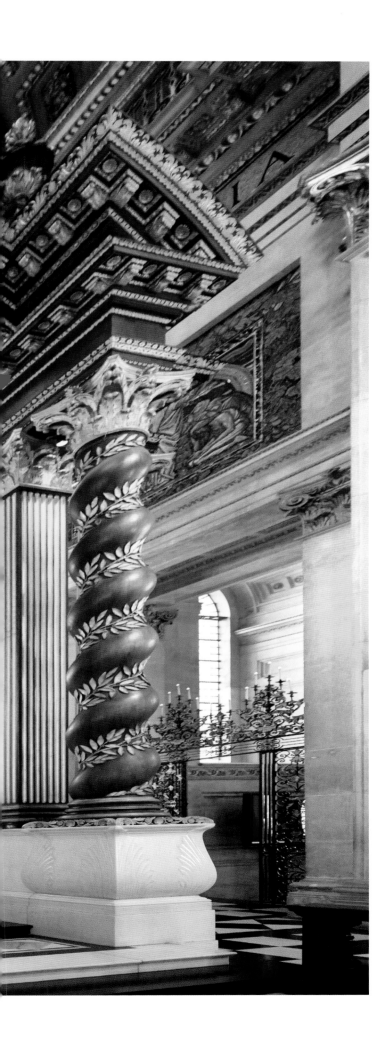

St Paul's Cathedral

St Paul's most visible and greatest feature is its dome, which architect Christopher Wren combined with a gothic nave in the first cathedral to be built in England after the Reformation, consecrated in 1697. The cathedral's hidden features are found in a place called the triforium, filled with spaces and artefacts that unlock a further understanding of the construction of the cathedral and its dome.

The triforium itself is essentially an enclosed corridor high alongside the nave, made as a consequence of the scale and height of the building. One of the adjoining rooms houses the so-called Great Model. Built to a scale of 1:25 and made of wood, it measures nearly 6 metres/20 feet long and at first glance seems to be largely the same design as the finished cathedral, but there are major differences. Accompanying exhibits, drawings and models show the stages Wren went through of developing an acceptable design. His intention was to depart from the tower layout of gloomy medieval churches and introduce a dome to the design, which would be the first of its kind in an English church. He was obliged to present several different proposals, the first in 1669 and the final design in 1675. The Great Model represents a transitional design: a variant on the ideal symmetrical Greek Cross layout that Wren had favoured most, with a central dome. This was not accepted by clergy, who sought to reassert tradition, and Wren was obliged to compromise with a plan closer to an English Norman cathedral, with a long nave and transepts and a long choir with an apse: classical meeting gothic. The tug between the two influences continued until May 1675, when a plan finally received the royal warrant. This was called the Warrant Design, and seemed to be the last word, but Wren was able to refine the drawings much further and managed to

The awe-inspiring High Altar in St Paul's Cathedral.

RIGHT *The trophy room featuring Christopher Wren's Great Model of St Paul's Cathedral, made to a scale of 1:25, which King Charles II climbed inside to approve.*

OPPOSITE *Horatio Nelson's tomb in the crypt (above). He was laid to rest in a coffin made of wood from a French warship; stone relics from the Old St Paul's, both Norman and Gothic, now held in the triforium (below).*

OVERLEAF *The magnificent dome was painted by Sir James Thornhill in monochrome, illustrating the life of St Paul.*

abandon an ugly spire on the dome that had been introduced to mollify the traditionalists. The Great Model was intended to be walked through and examined at eye-level to give an impression of the finished interior. It cost £600 to make, the price of a good London house at the time. King Charles II walked inside and expressed his approval, but the model turned out to represent only a staging post.

Along the walls of the triforium passage are shelves of broken moulded stonework salvaged from Old St Paul's Cathedral, which was reduced to a gutted shell after its lead roof blazed in the Great Fire of 1666. In places the stones are tagged 'Norman' or 'Gothic', a reminder that the cathedral that exists today is the fourth or even fifth church to be built on the site, with much rebuilding and reuse of material. Some stone from Old St Paul's were used in the construction of the outer walls of the present crypt, where the tombs of Nelson and Wellington are found. After the Great Fire there was a chance that the cathedral's nave and portico, which remained standing, might be repaired and incorporated into the replacement building. It was not until 1668 that a warrant was issued to demolish the remains, and this was done partly with the use of gunpowder.

The library of Old St Paul's was lost in the Great Fire and the new library, in a chamber off the triforium, was completed in 1709 and quickly restocked. It houses collections on theology and church history, classics and medical volumes dating from the age when priests still treated illnesses. Its greatest treasure, not always on display, is a Tyndale New Testament of 1526, which was acquired as part of a bequest in 1783, one of only three remaining copies. This small volume measuring inches was the first holy book published in English and was once described as the most dangerous book in Tudor England.

Descending from the triforium down the south-west tower is the spiral Dean's Stair, known as the geometric staircase, once a considerable secret, made more famous by its appearance in *Harry Potter and the Prisoner of Azkaban*. Its construction is a visual and structural marvel, built by a master mason to a design mathematically generated by Wren, turning two perfect rotations from top to bottom, and supported only on the outer side of the spiral where the steps meet the tower wall.

The dome, which Wren had envisioned from the start, stands triumphantly today, massive in scale and visible across much of London. This outer silhouette is shaped and supported by a light frame; the inner dome seen from the floor of the cathedral. There is a third element, a brick cone hidden inside, which supports the lantern and enables light to enter. It took clever engineering by Wren to couple function with spirituality.

—

St Paul's Cathedral, St Paul's Churchyard, London EC4M 8AD

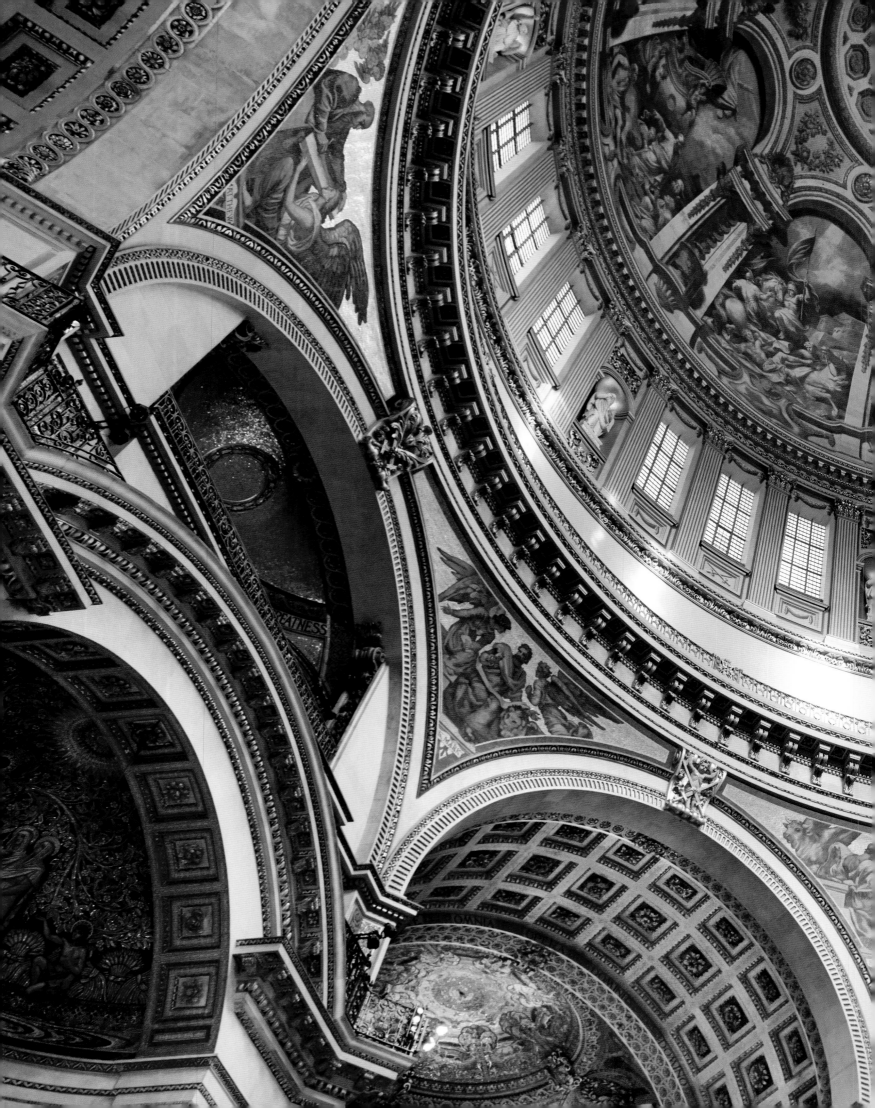

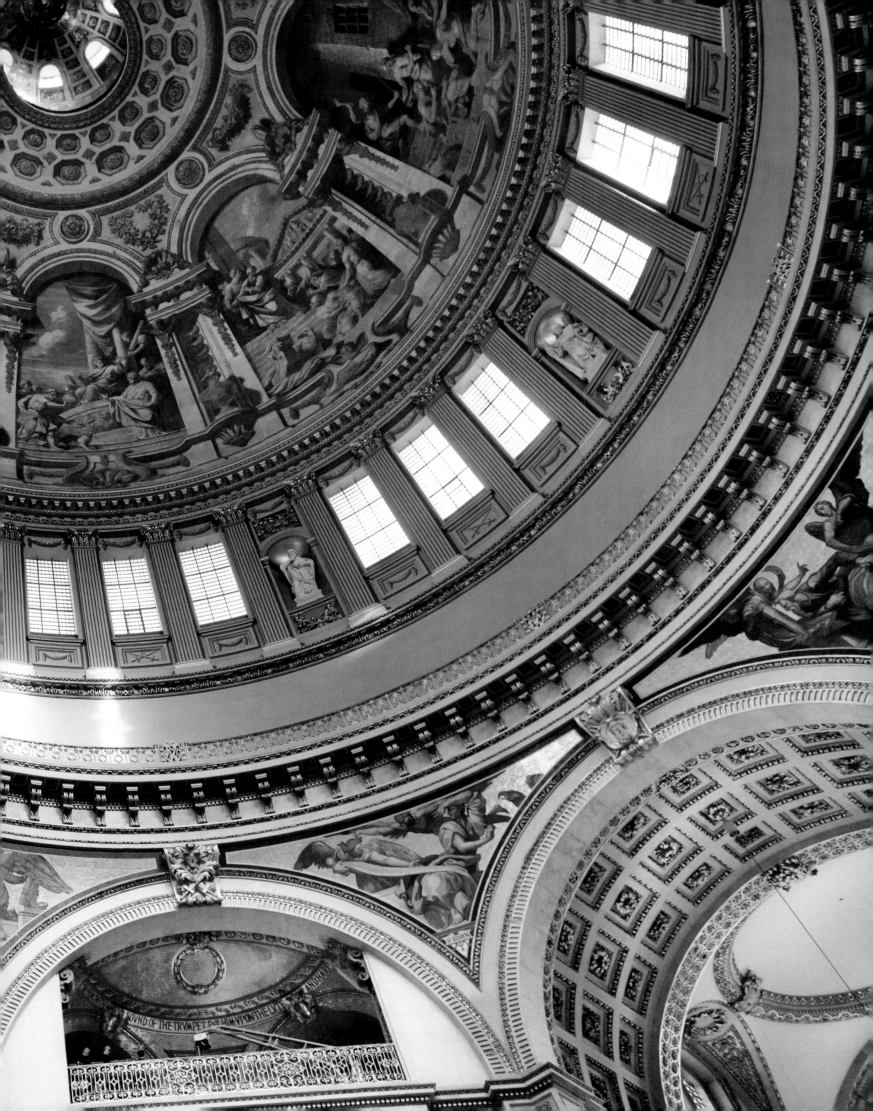

Greathead Shield

Marooned at Moorgate station for almost 120 years is a rare example of the Greathead Shield, the technology that dug tunnels for much of the London Underground system. While the earliest tunnels, for the Metropolitan, Hammersmith & City, Inner Circle and District lines, were made by digging up the streets – a process known as cut-and-cover – later routes were bored by the Greathead Shield at deeper levels.

James Henry Greathead's device improved on an invention used by Marc Brunel for London's first deep tunnel: the Wapping–Rotherhithe of 1843. Here, a massive tunnelling cylinder housing a honeycomb of thirty-four cells worked by miners had slowly inched forward. Greathead's smaller shield had fewer cells and the advantage of hydraulically powered rams pressing against the completed tunnel segments to advance the cutting face. Circular tunnels cut by this method were smaller and the expression 'Tube' began to be used to describe them and the trains that ran inside.

The shield lying at Moorgate is unique. The Great Northern & City Railway planned a route for main-line suburban trains from the north right into the centre of the City, and a Greathead Shield was designed to bore twin tunnels 5 metres / 16 feet in diameter for full-sized rolling stock. It opened between Finsbury Park and Moorgate in 1904, but the track connections intended at the northern end for through trains were barred by the main-line surface operator. The line, destined to be known as the Big Tube, was worked back-and-forth in isolation for years.

A southward extension to Lothbury, close to the Bank at the heart of the City, was authorized but progressed only a few yards before the GN&CR were forced to pause and park the shield at Moorgate. There was a chance it would be revived when fortunes improved, but the boom years of developing London's underground system were ending and the GN&CR disappeared in a round of takeovers and amalgamation.

In 1976, following a reshuffle of transport responsibilities, the Big Tube was connected to the British Rail surface network between Finsbury Park and Drayton Park, enabling trains from the far north, or at least Hertfordshire, to run into Moorgate, fulfilling the original vision of the GN&CR promoters after seventy years.

—

Moorgate station, Finsbury, London EC2M 6TX

At the end of a short tunnel by Moorgate's platform 10, lies a Greathead Shield with its ring of hydraulic rams, positioned for work but destined to be abandoned.

Worshipful Company of Ironmongers

The rankings of the livery companies of the City of London are traditionally described in terms of the Great Twelve in order of precedence, dating back to 1516 when the Lord Mayor ranked the forty-eight companies existing then based on their wealth and influence. The Worshipful Company of Ironmongers stands tenth. The company acted as a fraternity of professionals operating as a society for the mutual benefit of its members but the association with its namesake trade faded long ago as the iron industry shifted northwards away from Kent. The Ironmongers' Company moved to philanthropy and education. Its work now is the administration of charitable trusts and participation in the pageantry of the City.

Ironmongers are believed to have created a collective body to protect and regulate their trade as early as 1300 and within thirty years they were participating in the elections of City officials and choosing four of their members to work with the mayors and sheriffs of the capital. The Ironmongers received a grant of arms in 1455. The charter of incorporation from Edward IV followed in the 1460s. It lost its charter and suffered extortion under King Henry VIII and later monarchs. It was obliged to pay a fine to the notorious Judge Jeffreys in 1668 to redeem the charter.

The guild's first home was in Fenchurch Street, at a property purchased in 1457. The building was converted into a hall for the fraternity, and later enlarged, before being rebuilt by 1587. Unlike many other livery halls, the Ironmongers' Hall was not destroyed in the Great Fire of 1666, although the building was again rebuilt in 1745. This structure was damaged in an air raid in July 1917 but survived. The damage may have led to the decision to sell the site after the war and the building was demolished. The decision came to acquire land in Shaftesbury Place, in a cobbled courtyard behind Aldersgate, in 1922; three years afterwards, the

The staircase and landing, featuring a portrait from 1685 of Sir Robert Geffery, Lord Mayor of London.

present building, designed by architect Sydney Tatchell, was formally opened.

The L-shaped hall is built in the neo-Tudor style to reflect the company's long and distinguished history, although it was built around a modern steel frame. It now strikes a great contrast in architectural style with the brutalist Barbican estate close by. It escaped serious damage during the Second World War, in an area of great devastation. The ground and first floor storeys are of handmade red brick, the second upper floor storey half-timbered. There is a cloister and fountain in the outer angle of the ground plan.

Above the front porch, which is approached through a courtyard, is a carving of the Ironmongers' Company's coat of arms, incorporating two salamanders. Salamanders, like iron, were reputed to be able to survive fire. Inside the porch is the entrance hall, its walls of the wood panelling that continues as a main feature of the building, together with a fireplace in antique style and, leading off it, a wide staircase.

The luncheon room on the ground floor also features the traditional oak panelling, with Regency furniture, a Turkish carpet and an impressive stained-glass window at one end of the chamber. Along from the luncheon room, the court room includes high settees from the previous hall along the walls and a statue of Edward IV, who gave the company its royal charter in 1463, while the chamber is overlooked by a magnificent stained-glass window that incorporates glass from the company's first hall dating back to 1457.

Upstairs is the drawing room, where a visitor's eye is immediately drawn to a huge William Morris tapestry. It is hung in place of wallpaper and is claimed to be the largest William Morris tapestry in England. The room also features a massive fireplace and elegant windows, along with a large bookcase. Among the many paintings is a portrait of Izaac Walton, author of *The Compleat Angler*.

On the first floor is the double-height banqueting hall, the centrepiece of the Ironmongers' Hall. The oak panelling and Waterford chandeliers, which hang from the elliptical ceiling, were salvaged from the previous hall in Fenchurch Street.

The Ironmongers' Company, Ironmongers' Hall, Shaftesbury Place, Barbican, London EC2Y 8AA

The banqueting hall, where the decoration conjures up heraldic imagery and connections with the monarchy and lord mayors of London.

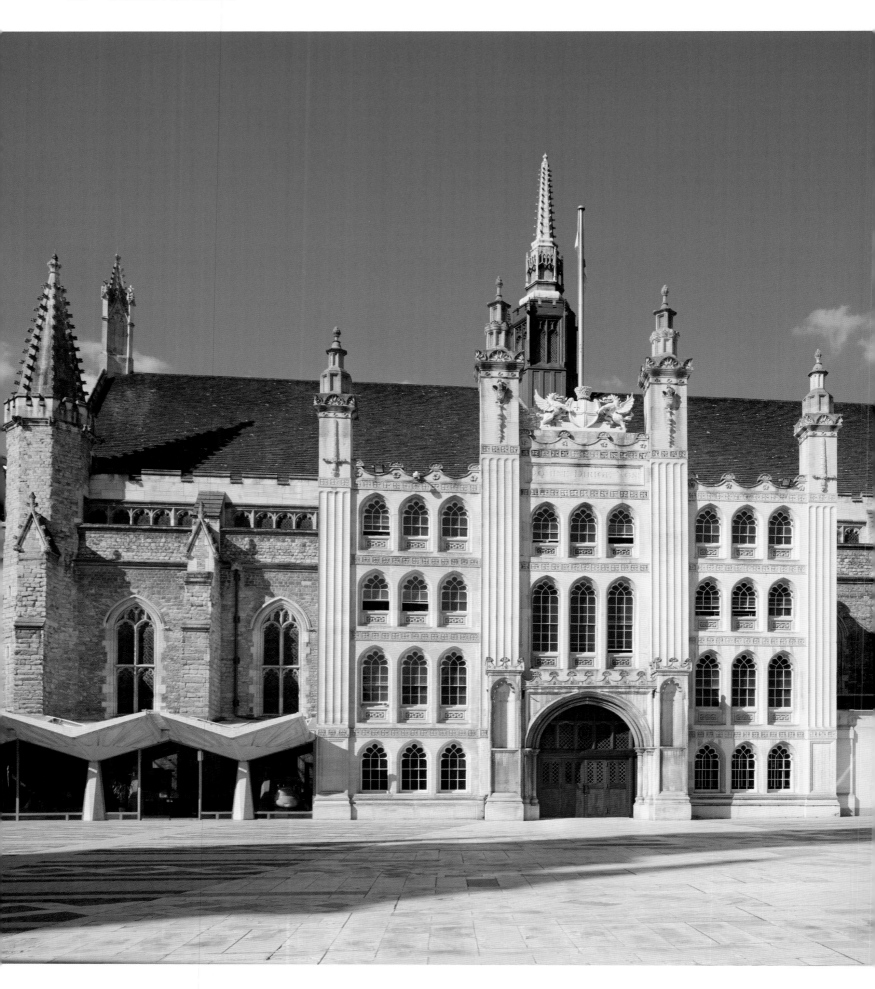

Guildhall Yard

Roman Amphitheatre
City of London Police Museum
St Lawrence Jewry

Under the yard of the Guildhall, London's oldest secular building, lies something far older – the remains of a Roman amphitheatre dating from the second century. Its position is picked out by an oval of dark stone on the floor of the yard. The amphitheatre is one of a cluster of historical sites centred on the Guildhall and Guildhall Yard and associated with the City of London.

Archaeologists and historians were certain that an amphitheatre once existed for Londinium and suspected that the most likely site was outside the city walls, based on what was known about other ancient Roman sites. During 1987, a new art gallery for the Guildhall was being constructed, which enabled an investigation of the area being prepared for the foundations by the Museum of London Archaeology Service. As expected, Saxon specimens were found but discovery of the amphitheatre just as the dig was being completed was a great surprise. It caused the complete redesign of the gallery building in order to encapsulate the remains in a space at 8 metres/26 feet below ground level. As a consequence, the art gallery was not completed or opened until 1999. It provides access to the remains of the amphitheatre. The stone foundations of the east gate and entrance tunnel are preserved, parts of the wooden drainage system can been be seen, and the sand which remains is from the original arena floor. A digital visual projection fills the space with images of part of the terraced cavea, which once accommodated 6,000 spectators.

A contrasting slice of history positioned at Guildhall is the City of London Police Museum, accessed from the west wing entrance at the corner of Aldermanbury and Gresham Street by the Guildhall Library. A space of small rooms and corridors, its displays are devoted to the history of the police force of the Square Mile, which is a separate authority to the Metropolitan

The façade of the Guildhall in the City of London.

Police and dates from 1839. Its officers have a distinctive cap badge with the City Crest, compared to the Brunswick Star worn by all the other police forces of England and Wales. This can be seen on several exhibits, including a damaged helmet worn by an officer called to the Old Bailey when a car bomb exploded there in 1973, which serves as a reminder that terrorism has been a leading threat in London for many decades. The museum charts the time when watchmen employed by the City of London Guilds protected property through to its modern role in countering fraud and economic crime. There is a wall of ferocious improvised weapons, which have been confiscated by the force over time. There is particular focus on two famous crimes, the Houndsditch Murders of 1911, which proceeded the Siege of Sidney Street, and the murder of Catherine Eddowes, a victim of Jack the Ripper, whose final hours are recreated in a hologram display. The history of communication is described from the early police public call posts, a blue-painted example of which is preserved here. There is a timeline of the development of police uniform and also an offbeat story that ties together the Olympic Games, tug of war and the City of London police. The collection also tells the story of the Suffragette movement and the escalation of their campaign for women's emancipation. Housed in the museum are two homemade bombs believed to have been used by the suffragettes but which failed to detonate – one explosive device made from a milk tin was found outside the Bank of England, while the second was made from a mustard tin and left under the Bishop's chair in St Paul's Cathedral in May 1913.

On the south side of Guildhall Yard is St Lawrence Jewry church. The name was applied to distinguish it from other St Lawrence churches, and comes from the Jewish enclave which thrived here before the Jewish people of London were expelled by Edward I in 1290. There is a street nearby called Old Jewry. The church that first existed here was reported to be particularly fine with much stained glass, but this was destroyed in the Great Fire. The replacement was designed by Sir Christopher Wren, who managed a nave of symmetrical proportions with few right angles by thickening the walls. It was one of the most expensive churches designed by Wren. The church was severely damaged in 1940 but rebuilt to the original design between 1954 and 1957, with the richly detailed interior of white walls and dark carved oak screens restored. The weathervane is in the shape of gridiron, the symbol of the martyrdom of St Lawrence. St Lawrence Jewry is a guild church rather than a parish church. It is the official church for the City of London, hosting events and ceremonies involving the Lord Mayor of London and concerts and organ recitals. A

The Roman amphitheatre's original walls, built in the second century.

window near the pulpit depicts Sir Thomas More, former Lord High Chancellor under King Henry VIII, who was born in Milk Street, just a few paces from the church. In 1501, More delivered lectures here on the relationship between Church and State. The churchyard is long paved over and is encompassed by the dark oval stone marker outlining the site of the Roman amphitheatre.

—

Guildhall Yard, off Gresham Street

London EC2V 5AE

ABOVE *A long gallery of seized weapons feature in the police museum.*
OPPOSITE *The plaque pictured here commemorates Sir Thomas More's birthplace in Milk Street (above); the interior of the church St Lawrence Jewry, near the former medieval Jewish ghetto (below). The medieval church was destroyed in the Great Fire of London but designed and rebuilt by Sir Christopher Wren.*

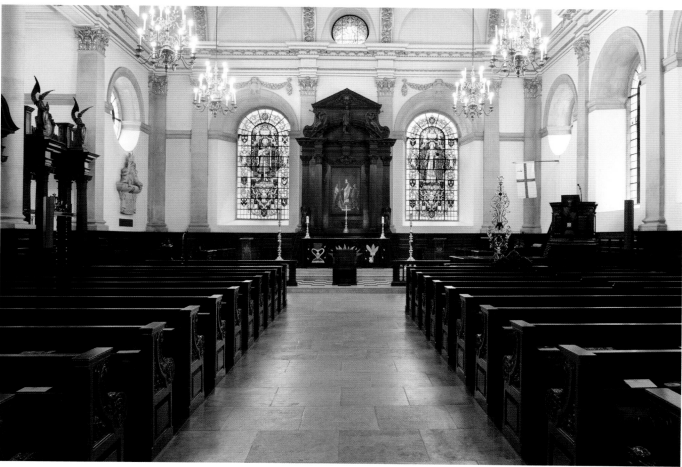

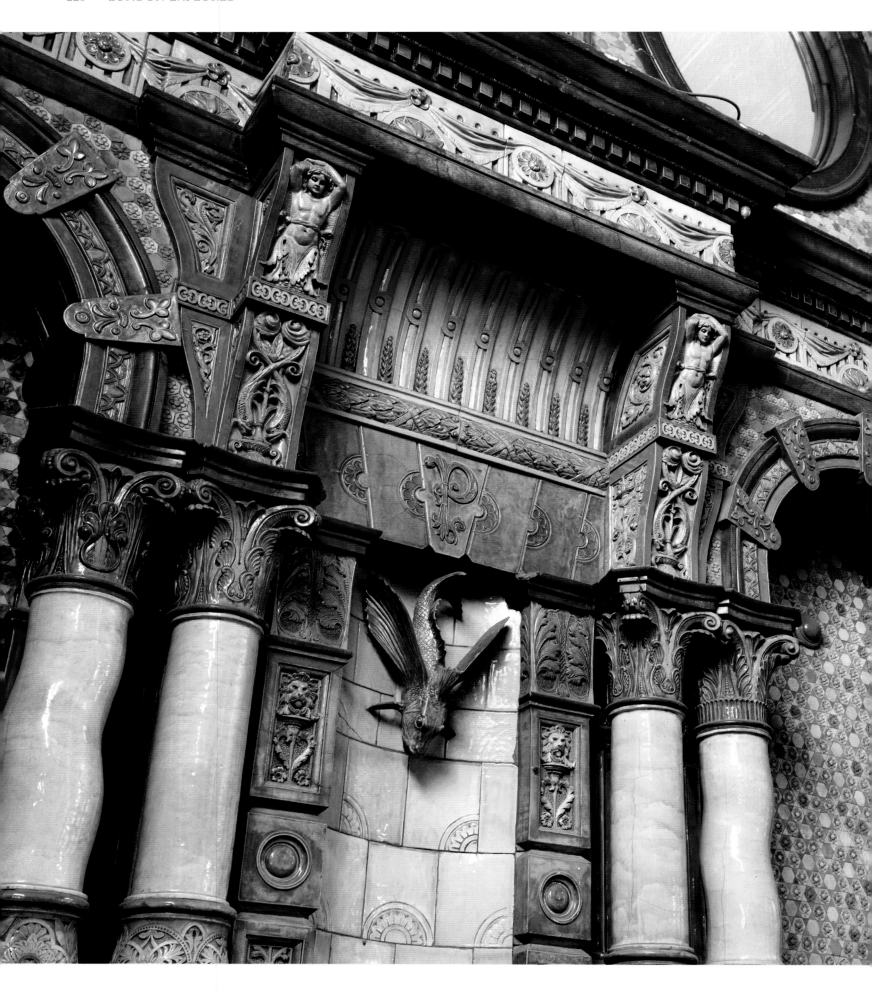

Old Lloyds Bank

Best known as the home of the Law Courts branch of Lloyds Bank, this building on the Strand was poised to become a restaurant pub in 2021, returning close its original purpose after a span of almost 140 years.

After the opening of the Royal Courts of Justice complex on the Strand by Queen Victoria in December 1882, a new eating house was established directly across the road. Known as the Royal Courts of Justice Restaurant, it was aimed at serving lawyers, their clients and other members of the legal profession.

The most remarkable feature is its exotic entrance lobby, with walls and ceiling completely lined in glazed tiles and unglazed mosaics. Twisted barley sugar pillars, ornamental fountains, floral medallions and flying fishes are rendered in translucent glazing in shades of blue, brown and sea-green. A second inner lobby is panelled with American walnut and sequoia, and detailed with flora and fauna. The hall, which served as the dining room, is restrained by comparison but boasts white painted columns mounted on dark wood bases carrying pictures of flowers and plants. The walls have more hand-painted Royal Doulton panels showing characters and quotations from Ben Jonson plays and quotations from Shakespeare.

The architects of the restaurant were Goymour Cuthbert, who had designed the Union Bank of Australia in Cornhill in London and William Wimble, creator of the Baltic Exchange, while the tiles were made by a craftsman named John MacLennan, but it is not clear whose inspiration and guiding hand was behind all of the lavish decoration. It seems to have owed something to the vogue for Merrie England at the time, or the Arts and Crafts Movement. Whoever curated the designs was closely in tune with the history and folklore of the locality. Dramatist Ben

Close-up of the entrance hall at the old Lloyds Bank. When it opened, it was described as the 'handsomest and most elegant bank in London'.

ABOVE *Highlights of the banking hall – a series of Royal Doulton tiles depicting characters and scenes from plays by Ben Johnson.*
OPPOSITE *Ornate tiled friezes, pillars and a fountain played host to London's legal elite who practised law at the Royal Courts of Justice opposite.*

Jonson had indeed been a local figure whose place of worship had been St Clement Danes across the road (see pages 34–7). The gardens of the Inner Temple nearby grew the flowers depicted on the panels, one of which evokes the scene in Shakespeare's *Henry VI Part 1*, where red and white roses are plucked in the Inner Temple Gardens. Inner Temple Gardens was home to the Royal Horticultural Society Spring Show until it was switched to Chelsea in 1911.

Another inspiration was the old Jacobean Palsgrave's Head Tavern which once stood close by, where Ben Jonson was reputed to have been a regular. The name came from Frederick, the Elector Palatinate of the Rhine, later King of Bohemia, whose royal title included Palsgrave. He had come to England in 1613 to marry Princess Elizabeth, eldest daughter of James I of England and VI of Scotland. Frederick and Elizabeth are depicted on panels flanking a doorway.

The Royal Courts of Justice Restaurant looked like a sound commercial proposition. It featured much modern technology, electric lighting from its own steam-driven generator and an early form of assisted ventilation, and drew water from its own

artesian well. But with lawyers able to dine at nearby Inns of Court, business was disappointing and the restaurant closed after three years. Another attempt to operate it was made when it was acquired by owners of the Spears & Pond restaurant chain and it opened after a rechristening as the Palgrave on the Strand. Again it was not successful and the restaurant closed once more.

At this time Lloyds Bank, Birmingham-based, was growing by acquisition and aiming to establish a stronger presence in London. It took over the small Twinings bank related to the tea business, which had its heartland on the Strand, and installed Herbert Haynes Twining as manager in the newly acquired building at 222 Strand in 1895. Lloyds Bank operated there until 2017. In early 2020, permission was granted for its conversion into a Wetherspoons pub serving up to 591 customers.

—

222 Strand, Temple
London WC2R 1BA

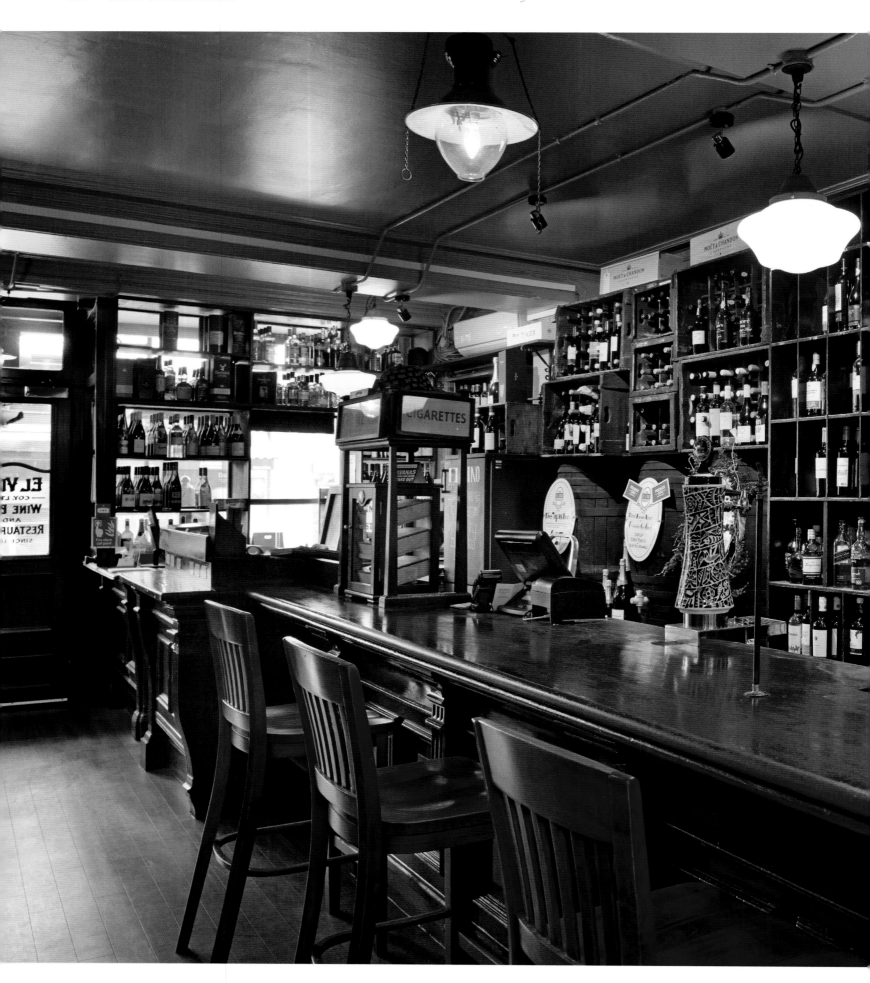

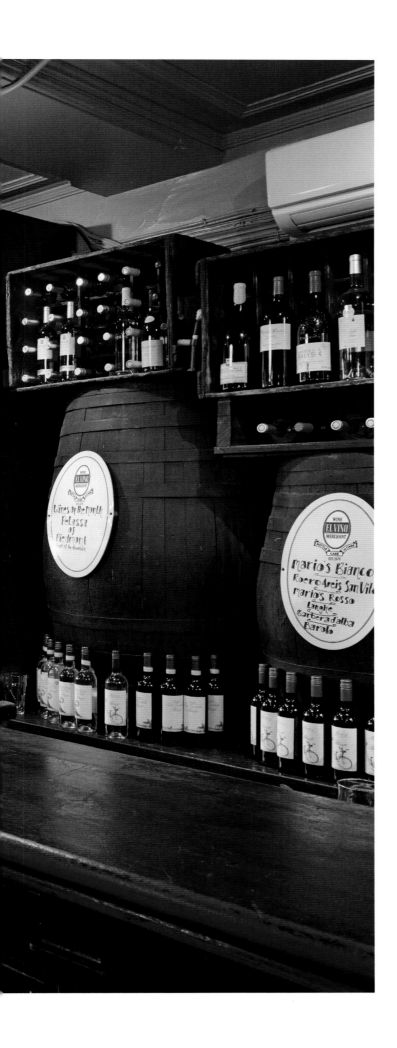

El Vino

The most famous of several El Vino wine bars in London is the one at 47 Fleet Street, a place with indelible links to journalists and lawyers. Its location has determined its legendary status. A few steps east is the place where newspapers once boomed, and to the west are the Law Courts, Inns of Court and lawyers' chambers. El Vino thrives today and is still a lawyers' local but with a more eclectic crowd now replacing the departed journalists.

El Vino is a wine bar of the old style, with a polished counter fronting racks of bottles and barrels of sherry and port. Alongside is more wine in cabinet cages. There is a cosiness at the back bar where table service operates and in the dining room downstairs, partly divided into booths. Some of the tables and chairs bear the names of illustrious former customers and the walls are hung with caricatures and cartoons, a reminder that El Vino has been moulded by the personalities of its inhabitants.

It is necessary to imagine El Vino with newspapers in London at their high-water mark, more than 3,000 journalists working on twelve national morning newspapers, eight Sunday papers and three London evening titles and the printers and presses that served them. Add to this teeming mix six domestic news agencies and several international wire services, numerous offices for provincial newspapers, offices of foreign papers, and magazines and trade papers. All of this was on Fleet Street and the streets nearby. There was a distinct social order at lunchtimes and evenings, with reporters and subeditors and printers generally favouring different places. El Vino attracted a high-level crowd of professionally opinionated editors and columnists and writers. Its regulars included: from the *Daily Mirror*, its chief, Hugh Cudlipp and the columnist William Connor, who wrote under the pseudonym of Cassandra; from the *Telegraph* and *Sunday*

The main bar at El Vino in Fleet Street, a meeting place for exalted editors, humble hacks and lawyers.

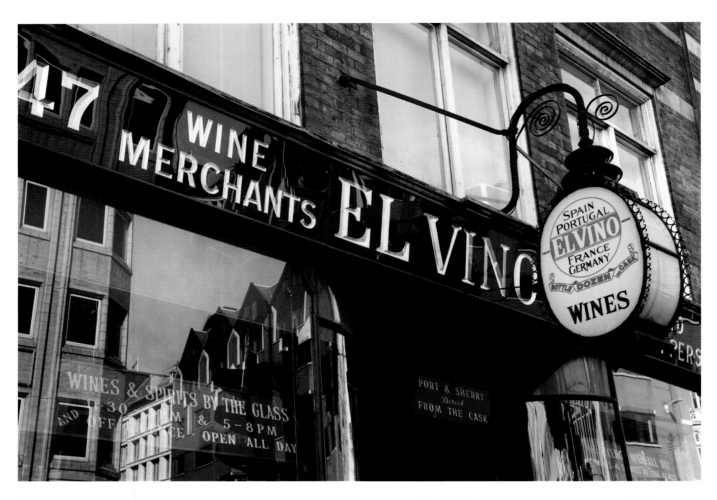

Early telephone communications in the main bar.

Telegraph, Peregrine Worsthorne; from the *Daily Mail*, columnists Peter McKay and Nigel Dempster. The political commentators Paul Johnson and Alan Watkins were El Vino regulars. It was also a regular watering hole for Bond author Ian Fleming when he worked for stockbrokers nearby before the war and had his writing office between 1957 and 1964 just around the corner in Mitre Court. Novelist Michael Frayn, himself a former Fleet Street operator, recreates a scene in his novel *Towards the End of the Morning*. From a Fleet Street window at lunchtime the literary editor and the foreign editor are seen departing for the Garrick by taxi, the subs are walking to the café, and the advertising chiefs are strolling to El Vino. The El Vino manager for many years, Geoffrey Van-Hay, was a legendary character, a big man, impeccably dressed, who kept order with considerable wit and charm and was also capable of ejecting and banning Fleet Street's highest and finest when necessary.

For years El Vino ruled that women could not order their own drinks at the bar and had to accept table service or ask a man to buy them a drink. A controversy followed after that was challenged by solicitor Tess Gill and journalist Anna Coote, who won a case in the Law of Appeal in 1982 that overturned the policy. El Vino marked the 35th anniversary of the ruling in November 2017 with a special event, emphasizing that everybody is now welcome at El Vino in equal measure.

The popularity of El Vino within the legal world continues as strong as ever and *The Law Society Gazette* has noted you might see 'on the right night any number of QCs (Queen's Counsels) deftly avoiding their round'. Another indicator is found in the Rumpole connection. For years followers of John Mortimer's *Rumpole of the Bailey* stories have wondered about the inspiration for the barrister's watering hole, Pomeroy's wine bar, and legal insiders have always said that it was modelled on El Vino. Now the wine bar has christened one of its spaces the Rumpole Room, which makes it official.

The business was started in 1879 by wine merchant Alfred Louis Bower on Mark Lane, in the City of London. In 1915, with the ambition of becoming the Lord Mayor of London, he stood to become an alderman, but was told that for his ambition to be fulfilled, he would have to cease trading in the City under his own name. As a result, the company name was changed to El Vino and Alfred Bower became Lord Mayor between 1924 and 1925. In the early 1950s, two descendants, brothers Christopher and David Mitchell, joined the business as the third generation becoming joint managing directors in 1960. They guided the company until 1979, when David took up a post as a government minister and Christopher became sole managing director. It was purchased by another family wine business, Davy's, in 2015.

El Vino at 47 Fleet Street first appears in the Post Office Directory of 1920. The building housed a hall of mirrors before the wine company acquired it.

—

El Vino

47 Fleet St, Temple

London EC4Y 1BJ

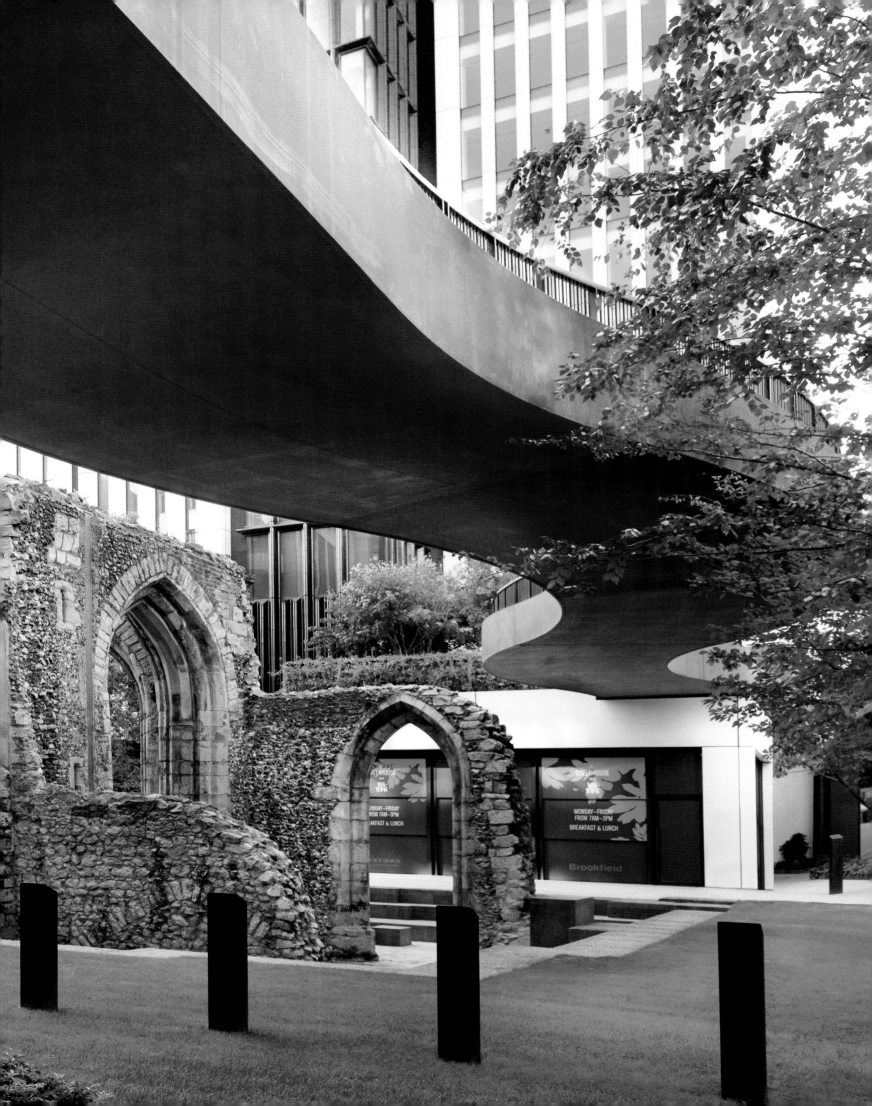

Pedway at London Wall

Once upon a time there was a dream of pathways rising above the bustle of the old City streets to connect places of commerce, hospitality and residence. This was not just a fairy tale, as evidence suggests alongside the street named London Wall. Here a curvaceous elevated footpath, St Alphage Highwalk, spans an ancient churchyard. It is a modern fragment of the pedway, a system of high-level footpaths once intended to cover the City.

A masterplan in 1947 to reconstruct the devastated City by architect Charles Holden and planner William Holford included making the minor London Wall into a multi-level, four-lane, east–west inner ring road. It was designated Route 11. Most of the Holden-Holford plan languished, but a scrap of the Route 11 proposal survived and construction started in 1960 on a group of six modernist high towers by a widened London Wall. These included connecting pedestrian walkways with shops and kiosks on an elevated deck. Alongside came the residential Barbican Estate development, with its own network of pedestrian thoroughfares. While the Barbican prevailed and gained the grudging respect of Londoners, the towers on London Wall were built, demolished and replaced, and some of the pedestrian deck disappeared. Elsewhere the pedway plan barely got started. A few isolated parts and some linking footbridges remain across the City.

St Alphage Highwalk is an exception, completed in 2018 after the first wave of towers were replaced. Designed by Make Architects, it links with a cable-stayed bridge that crosses the street at a rakish angle. The new highwalk, designed as a long cantilever that required no supporting struts, opened up a niche of history.

Below stand the ruins of St Alphage's Church, a pretty garden and a length of wall. The church has the strange distinction of being bombed in two world wars, blitzed by biplanes in 1917, before being gutted by fire again in 1940. The remains narrowly survived peace as the Route 11 plan made it a prime candidate for demolition and neo-gothic parts were stripped away, partly to enable the construction of the original highwalk. This left the gaunt stonework of a tower dating back almost 700 years. Beyond this now, in plain sight, is the City Wall itself, medieval stone at the top and second century AD Roman construction below.

—

London Wall Place, Barbican, London EC2Y 5AU

St Alphage Highwalk, a sinuous essay in pre-oxidized metal known as weathering steel, snakes above the ruins of the tower in the ancient churchyard.

Museum of the Order of St John

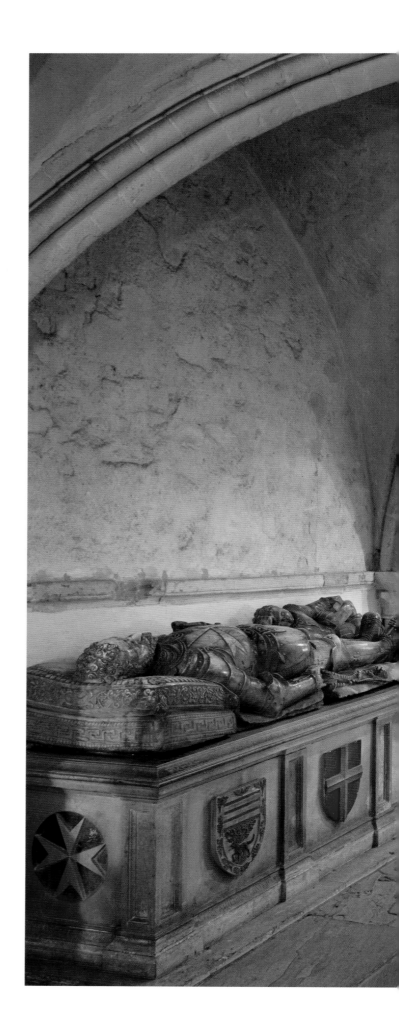

The secrets of the Museum of the Order of St John are best appreciated by visiting two places: a gatehouse that straddles St John's Lane and the separate church and ancient crypt of St John Priory.

These places were once grouped together in the precinct of the Knights Hospitaller's Priory of St John. The priory was an extensive establishment in Clerkenwell set up in 1140s covering ten acres. It was the English headquarters of an order derived from a place established by monks in Jerusalem to look after pilgrims to the Holy Land, which later took on a military role to protect those threatened in its care.

With the dissolution of religious houses by King Henry VIII, the English order was ended and the priory closed in 1540. The order was restored briefly by Queen Mary but on the accession of Queen Elizabeth I it was dissolved and fell into abeyance. Later, the gatehouse, St John's Gate, became the office of the Master of the Revels, deputy to the Lord Chamberlain, who was responsible for theatrical censorship and granting approval of plays for production. Several of Shakespeare's plays were licenced here and some historians and researchers claim that William Shakespeare regularly visited St John's Gate. It later housed the print works and office for *The Gentleman's Magazine*, a place where Samuel Johnson worked, and part of it was a coffee house that later became the Old Jerusalem Tavern. Charles Dickens was a regular.

In the nineteenth century, the threads of the old Order of St John were picked up in England and a reconnection was made in 1873 when the modern Order of the Hospital of Jerusalem gained ownership of the gatehouse. The St John's Ambulance Association formed in 1877 and the St John's Ambulance Brigade in 1887 and the company was granted a royal charter by Queen Victoria in 1888, becoming an order of chivalry. The gatehouse,

The crypt, dating from 1140, underneath the priory church.

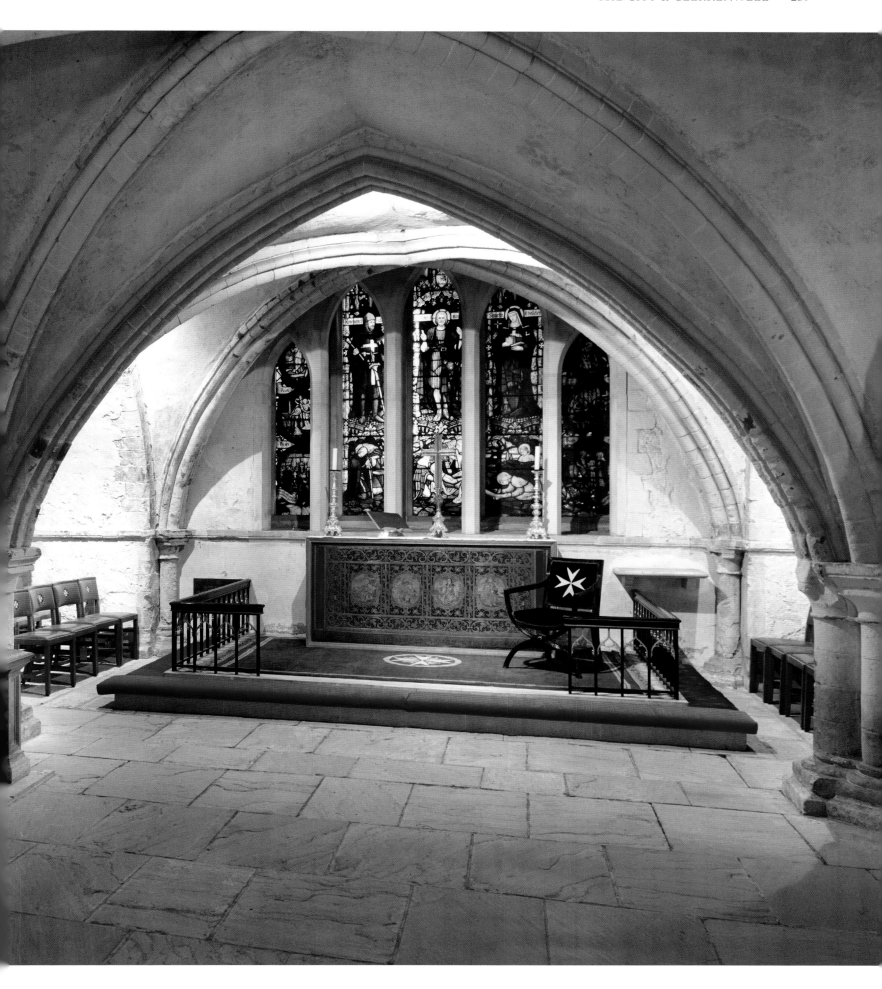

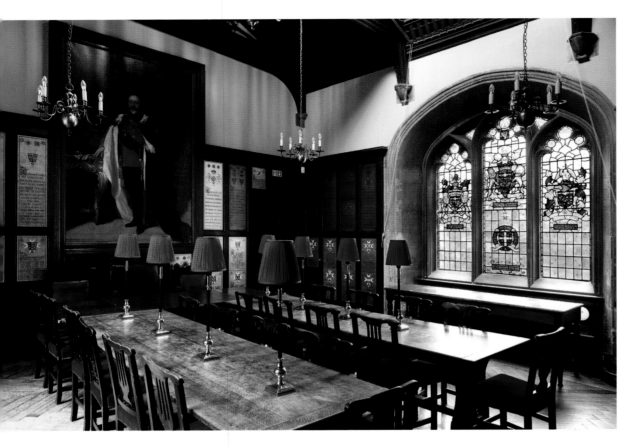

RIGHT *The council chamber room.*

OPPOSITE *The alabaster tomb of a knight of the Order of St John in the crypt (above); a nineteenth-century Furley stretcher in the priory church (below).*

OVERLEAF *The Chapter Hall has a high timber ceiling and lantern roof.*

which dates from 1504, was extensively reworked during these years, gaining a Tudor-style interior for the council chamber, which spans the archway. The pub was removed from the eastern part of the gate. The Chapter Hall, an extension added in St John's Lane, has a high timber ceiling and lantern roof, heraldic glass and perpendicular fireplace.

These rooms are on the upper levels and below are the museum galleries, which tell the history of the Order of St John from the twelfth century in pictures and furniture, silver, metalwork, armour, ship models, ceramics and sculpture.

Across the Clerkenwell Road lie the church and crypt, which complete the narrative. The crypt is a remarkable survivor dating from the twelfth century, once attached to a circular chapel modelled on the Church of the Holy Sepulchre in Jerusalem; the traces of its curved wall can still be detected. The crypt is a Romanesque arched space, which has a slightly subterranean quality, the street level of London having risen across 800 years. A recumbent alabaster tomb effigy of a Castilian Knight Hospitaller in full armour, with the Order's eight-pointed star on the breastplate, lies in the crypt. Stained glass shows the Order offering protection to pilgrims.

Some parts of the priory were used as a store for tents and military equipment after the dissolution, but the priory church was plundered for stone for improvements to Whitehall Palace. In 1549, the Lord Protector Somerset used explosives to flatten the remains to provide building material for his new house in the Strand, Somerset House.

The replacement was a parish church completed in 1723. In 1931, the Church of England transferred ownership to the Order of St John. It was gutted by fire in the Second World War and rebuilt between 1951 and 1958. It carries the colours of the Order in the black-and-white terrazzo floor. Simple and hall-like in design, finished all white with plain rather than stained glass, it is intended to be equally suitable for secular and religious purposes. A memorial garden was created to the south of the church.

The Order of St John has 25,000 members around the world. Its full name is the Most Venerable Order of the Hospital of St John of Jerusalem. The museum galleries on the ground floor at St John's Gate can be visited at any time during opening hours and so can the garden, but visits to the historic rooms and the crypt and church can only be made on tours with a guide.

—

Museum of the Order of St John
St John's Gate
26 St John's Lane, Clerkenwell
London, EC1M 4DA

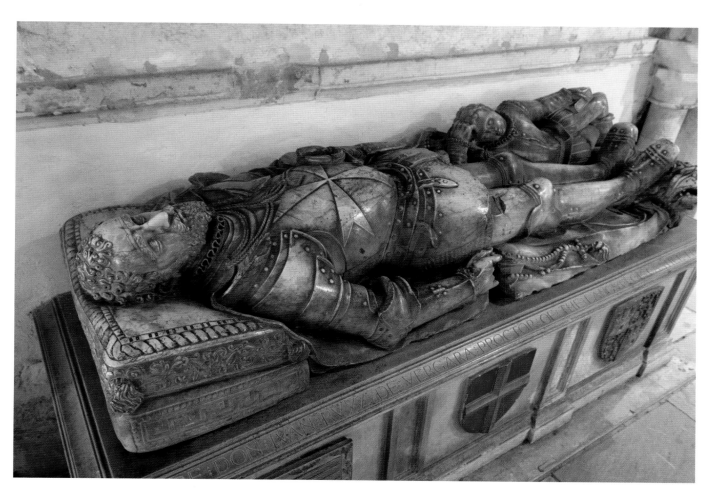

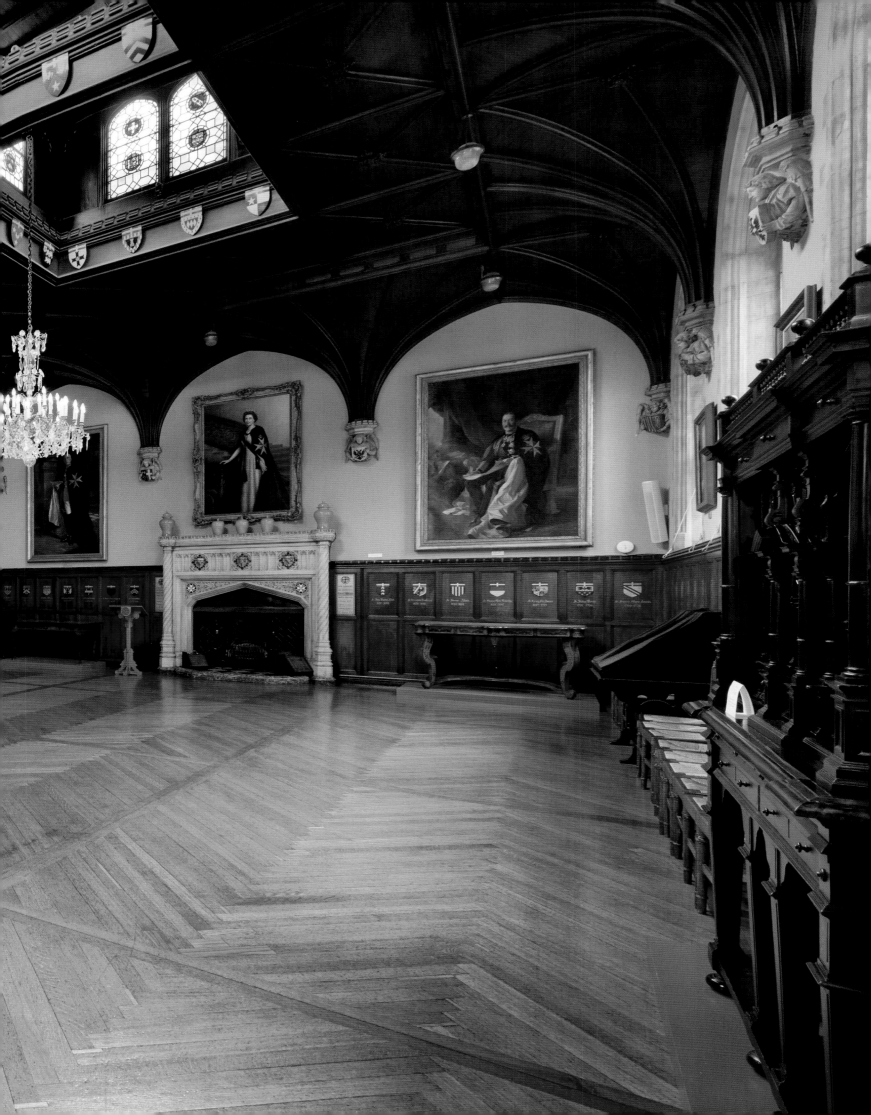

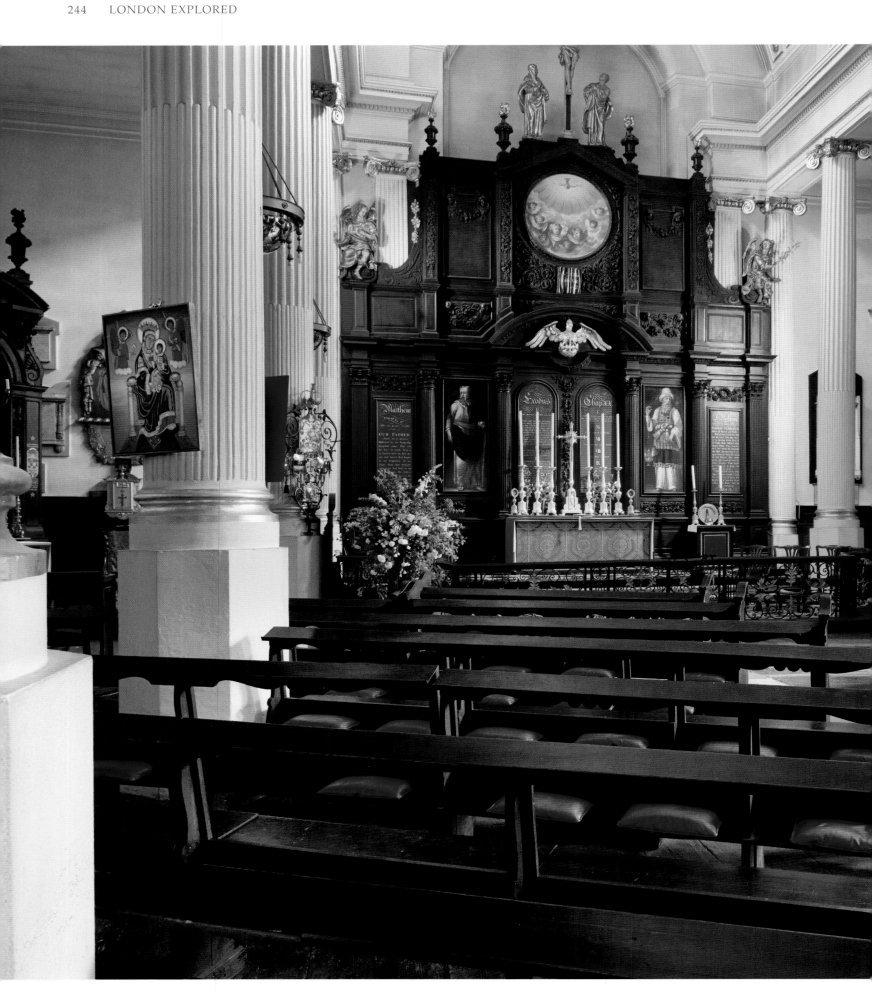

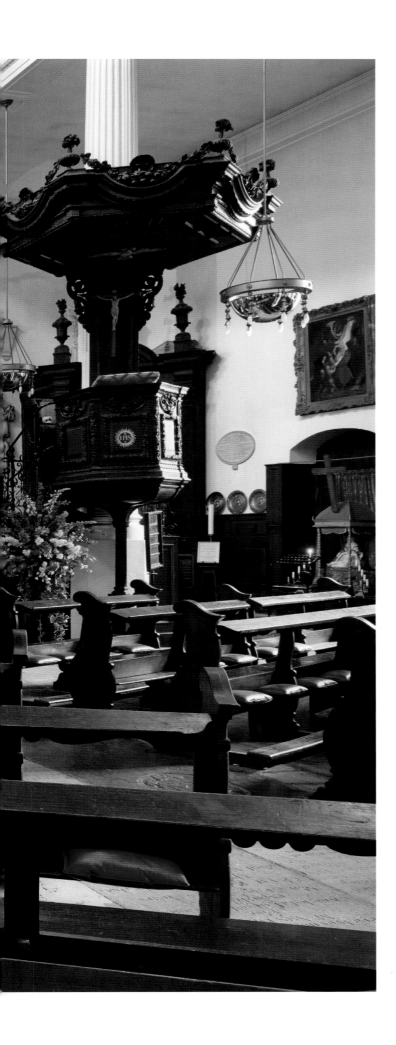

Looking towards the altar at St Magnus the Martyr.

St Magnus the Martyr

St Magnus the Martyr church has been shaped by fire and water throughout its history, and it occupies a special position as the City of London church closest to the river. It once flanked the main gateway into the City from London Bridge. Always subject to the encroachment of surrounding buildings and roads, the architecture of the church has not escaped molestation, but it remains as a mostly elegant survivor, and one of the most active and best liked of City of London churches.

Its origins are dimly glimpsed, with the first church close to this place recorded in 1128–33, and its likely dedication is attributed to the Viking St Magnus, Earl of Orkney, who died in 1118. The existence of a timber Saxon bridge at this spot determined the positioning of a church. The church grew in importance after the stone bridge, known as Old London Bridge, was built between 1176 and 1209 and soon covered in buildings. The parish spanned the bridge approach on the north side and the church was sited on the waterfront. The fabric of the church survived the turmoil of the late Middle Ages and the Tudor years that followed. Playwright Ben Jonson is believed to have been married at St Magnus in 1594. The church narrowly escaped destruction by fire in 1633 when forty-two neighbouring houses were destroyed but did not escape the Great Fire of 1666. The bakehouse in Pudding Lane where the fire began was less than 300 yards distant from where St Magnus stood. The church was one of the first buildings to be destroyed.

The replacement church was designed by Sir Christopher Wren and at a cost of just over £9,500 was one of his most expensive churches. The new church was finished in 1684 and has one of the most impressive towers of any of his London churches, but the building was altered in the 1760s, mostly to accommodate changes to London Bridge. Two west bays were demolished when

Surviving remains of Old London Bridge, next to the church.

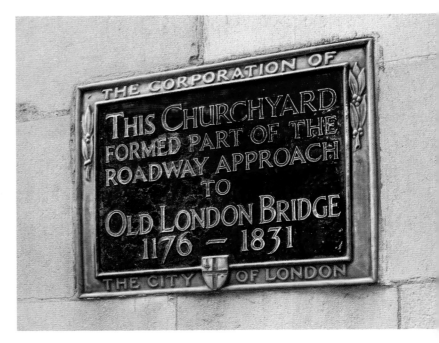

A plaque on the wall of the church commemorates the connection to the old bridge.

the bridge was widened and the pavement needed to be run under the tower. A further fire, which broke out in an oil shop at the south-east corner of the church, destroyed the roof in 1760 and damaged the fabric of the building. At some point an entrance door on the north face of the church was closed off and the large windows which once existed here were closed up, leaving only circular windows high on the wall, possibly brought about by the need to shut out the noise and smells of Billingsgate fish market nearby. St Magnus narrowly escaped damage from a major fire in Lower Thames Street in October 1849. Yet it suffered once more during the Blitz in 1940, when a bomb that landed on London Bridge blew out the windows and damaged the roof. St Magnus was designated a Grade I listed building in 1950 and repaired in 1951 before finally re-opening for worship later that year.

The perspectives and the environment changed over time. When the Old London Bridge, the medieval relic once festooned with shops and houses, was finally pulled down in 1832, the replacement bridge was built on an alignment further west. St Magnus the Martyr eventually gained a new neighbour in the shape of Adelaide House, a forbidding modern office building. The architectural authority Nikolaus Pevsner marvels that its positioning close alongside St Magnus the Martyr's steeple is entirely successful. The iconoclastic writer Ian Nairn admired the way the western side of the church, with its 1709 bracket clock, generated a sympathetic space alongside Adelaide House. On the other side of the church lies another concrete office edifice, St Magnus House, including a modern rarity in the form

of a pedestrian pedway bridge and again the contrast is not incongruous. The working waterfront close to St Magnus just yards below its churchyard remained busy until the 1960s, with sizeable freighters moored alongside in the Upper Pool and wharf-side cranes active. The Billingsgate Market remained until 1982, while London Bridge was replaced again between 1967 and 1973.

The interior of the church comprises a nave and two aisles and slender columns marking divisions, although the arrangement is not to the original Wren design. The church was restored in 1924, in a neo-baroque style, reflecting the Anglo-Catholic character of the congregation. It continues in High Church tradition. The organ case, which remains in its original state, is claimed as a fine example of the Grinling Gibbons' school of wood carving, while the organ itself, the first to have a swell-box, has been restored ten times, most recently in 1997. The stained-glass windows in the south wall, which date from 1949 to 1955, represent lost churches associated with the parish: St Magnus and his ruined church of Egilsay, St Margaret of Antioch with her lost church in New Fish Street, St Michael with his lost church in Crooked Lane and St Thomas Becket with his chapel on Old London Bridge.

St Magnus' close relationship with the ever-changing London Bridge has continued for more than 800 years. A prized exhibit inside the church is an accurate and detailed model of Old London Bridge, created by David T. Aggett, a liveryman of the Worshipful Company of Plumbers. Over 900 model people can be seen on the bridge, including a miniature King Henry V. Outside lie some stone arch pieces rediscovered from the old bridge and beneath

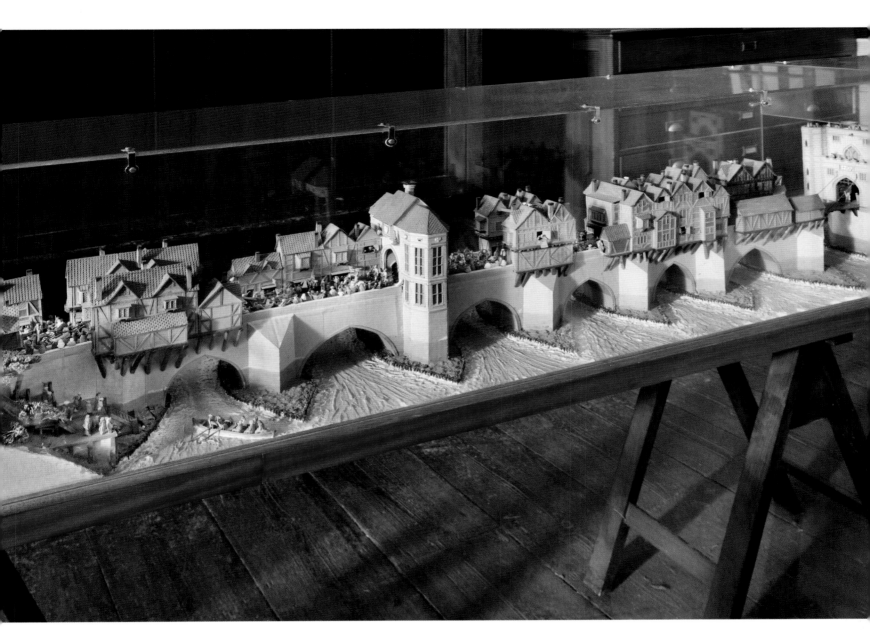

Inside the church is a detailed scale model of Old London Bridge, which was covered with buildings and was a main thoroughfare in medieval times.

the tower are preserved some fragments of oak from the ancient Roman embankment.

The church's prominent position and noted design have induced a number of mentions in literature. Charles Dickens described the spire of St Magnus in his novel *Oliver Twist* and the poet T.S. Eliot, who once worked nearby at Lloyds Bank in King William Street, was moved to write about St Magnus the Martyr in *The Waste Land*, praising its location and its interior:

O City city, I can sometimes hear
Beside a public bar in Lower Thames Street,
The pleasant whining of a mandoline
And a clatter and a chatter from within

Where fishmen lounge at noon: where the walls
Of Magnus Martyr hold
Inexplicable splendour of Ionian white and gold.

—

St Magnus the Martyr
Lower Thames Street
London EC3R 6DN

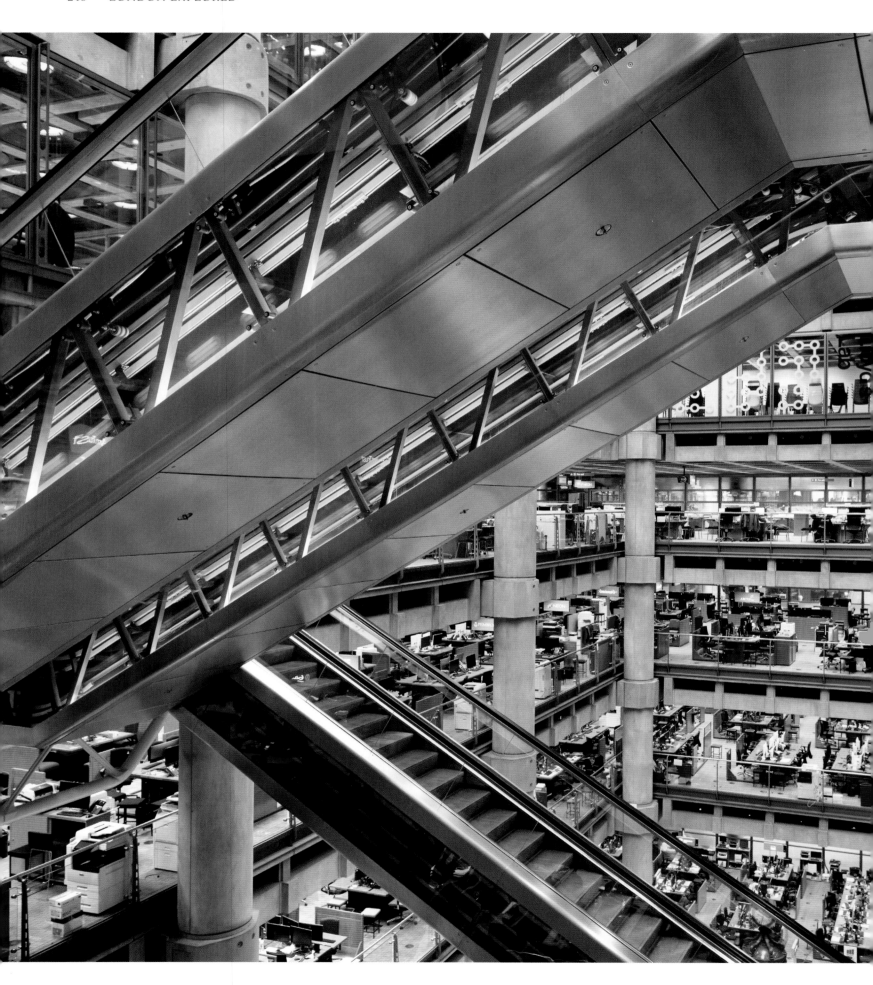

Lloyd's of London

In the City, the application of facetious names to new buildings has flourished: the Gherkin, the Cheesegrater, the Walkie-Talkie and the Scalpel. One particular building was once dubbed the Oil Rig, the Coffee Percolator and the Motorcycle Engine, but these names did not stick. Lloyd's of London on 1 Lime Street brushed them off to be celebrated as one of the outstanding British architectural achievements. It became the youngest structure to be awarded Grade I listing, receiving the recognition in 2011, just twenty-five years after it was completed. The Historic England listing describes it as 'an awe-inspiring futuristic design with essential elements that survive remarkably well' and 'form a wonderfully incongruous backdrop' to many neighbouring listed buildings in the City.

It was also once described as 'a building on life support', a reference to the way the pipes, ducts, lifts, staircases and toilet pods are hung outside the supporting structure. The architecture was by the Richard Rogers Partnership. Richard Rogers had collaborated on the Centre Pompidou in Paris, a trail-blazing design of the 1970s, which had externalized air conditioning, electricity and water supplies in order to free up usable space inside. In the Lloyd's building the idea was taken further, but unlike at the Pompidou, the building does not depend on a steel frame. Although from most outside aspects the Lloyd's building appears dominated by six gleaming stainless-steel towers, the heart of the structure is a series of twenty-eight concrete columns, which carry the fourteen floors by pre-cast brackets. The atrium rises 60 metres/200 feet to a steel-and-glass, barrel-vaulted roof. The principal business of Lloyd's is conducted in the main underwriting room – the first four levels of the atrium connected by banks of escalators. This is known simply as the Room and the desks where the underwriters work are known as boxes, a back

The Lloyd's building was designed by Richard Rogers Partnership and built between 1978 and 1986.

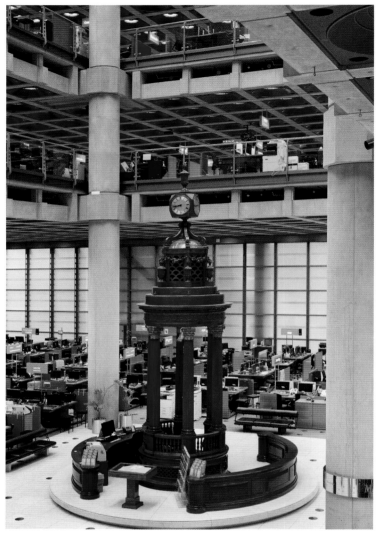

The logbook of lost ships (above) and the Lutine Bell on the ground floor (right).

OPPOSITE *A close-up of Lutine Bell, which is rung before announcements of ships overdue or lost at sea (above); the Lloyd's of London boardroom (below).*

OVERLEAF *The Lloyd's building is designed 'inside out' – all of the service functions are removed from the interior and placed at the exterior of the building. This frees up the interior to create an open and flexible plan that allows for uninterrupted activity on each level.*

reference to the tables in the corners of Edward Lloyd's Tower Street Coffee Shop of 1688. It was here that merchants with foreign interests and shipowners first did insurance business for ships and cargoes. Lloyd's has lived in eight buildings across the City over its 300-year history, while developing marine insurance underwriting into all fields of insurance. Insurance companies still pay a fee to have a box and a small percentage on every policy written goes to Lloyd's. Lloyd's provides the building and regulates how the underwriters work.

On the ground floor of the Room is the Lutine Bell, first hung in Lloyd's Royal Exchange headquarters in 1859. It was salvaged from the wreck of HMS *Lutine,* which sank carrying £1 million of gold and silver bullion insured by Lloyd's. The bell became part of Lloyd's tradition, rung twice when overdue ships came in safely, or once to signify if a ship was lost. It is mounted in the rostrum, a mahogany temple designed for the 1928 Lloyd's building based on the monument of Lysicrates in Athens. Now the Lutine Bell is struck to mark occasions of ceremony and mourning. Lost ships

are still recorded in logbooks at Lloyd's, handwritten in ink and cursive script.

Lloyd's legacy and tradition are embedded in other parts of the building. Lloyd's has a display of artefacts and memorabilia associated with Lord Nelson and Trafalgar, including his collar of the Order of the Bath, the logbook of HMS *Euryalus* active at Trafalgar, recording receipt of the signal 'England expects every man to do his duty' and a fragment of a piece sail from HMS *Victory.* The uniformed assistants at Lloyd's wearing red or blue livery who call out the names of brokers are still known as waiters, a legacy of the coffee shop origins. The Robert Adam Room on level 11 is a 1770s interior salvaged from Bowood House in Wiltshire and first intended for the committee room of the Lime Street headquarters of 1958. The façade on the Leadenhall Street side of the building working as the entrance to Tower 5 is the stone frontage of the Lloyd's premises of 1928.

—

Lloyd's of London, 1 Lime Street, London EC3M 7HA

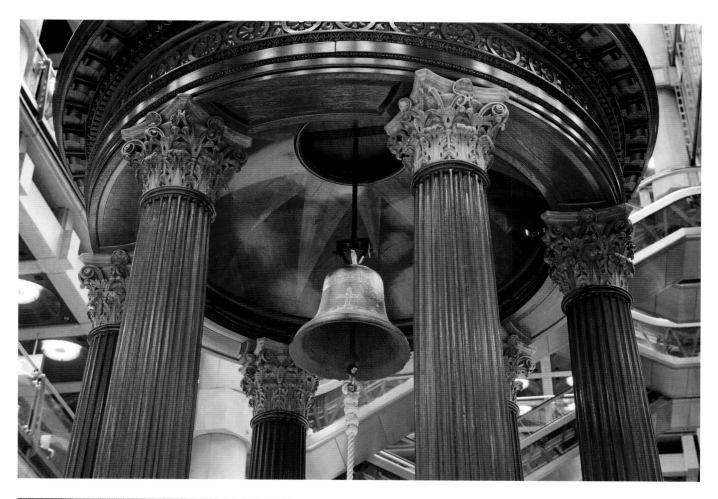

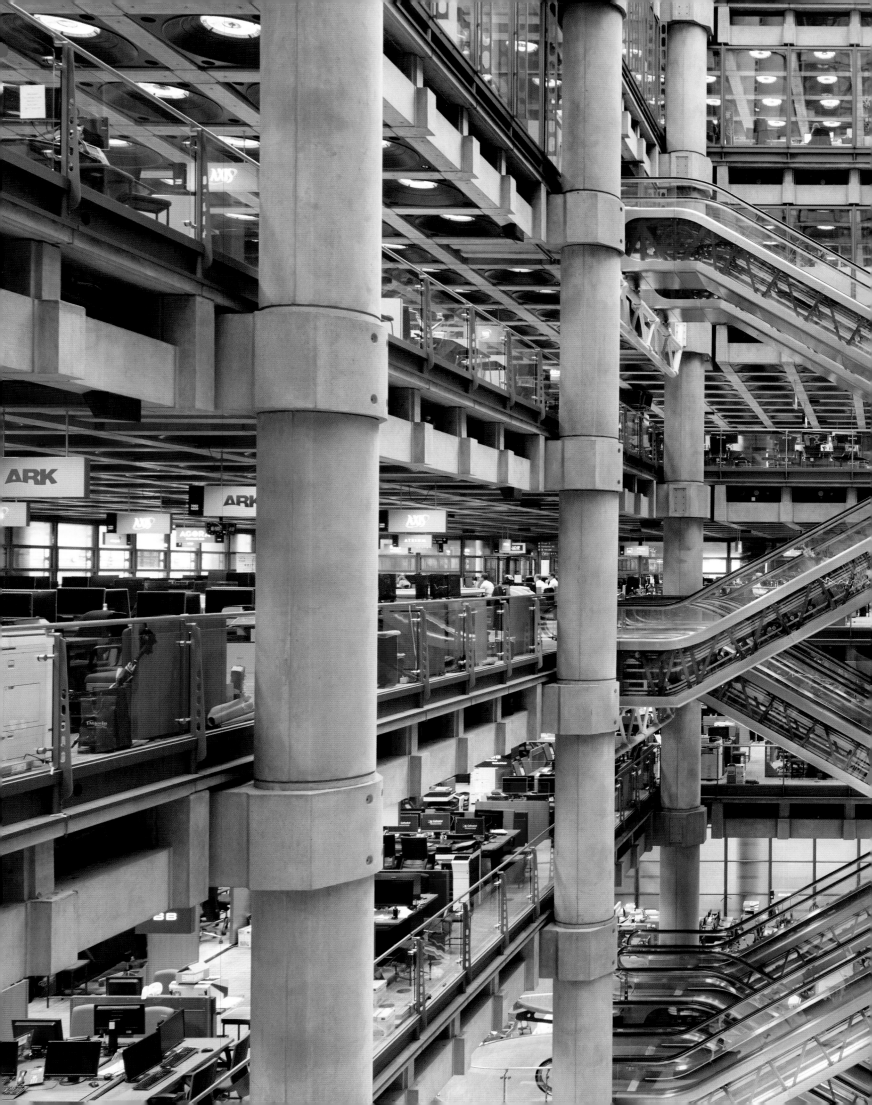

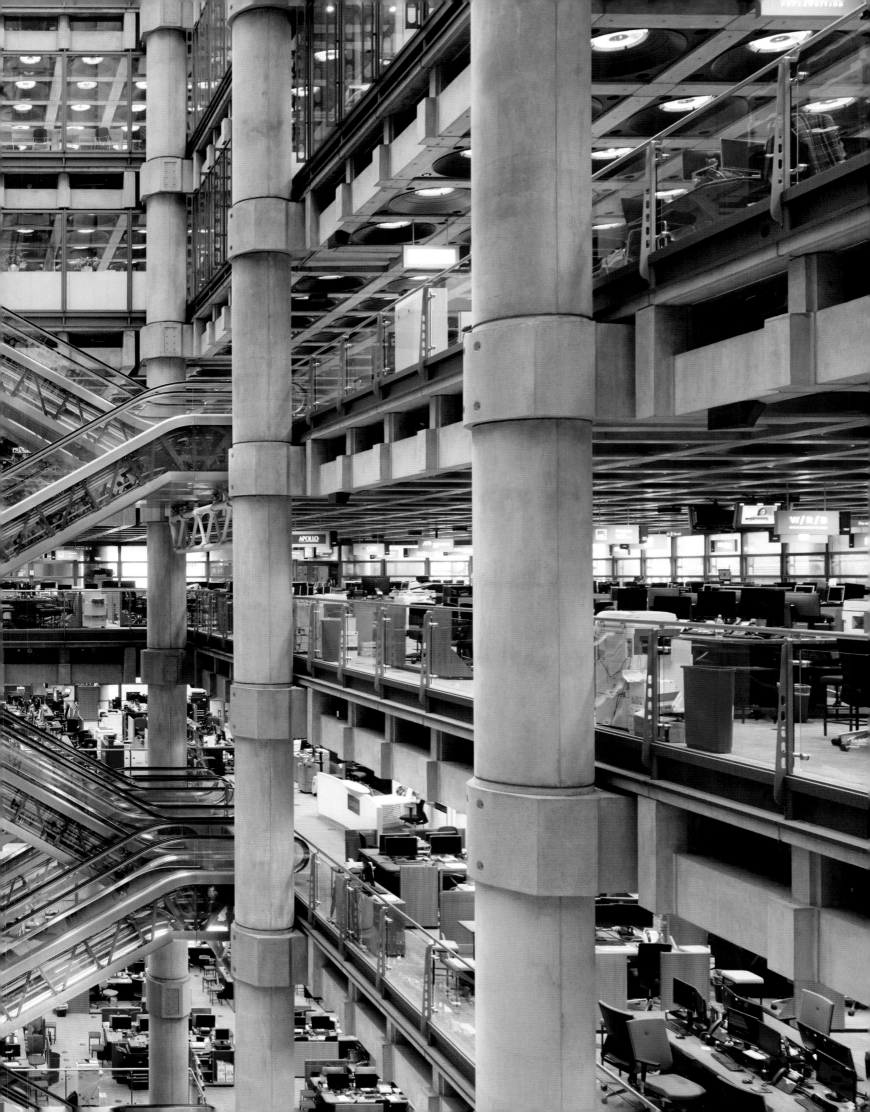

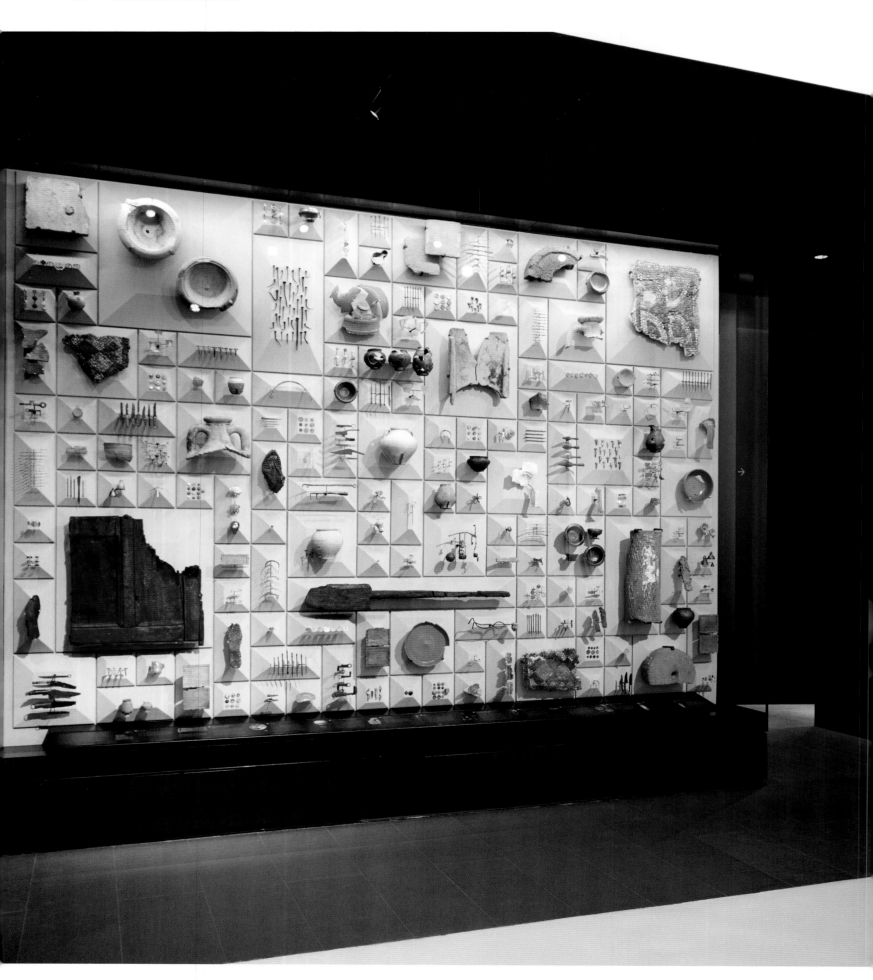

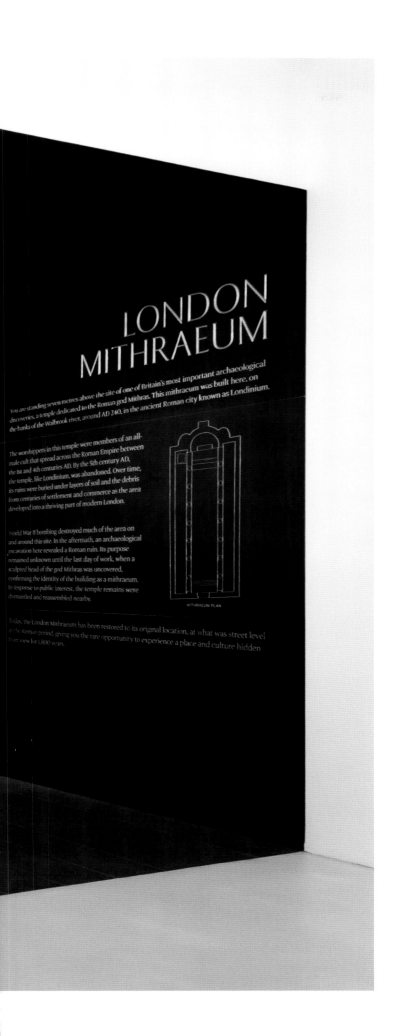

London Mithraeum

'Temple of Mithras' was once the official name of a bus stop close to the Bank of England. The name was deleted because the temple, a Roman ruin standing in plain sight on Queen Victoria Street for fifty years, disappeared in 2012.

The temple remerged under the new European headquarters building for the Bloomberg business data and news organization in 2017, as a startling recreation using smoke and mirrors to conjure the illusion of walls and columns above the ruins. Known as the London Mithraeum, it is part original stone and brick, part lightshow and part audio environment. The origins and curious mobility of the temple are a slice of London's history at both deep level and street level and also a monument to mystery and chance.

Archaeologists calculate that the temple was built during the middle of the Roman occupation of England, close to AD 240, as a gathering place for followers of a certain cult. The site lay inside the walls of Londinium on the side of a small river known as Walbrook, which ran through the middle of the city. It was built partially underground to evoke a cave-like environment.

Here lies the original mystery of the Temple of Mithras: no authority can provide an explanation of the belief system on which it is based. Some Romans, many of them soldiers, were inspired to follow a cult, which emerged in first century AD, derived from an older Eastern civilization, possibly Indo-Persian, with elements that included the killing of a bull in a cave by a deity known as Mithra or Mithras. Although Mithras had followers throughout the Roman Empire, there are no texts. Almost everything known about it has been derived from archaeology. Certain elements and symbology can be glimpsed: a god figure astride a bull being stabbed with a knife, and connections with astronomy, astrology and the cosmos. Sacrifices may have been performed during initiation ceremonies

A selection from the 14,000 individual artefacts recovered, including the first written reference to London on a writing tablet dated AD 65.

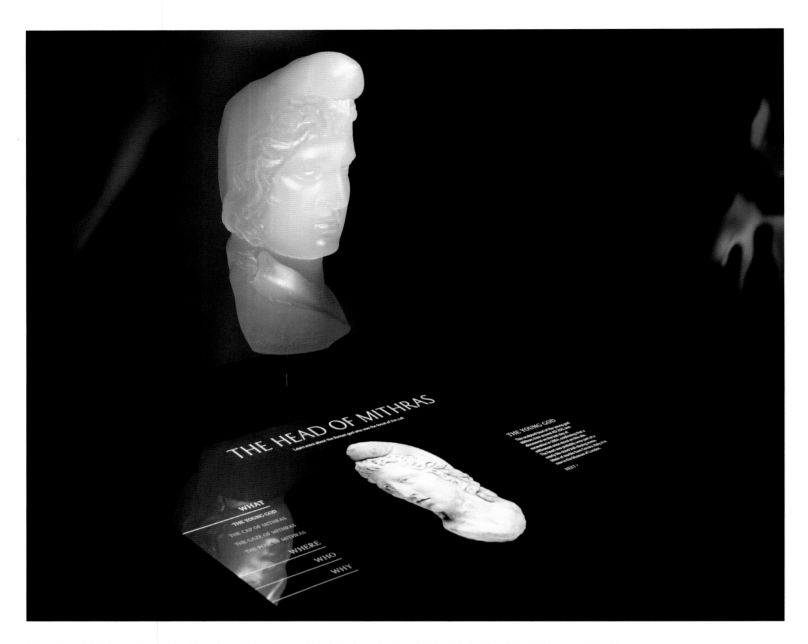

The enigmatic Mithras, characterized by soft conical cap. The original head carving found in 1954 is displayed in the Museum of London.

that included a feast, as the room seems to have been lined with dining benches. Mithraism was tolerated alongside worship of classic gods of the Roman state, such as Jupiter, Mars and Minerva, without conflict or contradiction, but Mithraism declined and there are signs that the temple was later re-dedicated to the god Bacchus.

After the last Romans departed Britain in the fifth century AD, Londinium fell into ruin. Over time the Walbrook river spread, ground levels rose and the remains of the collapsed temple were slowly buried. By the 1440s the upper part of the river was vaulted, and eventually all its length was culverted and built upon. It became a lost river of London and Walbrook became a street name.

Five hundred years later, during the heaviest night of the Blitz, 10–11 May 1941, a triangle of territory between the street of

Walbrook, Queen Victoria Street and Cannon Street was severely hit. The destruction was sealed by a V-1 flying bomb impact on 19 July 1944.

Classified under a post-war compulsory purchase declaratory order as an area damaged beyond repair, an opportunity came to mount an archaeological dig when ground was cleared for the new Bucklersbury House office complex. The team was led by William Grimes of the London Museum. As the excavation was ending in 1954, a stone-and-brick structure was uncovered. On the final scheduled day of excavation, a carved head of the god Mithras was discovered. By chance, the discovery was captured by a newspaper photographer and the publication of the picture and story caused a sensation. The freakish series of events continued as thousands

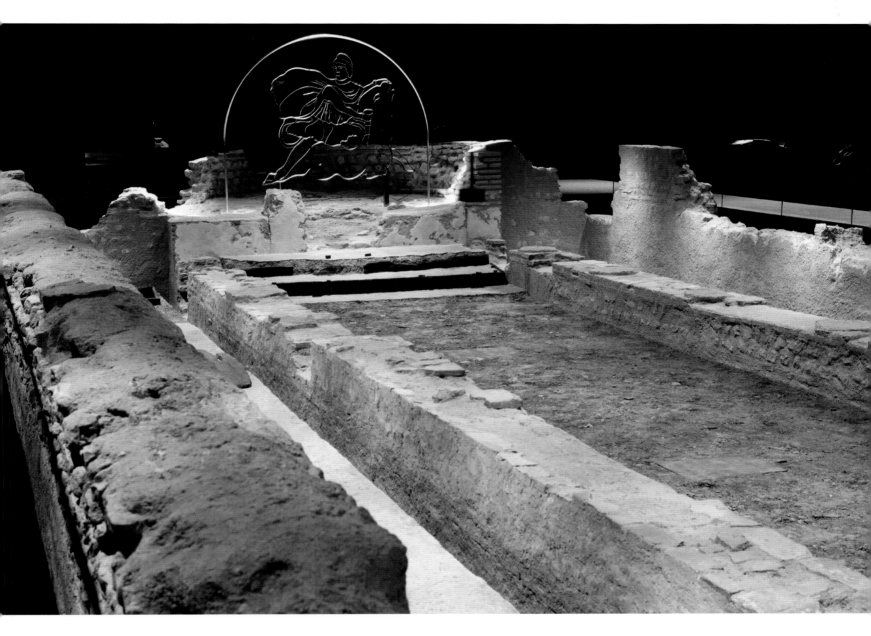

The nave and aisles of the Temple of Mithras, recreated close to its form when uncovered.

came to visit the site and view the remains. In the gloomy Britain of 1954, the find seized the public imagination and there was a strong call for preservation.

Professor Grimes had started excavations in that area only because the buried Walbrook river was likely to hold pottery remains. He later described it as 'in the nature of a fluke . . . I had no choice where to dig, there was no heaven-sent inspiration to guide the trench that revealed the temple'.

The site owners agreed to dismantle the stonework and move it, which is how the Temple of Mithras was placed over a car park on Queen Victoria Street, some 100 metres/330 feet to the west. It was far from a perfect solution, but the City of London experiences relentless cycles of change and another opportunity came when

Bucklesbury House was demolished after Bloomberg acquired the site in 2010. The temple was returned close to its original location, at the correct orientation and to a depth of 7 metres/23 feet below street level. This is under the Bloomberg building, a cutting-edge creation designed by Foster & Partners to be the most advanced commercial space in the City. Before it was constructed, another round of archaeology on the site found hundreds more artefacts in the waterlogged ground beside the Walbrook river, including a writing tablet bearing the first written reference to London.

—

London Mithraeum

12 Walbrook

London EC4N 8AA

Early morning in Leadenhall Market.

Leadenhall Market

At Leadenhall Market a sharp-eyed visitor might spot disused wrought-iron racks over smart shopfronts and wonder about their purpose. These racks are a sign of its former life as a poultry and game market, where close to 50 tonnes of poultry were hooked up for sale every week as recently as the 1970s. Leadenhall Market's history reaches back much further than that.

Formerly there was a lead-roofed manor house here, owned by Sir Hugh Neville of Essex, with a courtyard where tenants of the estate did business in poultry and cheese. Later, 'Leadenhall' came into the possession of the Lord Mayor Richard 'Dick' Whittington. He gifted it to the City in 1411. Under the instructions of a subsequent Lord Mayor, Sir Simon Eyre, a master mason named John Croxton, who had worked on the Guildhall, redeveloped the old manor house into a two-storey structure, incorporating a large rectangular marketplace and a grain store. This gradually became surrounded by sprawling medieval streets.

Leadenhall survived the Great Fire, although the fourteenth-century manor house and fifteenth-century market buildings were damaged and the City Corporation took the opportunity to re-organize the layout based on three walled courtyards. The first was the beef market, which also handled leather, raw hides and wool; the second was for veal, mutton and lamb and also accommodating fishmongers, poulterers and cheesemongers; the third courtyard, called the herb market, was for vegetables and fruit. The poultry business in particular thrived and the market was rebuilt again between 1794 and 1812, retaining its narrow entrances from Lime Street and Gracechurch Street. As this part of the City became increasingly occupied by offices devoted to banking and commerce, the corporation grew concerned about the state of the stalls set up by traders inside the market and launched a clean-up campaign. Parliamentary powers were gained by the

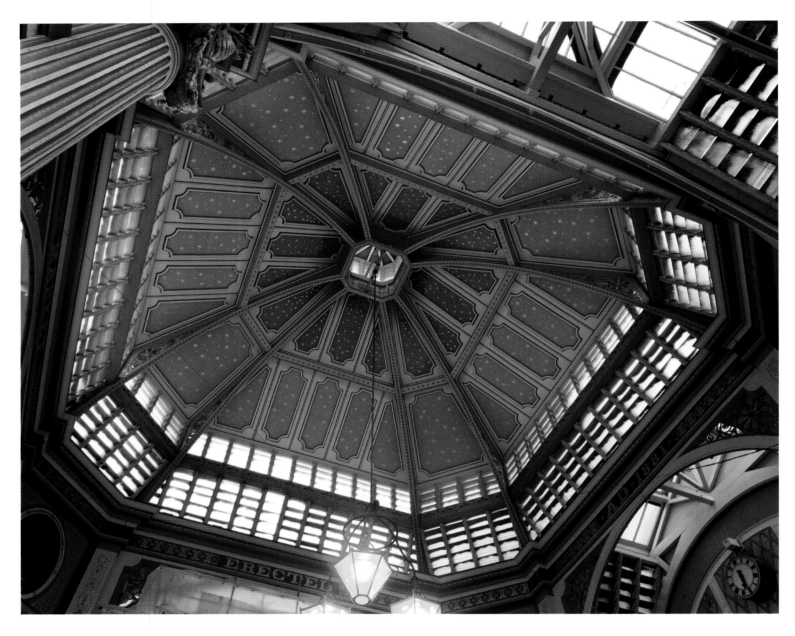

The octagonal lantern at the crossing.

City Corporation to end the hide and meat trade at Leadenhall and from the 1860s the meat trade began to shift to the new buildings at Smithfield.

Sir Horace Jones, the architect and city surveyor responsible for the development at Smithfield and also Billingsgate, was assigned to make a new arcade for the Leadenhall poultry market. At Smithfield it had been possible to clear a comparatively large area for the layout, but at Leadenhall Market the surrounding misshapen street pattern and medieval rights of way were unassailable. The challenge was to design a smart-looking covered arcade market fitting into the existing space. Jones is said to have studied the newly opened Galleria Vittorio Emanuele II in Italy – a vast four-storey glass-roofed shopping arcade that had been

devised by architect Giuseppe Mengoni to fit into the irregular historic street plan of central Milan.

The new Leadenhall Market emerged in 1881 as two avenues built on a crooked cross-plan housing two-storey iron-fronted shops to a uniform design, the retail parts below linked by internal spiral staircases to office or storage spaces above. In the middle of the market is an octagonal crossing under a lantern and a pitched roof. There is an elaborate stone gable main entrance from Gracechurch Street and many iron columns, some topped with castings of dragons. The restoration in rich colours throughout, authentic to the original Victorian scheme, dates from 1990s.

The character of the market had changed forever, although the business activity changed more slowly as most of the shops were

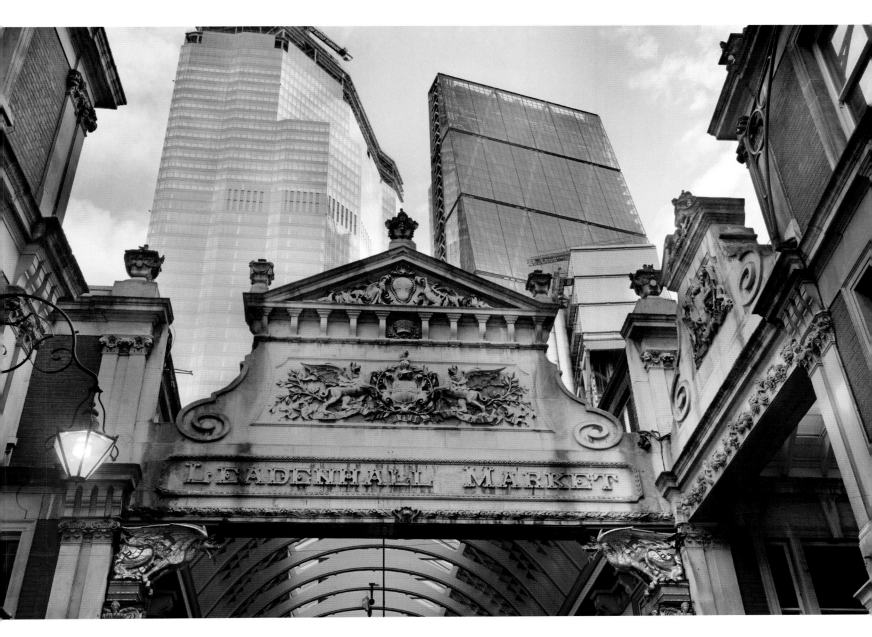

The historic entrance to the market among the high-rise buildings of the City.

originally still occupied by wholesalers of poultry. From the 1920s wholesaler traders moved out to the poultry market at Smithfield while retailers of poultry, meat and fish stayed or moved in. There were always three pubs in Leadenhall Market, and during the early 1980s more bars and restaurants came and the shops increasingly became boutiques dedicated to selling smart goods. The character of the place was well-suited to hospitality and the City was soon experiencing the deregulation of the financial markets.

Leadenhall Market has appeared in several feature films, many of which have harnessed its antique character for fantasy effect, most notably *Harry Potter and the Philosopher's Stone*, but the 1975 crime thriller *Brannigan* used the market as a realistic backdrop for an unlikely fist fight involving John Wayne and Richard

Attenborough. The market can be glimpsed for a moment in the background, with poultry sellers in white coats still at work in the arcades.

Although it is customary to trace the start of Leadenhall Market history from the Middle Ages, there is deeper ancient market history attached to this place. When Leadenhall Market was under construction in 1880, a line of Roman stonework was unearthed, later proved to be part of the archway of the great Roman basilica and forum of second-century Londinium. This great square served as a public meeting place and housed many shops and market stalls. The forum was also a popular place for socializing.

—

Leadenhall Market, Gracechurch Street, London EC3V 1LT

London Stone

The few facts known about London Stone are so outnumbered by myths that most accounts are compelled to describe it in legendary terms. The idea exists from early folklore that if the stone was moved, damaged or destroyed, the future of London itself would be jeopardized. Another legend is that it is part of a Druid altar, as described by visionary poet-painter William Blake.

It is known that the London Stone is oolitic limestone, serving as a Roman milestone or monument. A recent study by the Museum of London Archaeology suggests it was quarried in the Cotswolds. The stone is shown on medieval maps located on the south side of Candlewick Street (afterwards Cannon Street), opposite St Swithin's church.

In legend, the stone was said to represent a touchstone of power. In 1450, when Jack Cade, leader of the Kentish rebellion, entered London, he is said to have struck the stone with his sword and declared himself lord of the city. This is dramatized in Shakespeare's *Henry VI, Part 2*.

In truth, it was likely damaged by the Great Fire of 1666. In 1742, it became a traffic hazard and was moved north of the street against the new Wren church of St Swithin. There seems to have been a compelling need to preserve the stone and it was moved twice more in 1798 and in the 1820s and placed in the church's south wall. St Swithin's was bombed, but the stone remained in the ruined wall until 1960 when it was moved to the Guildhall Museum for safekeeping and then returned to Cannon Street in 2018.

London Stone was officially listed (Grade II*) as a structure of special historic interest in 1972. Its origin and the true purpose remain unknown.

—

London Stone, 111 Cannon Street, London EC4N 5AR

First recorded c.1100, London Stone is an historic landmark of oolitic limestone.

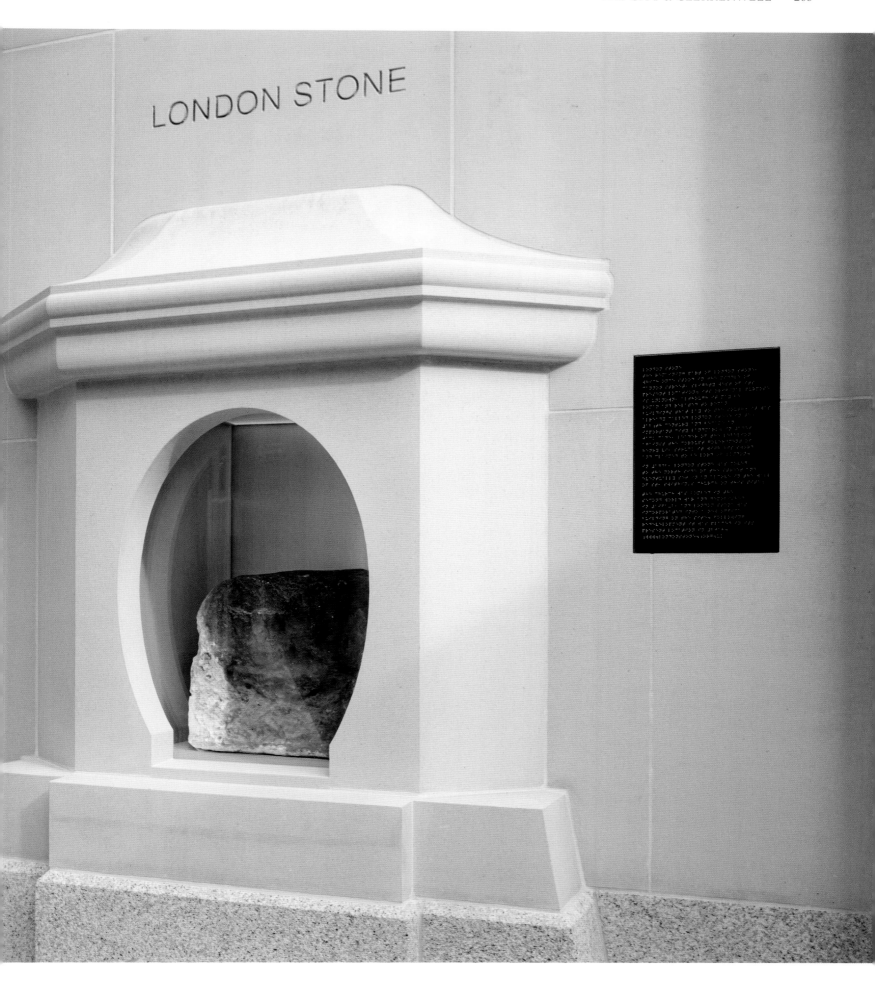

Drapers' Hall

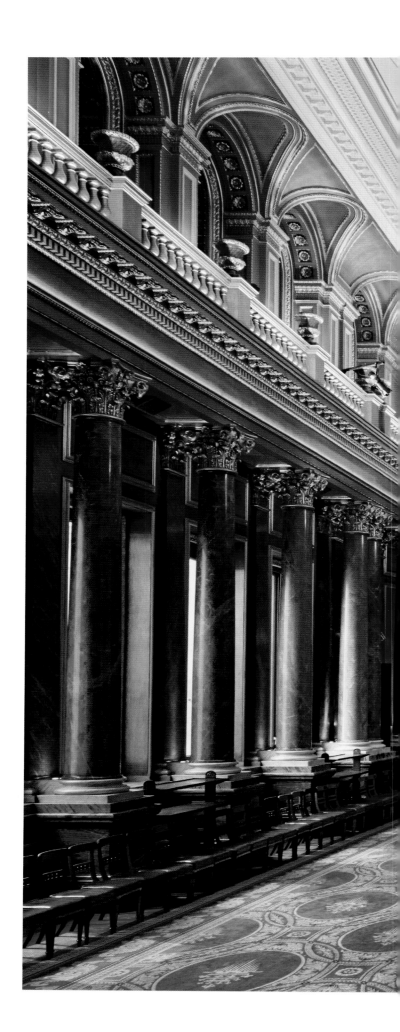

Drapers' Hall on Throgmorton Avenue is home to the Drapers' Company, third in precedence of the Great Twelve livery companies of London. The building is largely Victorian, based at a site with a long history stretching back to the Tudors. The Drapers' Company's first hall had been built in the 1420s in St Swithin's Lane, not far from here, but in 1543 the company moved to the current location and a house that had been home to Thomas Cromwell, chief minister to King Henry VIII. The building was sold after Cromwell's execution and the sequestration of his property by the monarch. This house burned down in the Great Fire of London of 1666, with little of it salvaged. Such was the devastation of 1666 that forty-three livery halls were lost out of more than a hundred livery companies of the City of London of the time.

The Drapers' Hall was rebuilt between 1667 and 1671 according to a design by Edward Jarman, a London surveyor commissioned to help with the rebuilding of the capital in the wake of the Great Fire. He provided the plans for the rebuilding of several of the city's livery halls. However, the process of rejuvenation did not end there. The hall was again rebuilt after another fire in 1772, and then in the 1860s Herbert Williams made changes both to the front of the building and its interior. Further alterations were made by Thomas Jackson more than a century later, while damage caused by bombing during the Second World War also required renovations to be made.

Drapers produced woollen cloth. The full title of the Drapers' Company is the Master and Wardens and Brethren and Sisters of the Guild or Fraternity of the Blessed Mary the Virgin of the Mystery of Drapers of the City of London. Documents suggest that the company can trace its history back to the late twelfth century.

The main entrance to the building is flanked by two imposing statues of the Titan Atlas, with the coat of arms of the company

The Livery Hall features twenty-eight marble Corinthian columns.

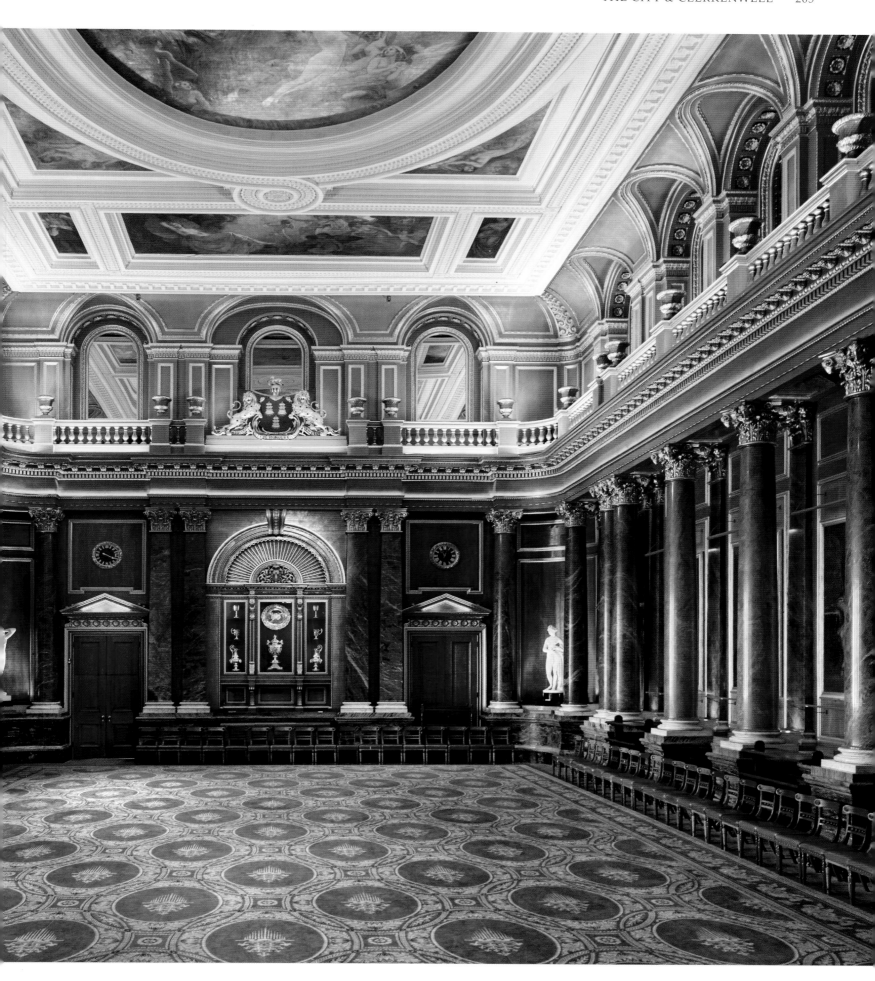

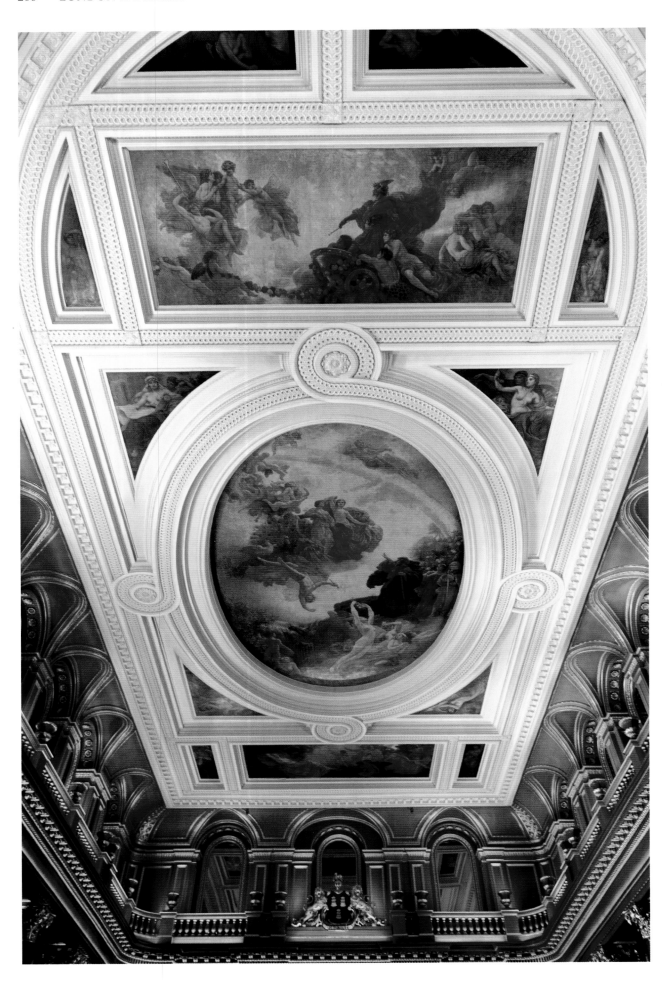

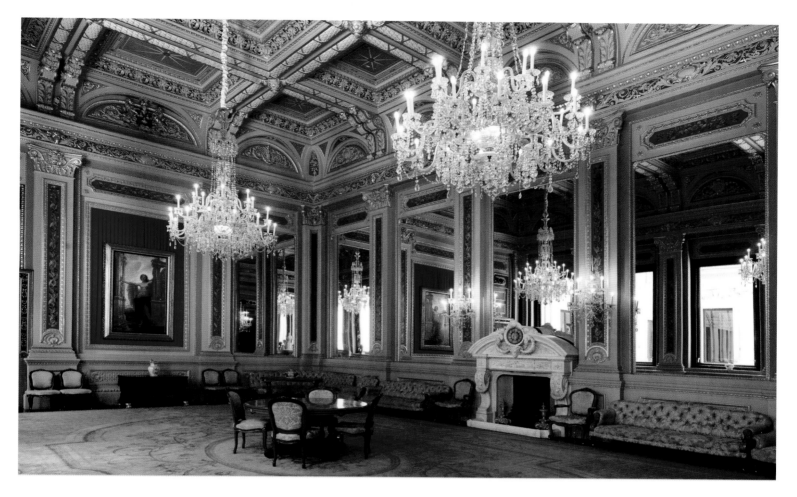

OPPOSITE *In 1901, the Drapers' Company commissioned Herbert Draper, a neo-classical artist, to create paintings for the Livery Hall ceiling panels. These were produced between 1903 and 1910.* ABOVE *The drawing room with its elaborate chimneypiece.*

above the doorway. A visitor's first taste of the interior of the building comes after the heavy bronze doors into the entrance hall, which was built at the end of the nineteenth century. Less a hall and more of an oak-panelled corridor, along its length it features the coats of arms of notables such as Lord Nelson, Sir Francis Drake and the Earl of St Vincent, famous names of England's naval tradition as well as Freemen of the Drapers' Company, in addition to numerous royal coats of arms, including those of the City and the Drapers' Company. Portraits of the Lambarde family can also be found here, the family having had a close association with the company dating back to the sixteenth century.

A marble and alabaster staircase accompanied by Ionic columns, also by Jackson and in the Italian Quattrocento (fifteenth-century) style, is a prominent feature leading away from the entrance hall up to a large first-floor landing, beyond which is the court room, with its decoration of wainscot, plaster ceilings, marble chimneypieces and statues.

At the heart of the building is the impressive and colourful Livery Hall, comprising twenty-eight marble Corinthian columns, between which are full-length portraits of royals dating from William III to Edward VII. The painted ceiling carries allegorical imagery and Shakespearean scenes. The grandeur of the room inspired the makers of the film *The King's Speech* to employ it as a royal palace, in a scene where the new king, George VI, is seemingly overawed by the portraits of former monarchs.

The drawing room has wall hangings, upholstered sofas and chairs and an elaborate chimneypiece, while the court dining room features more of the large Gobelin silk woven tapestries that are also to be found elsewhere in the building (the Gobelins were a family of French dyers and cloth-makers). The more modern-looking wardens' room is used as a general meeting room by the company.

Supporting charities is a key mission of the current-day company, as it is for other City livery companies; for example, the Drapers' Company is trustee to three almshouses, while also supporting several educational establishments.

—

Drapers' Hall

Throgmorton Avenue

London EC2N 2DQ

Photographer's Note

I'm a born and bred Londoner who thought he knew London incredibly well; yet my fourth London book has been another extraordinary journey of discovery for me. So, it is a joy to share the amazing secrets and surprises of my wonderful city in *London Explored*, with you the reader.

I'm seen here photographing one of my favourite locations from the book, the stunning, and rarely seen, Crystal Palace Subway, with its fan-vaulted ceiling of red-and-cream brickwork. The subway supports a four-lane highway and was built to connect Crystal Palace High Level station with the celebrated Crystal Palace building, a cast-iron and plate-glass building originally erected in Hyde Park to house the Great Exhibition of 1851. After the exhibition, it was rebuilt in an enlarged form at the top of Sydenham Hill. It proved a popular attraction and stood from 1854 until its destruction by fire in 1936.

As befits Victorian thinking, the poor left the station by the front entrance walking 450 metres / 500 yards up the hill across the road and into the palace via a public entrance. The rich though, with first-class tickets, used the private Crystal Palace Subway under the road and walked directly, via their own private staircase, into the palace.

London Explored was photographed over a period of eighteen months. Access was made possible through the generosity and help of friends and clients made throughout my career. The locations were all photographed on my Nikon cameras, using available light to capture each one's unique ambience.

Credit for photograph: Sarah Ryder Richardson

Index

London Explored is dedicated to my parents William and Freda MBE
and to my family Jannith, Tiger Itasca and Indigo Noa.

Acknowledgements

I would like to thank my family – Jannith, Tiger Itasca and Indigo Noa – for all their
encouragement; Mark Daly for his fantastic contribution and insight and for bringing the
book to life; my digital manager Esther Salmon; agent and producer Sarah Ryder Richardson,
publishers Richard Green and Jessica Axe, editor Michael Brunström and designer Sarah Pyke
for their invaluable expertise. Thanks as well to Carol Boxall, Mike Bryant, Simon Michell and
Brian Stater for their assistance in research. Finally, enormous thanks for the kindness and
generosity of all the locations that allowed access and helped make *London Explored* happen.

London Explored

First Published in 2021 by Frances Lincoln,
an imprint of The Quarto Group.

The Old Brewery, 6 Blundell Street,
London N7 9BH, United Kingdom.
T (0)20 7700 6700 F (0)20 7700 8066
www.QuartoKnows.com

Text © Mark Daly 2021
Photographs © Peter Dazeley 2021

A catalogue record for this book is available from the British Library.

ISBN 978-0-7112-4035-3

2 4 6 8 9 7 5 3 1

Typeset in Palatino and Scala Sans
Design by Sarah Pyke www.sarahpyke.com

Printed and bound in China

Brimming with creative inspiration, how-to projects and useful information
to enrich your everyday life, Quarto Knows is a favourite destination for those
pursuing their interests and passions. Visit our site and dig deeper with our
books into your area of interest: Quarto Creates, Quarto Cooks, Quarto Homes,
Quarto Lives, Quarto Drives, Quarto Explores, Quarto Gifts, or Quarto Kids.